EARLY MODERN VISUAL CULTURE

NEW CULTURAL STUDIES

Series Editors

Joan DeJean
Carroll Smith-Rosenberg
Peter Stallybrass
Gary A. Tomlinson

A complete list of books in the series
is available from the publisher.

Early Modern Visual Culture

Representation, Race, and Empire
in Renaissance England

Edited by
PETER ERICKSON and
CLARK HULSE

PENN

UNIVERSITY OF PENNSYLVANIA PRESS
Philadelphia

10 9 8 7 6 5 4 3 2 1

Published by
University of Pennsylvania Press
Philadelphia, Pennsylvania 19104-4011

Library of Congress Cataloging-in-Publication Data
Early modern visual culture : representation, race, and
empire in Renaissance England / edited by Peter Erickson
and Clark Hulse.
 p. cm. — (New cultural studies)
Includes bibliographical references and index.
ISBN 0-8122-3559-2 (cloth : alk. paper) —
ISBN 0-8122-1734-9 (pbk. : alk. paper)
1. Arts, English. 2. Arts, Modern—England.
3. Renaissance—England. I. Erickson, Peter.
II. Hulse, Clark, 1947–. III. Series.
NX544.A1 E18 2000
700'.942'09031—dc21 00-039287

In Memory of

TAY GAVIN ERICKSON

CONTENTS

INTRODUCTION

CLARK HULSE AND PETER ERICKSON

The field of visual culture has emerged in the past decade as a heterogeneous collection of disciplines and practices, potentially including all that is "culture" so long as it partakes of the "visual." In their seminal collection *Visual Culture: Images and Interpretations* (1994), Norman Bryson, Michael Ann Holly, and Keith Moxey characterize the field of visual culture as "a history of images rather than a history of art," in which students of visual culture move away from the study of the creation of aesthetic masterpieces which has characterized traditional art history, and move toward the study of the social meaning of visual images, both within the cultures that produced them and within the culture of our own time.[1] The transformation of the history of art into the history of images would, in their view, bring visual studies into closer contact with other disciplines, especially the varied strains of semiotic, deconstructive, new historicist, and feminist work found in literary studies.

Simultaneously, much of the innovative work being done in literary studies is undergoing a transformation toward the visual. Modern literary theory has up until now produced a linguistic turn in the study of culture in which the semiotic structure of language is read onto the symbolic structures through which social order and individual identity are formed. Yet Martin Jay has demonstrated in *Downcast Eyes: The Denigration of Vision in Twentieth-Century French Thought* (1993) that a fundamental substrate of visual metaphor persists in the writings that form the basis for contemporary literary and cultural theory. Drawing on Jay's analysis, W. J. T. Mitchell proposes that the "linguistic turn" of the mid-twentieth century is now being supplanted by a "visual turn" of thought that generates two forms of visual study: iconology, or the study of images across various media, and visual culture, or "the study of the social construction of visual experience."[2]

The study of visual culture thus emerges at the intersection of these two trajectories, one running from art history toward cultural and literary studies, the other running from literary and cultural studies toward the history of images. The duality of trajectories in turn demands that Mitchell's definition of visual culture be extended and reversed: if visual culture is the study of the social construction of visual experience, then equally it is the study of the visual construction of social experience.

* * *

The essays in this volume explore central concepts in literary and cultural studies in order to move them along the trajectory toward visual culture. Focusing on the

CLARK
HULSE AND
PETER
ERICKSON

early modern period (which we take roughly as the period of 1500 to 1700), and in most cases specifically on England, the authors write in a diversity of voices on a range of subjects. Common to them, however, is a concern with the visual technologies that underlie the representation of the body, of race, of nation, and of empire. While the essays explore the social context in which paintings, statues, textiles, maps, and other artifacts are produced and consumed, they also explore how those artifacts, and the acts of creating, collecting, and admiring them, are themselves mechanisms for fashioning the body and identity, situating the self within a social order, defining the visual otherness of race, ethnicity, and gender, and establishing relationships of power over others based on exploration, surveillance, and insight.

Our collective investigation of early modern visual culture can inevitably touch on only a few important aspects of an enormous area. The artifacts and social practices that make up the potential subject matter of the field are nearly innumerable, including those things made solely to be seen, such as painting and sculpture, but also things made to be used while being seen, such as maps, fabrics, and architecture. They include ritual and spectacle, whether religious, political, theatrical, or penal, and the sites of spectacle, such as the stage, the gallery, and the public square. They include the technologies of seeing, such as mapping, surveying, anatomizing, and gazing, the exhibitionist technologies of self-display, and the economies within which some people get to look, and others get looked at. They include the systematizing of vision as a form of knowledge or pleasure, and the repression of vision through iconoclasm—a subject in itself in the era of Reformation and Counter Reformation. Finally, they include the transformation of the natural into culture through these actions of seeing and being seen, whether it is the body natural that is thereby transformed, or the body politic, or the body of the earth as it is molded into landscape and circled into a globe.

Hence our enterprise in this volume shares with and depends upon the work of others in early modern art history and literary studies. Especially important are the contributions of the new art history. The project of "visual culture" as an academic inquiry is commonly traced to Michael Baxandall's *Painting and Experience in Fifteenth Century Italy* (1972), which gave equal space to both linguistic and nonlinguistic modes for the construction and social deployment of visual knowledge. The term "visual culture" was given wide currency by Svetlana Alpers with her influential book *The Art of Describing: Dutch Art in the Seventeenth Century* (1983), which argued for a geographic contrast between a more linguistically centered painting of "narration" in southern Europe, and a more visually centered painting of "description" in the North. More recently, Joseph Koerner has put the foundational precepts of Renaissance aesthetics under scrutiny in his monumental *The Moment of Self-Portraiture in German Renaissance Art* (1993), tracing out visual aporias and deconstructive moments within Dürer's recapitulations of the motifs central to Christian and humanist

art. Keith Moxey deviated from the usual focus on high art to examine popular wood-cuts and other ephemeral materials in *Peasants, Warriors and Wives: Popular Imagery in the Reformation* (1989). Claire Farago follows on Moxey's shift of attention to the subcanonical in her collection *Reframing the Renaissance: Visual Culture in Europe and Latin America, 1450–1650* (1995), while introducing race and empire as formative terms for understanding the creation of canonical art-historical artifacts.

Arrayed in this sequence, these exemplars of the new art history trace an arc from an Italocentric to a cross-cultural perspective. The volumes by Baxandall, Alpers, Moxey, and Koerner each focus on a single national culture—the first two on Italy and the Netherlands respectively, and the last two on Germany—though Alpers and Koerner necessarily define the national visual culture through and against the hegemony of Italy, as Baxandall likewise does in *The Limewood Sculptors of Renaissance Germany* (1980). Farago moves forcefully toward a Pan-European and transatlantic intercultural perspective, as is indicated by the subtitle of her collection. While the focus of traditional Renaissance art history has been primarily on Italy, secondarily on northern Europe, and only incidentally on England or the New World, the contributions to the present volume attempt to exploit the opening made by the new art history to just about exactly reverse the traditional emphasis: we focus primarily on the singular culture of England, then on the New World, northern Europe, and least on Italy.

The potential for this reversal lies in part in the long-standing alliance between the literary and the art-historical study of early modern England, an alliance that has always been founded on the premise that visual and literary artifacts alike must be understood in relation to their social meaning. The ancestry of this alliance can be distantly traced to the emigration of Aby Warburg and the Warburg Institute from Nazi Germany to London in 1933, for Baxandall, Alpers, and other leaders of the new art history represent one line of intellectual descent from the Warburg Institute, just as the new historians of English Renaissance literature represent another line. More particularly, the reestablished institute in London drew English scholars, notably Frances Yates and D. J. Gordon, who worked forcibly across the line between literary and visual materials in order to trace out the symbolic superstructure of Renaissance culture. And it provided a site for the collaboration of Yates's student Roy Strong with the American literary scholar Stephen Orgel.

Strong's early work on Tudor portraiture shows a concern with central questions of traditional art history: the identification of sitters, the definition of a repertoire of forms, and the authentication and attribution of artifacts. Strong was, however, simultaneously making explorations into the symbolism of the portraits and their relation to Elizabethan royal ceremony, explorations that culminated in *The Cult of Elizabeth: Elizabethan Portraiture and Pageantry*. Though published in 1977, the book includes essays from the 1950s and 1960s and thus "expresses a thought pattern about Elizabethan portraiture that went back to my earliest research years at the Warburg Institute"

CLARK
HULSE AND
PETER
ERICKSON

with Frances Yates.[3] The great value of *The Cult of Elizabeth* is the organizing force of its central concept of a systematic cult by which monarchial power was orchestrated and asserted. The concept of "cult" is a problematic one, however, and while the book shrewdly observes the element of Realpolitik in the power relations that underlie the portraits, it remains celebratory both of the artifacts and of the authority of the queen herself.

Strong's work marked him as the most prominent of a group of British scholars who established the importance of the study of English Renaissance painting and spectacle, including Sidney Anglo, Oliver Millar, Graham Parry, and Frances Yates herself. But Strong's centrality was reinforced by his collaboration with Stephen Orgel in an investigation of the Stuart court masque, an investigation that culminated in their two-volume work *Inigo Jones: The Theatre of the Stuart Court* (1973). Together they defined the masque as a verbal and visual medium that placed the artistic form in the service of royal propaganda even as it recast power itself into aesthetic terms. The result was not only a set of powerful insights into the work of Jones, Ben Jonson, and others and into the operation of symbolic power in the early seventeenth century, but a powerful methodology for understanding the intersection of art and ideology.

While the techniques of Orgel's and Strong's analysis of the Stuart masque have their roots in the work of the earlier Warburg scholars, *Inigo Jones: The Theatre of the Stuart Court* marks a turn toward a new mode of study. Traditional iconography emphasizes the inner workings of the symbolic artifact; once its allegory is interpreted, the painting is wholly understood, and the work of interpretation is done. The implicit assumption is that iconography works exactly as its creators intend it to work and should be accepted by its later audiences within the ideological intentions of those creators. But this investment in intended meanings makes the location of the critic problematic: the tight restriction of his or her point of view by a tacit identification with the creative act leaves little or no room for critical perspective. Rich iconographic material is assembled but held in an interpretive vacuum, and investigation never proceeds to the second line of questioning about tensions in a complex work of art that might counteract or undermine its intended orthodoxy. Orgel and Strong, by contrast, focused on an ideological art deployed in the service of a failing political culture—an art that was, indeed, under savage attack by the opponents of that political culture—and so opened the way to seeing the intended ideological work of the artifact as itself just one force in an array of forces at its moment of creation, and just one in an array of forces at its moment of modern critical interpretation.

The keynote in Strong's later work is continuity and consolidation. *Gloriana: The Portraits of Queen Elizabeth I* (1987) looks back to and recapitulates *Portraits of Queen Elizabeth I* (1963) and *The Cult of Elizabeth*. His prefatory survey in *Tudor and Stuart Portraits, 1530–1660* (1995) justly celebrates his achievement in winning recognition for British Renaissance painting as a significant area of study. On a more massive scale,

the three-volume project entitled *The Tudor and Stuart Monarchy: Pageantry, Painting, Iconography* (1995–1997) gathers previously published essays with retrospective headnotes that narrate and summarize an entire career. Strong's dramatic description of his knighting by the second Elizabeth suggests a remarkable internalizing and modernizing of his scholarly identification with the cult of Elizabeth: "At the moment my surname was called I advanced, went towards the Queen, knelt, the sword catching the light while her hand placed an order around my neck. . . . I wonder whether it was different for Ralegh or Drake? Certain sensations must have been the same: the presence of the sovereign, the throne, kneeling, the flash of steel across the shoulders" (*Diaries*, p. 313). This construction of an internal iconography is matched by a political one as well. "As I wrote the book [*The Story of Britain* (1996)] I was intensely aware of the fact that the very idea of Britain was being deconstructed" (p. xi), and "the very concept of Britain is now being deconstructed by historians as an invention elaborated over the centuries to persuade those of us who live here that they share a common identity" (p. 567). The critical examination of how national and monarchial ideology is formed, initiated in part by *The Cult of Elizabeth* and *Inigo Jones: The Theatre of the Stuart Court*, is here arrested in its tracks, and Strong's own contribution to that work of deconstruction is elided.

* * *

In a different context and a different nation, two contributors to this volume, Harry Berger, Jr., and Stephen Orgel, have been leading figures in the development of new, de-idealizing approaches to the analysis of the inner organization of the visual or literary symbol. In a series of essays written mostly in the 1960s, Berger developed the concept of a "second world" constructed by the mind or imagination that could take on ontological force as a hypothetical competitor with and critic of the "first world" we accept as reality.[4] Berger traced such fictions across a variety of early modern instances, including Shakespeare's *Tempest*, scientific methods, cosmological representations, and the works of visual artists, especially Leonardo and Alberti. In more retrospective and introspective essays and books written since the 1980s (and including the essay in this volume), Berger has subjected his understanding of the imaginary force of "second world" constructions to an ethical scrutiny that brings to the surface the ways in which these constructions are in malevolent complicity with the social constructions of first-world reality. Again his analyses have drawn on both literary and visual examples, including, most recently, an examination of portraiture in *Fictions of the Pose: Rembrandt Against the Italian Renaissance* (2000).

From the time of his collaboration with Strong to its more recent phases, the body of Stephen Orgel's work has exhibited a critical turn. Orgel followed out the critical examination of political art begun in *Inigo Jones: The Theatre of the Stuart Court*

with the slender but revolutionary volume *The Illusion of Power: Political Theater in the English Renaissance* (1975), which examines a general shift in seventeenth-century theatrical representation and relates it to the conflict of forces within English society. Later, in his Oxford edition of *The Tempest* (1987), Orgel carried the deconstructive implications of his arguments to the examination of the text of Shakespeare's most masque-like play, tracing the marks of gender politics, in Shakespeare's age and in modern editing practices, as they erased Prospero's wife from the represented scene and from the text itself. The recent *Impersonations: The Performance of Gender in Shakespeare's England* (1996) carries his analysis of the power relations of Shakespearean theater from male-female to male-male relationships, while his article on "Teaching the Postmodern Renaissance" institutionalizes this set of insights in the classroom.[5]

Together Berger and Orgel have been powerful influences on the new historicist movement in English Renaissance literary studies, a movement which from its inception has dealt with a wide range of visual media. Stephen Greenblatt began *Renaissance Self-Fashioning* (1980) with a discussion of Holbein's *Ambassadors*, inspired in part by Lacan and modeled on Foucault's analysis of Velázquez's *Las Meninas*. Louis Montrose placed images of Henry VIII and Elizabeth I at the center of his historical/psychoanalytic examinations of the Elizabethan subject. Jonathan Goldberg linked painted representations of noble families to the Jacobean reassertion of patriarchy in *James I and the Politics of Literature* (1983), while Don Wayne examined the social history of Penshurst to unravel the celebratory work of Jonson's poem in *Penshurst: The Semiotics of Place and the Poetics of History* (1984). Steven Mullaney's attention to urban topography and the phenomenon of the wonder-cabinet in *The Place of the Stage: License, Play, and Power in Renaissance England* (1988) demonstrated how the "collecting" of exotic peoples and materials in theaters and elsewhere organized social forces, while Richard Helgerson's analysis of maps in *Forms of Nationhood: The Elizabethan Writing of England* (1992) revealed how they not so much reproduced as called into being the ideological concept of the state.

Much of this writing is deeply indebted to Strong's work on Tudor pageantry and portraiture, as well as to Frances Yates's influential book *Astraea: The Imperial Theme in the Sixteenth Century* (1975), but it takes the material in such strikingly different directions as to overturn their original conclusions. Like Strong and Yates, the new historicist writers of the 1980s and early 1990s focused on the mechanisms of royal and aristocratic power, but their overall emphasis shifted from intended iconographic meanings to a more intensive scrutiny of how art, and the idea of art itself, could act as a form of political communication. The relationship of new historicism to a Warburgian historical study of symbolic forms is likewise described more as a break than a continuity. The break may be typified in Stephen Greenblatt's critical review of *The Cult of Elizabeth*, written shortly before the publication of *Renaissance Self-Fashioning*, where he notes how the older line of analysis confronts "the extreme difficulty of find-

ing a satisfactory way of characterizing the relationship between ideology and power, a way of avoiding the collapse of one into the other."[6]

Hence the position of the political as an element within the aesthetic comes under critique, and the idea of the political is necessarily broadened to embrace other forms of social power, especially gender difference. The turn marked by the deconstructive social analysis of new historicist and feminist work in literature is thus parallel to the turn of the new art history. Their inevitable convergence can be epitomized by the two essays on visual subjects in the 1986 volume *Rewriting the Renaissance*. The analysis of a Rubens family portrait by the literary scholar Jonathan Goldberg and the analysis of Italian portraits of women by the art historian Elizabeth Cropper share a common disenchantment from the masculine power that gives form to these paintings, and a disenchantment from the aestheticization of that power through art. Each in effect uses the scholar's own power of critical analysis to mark the convergence of patriarchal power with aesthetic form in the early modern period and to point to the possibility of their divergence in the present.

The appearance of Cropper's essay in a volume primarily devoted to literary studies gave an impetus to a growing attention to visual materials by feminist literary scholars. It was, however, really the emergence of the study of the construction of the body in the early 1990s where feminist literary critics fully embraced visual subjects, especially the portraits of Elizabeth I. The development of "body criticism" is in turn tied to the emergence of a new material cultural criticism in early modern studies, which has brought critics informed by both feminist and new historicist criticism to turn their attention to a range of visual artifacts, especially engravings and other forms of book illustration. Notable here are the analyses of gender in engraved title pages by Wendy Wall in *The Imprint of Gender: Authorship and Publication in the English Renaissance* (1993) and Jonathan Sawday's analyses of anatomical illustrations in *The Body Emblazoned: Dissection and the Human Body in Renaissance Culture* (1995).

In the wake of the critical developments in literary studies and the new art history, the art history of early modern England has reached a watershed of its own. In a trenchant account of recent criticism in the introduction to the fifth edition of Ellis Waterhouse's *Painting in Britain, 1530–1790*—published in 1994, nearly a decade after Waterhouse's death and fifteen years after the previous edition—Michael Kitson charts the emergence in the early 1980s of a methodological "revolution" in British art history. In Kitson's judgment, this revolution has produced a division between traditionalist and new art history so fundamental as to make further revision of Waterhouse's text impossible (p. xii). The social analysis and demystification of recent scholarship are simply incompatible with Waterhouse's excessive "gush" (p. xxvii). Kitson points especially to work on eighteenth-century English art as suggestive of what might be done for the sixteenth and seventeenth centuries, and indeed some work in the new mold is appearing. The state of scholarship on early modern English visual art

CLARK
HULSE AND
PETER
ERICKSON

is epitomized by the volume *Albion's Classicism: The Visual Arts in Britain, 1550–1660* (1995). The foreword to that volume refers to the field of British Renaissance art as "a comparatively underdeveloped area of scholarship" (p. vii), at least in relation to English literature or Italian Renaissance art history, but *Albion's Classicism* significantly advances that development by bringing together work on architecture, painting, and sculpture, while opening up issues of visual ideology connected with humanism and reformation. The problematic identity of England as a nation-state and an imperial power is, however, brought under only a limited scrutiny by the term "Albion" and issues of cross-cultural analysis are compressed into the narrow range of "classicism."

A goal of this volume is to build on the beginning marked by *Albion's Classicism* and bring the field of early modern English visual culture even further within the critical revisions of literary/cultural studies and the new art history. Those revisions are in many ways epitomized by the substitution of the term "early modern" for "Renaissance"—a substitution far more widely practiced in literary and cultural studies than in art history. As a field descriptor, "early modern" displaces the progressive implications of "Renaissance," decentering its implicit claims to establish a normative or classical form of human subjectivity and the human body which can be seen as Italy's and Europe's benign gift to the world. In its place, "early modern" has become a site for a series of critical discourses—feminist, new historicist, deconstructive—which have developed a description of the period as a time marked by ideological, class, and gender conflict and technological transformation, as well as the emergence of early forms of the modern state, modern imperialism, and modern conceptions of the body, of race, and of sexuality still persistent both within Europe and in the postcolonial world that in the interim existed under Europe's sway. A more complex model of the underlying society in turn allows for a positive expansion both of the range of artifacts considered within "visual culture" and of the interpretive possibilities for those objects, especially with regard to issues of gender and race.

By focusing on England, we mean to portray it not just as a special case within the early modern world, but as a paradigmatic case that presents interesting conceptual problems for the very issues of gender, ethnicity, and national identity that are now being posed within the new art history of Italy, northern Europe, and the New World. By examining the interplay of visual elements within English culture, we hope to show how they are a part of the fashioning of communal and national identity and hence part of the formation of the nation-state itself. In visual terms, ethnicity and race emerge in the British case as internal concepts that are inseparable from conceptions of personal identity. By moving our analysis to a point largely outside of the normative geography of central Italy, it may be possible to reconceptualize the analytical categories of the human figure, of the nature of visual display, and of the metaphorics of "color"—all categories which have always been at work within traditional art-historical scholarship—and to redeploy them in ways that may eventually

be reapplied to Italy as a special case rather than as the paradigmatic event. From that inverted perspective, English-Continental and European–New World cultural interactions may likewise be reunderstood.

* * *

Indeed, the geographical sequence of this volume stands in an order that almost exactly reverses the usual emphases in art history. It begins with essays focused on transatlantic and Pan-European issues, moves tangentially to Italy in order to address issues that proved central to early modern European culture as a whole, and then settles on English topics for the six essays that make up the center of the volume, before returning to a broad consideration of materials drawn from the entire Atlantic rim, from Europe to Africa to the New World.

In thematic terms, the essays in the volume fall into four interlocking subgroups. The first, focusing on technologies of visual representation, begins with Steven Mullaney's examination of the reciprocal spectacles of the sixteenth and early seventeenth centuries in which Spanish and English colonizers amazed the inhabitants of the new worlds with visual artifacts. His analysis begins with the "trifles"—especially glass beads—that Europeans brought as objects of wonder to the inhabitants of the New World, and ends with representations of the New World—or even actual inhabitants from the New World. These exhibitions, Mullaney argues, acted as ways of formulating and enforcing a consciousness of subjugation which he calls, in a historicizing of Lacan's vocabulary, a colonial mirror stage. Mullaney's concern with the display of exotic peoples is picked up and extended by Valerie Traub in an essay tracing the "marginal" deployment of women's bodies as vehicles for the development of categories of gender and race in the illustrations of European maps and atlases of the sixteenth and seventeenth centuries. Traub demonstrates how the cartographic processes of spatialization and rationalization, when applied to ethnographic images, worked to normalize gender difference and marital heterosexuality.

In an essay that turns our attention from the conquest of the New World to the conquest of nature itself, Harry Berger, Jr., proposes that Renaissance technologies of visual representation were conceived of as prosthetics, that is, as mechanisms for artful repair of a defective human body. Berger examines how Alberti, Leonardo, Vesalius, and Vasari conceived of visual representation as a "second nature" that generates a disgust for the decaying natural body even as—indeed, so that—it may resurrect that body into art.

Together the three essays—by looking at mirrors, maps, festivals, anatomies, and artists' lives—indicate the range of visual technologies at work in early modern culture. At the same time, Traub's, and to an even greater extent Berger's, essay forms a bridge to a second section focused on the art of portraiture. Traub's essay attends to

the representation of generic bodies, rendered not as individuals but as examples of gender and ethnicity. Berger likewise focuses on the generic body as it is examined, dissected, and repaired by Italian Renaissance artists. Clark Hulse then turns our attention to the canonical art of portraiture, that is, the representation of a historically specific individual face or body. Recalling Berger's concern with prosthetics, Hulse examines the process by which the physical and painted bodies of Thomas Cromwell are dismembered and remembered, especially through the beheading of its subject and the copying and alteration of Holbein's portrait. In the process, Hulse offers a coda to the section on visual technologies by reflecting on how the verbal process of "reading" can—and cannot—be transferred to the visual object.

With Hulse's essay, the focus of the volume moves decisively to England in the early sixteenth century. Karen C. C. Dalton then surveys English portraiture of the mid-to-late sixteenth century, organizing her discussion around ideas of empire, as they emerge from a juxtaposition of the Drake Jewel and the image of a black emperor, both of which serve as indexes of Elizabethan ideology. The only art historian among the contributors, Dalton works in a methodological vein that is indebted to Strong, demonstrating the continued vitality of traditional iconography as a mode of "reading" images. Her concern with the issue of race in its visual dimension hearkens back to Traub's essay and forward to the concluding essays of the volume.

Together, Hulse's and Dalton's essays describe the play of meanings that portraits may acquire as they are produced and consumed within specific social groups. Susan Frye picks up this theme from another angle in her examination of the symbolic identifications made between the bodies of women and the textiles that they make. Frye develops her argument through an analysis from private and public rooms of Hardwick Hall to the open spaces of the Shakespearean stage, so that textiles become readable as portraits of a particularly gendered nature for historical women, such as Bess of Hardwick and Mary, Queen of Scots, as well as for fictional characters such as Desdemona or Imogen. The placement of these three essays after the opening group repositions our understanding of portraiture, not as a prescriptive category of high-art production, but as another powerful "visual technology," a way of constructing body and identity through materials of wood, canvas, and paper, as well as through social and ideological forms.

At the same time, Frye's essay forms a bridge to the third group of essays, focused around patronage. While Frye examines the patronage of Bess of Hardwick, the essays that follow focus on the greatest English nonroyal patron of the early modern period, Thomas Howard, earl of Arundel. Stephen Orgel is the first to address Arundel, placing him within the history of seventeenth-century collecting, while connecting the public display of high art to the political interests of the English elite. Orgel's essay harks back to his earlier work with Strong in its description of the court masque, while building on his subsequent directions in his focus on the specific aims

of Arundel's collecting projects. Ernest B. Gilman follows with an exploration of the aesthetic and imperial agendas of Van Dyck's "Madagascar" portrait of the earl, which celebrates his position as earl marshal of the aristocracy, promotes his identity as England's premier collector, and publicizes his colonization schemes for East Africa. In the process, Gilman establishes the ideological kinship between the cultivation of artistic connoisseurship and the "art of colonization" by which the English acquired new plantations overseas. Gilman describes this kinship as the work of a "protocolonial imagination," through which Arundel—and England—began to imagine an imperial expansion that still lay largely in the future.

As Gilman did with "empire," Peter Erickson in his essay addresses race as an emergent category, picking up an issue broached earlier by Traub and Dalton. Erickson traces the deployment of whiteness as a trope for cultural superiority in a series of paintings associated with the Order of the Garter, including Raphael's *Saint George and the Dragon*, Elizabeth's Garter portrait, and the Madagascar portrait of the earl of Arundel. Finally, Kim F. Hall offers a discussion of the "presence" of black women in early modern painting, focusing especially on depictions of the Queen of Sheba. In its wide range, the essay gathers up the themes that have been woven through the volume, and reasserts the volume's cross-cultural frame of reference. In an epilogue, Peter Erickson draws out one especially important strand for further cross-disciplinary work, through the convergence of the issues of race and homosexuality within the visual field.

* * *

By drawing together this body of theoretically informed work on visual matters, the volume as a whole is intended as a set of provocations to its audiences. First, these essays are meant as a provocation to the field of English Renaissance art history, a provocation to continue the widening of subject matter and methodology that it is already beginning to experience. Indeed, many of the characteristics that have in the past contributed to the low status of English art within the field of Renaissance art history may now play as advantages: the relatively high status within the culture of subcanonical materials such as textiles, maps, and graphic arts; the interest in anamorphic forms; the predominance of social over aesthetic concerns; the persistence of craft traditions; and the late emergence of humanistic patronage.

Second, the volume is meant as a provocation to the field of Renaissance art history generally, insofar as it continues to focus almost exclusively on Italy and northern Europe. Much of the intellectual rigor of Renaissance art history over the past century has derived from its absorption in a restricted set of canonical objects of the Italian Renaissance (and, to a lesser extent, in the works of a few northern artists such as Van Eyck and Dürer), and its claims to disciplinary centrality have derived from the pre-

CLARK
HULSE AND
PETER
ERICKSON

supposition that these objects are the foundation both of the modern subject and of the civilization he has built. If Renaissance art history is axiomatically the most relevant visual discipline for the study of the subject matter of early modern visual culture, it is also the one whose relationship to the emerging discipline of visual culture is inevitably the most contentious. Even as "visual culture" as a subject matter breaks down the cult status of this restricted set of artifacts and disseminates interest across a wider field of objects, "visual culture" as an emerging discipline proposes the decentering of the modern subject into a scopic regime, as well as the disruption of any benevolent account of civil order of the early modern period.

Third, these essays address the reciprocal challenge facing the field of early modern literary and cultural studies, which is to attend in a critical way to the visual dimensions at the core of its prevalent methodologies. These visual dimensions have often been unexamined and unexplained precisely to the extent that they have seemed to be easy tools for examining and explaining literary texts and explaining cultural phenomena as texts. It is therefore important to note a significant strand of work in the theorization of visual culture that has protested against the subjugation of visual studies to the linguistically and textually centered currents of postmodern literary theory. In *Downcast Eyes*, Martin Jay has demonstrated that the strain of visual metaphor that runs through most of the important practitioners of twentieth-century French theory persistently involves a denigration of vision. This "anti-ocular discourse" is reflected in the negative connotations of many of the critical terms, including "surveillance," "gaze," and "spectacle," that are central to cultural studies generally and to the essays in this volume.

Seconding Jay's analysis, W. J. T. Mitchell has proposed that the "linguistic turn" in modern thought was achieved by this body of theory not only through an antiocular vocabulary but through a disparaging of nonlinguistic forms of knowledge, and that the incipient "visual turn" must begin by resisting this disparagement and denigration.[7] Barbara Stafford pursues this dimension of the visual turn to its logical conclusion in calling for a return to the understanding of vision and visual knowledge as primary and material processes, embedded in the material understanding of the mind now emerging from cognitive science.[8] In the process, she challenges the quest for a semiotics of the visual that characterizes much of the new art history in its desire for a rapprochement with cultural studies. Hence Stafford questions whether cultural studies and the new art history can proceed through a reliance on theories of discourse or other critical tropes derived from adjacent fields, even as those other disciplines are "themselves, ironically, in the throes of blurring or dissolving."[9]

Hence the perceived danger of a subjugation of the visual to the verbal is tied up with the utopian goal of undoing the restrictive force of disciplinary discourses—a goal that is widely shared by cross-disciplinary and interdisciplinary work, including much of cultural studies and the new art history. Some such utopian impulse

hovers over the pages of Jay and Stafford in their critique of these fields, and espe-
cially characterizes Mitchell, who calls for a liberatory "indiscipline" that will arise
from the emerging convergence of literary and visual studies. The essays in this vol-
ume are intended as examples of such a convergence. They are all the work of scholars
who have been participants in the development of feminist and new historicist cul-
tural studies. With one exception, they are the work of literary scholars, or at least of
scholars whose original field was literature, all of whom have given their prior work
a significant visual direction. Hence the cross-disciplinary nature of the volume is de-
fined first and foremost by the work itself, through a convergence of subject matter
and of languages of interpretation.

While we will embrace any paradigmatic novelty that might emerge from these
pages, we conceive of the project in terms that are more disciplinary than utopian. As
Stanley Fish has observed in his *Professional Correctness* (1995), the liberatory rheto-
ric of interdisciplinarity depends on a contradiction, whereby the difference of disci-
plines from one another is restrictive and limiting, while the difference of interdisci-
plinarity from those disciplines is somehow transcendent.[10] But Fish is not arguing
against interdisciplinary work, only against unrealistic claims about how that work
does its work. That is to say, cross-disciplinarity of the kind we here embrace is a dis-
tinct practice, with its own specific objects, methods, results, and limitations, just like
traditional disciplines. It is a cross-disciplinarity generated not only at a conceptual
level, but through the bottom-up, archivist cross-discipline of the intellectual shop
floor, by which the broad concepts of interdisciplinarity are subjected to the critique
of a particular and material study of culture. To the extent that these studies may con-
tribute to the redefining of the central concepts of cultural studies as primarily visual,
and may participate in the turn from a linguistic to a visual conception of the substrate
of culture, they may contribute as well to the historicizing and eventual undoing of
the anti-ocular discourse.

Indeed, the logic of this introduction is that cross-disciplinarity arises not from a
transcendence or even a blurring of discipline, but from an embracing of the dynamic
and self-transformative quality of intellectual work, which is characterized in this case
by a happy convergence and intersection of a variety of disciplinary logics. We hope
thereby to dwell at that point of intersection, in order to take the visual issues that
have appeared persistently, though often marginally, in the new literary and cultural
criticism of the last twenty years, and bring them to the center of the debate.

Notes

1. Norman Bryson, Michael Ann Holly, and Keith Moxey, eds., *Visual Culture: Images
and Interpretations* (Hanover, N.H.: Wesleyan University Press, 1994), p. 2.

2. W. J. T. Mitchell, "Interdisciplinarity and Visual Culture," *Art Bulletin* 77 (1995): 540.

3. Strong's relationship with Frances Yates is described in *The Roy Strong Diaries* (London: Weidenfeld and Nicolson, 1997), pp. 296, 304–8.

4. These essays are collected in Harry Berger, Jr., *Second World and Green World: Studies in Renaissance Fiction-Making*, ed. John Patrick Lynch (Berkeley: University of California Press, 1988).

5. Stephen Orgel, "Teaching the Postmodern Renaissance," in *Professions of Desire: Lesbian and Gay Studies in Literature*, ed. George E. Haggerty and Bonnie Zimmerman (New York: MLA, 1995), pp. 60–71.

6. Stephen Greenblatt, review of Roy Strong, *The Cult of Elizabeth* (London: Thames and Hudson, 1977), *Renaissance Quarterly* 31 (1978): 643.

7. W. J. T. Mitchell, *Picture Theory: Essays in Verbal and Visual Representation* (Chicago: University of Chicago Press, 1994), chap. 1.

8. Barbara Maria Stafford, *Good Looking: Essays on the Virtue of Images* (Cambridge, Mass.: MIT Press, 1996), pp. 3–17.

9. Ibid., pp. 8–10.

10. Stanley Fish, *Professional Correctness: Literary Studies and Political Change* (Oxford: Clarendon Press, 1995), p. 138.

1. IMAGINARY CONQUESTS

European Material Technologies and the
Colonial Mirror Stage

STEVEN MULLANEY

Coming upon a group of Tswana natives in early-nineteenth-century South Africa, William Burchell did what European explorers and colonists had done at such moments since the earliest days of European expansion. He presented them with a series of gifts, including in this instance a relatively unadorned looking glass. From Burchell's point of view, the Tswana reaction was as simple as the glass in which they viewed themselves—but also revealing. The natives, he recounted,

> laughed, and stared with vacant surprize and wonder, to see their own faces; but expressed not the least curiosity about it; nor do I believe it excited in their minds one single idea; and I may not, perhaps, be doing them an injustice by asserting that, whether capable of reflection or not, these individuals never exerted it.[1]

The natives' "surprize and wonder" are hardly surprising, in and of themselves. After all, what the Tswana encounter in Burchell's glass is not merely their own visage, reflected back to them more clearly than they have seen before in pond or pool or clay washbasin, but a portable token of a technology entirely alien to them. In this context, "surprize and wonder" are entirely appropriate emotional responses, and they are entirely appropriate social responses as well, the customary reaction, whether the gift in question is extraordinary or mundane, of a host who presumes to be receiving a gift-bearing stranger or guest—as soon-to-be-colonized peoples typically misrecognized their situation.

More noteworthy, at least from our perspective, is the casual quality of Burchell's own reflections on self-reflection—his almost matter-of-fact elision of specular and speculative phenomena, optical and contemplative operations, the physics of light and the metaphysics of thought. Yet as Jean and John Comaroff have detailed, this aspect of the scene was also a commonplace.[2] Early explorers and missionaries in South Africa handed out mirrors as ubiquitously as their sixteenth-century counterparts in the New World distributed glass beads; Burchell's commentary is simply more explicit than others in its "extension of the mirror-image to the notion of reflective thought."[3] A product of the Enlightenment, Burchell "wipes his glosses" (as a bespectacled Joyce once aptly punned) with what he knows. As W. J. T. Mitchell has demonstrated, optical metaphors and the technologies from which they derived were central to post-Enlightenment political philosophy,[4] and they were central as well, as the Comaroffs

have shown, to the religious thought that informed the Nonconformist missionaries who would soon follow Burchell, like him distributing mirrors to the Tswana and, like him, conflating sight and insight, reflection and self-reflection, vision and Christian spiritual illumination. From a European perspective, what lies at the heart of such encounters is, if not darkness, then a vacancy (as in "*vacant* surprize and wonder"), an absence of illumination or insight or proper self-reflection. Held up for reflection but unable or unwilling to reflect upon themselves, the not-yet-enlightened Tswana need to be taught to see in the mirror a self *in abstracto*:[5] a self liberated (or alienated) from what Nonconformist missionaries regarded as the "socialistic" webs of tribal life; a self divided from and turned back upon itself, capable of introspection and hence self-discipline. "The 'native,' though he might not have known it," write the Comaroffs, "had come face to face with the Christian subject."[6]

It should be clear by now that Burchell's looking glass is not merely a material object, an amalgam-coated oval of silicon with peculiar optical qualities; it is also an ideological device of some significance, a tool that focuses Burchell's reflections on the post-Enlightenment European mind and provides that mind with an emblematic justification for colonization and conversion, a glimmering vacancy that others will soon be impelled to fill. Missionaries, like empires and nature, abhor a vacuum, but missionaries and empires usually have to do a considerable amount of ideological labor to construct the vacuums or vacancies that they can then—naturally—fill in or occupy. What we encounter when we read Burchell's meditations on the Tswana is precisely this kind of ideological labor in action; to recast his Enlightenment metaphors in their proper, or properly demystified, mold, we might call this moment an act of colonial speculation, an invested reflection upon and ideological rationalization of an emerging colonial project. The labor or work thus performed depends little on the accuracy of Burchell's observations, for ethnographic knowledge is not the primary object here (although what passes for such will be another useful tool in the rationalization of empire);[7] even if Burchell's interpretation of the Tswana could be viewed as largely or entirely his own projection onto the scene (and so it can be), what it accomplishes would be the same. Although prompted by a particular encounter on the plains of South Africa, his speculation takes place in what I would call the colonial imaginary, understood as that part of the larger political unconscious in which specifically colonial rationales are worked out, as ideology.[8] And yet, we should not dematerialize the moment entirely. To reverse my earlier formulation, Burchell's mirror is not *merely* an ideological device; it is *also* a material object, and the acts of colonial speculation I will be considering here are likewise rooted in the material. Deploying material artifacts as tokens and near-fetishes of Western culture, colonial speculation seems to be a way of thinking *through* things in order to think through or work out a colonial rationale, and as such it has a considerable history. In the *longue dureé* of Western colonial expansion, it is difficult to find a narrative that is not punctuated by similar mo-

ments, which means that Burchell's gift is the colonial equivalent of a rhetorical *topos* or commonplace. A European explorer-cum-colonist—a Columbus, a Cortés, a John Smith—ventures upon a hitherto unknown people and the country they inhabit; a token of European culture is either presented as a gift or displayed or demonstrated (firearms are favored here) or offered in trade, and the natives' awe or wonder or other signs of their credulity and naïveté—including in some instances the absence of "appropriate" awe or wonder—are duly recorded.

So common are such moments, in fact, that it is easy to regard them as unremarkable, to neglect to wonder why they are so frequently produced and reproduced. Although I will be concerned with the early modern period, I have begun thus far afield because Burchell's mirror scene (and the Comaroffs' astute analysis of it, which I have both redacted and expanded upon above) has helped me to think about what is being accomplished by such moments—to think beyond "naive" native wonder and to wonder instead about the role it plays in the colonial imaginary, even when staged with less luminous objects in the pre-Enlightenment New World. It is the colonial investment in such moments—often inaugural moments of first encounter—that will concern me here, whether they are focused on gifts or items of trade, relatively ordinary and mundane objects (at least from a European perspective) or more complexly wrought and culturally resonant ones.

* * *

Whether bestowed as gifts, traded in exchange for other commodities, or otherwise deployed, the material objects that came into play in European encounters with New World peoples ranged from what the English called "trifles," such as "looking Glasses, Bells, Beads, Bracelets, Chains, or Collars of Bugle, Crystal, Amber, Jet, or Glass,"[9] to more powerful tokens of European technology and Christian culture, such as firearms, navigational instruments, crucifixes large and small, and the Bible itself. The range is not only material but also national: Spanish, English, French, and Portugese narrators record, often in great detail and delight, the naïve wonder (or other evidence of cultural naïveté) to be induced in New World peoples simply by exposure to artifacts of European manufacture.

Even so trifling an object as a glass bead can raise questions about the work being accomplished in such transactions, the motives behind such accounts, and the narrative labor expended on them. Glass beads were everywhere in the Americas; that is to say, they operated as a kind of *lingua franca* of material cultural exchange, or rather (to give Spanish predominance its due) as a kind *lingua hispanica*. Beads produced a less hyperbolic wonder or delight than other European artifacts but were nonetheless highly prized and desired, traded for everything from food to precious metals. There are few accounts of encounters between European and New World cultures that do

not record beads passing from one hand to the other, and equally few that do not present the transaction as an example of the utter simplicity and naïveté of a people who would trade their own wrought gold or silver (an exchange rare in actuality, but discursively much fabled) [10] for such "baubles." The double-edged nature of such accounts is also typical. Whether overwhelmed by wonder or desire, the natives are impressed. Or more accurately, a European narrator claims they were and lays great emphasis on this, recording a reaction that is at once fully expected (why else greet such cultures with artifacts known to be unknown to them, or beyond their own means of manufacture?) and just as fully mocked or derided as inappropriate. It is hard not to be troubled by such a dynamic, to find it not only double-edged (a morally neutral term for duplicity) but also two-faced, an emblem of the hypocrisy and even "bad faith" that characterized Europe's extensive dealings with its New World others.

Moral terms such as hypocrisy and bad faith are unavoidable and quite accurate, as far as they go; they are also quite inadequate if regarded as conclusions, as stopping rather than starting points in our effort to decipher cultural (as opposed to individual) practices, especially ones as pervasive as those being considered here. An individual who contradicts a preexisting moral system which s/he professes to embrace is guilty of hypocrisy or bad faith; here we are dealing with a culture, or rather a set of cultures bound to one another by conflicting versions of Christianity, that repeatedly contradicts such a moral system and even celebrates its contradiction—or at least it does when New World trade is at issue. Such pervasive, collective behavior seems to call for further explanation. Stephen Greenblatt has suggested that European naïveté about economic realities may be partly to blame: "The concept of relative economic value—the notion that a glass bead or hawk's bell would be a precious rarity in the New World—is alien to most Europeans; they think that the savages simply do not understand the natural worth of things and hence can be tricked into exchanging treasure for trifles, full signs for empty signs." [11] Europeans of the period are indeed "taking advantage of native innocence," as Greenblatt strongly puts it, and taking a smug, self-congratulatory pride in it that is troubling to encounter; they are guilty, he suggests, but they are guilty not so much of bad faith as of their own historically determined ignorance or innocence.

Such an ignorance would explain a great deal, but it is hard to credit when one considers the extensive prior history of intra- and extra-European trade founded on the premise that a commodity abundant in one clime will garner the greater price in another, where it is relatively scarce. [12] The concept of relative economic value is not alien to most Europeans, but this and other economic "realities" do seem to be undergoing a radical transformation in the period, especially in terms of New World trade, and glass beads are one of the catalysts of that transformation. As European trifles go, glass beads are not exactly "empty signs"; they are two-faced commodities in a material as well as a moral sense, for they were produced in the sixteenth century by two

entirely different processes, one relatively costly and the other less so, one of long-standing practice and the other of quite recent vintage—developed just in time, in fact, to play its not entirely "trifling" role in the New World.

In Spanish, glass beads were known as *cuentas* or "counters," a usage that may derive from the beads of the rosary, used for "counting off" the decades of prayers recited to the Virgin Mary. Since *cuenta* also meant "account" or "story," Spanish stories about beads in the New World rather nicely conflate vehicle and tenor, colonial narrative and the material objects conveyed to New World cultures by boat, to the reader by the narrative account itself.[13] But in the first *cuenta sobre cuentas* or story about beads in the Americas, the objects thus conveyed—to them, and to us—are not as mundane as we might expect. When Columbus met the cacique of Tortuga during his first voyage, he did indeed present him with a string of beads, but they were "some *very good* [my italics] amber beads that I wore on my neck." Seeing the cacique was pleased, Columbus followed the gift with another, even more impressive set of glass beads. "I sent for some beads of mine on which, as a token, I have a gold *excelente* on which your Highnesses are sculptured."[14] Columbus' beads are hardly trifles; highly valued by him (they are his own personal jewelry), they are also clearly valuable in and of themselves, even by European standards; the *excelente* on the second set not only confirms this but also reveals, in the figures of the Spanish monarchs, the import of such gifts. These are gifts of state passing from one ruler to another, from the admiral of the oceans, himself the representative of the Spanish crown, to the ruler of the Arawak.

European beads of the period cannot be automatically regarded as the early modern equivalent of our own costume jewelry.[15] They were often complexly wrought, multicolored and multifaceted, and worn by even the upper ranks of European society; they could also be quite costly to produce. The highest quality beads were manufactured principally in Murano, an island located off the shores of Venice, and were made by winding individual layers of colored glass around a wire core. The glass was shaped while still malleable, then cooled before the subsequent layers of glass were added and shaped; once the layers were completed, the rough bead was then cut or faceted according to the desired design, thus revealing the underlying colors, after which the bead was finally polished. Columbus's beads had to have been painstakingly crafted in this manner, for it was only in 1490—too late for Columbus's first voyage—that the craftsmen of Murano rediscovered an ancient Egyptian method of producing what are known as hollow-cane beads, made by drawing glass out into a long, hollow-cored cylinder that could then be cut and polished into individual beads.[16] Hollow-cane beads (Figure 1) could still be highly intricate, but the time-consuming labor now went into preparing the glass that would be drawn; once drawn, a single cane resulted in a number of virtually identical beads. What this meant was that, whether a given design called for a bead that was single or multicolored, complexly faceted or plain, it could be produced *relatively* less expensively than a similar bead made by the

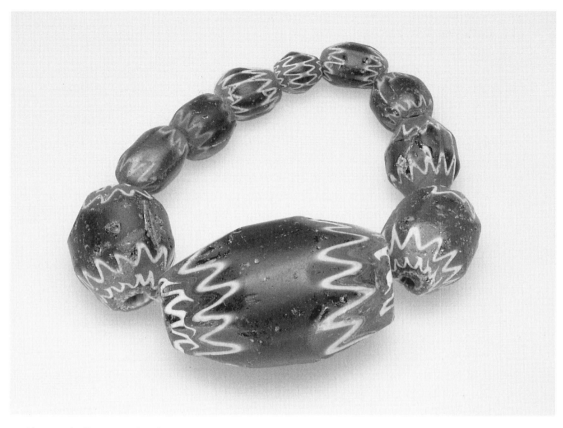

I. Chevron hollow-cane beads. Venice, sixteenth century. Corning Museum of Glass.

wire-core process. Although still time-consuming, only gradually perfected and for some time a well-guarded secret, the new process (as in the "New" World) allowed for something like an early modern version of mass production: eight or ten beads might be produced in the time it previously took to produce one. These were of course the beads that would fill the holds of post-Columbian voyagers to the New World in the sixteenth century. The more costly wire-wound beads were still produced, worn, and highly valued by European elites; drawn beads were shipped in quantity abroad, serving as ballast on the outward voyage and—so it was hoped—replaced by gold or captives on the return home. Oftentimes wearing the wire-core beads and sometimes bestowing them as gifts to high personages, Europeans traded the less labor-intensive, drawn beads in bulk.

As I have already intimated, what this means is that hollow-cane beads, only recently available and for some time thereafter available only from the craftsmen of Murano, were nearly as novel to Europeans as they were to New World peoples. Fully

aware that they were not only encountering but also deploying relative values of economy and technology—the beads around the neck and the beads in the ship's hold were, taken together, a concrete embodiment of the concept of relative economic value—European traders nonetheless misrepresented or misrecognized this awareness, casting native wonder at and desire for such commodities as merely credulous, the mark of a people easily allured by bright surfaces. That their rhetoric of derision is also smug, overblown, boastful, or otherwise troubling might have something to do with the strain that such trading practices could produce in a culture that lacked, not a concept of relative value, but an economic ideology that could fully rationalize and justify profit-taking;[17] such a strain, overdetermined and mystified, is one of the signs of the early stages of such a rationalization taking shape, the outlines of such an ideology first being glimpsed in the colonial imaginary. Elsewhere, in the Old World, trade was supposed to be organized around a principle of economic equity, of exchanges based on comparable value; one was not supposed to profit, especially to profit exorbitantly, at the expense of another. It was a principle often violated, of course, but it was only in the New World, around such trifles as glass beads, that its violation was not only common but also heralded and advertised with a crass delight whose strained extremity marks the anxiety still surrounding such gain, lacking as the period did a subtler ideological take on profit. And it should come as no surprise that the early signs of such an ideology in the making should appear in the New World, where Europeans encountered such a massive need for the rationalization of profit. Here was a world with no history, meaning no history in relation to us; it was there for the taking, and the taking advantage of, on a scale of colonial plunder so unprecedented that it provided the surplus capital necessary—at least according to Marx, for whom this was the crucial period of "primitive accumulation"—for the emergence of capitalism itself.[18]

* * *

John Smith claims to have profited from the allure of bright surfaces in a different sense. When he was first captured and taken before Opechankanough, leader of the Pamaunkee and brother to Powhatan, Smith presented Opechankanough with a "round Ivory double compass Dyall." His captors, as we might expect by now, "marvailed at the playing of the Fly and Needle, which they could see so plainely, and yet not touch . . . because of the glass that covered them." They marvel at what seems so immediate, in apparent vital motion, yet remains so alluringly inaccessible behind the glass that simultaneously withholds and reveals. Interestingly enough, Smith does not mock their wonder. If anything he shares it, for the compass is a marvel to him as well, at once a synecdoche for and a doorway into motions and realms beyond its enclosed dial, destinations inaccessible to his captors but not to those who know the

mysteries of lodestones and navigation beyond the sight of land. As part of his gift, he claims to have shared those mysteries with his captors:

> But when he [Smith] demonstrated by that Globe-like Jewel, the roundnesse of the earth, and skies, the spheare of the Sunne, Moone, and Starres, and how the Sunne did chase the night round about the world continually; the greatnesse of the Land and Sea, the diversitie of Nations, varietie of complexions, and how we were to them Antipodes, and many other such like matters, they all stood as amazed with admiration.[19]

According to Smith, he owed his life to this speech and the admiration it provoked. An hour later, when a group of warriors had tied Smith to a tree and threatened to shoot him, Opechankanough intervened "by holding up the Compass in his hand." Weapons were laid down, Smith was untied, and later "he was after their manner kindly feasted, and well used."

So much is encompassed, as it were, by Smith's double dial: not only everything under the sun but also the motions of the spheres beyond it; not only the great globe itself—which this "Globe-like Jewel," like a magnetic, pocket version of Shakespeare's stage, at once represents and refers us to—but also, somehow, the racial and political diversity of its inhabitants.[20] Given Smith's proclivity for borrowing—not as odd for the period as is his erratic tendency to write of himself in the third person—the echoes of *The Tempest* may be more than accidental.[21] But whatever the relation to Shakespeare, Smith's account of his salvation is drawn from the stuff that dreams are made on, since his speech had to have been largely, and quite probably entirely, indecipherable to his captors. It is unclear whether Smith's Algonquian guide and interpreter survived the battle in which Smith was captured: when first surrounded by Opechankanough's warriors, Smith was forced to use the interpreter as a shield, but the strategy was short-lived. Smith was wounded numerous times; presumably his "buckler" or shield suffered more, and more severe, hits. And even if he or another interpreter were present, the level and nature of interaction between the Algonquian and the English in 1607 were hardly sufficient to have provided the terms needed for even the humblest translation, much less one so rhetorically impressive as to save Smith's life. Other than his readers, the one person we can be sure was "amazed with admiration" at the wonders of the compass—at the navigational and rhetorical access it provided to its bearer—was John Smith.

Smith is not alone, however, in presenting us with a moment of colonial speculation that strains our own credulity. Whether our suspicion is raised by improbabilities of translation or independent historical knowledge that casts doubt on how amazed or admiring a particular culture was rendered by exposure to superior material technologies, such improbable and even impossible accounts still have a great deal to teach us. Whatever is being worked through at such moments—whatever aspects of colonial ideology are being conceived or thought out through the medium of a particular ob-

ject or artifact—native wonder is oftentimes less significant than, and indeed may only
exist in, the colonial imaginary. Thomas Harriot provides another, more elaborate ex-
ample. In his *Brief and True Report*, he claims that the Algonquian Indians were so
impressed by the power of English firearms that they were quick to extrapolate such
novel power in order to explain other unprecedented events, such as the mysterious
and fatal epidemic that seemed to accompany the English but to affect only the in-
digenous population. Concluding that the English had the power to shoot "invisible
bullets" into those who did not seek their favor and that of their god, the Algonqui-
ans "could not tell whether to think us gods or men," as Harriot reports.[22] In this they
reveal a naive credulity "so simple" that the English will find it easy to undermine
indigenous beliefs and culture in order to establish their own colonial hegemony.

Or so Harriot claims. Hegemony proved more difficult to establish and involved
massacre more than the technology-induced mind games that Harriot envisioned.
"The history of subsequent English-Algonquian relations," Stephen Greenblatt notes
with considerable understatement, "casts doubt on the depth, extent, and irreversi-
bility of the supposed Indian crisis of belief."[23] In other words, however much the Al-
gonquians were (understandably) impressed with firearms, Harriot's account of their
response is largely a fiction—a potentially potent and revealing fiction, as Greenblatt
has demonstrated at length, but a fiction nonetheless. What is striking to me, however,
is the role played by European material technology, here and elsewhere, in the pro-
duction of such partial or entire colonial fantasies. With a largely imaginary cultural
logic, English religious and political superiority is conceived through the medium of
its material artifacts—and conceived not so much in the minds of the Algonquians,
who would lose little time in acquiring their own fully demystified guns and all-too-
visible bullets, as in the minds of Englishmen like Harriot and his readers.

It may seem surprising to suggest that European cultural chauvinism requires
such labor to be produced in the sixteenth century. The colonial expansion of this
period was distinguished, to put it mildly, by its sometimes rabid exclusionary pre-
sumptions. Whether Catholic or Protestant, proselytizing or enslaving or genocidal
in their commitment to (whichever) one true faith, early modern colonial enterprises
mark the moment at which monotheism entered the stage of world empire, and it
was a monotheism less tolerant of local customs and beliefs than earlier variants, such
as the version of Christianity that had expanded throughout most of Europe during
the Middle Ages, precisely because it was no longer one but two fratricidal monothe-
isms, at literal and ideological war with one another, in the Old World as well as the
New. And yet these chauvinistic theologies, driven by a sense of divine mission made
all the more zealous by their religious and colonial rivalries, seem to need a kind of
ideological scaffold to bridge the gap between colonization and conversion, between
the impetus to conquer territories and the mission to conquer or colonize minds as
well.[24]

Catholics and Protestants alike spend a great deal of time being impressed by how impressive they and their various trinkets are in the eyes of their colonial subjects-to-be, sometimes so impressive that those subjects "could not tell whether to think us gods or men." For a Christian of whatever sect, this is a decidedly odd example of indigenous credulity to take delight in, much less to foster. Idolatry is, after all, the most egregious of sins for both sides of the Counter Reformation; Catholics and Protestants simply disagree as to what constitutes it. Yet from the first landing in the New World, Catholics and Protestants find common ground in the delight they take when they think they are regarded as gods—as objects of idolatry—and in many instances we can be quite sure that the signs of such regard are fully imaginary ones. Thus Columbus, although communicating only through the crudest of gestures upon his landing at San Salvador—this is the first of all first encounters—is sure that the natives are telling him that they think he came from the heavens;[25] thus Cortés "discovers" that Montezuma regards him as a long absent, messianic god, thereby initiating an enduring and exfoliating myth that apparently has nothing to do with Mexica beliefs.[26] It is, of course, both possible and probable that some New World peoples did view such strange beings as gods; pantheistic cultures can be quite accommodating in this respect.[27] But monotheism and idolatry should be mutually exclusive terms; the fact that they are not quite so in the New World highlights some of the tension between colonization and conversion. To seek out or fabricate idolatrous regard directly contradicts the central tenet of Christian faith, but it is clearly an enabling contradiction for the colonial armature of Christian expansion, for that "peculiar European will to expand itself and to dominate others."[28] The epitome of naive wonder, indigenous idolatry serves as both the tool and the justification of that will, in both its secular and religious aspects. Embraced as a means of subjection, a form of naïveté easily manipulated by the secular will to dominate, such idolatry also makes domination and subjection imperative; it is the sign of what the monotheistic will to dominate must eventually correct in order to produce what is at once a colonial and a Christian subject. And since such idolatry is unwittingly directed not toward false gods but toward true Christians, its intended object of worship—these true, European Christians—is also its means of correction. In a curious perversion of Augustine, such idolatrous regard could be both enjoyed by colonizing powers and put to Christian use; the contradiction, as it were, resolves itself.

Whatever the cultural logic that might explain the untroubled ease with which Christian colonizers embraced and encouraged native idolatry, they were a great deal less tolerant when awe, whether proper or improper in theological terms, was not forthcoming. It was the lack of "proper" regard for the material artifacts of Christian faith—a skepticism that, although naive, might be seen as a healthy resistance *to* idolatry—which proved the downfall of the Incan ruler Atahualpa, at least according to Spanish accounts. When Atahualpa officially received Pizarro and his men in the In-

can city of Cajamarca, he was initially receptive to what they had to say about their god. Pizarro's clerical lieutenant, Fray Vicente de Valverde, responded to Atahualpa's questions with a quite lengthy discourse on matters worldly and divine, moving with apparent ease from a digest of biblical history to the role of Charles V in completing that history; after declaring that Charles was the "monarch of all the universe," he went on to assert the absolute power of the pope, and concluded with a catechism on the mysteries of the Catholic faith. Much of Valverde's diatribe (for such it seems to have been) was lost on Atahualpa, due at least in part to the fact that the Spaniards' captive interpreter, Felipillo, had small Quechua and less Spanish; he apparently spoke a rather obscure dialect of the Incan language and was even more limited in his knowledge of Spanish and the basic tenets of the Christian faith.[29] But according to the Inca Garcilaso de la Vega, Atahualpa nonetheless made a studied effort to respond when Valverde had finished:

Your mouthpiece [Felipillo] has told me that you have mentioned five great men I should know. The first is God three and one, or four, whom you call creator of the universe. . . . The second is he whom you say is the father of all other men, on whom they have heaped all their sins. The third you call Jesus Christ, the only one who did not lay his sins on the first man, but he was killed. The fourth you call the pope. The fifth is Charles, whom you call the most powerful and monarch of the universe and supreme above the rest, without regard for the other four. If this Charles is prince and lord of the whole world, why should he need the pope to give him a new grant and concession to make war on me and usurp these kingdoms? If he has to ask the pope's permission, is not the pope a greater lord than he, and more powerful, and prince of all the world? . . . I also desire to know of these five you have mentioned to me as gods, since you honor them so. For in this case you have more gods than we, who adore only Pachacámac as the Supreme God and the Sun as the lower god, and the Moon as the Sun's wife and sister.[30]

Despite the fact that Felipillo, the Spaniard's "mouthpiece," has to be numbered among the linguistically challenged, not all of Atahualpa's confusion can be laid to the betrayals of translation. Indeed, his response amounts to a rather effective New World deconstruction of Old World powers, of Europe's still chronic mystifications of secular and religious authority, and his comments on the trinity, recasting Catholic mystery as mathematical quandary, would have been well-received among certain Old World factions—spoken, one might say, like a true Protestant.

During Valverde's lengthy speech, the friar held a crucifix in one hand and a book in the other; he apparently referred to the book repeatedly, citing it as the authority for much of what he had to say. According to most Spanish sources, the book was the Bible. Valverde held it up as an example of the power of the written word to speak from afar—another icon of European technology, of both phonetic writing and the printed page—and he spoke as well of the power of this particular Word to address each of us individually. Again according to Spanish accounts, Atahualpa took him at his Word. Seeking answers to his questions, he asked to consult this mysterious ob-

ject: the Inca took up the Book to see, or hear, for himself. Holding it to his ear for some time, showing signs of increasing frustration, he eventually grew incensed and threw it down on the ground. Pizarro ordered the Incan ruler seized and the rest, as they say, is history.

Pizarro had no authority to seize a foreign monarch, hold him for ransom and then, after receiving the ransom, have him strangled with a garrote; Atahualpa's act of sacrilege provides justification (albeit still questionable) by recourse to an authority higher than the Spanish monarch. According to Guáman Poma, however, the book in question was not the Bible but merely Valverde's breviary, and the woodcut of this encounter in Poma's *El primer nueva crónica y buen gobierno* shows the breviary still in Valverde's hand (Figure 2).[31] The Inca Garcilaso de la Vega, working from Incan and Spanish sources—the event as related by oral tradition, disseminated in primarily Spanish printed accounts, and recorded on the Incan *quipu* (a complexly knotted rope that seems to have served as a nonphonetic form of writing)—notes that, in some accounts, the book in Valverde's hand was Silvestre's *Summa*, in some his breviary, and in others, the Bible itself.[32] But Garcilaso also claims that Atahualpa neither held it nor cast it down: misunderstanding celebratory shouts from the Incan crowd, Valverde himself dropped both crucifix and book when he rose in panic from his seat beside the Incan ruler.[33] If Garcilaso is correct, Pizarro's justification for an act of regicide is the Peruvian equivalent of the Gulf of Tonkin resolution. Whether an entire fiction or not, it has proved a powerful tale; despite the many reasons to doubt it, this is still the story told in classrooms and reiterated by many modern historians of the conquest, perhaps because it combines so fully native naïveté with pagan sacrilege. *Se non è vero, è molto ben trovato*. In this confrontation with European phonetic writing—quite possibly untrue, but very well made—there is neither awe nor wonder, merely (or so it would seem) a naive, inadequately literate subject. Unaware that there is a sign system to be mastered before a book can communicate its secrets, Atahualpa is also unversed—he holds the book to his ear—in the difference between speech and writing (or at least he is from the European perspective, which is blind as yet to the existence of the Peruvian *quipu*). And yet, since this book is ostensibly—according to Spanish accounts—*the* Book, shouldn't Atahualpa's expectation be regarded as less naive than premature? Christian delight in his naïveté is always combined with shock at his sacrilege, but such delight is an example of bad faith writ large. Atahualpa expects the book to *speak* to him; but if this is *the* Book, he is not really in error. Rather, he is displaying the fact that he suffers from a kind of spiritual aphasia, one that prevents the Book from speaking to him yet, individually and particularly, as it would do to any properly interpellated Christian subject. Atahualpa sees through a glass darkly; his experience, that of the not-yet-colonized or Christianized subject, provides for his onlookers a negative but proleptic image of what would transpire if he were capable of coming, as the Comaroffs put it, "face to face with the Christian subject." Like the

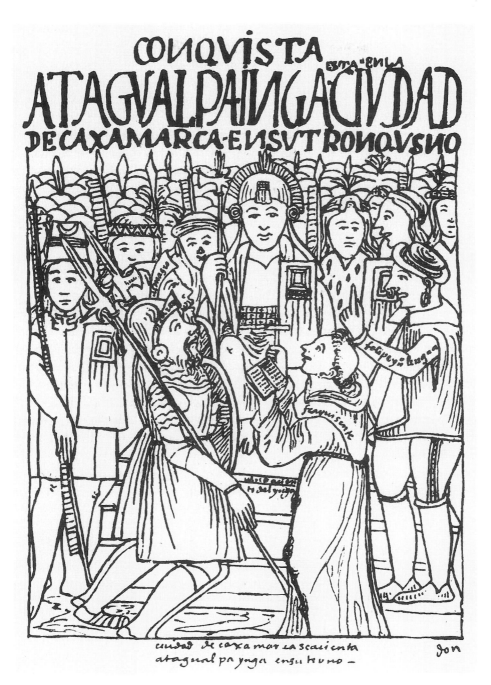

2. "Atahualpa receiving Pizarro," from Felipe Guáman Poma de Ayala, *El primer nueva crónica y buen gobierno*, ca. 1613. GKS 2232, Royal Library, Copenhagen.

Tswana, Atahualpa sees what is before him but is incapable of seeing himself in it properly; both are still on the wrong side of the looking glass, not yet having worked or passed through what I would like to think of as a colonial mirror stage.

* * *

To clarify what might be meant by such a phrase—a *colonial* mirror stage—I want to turn to the example of a group of Englishmen, imagining a close to literal (yet largely fantasized) instance of just such a mirror stage. On Martin Frobisher's first voyage to Meta Incognita in 1576, he captured a Baffin Island Eskimo whom he hoped would fill the need for a native interpreter. The man had been shadowing Frobisher's ship in a kayak (similar to that depicted in Figure 3), but kept his distance until he was lured into capture by the sound of a mere trinket, a cowbell. During the scuffle of his capture and presumably due to it, the Eskimo bit his tongue out, but his captors, finding their hopes thus dashed, projected a rather full intentionality onto the act. "For very choller and disdain," as George Best recounts, "he bit his tong in twayne within his mouth."[34] So much for the hope for an interpreter. During the voyage home the captive fell ill and died shortly after he was displayed to Elizabeth at court. When Frobisher set sail again the next year, he went forewarned about the potential power of native "choller and disdain," but he also went forearmed, taking with him a portrait of last year's captive that had been painted by Lucas de Heere, who happened to be visiting Elizabeth's court when the man was all-too-briefly displayed (Figure 4).[35] A second Eskimo was captured in due course, but at the first signs of despondency the new captive was introduced to his predecessor. It is again George Best who narrates the ensuing engagement between the imaginary and the real:

For afterwardes, when we showed him the picture of his countreyman . . . he was upon the suddayne much amazed thereat, and beholding advisedly the same with silence a good while, as though he would streyne courtesie whether [he] shoulde begin the speech (for he thought him no doubte a lively creature), at length began to question with him, as with his companion, and finding him dumme and mute, seemed to suspect him, as with one *disdaynful*, and would have with little helpe have grown into a *choller* at the matter, until at last by feeling and handling, he founde him but a deceiving picture. And then with great noyse and cryes, ceased not wondering, thinking that we coulde make men live or die at our pleasure. (my italics throughout)[36]

Best presents the moment as one in which the captive was impressed, as it were, into service—produced, through a complex induction of unceasing wonder, as a willing and even eager interpreter.

The replay of the precise terms of conflict from the first voyage—"choller and disdain"—seems highly determined, to say the least; whatever took place on the shores

of Meta Incognita, Best's account of the scene is clearly a projection onto it, whether in part or in whole, an effort to resolve the alien resistance on which the first voyage foundered by making the very signs of that resistance the means by which it can be effaced.[37] But even if we assume that the scene as presented takes place entirely in the colonial imaginary, the ineluctable dynamic with which it unfolds is a compelling one in its social and psychological dimensions. Native intransigence is reproduced—willfully mute in life, Frobisher's first captive is no less unresponsive in pictorial effigy—but also turned back upon its source; "choller and disdain" are artfully induced, dis-

3. After John White. *Eskimo in Canoe.* 1577. Woodcut. © The British Museum, London.

4. Lucas de Heere. *Eskimo*. 1577. Watercolor. Rijksuniversiteit Bibliotheek, Ghent.

placed, and turned to Elizabethan advantage. Confronted by an image of his own kind, the captive attempts to respond in kind. His initial hesitation and his subsequent efforts to communicate with his presumed fellow are both presented by Best as expressions of kinship and community, intended tokens of cultural recognition; his actions, that is to say, manifest a code of socially inscribed behavior of the kind that serves to define any given cultural community and to set it apart from all others—a social decorum Best familiarizes as "courtesie." Such overtures are unreciprocated, of course, but this lack of reciprocation is also, and more crucially, observed by others. From the native's perspective (as reflected, of course, in Best's defining gaze and narration), he has been drawn out of himself and left exposed, not only spurned but also humiliated, and his manifested desire for fellowship gives way to an equally powerful sense of outrage and betrayal—a betrayal first projected onto his "disdaynful" companion and then reproduced and acted out by the new captive himself, in a choler directed not at his captors but at an emblem of his own cultural identity. His wonder at the close thus makes a certain sense: what has indeed lived and died in this scenario is nothing less than the native's sense of himself, of those tribal loyalties that had, up until this moment, defined and produced in him any sense of self he possessed. Far from naive, his unceasing wonder is in fact the sign of this alienation: produced at the moment when he realizes his error, it marks the distance between his former näiveté and a new perspective that comes from seeing himself, in error and humiliation, through the eyes of his captors.

Needless to say, the actual process of conversion, whether political or religious, was a great deal more complicated in European encounters with New World cultures. But something significant is nonetheless being worked through here and in other moments where so much seems to be invested in the way that New World peoples react to or interact with various totems of Old World material culture. An initial affective response may be characterized as awe or wonder, up to and including idolatry. But registering or in some cases fabricating evidence of naive credulity is not the point, or to be more precise, not the end point. Despite all their differences, Catholic and Protestant colonial powers shared an ideology that demanded the eventual colonization of minds as well as bodies and territories—demanded that New World colonial subjects be Christian subjects as well, not only true in outward adherence to religious doctrine but also willing converts, prime movers in their own ideological subjection (or salvation). What is sometimes adumbrated in the moments of colonial speculation I have been considering is a process, partly or wholly imaginary, that might accomplish such an end. When this adumbration is less occluded, as in the example of Frobisher's Eskimo, native credulity can be seen (at least in and by the colonial imaginary) to initiate a dialectical, affective transaction between "us" (and our material artifacts, serving as affective catalysts) and them—a transaction whose dynamics seem to demand a historicized appropriation of Lacan's mirror stage.

Lacan's mirror stage produces the infantile self.[38] It is a self born in division, an ego that is always already an alter ego, captivated by the image of an apparently fuller, more autonomous and whole self in the mirror: a self that is me but not me (it is so much better), at once self and other. And the infantile self—Lacan's *moi*—that is produced by this erroneous apprehension of an imaginary self/other remains thus captivated, never realizing its error—its imaginary projection of this "other" self— or the illusion on which its fully binary production is based. A colonial mirror stage as figured here produces neither a fledgling self nor even an initial version of a subject. It dismantles an already interpellated subject, then reproduces it through a process of projection and displacement. As in Lacan, the colonial mirror stage begins in error—but it is an error that must be *realized* if the colonial subject is to emerge. Hence there are two gazes involved, that of the soon-to-be-colonized subject and that of the colonial supervisor. It is the pressure of the latter gaze which produces the realization of error (this is the moment when Frobisher's Eskimo begins to see his own näiveté through the eyes of his captors) and with it a humiliation that is also a subjection, an affective and ideological humbling that puts the colonial subject in its place and accords the colonizing presence—the colonial supervisor—its imaginary but overpowering fullness. Instead of his or her own image, the colonial subject apprehends as "its" ideal Other what it of course can never be, this mystified image of the dominant, overseeing, and colonizing subject. Passing through the colonial mirror stage, the subject thus produced will also be always thus distinguished from his or her other, always aware that there is another side to the glass, a defining gaze situated there, a site which the colonial subject can apprehend but never occupy.

Such at any rate is the fantasy. Frobisher's pictorially induced mirror stage does not produce a colonial subject any more than Burchell's mirror produces a Christian one. What is produced in each, however, is an aggrandized image of the colonizing subject, an imaginary fullness possible only through the alienated and abject gaze of the colonized—and here, the line between fantasy and actuality is difficult to draw. For this aggrandized image or imaginary fullness may be born in fantasy, but its effects are felt elsewhere; once produced, it inhabits—or rather, colonizes—worlds that are all too real. According to Freud's famous dictum, the psychological ego constitutes itself by striving to occupy an imaginary terrain. *Wo Es war, soll Ich werden*: where it (id) was, there must I come about. The colonizing subject constitutes itself in its fullness by striving to occupy, to be the focal point of, an imaginary gaze: where *they* see us, there must *we* come about.

* * *

This imaginary fullness, this self-interpellation of the colonizing subject, was produced not only in the minds of European voyagers and colonizers but also in the

readers of these accounts of colonial speculation. For a glimpse of such an image being thus produced, I want to consider a final example of European speculation on the New World that is quite unusual, in part because it seems to betray an uncharacteristic ambivalence toward the emerging colonial ideology being fashioned in first-encounter narratives. In a sense, it is a critical reflection on such speculation, presenting us with both sides of the colonial looking glass.

In 1634, Prince Ferdinand (brother of Philip IV and the new Spanish governor of the Netherlands) made his ceremonial entry into Antwerp. As Ferdinand made his way through the city he passed through a series of arches especially constructed for his procession. Among them was the Arch of the Mint, financed by the city's Royal Mint and jointly designed by Peter Paul Rubens and Johann Caspar Gevaerts. Seeking a theme that would presumably compliment both the mint and the Spanish governor, the artists designed an arch in the form of Mount Potosí in Peru, long-fabled as the richest silver mine in the world and the pride of Spain's colonial empire. As processional architecture goes, an arch in the form of a mountain was an unusual conception but not entirely unprecedented; the Rubens-Gevaerts design is thought to have been influenced by one of the arches erected for Henry II's triumphal entry into Rouen in 1550 as well as the engraved title page of Theodor de Bry's *Americae pars sexta*.[39] What is immediately distinctive about the Arch of the Mint, however, is the striking contrast between the scenes depicted on its front and rear faces.

On the front of the arch (Figure 5), the columns of the portal merge into the rough and massive boulders of Potosí, creating an unusual impression of sculpted and unworked, craggy stone relief. On top of the mountain is a tree framed by two figures: on the right is Jason, who is about to pluck the golden fleece from the tree, and on the left is the figure of Felicitas, who both represents and guarantees a happy voyage. Lower down on the left side of the façade are figures representing the region of gold; on the right is the realm of silver, and each side is governed respectively by the sun and the moon, which rest upon the twin pillars of Hercules (the emblem of Charles V, during whose reign the Spanish conquest was begun). A profile of Philip IV appears on a medallion just under the tree at the top, and the inscription grants him the title of *locupletator orbis terrarum*, the benefactor of the world.

Despite the various symbols and emblems of the *conquistadores* (whom Gevaerts styled "the new Jasons and Argonauts")[40] and the epic presence of Jason himself, the front of the arch conveys a sense of stately accomplishment that is neither martial nor violent, and the depiction of Jason, despite its unavoidable epic connotations, is almost pastoral in its sense of calmness and ease. Parrots perch upon the tree, and although a guardian dragon lies at its foot, the serpent is either sleeping or already vanquished; although Jason wears classical armor, his sword is sheathed and the fleece hangs from the tree like a ripe fruit waiting to be plucked. The rear of the arch, however, conveys a different mood entirely (Figure 6). Here, a scene of ardu-

5. Peter Paul Rubens. *Arch of the Mint* (front), from Johann Caspar Gevaerts, *Pompa introitus honori serenissimi principis Ferdinandi Austriaci* (Antwerp, 1635). By permission of the Folger Shakespeare Library, Washington, D.C.

6. Peter Paul Rubens. *Arch of the Mint* (reverse), from Johann Caspar Gevaerts, *Pompa introitus honori serenissimi principis Ferdinandi Austriaci* (Antwerp, 1635). By permission of the Folger Shakespeare Library, Washington, D.C.

ous, forced labor replaces stately allegory: on the left, two workmen wield pickaxes against the rock while on the right two laborers emerge from the mouth of a mine, nearly doubled over from the heavy loads of ore on their backs. One of these is beardless, the hair on his head a tightly curled cap, with features that are identifiably more African than Peruvian; he is clearly a slave imported from abroad, and his presence has a strong historical register. African slaves were indeed transported to work the mines as replacements for the indigenous Peruvian slaves who had preceded them—so many of whom "gave" their lives to Potosí that the local slave pool was greatly diminished long before the riches of the mine were exhausted. At the top of the mountain is again a tree, but the scene under it is a violent one, representing Hercules in the Garden of the Hesperides. The guardian dragon beneath the tree is clearly awake and alive but contorted in its death throes; its clawed foot is upraised and reaching out to strike, but it is about to receive another blow from the club that Hercules holds high above his head in a two-handed grip, his body coiled to deliver its full power in the next and presumably final swing. Opposite Hercules is the figure of Hispania, plucking golden apples from the tree and dropping them into a fold in her robes. That her action is taking place before the dragon has been killed conveys a sense of haste and stealth, of a theft in the midst of a battle whose outcome, though presumably certain, is not yet accomplished.

It is hard to view the two scenes without a sense of extreme contradiction. What is easy and decorous, almost an act of Nature rather than an exploit of Man, on the front of the arch is brutal and violent on the rear; it is almost as if we are given two incompatible views of Spanish wealth and its New World origins, the official myth and the harsh, underlying reality which that myth was created to obscure. The incongruity between the two views is heightened rather than diminished when we try to imagine the arch as Ferdinand experienced it—as a three-dimensional portal through which he passed. In the detailed depictions done by van Thulden, the front and the rear of the arch are portrayed in separate etchings, and this is how Ferdinand would have viewed the two scenes—first the front side and then (assuming he turned around after he passed through) the rear, never having both in view at once, except of course where front and rear can no longer be defined, that is, at the top of Mount Potosí, where both Jason and Hercules, Felicitas and Hispania enact their contrasting scenes under their respective trees.

Processional arches are curious constructions. They are three-dimensional figures that seek to emulate two-dimensional form; that is to say, unless they are freestanding so that one can walk around them (and the Arch of the Mint was not),[41] they confine their three-dimensionality and their message to two visual planes that are impossible to view at one and the same time. Although physically united, the front and the rear of the arch are disjunct and separate in both an architectural and an experiential sense. The overarching space at the top is the one exception to this virtual two-

dimensionality, not only because it is a space that is neither here nor there, front nor back, but also and more importantly because it is here that the eye might glimpse, depending on the design, something proper to the other side. The architectural paradox is easily resolved, of course, and most designs make sure that the figures at the top can be glimpsed only from the proper side and perspective, oftentimes by incorporating a visual barrier of one sort or another. But the tree or trees that crown the Arch of the Mint can hardly be said to block the gaze. Was there one tree, or two? If only one, then the four figures clustered under it must have been visible from either side of the arch. Van Thulden's etchings seem to represent two different trees, distinct in both foliage and branches, for the two contrasting scenes. But even if there were two trees occupying separate spaces at the top, the known dimensions of the arch do not provide enough space to eliminate the shadowy glimpse of one scene behind the other, of the violence, theft, slave labor, and death that lay behind and adumbrated the wealth of these "new Jasons and Argonauts."

Rubens and Gevaerts seem to have intentionally exacerbated rather than resolved the overarching paradox of a processional arch, as if such adumbration were a key component in their design: as if they intended the rear of the arch to intrude upon the front, subtly but significantly; as if the rear of the arch were a critical commentary, not only on the mythic pretense of the front but also on the Spanish colonial exploitation that is mystified there. Is it imaginable that the arch could be perceived as such, at least when viewed from the proper ideological as well as visual perspective? If so, the notion of "critical commentary" might not be entirely adequate to describe the way in which each side communicates with the other: almost but not fully separate, starkly contrasted yet occupying the same represented geographical space of Mount Potosí, each side shadows the other so that in retrospect—looking backward—it is more difficult to say whether the arch comments on and demystifies empire, or whether it is instead a concrete rendering of the contradictions that empire brings together in order to realize itself. Representing the enslavement and physical labor of the colonized, the arch also embodies the ideological labor of the colonizer. As a processional arch it is highly unusual, but it is also a nearly impossible ideological construct, folding as it does two incongruent versions of Spanish wealth and Mount Potosí into one architectural figure. But then again, an arch is not merely a representational figure. It is also something that one passes through, and in a sense is not complete until it is thus realized or performed—but not just anyone will do. This is an arch of early modern empire, and what completes and momentarily unites the colonial contradictions built into its design is the passage of empire, in the person of Ferdinand himself.

Apparently, the Spanish governor of the Netherlands did not find the Arch of the Mint especially noteworthy; Ferdinand was presumably flattered by what he took in of it (perhaps he didn't turn around to view the rear of the arch), as he would presumably expect to be in any procession ostensibly honoring his new office—and

as we might expect him or any other dignitary to be flattered when honored by a civic procession. Artists like Rubens and Gevaerts were not hired, after all, to criticize their aristocratic audiences and patrons. All of which suggests that I might be reading too much into the Arch of the Mint. Early modern entries, however, were not mere shows or rituals of celebration; they were more pointedly rituals of negotiation between potentially rival powers, between strong, partially autonomous civic authorities and the royal or noble state authorities who wished to enter their domain.[42] And the situation of Antwerp in relation to Spain was hardly unproblematic. From the perspective of many inhabitants of the city, Ferdinand was hardly to be regarded as a beneficent patron; he was a colonial occupier and administrator, the representative of a foreign power that had for years exploited this largely Protestant city in the name of the Counter Reformation. Spanish occupation had reduced Antwerp's importance as a commercial center and thus its riches by cutting it off from the sea; by 1632, two years before the procession, conditions had deteriorated so much that Flemish resentment against the Spanish was widespread, but that resentment had been growing for some years.[43] What is Mount Potosí to Antwerp? At the height of its productivity in the 1590s, Potosí produced an immense amount of silver, but its riches combined with all other Spanish sources of New World gold and silver represented less than a sixth of Philip IV's extravagant expenditures. Moreover, by 1634 the surface veins of Potosí had been (like the indigenous slave labor) virtually exhausted, and the technology did not yet exist to extract deeper deposits. The vast riches of the mine never had and never would trickle down to Antwerp or its Royal mint, which may be why the "Arch of the Mint" bears not a single reference to the city or even to the Mint itself;[44] the arch is a monument to a largely past, entirely Spanish wealth and the wasting of it, through an extravagance that taxed all of Philip's colonial possessions, in the Old World as well as in the New.

Granted, the occupation of Antwerp was an intra-European and an intra-Christian instance of colonial occupation; for reasons of race, culture, and civic status, it is doubtful that any citizen of Antwerp saw himself (the gender here is a historically prescribed one) in the situation of the slave laborers, whether African or Peruvian, on the rear of the arch—at least not in any sense of full identification. While a citizen might not have found himself directly reflected there, he might have caught a refracted image of his own situation.[45] Here is a view of the glories of Spanish empire and conquest—in the Old World rather than the New—that was voiced by one such citizen in 1627:

This city [Antwerp] languishes like a consumptive body which is gradually wasting away. Every day we see the number of inhabitants decreasing, for these wretched people have no means of supporting themselves either by manufacture or trade.[46]

Aside from the reference to a city, the language is very close to that found in Elizabethan accounts of the state of the Irish during the 1580s, when Lord Grey employed a policy of strategic starvation to reduce local resistance. Whatever the language evokes in the reader, it is a powerful and far from complimentary comment on the effects of colonial occupation. Is it possible that someone who viewed the Spanish occupation of Antwerp in these terms might have viewed the Arch of the Mint, some seven years later, in the terms I've suggested above? Is this the kind of perspective that might glimpse the darker colonial adumbrations of the arch, finding in it not a monumental, celebratory construction of colonial ideology but rather its partial deconstruction? Such questions cannot, of course, be definitively answered, but we do know the author of the words which have prompted my queries. The passage quoted above, depicting Antwerp as a consumptive body wasting away under a disease called Spanish colonial occupation, is drawn from a letter written to Pierre Dupuy on 28 May 1627. The letter was composed by a citizen of Antwerp, an artist of some renown who was known as Peter Paul Rubens.[47]

Notes

1. William J. Burchell, *Travels in the Interior of Southern Africa* (London: Longman, 1822–24; reprint, 1967), I: 461; quoted in Jean Comaroff and John Comaroff, *Of Revelation and Revolution: Christianity, Colonialism, and Consciousness in South Africa* (Chicago: University of Chicago Press, 1991), p. 187.

2. See *Of Revelation*, pp. 170–97.

3. Ibid., p. 187.

4. See W. J. T. Mitchell, *Iconology: Image, Text, Ideology* (Chicago: University of Chicago Press, 1986).

5. The phrase is from Lewis Mumford's reflections on the cultural significance of mirrors in *Technics and Civilization* (New York: Harcourt, Brace, 1934), 129; quoted in Comaroff and Comaroff, *Of Revelation*, p. 187.

6. *Of Revelation*, p. 188.

7. For a seminal critique of the intertwined histories of anthropology and colonial administration, see Michel Leiris, "L'Ethnographie devant le colonialisme," *Les Temps modernes* 58 (1950); reprinted in *Brisées* (Paris: Mercure de France, 1966), pp. 125–45.

8. For the concept of the political unconscious, see Fredric Jameson, *The Political Unconscious: Narrative as a Socially Symbolic Act* (Ithaca: Cornell University Press, 1981). Although he does not use the phrase "colonial imaginary," Homi K. Bhabha implies something like it in his discussion of colonial discourse: "My anatomy of colonial discourse remains incomplete until I locate the stereotype, as an arrested, fetishistic mode of representation with its field of identification, . . . as the Lacanian schema of the Imaginary. The Imaginary is the transformation that takes place in the subject at the formative mirror phase, when it assumes a *discrete* image which allows it to postulate a series of equivalences, samenesses, identities, between the objects

of the surrounding world. However, this positioning is itself problematic, for the subject finds or recognizes itself through an image which is simultaneously alienating and hence potentially confrontational. This is the basis of the close relation between the two forms of identification complicit with the Imaginary—narcissism and aggressivity. It is precisely these two forms of identification that constitute the dominant strategy of colonial power" (*The Location of Culture* [London and New York: Routledge, 1994], p. 77). Like Bhabha's, my own use of "imaginary" is as much a displacement of Lacan as a borrowing from him—a displacement into history and the operations of hegemonic power. However, I would resist Bhabha's full elision of this (un)Lacanian Imaginary and "the formative mirror phase." Like the Imaginary, the mirror phase needs to be historicized, as I try to suggest later in this essay.

9. George Peckham, *A True Reporte, Of the Late Discoveries . . . of the Newfound Landes* (1583); in *The Voyages and Colonizing Enterprises of Sir Humphrey Gilbert*, ed. D. B. Quinn (London: Hakluyt Society, 1940), 84:452.

10. Examples of "trifles" being traded for precious metals or gems are relatively rare, and are typically early in the history of interaction with any given people—that is to say, before a New World culture has had the opportunity to ascertain the differences between its own relative values and those of its European visitors. In many cases, there is no trade involved but rather an exchange of gifts (this is clearly the case when Columbus receives highly wrought gold artifacts on his first voyage) which is sometimes misrepresented as an example of naive indigenous trading practices. However, the rhetoric of European amazement over such "practices" is quite pervasive and has led a number of modern commentators to imply that New World cultures regularly traded treasures for trifles.

11. Stephen Greenblatt, *Marvelous Possessions: The Wonder of the New World* (Chicago: University of Chicago Press, 1991), p. 110.

12. Greenblatt presumably means to emphasize the disparity between New and Old World cultural "treasures": that is to say, he seems to be thinking of the quasi-"natural" status that certain precious metals and gems had achieved through centuries of fetishization on the part of Old World cultures. However, such commodities accounted for very little trade (see note 10), and the disturbing tone with which Europeans celebrated native näiveté characterizes the most mundane transactions.

13. I owe this observation to David L. Johnson and discussions that grew out of an NEH Summer Seminar in 1995, "Inventing the New World: Texts, Contexts, Approaches."

14. *The "Diario" of Christopher Columbus's First Voyage to America, 1492–1493*, ed. and trans. Oliver Dunn and James E. Kelley, Jr. (Norman: University of Oklahoma Press, 1989), p. 243.

15. For a general overview of the history of glass beads with ample illustrations showing their variety and complexity, see Lois Sheer Dubin, *The History of Beads from 30,000 B.C. to the Present* (New York: Abrams, 1987). For a study that documents the extensive bead trade in the Old as well as the New World, see Jan Baart, "Glass Bead Sites in Amsterdam," *Historical Archaeology* 22:1 (1988): 67–75.

16. For the rediscovery of the hollow-cane method, see Dubin, *History of Beads*, p. 110.

17. See Louis Dumont, *From Mandeville to Marx: The Genesis and Triumph of Economic Ideology* (Chicago: University of Chicago Press, 1977).

18. For Marx on primitive accumulation, see *Capital, Volume One*, trans. B. Fowkes (New York: Vintage, 1977), pp. 873–940. For an astute study of the more "domestic" sense of primitive accumulation in the period (the wealth gained from enclosure and other more localized

economic transformations), see Richard Halpern, *The Poetics of Primitive Accumulation: English Renaissance Culture and the Genealogy of Capital* (Ithaca: Cornell University Press, 1991).

19. John Smith, *The Generall Historie of Virginia*, in *The Complete Works of John Smith*, ed. Philip L. Barbour (Chapel Hill: University of North Carolina Press, 1986), 2:147.

20. I use the term "racial" here advisedly, well aware that its relevance to the early modern period has been the subject of significant recent debate and that modern racialism (and racism) is under the early phases of its ideological construction at this time. For a stimulating and critical overview of these and other issues, see Peter Erickson, "The Moment of Race in Renaissance Studies," *Shakespeare Studies* 26 (1998): 27–36.

21. Although captured in 1607, Smith's expanded account of the compass and his discourse on it appears only in *The Generall Historie* of 1624, a year after the publication of the first folio; Smith was also in England when *The Tempest* was performed at the Globe in 1611, having left Virginia in 1609 after being wounded by a gunpowder explosion. Thus he could have seen the play and possibly had his memory refreshed by the publication of Shakespeare's works in the First Folio, dated 1623.

22. Thomas Harriot, *A Briefe and True Report of the New Found Land of Virginia*, ed. Paul Hulton (New York: Dover, 1972), p. 29.

23. Stephen Greenblatt, *Shakespearean Negotiations: The Circulation of Social Energy in the Renaissance* (Berkeley: University of California Press, 1988), p. 28.

24. For a searching analysis of the colonial impetus and logic of Christianity in its pre- and post-Reformation manifestations, see Greenblatt, *Marvelous Possessions*.

25. See *The "Diario,"* p. 75.

26. Cortés attributed two speeches to Montezuma, in which the Spaniard is described as a returning, vengeful messiah, but Cortés's account is so laden with Christian terms and concepts that many modern commentators regard such passages as "apocryphal" at best. Bernardino de Sahagún later enlarged upon such suggestions to claim that Montezuma thought that Cortés was the returning white god Quetzalcoatl, the "Plumed Serpent." But as Anthony Pagden has detailed, there is "no preconquest tradition which places Quetzalcoatl in this role"; he also notes that the cult of Quetzalcoatl was of little influence in central Mexico and was centered in the vassal state of Cholula (which Cortés infamously destroyed on his march to Tenochtitlán). For Pagden's concise treatment of these matters, see *Hernan Cortés: Letters from Mexico*, trans. and ed. Anthony Pagden (New Haven: Yale University Press, 1986), p. 467 n. 42.

27. Given the degree to which our own world has been shaped by the expansion of European monotheism, it is difficult to apprehend just how bizarre such a parsimonious exclusivity would appear to cultures who were not only pantheistic but also entirely innocent—as New World cultures were—of even the idea of monotheism. For a pantheistic culture, an encounter with another religion is a process of theological give-and-take, based on the relative strength and other appealing attributes of a new culture's divinities. An example from North America is revealing here. After listening patiently to a Jesuit missionary's explanation of the Christian God, a member of the Micmac tribe began to respond in kind, relating aspects and examples of his own deities—to the express exasperation of his spiritual interlocutor, who branded all the Micmac had to say as pagan superstition. To the Micmac, this was a shocking example of an extreme lack of manners. "If we reply that what they say is not true," as the missionary later recounted, "they answer that they have not disputed what we have told them and that it is rude to interrupt a man when he is speaking and tell him he is lying;" quoted in James Axtell, *The*

European and the Indian: Essays in the Ethnohistory of Colonial North America (New York: Oxford University Press, 1981), p. 78.

28. This quote is taken from the manuscript of John Comaroff and Jean Comaroff, *Of Revelation and Revolution: Christianity, Colonialism, and Consciousness in South Africa*, vol. 2 (forthcoming), p. 48.

29. Garcilaso de la Vega, El Inca, *Royal Commentaries of the Incas and General History of Peru* trans. Harold V. Livermore (Austin: University of Texas Press, 1966), 2:682.

30. Ibid., 2:686–87.

31. For Poma's account of Incan history up to and including the conquest, see Felipe Guaman Poma de Ayala, *Nueva cronica y buen gobierno*, ed. John V. Murra, Rolena Adorno, and Jorge L. Urioste, 3 vols. (Madrid: Historia, 1987); the incident with the book is narrated in 2:357. For an astute interpretation of Poma's text and the extensive woodcuts that illustrate it, see Rolena Adorno, *Guaman Poma: Writing and Resistance in Colonial Peru* (Austin: University of Texas Press, 1986).

32. Garcilaso, *Commentaries*, 2:679.

33. Ibid., 2:688.

34. George Best, *The Three Voyages of Martin Frobisher*, ed. R. Collinson (London: Hakluyt Society, 1863), p. 74.

35. The image reproduced here (Figure 4) is a watercolor by de Heere, identified as a portrait of the 1576 captive; however, there is no certainty that this is the painting that Frobisher took with him in 1577. John White accompanied Frobisher and also painted Eskimo men and women; for these portraits and reproductions of other artists' renditions of Baffin Island Eskimos, see Paul Hulton and David Beers Quinn, *The American Drawings of John White, 1577–1590, with Drawings of European and Oriental Subjects* (Chapel Hill: University of North Carolina Press, 1964), vol. 2: pls. 62, 63, 84ab, 85b, 146a, 147a.

36. Best, *The Three Voyages*, p. 138.

37. I should stress that the following reading is intended to render the cultural and psychological logic of the scene as described by, and from the perspective of, George Best—not to record the affective process that the Eskimo in question experienced, or to suggest that such experience necessarily accords with Best's account. I had assumed that this distinction was clear in an earlier treatment of the incident, but since not all readers found it to be so, I feel the need to emphasize that here as in the previous essay I am interested in the operations of the colonial *imaginary*. For my earlier treatment of Frobisher's voyages and the theatricality of the represented conversion, see Steven Mullaney, "Brothers and Others, or the Arts of Alienation," in *Cannibals, Witches, and Divorce: Estranging the Renaissance*, ed. Marjorie Garber, Selected Papers from the English Institute, n.s. no. 11 (Baltimore: Johns Hopkins University Press, 1987), pp. 67–89.

38. For Lacan's discussion of the mirror stage, see Jacques Lacan, *Ecrits: A Selection*, trans. Alan Sheridan (New York: Norton, 1977), pp. 1–7.

39. For this interpretation and an extended description of the arch, see John Rupert Martin, *The Decorations for the Pompa Introitus Ferdinandi*, Corpus Rubenianum Ludwig Burchard pt. 16 (London and New York: Phaidon, 1972), pp. 189–202. For another useful analysis of the arch which in many ways complements mine, see Elizabeth McGrath, "Rubens' Arch of the Mint," *Journal of the Warburg and Courtauld Institute* 37 (1974): 191–217.

40. Martin, *Decorations*, p. 191.

41. Based on the known width of the Arch of the Mint (11.5 meters) and the street it occu-

pied, it would have stretched from one side of the street to the other with no access to the sides.

42. For a more extended consideration of early modern entries, including the famous one of Rouen in 1550, see Steven Mullaney, *The Place of the Stage: License, Play, and Power in Renaissance England* (Chicago: University of Chicago Press, 1988; reprinted by University of Michigan Press, 1995), pp. 65–69.

43. Martin, *Decorations*, p. 20.

44. Elizabeth McGrath notes that most of the arches for the procession bear the Antwerp coat of arms, and that the Arch of the Mint is one of the few exceptions; she also notes a number of other anomalies that combine to make the arch "an unequivocal indication of Antwerp's position under Spanish authority" (McGrath, "Rubens' Arch," p. 215). Representing a mine whose height of productivity is past and celebrating a Spanish wealth that is also a thing of the past, given the depth of Spain's financial crisis in the 1630s, such a structure, both temporary and artificial, may have served (according to McGrath) as "an ironically appropriate symbol for the basis of the Spanish economy" (193–94). However, McGrath also feels the arch is ultimately an expression of hope on Rubens's part, an encouragement to Ferdinand to correct the errors of the past and rescue Antwerp from its colonial decline.

45. I owe these speculations to the thoughtful and incisive comments of Peter Erickson.

46. Quoted in Martin, *Decorations*, pp. 19–20.

47. Rubens' life was disrupted by Spanish occupation of the Netherlands even before his birth. His father, Jan Rubens, had to flee the country in 1568 with his wife and children to escape religious persecution for his Calvinist beliefs; Peter Paul was born in Germany, and later returned to Antwerp only after his father's death. His mother, who was a Catholic, raised Peter Paul in her own faith.

2. MAPPING THE GLOBAL BODY

VALERIE TRAUB

In the past several years, the work of a growing number of scholars has intimated that a wide gulf of intelligibility separates western European Renaissance understandings of race, gender, and eroticism from those of the Enlightenment. Race, for instance, seems not to have existed in the sixteenth century as a stable category of biological difference, but only as one concept among parallel and overlapping concerns of lineage, civility, religion, and nation. Rather than relying on the phenotypic characteristics—skin color, bodily structure—promoted as the basis of race in modern science, concepts of race in the early modern period drew from various, albeit exoticized, notions of social allegiance and geographical affiliation.[1] Gender appears to have been conceived, at least within the influential discourses of medicine, science, and theology, as a hierarchical manifestation of a normatively male bodily form. Men and women were not viewed as two opposite sexes, with incommensurate natures. Rather, they were thought to exist on a hierarchical continuum, differentiated by their relative moral capacities and humoral balances, with men being more perfect, more rational, hotter, and more active than women.[2] Nor, in the realm of erotic practices, was there a clear conceptual division between homosexuality and heterosexuality. Indeed, there was no erotic identity such as "the homosexual" (or "the heterosexual," for that matter), but only the legal and theological concept of sodomy—a capacious term that could be used to mark multiple forms of erotic and social transgression.[3] Despite the frequency of theological denunciations of sodomy, however, erotic bonds among men were clearly central to the management of early modern domestic and political power, helping to construct relations of patronage, pedagogy, apprenticeship, and alliance. If sodomy was an apocalyptic figure for social disorder, then orderly homoeroticism, at least among men, was one of the glues that held early modern patriarchal society together.[4]

It appears that it was only under the auspices of the Enlightenment that certain categories of social difference—which we now tend to consider as constitutive categories of modernity—were consolidated. Thus far, however, little scholarly attention has been paid to the historical mechanisms that fostered this movement from a nascent and in some respects rather lax paradigm of embodiment to the more neat, if ideologically pernicious, construction of elaborate racial and ethnic taxonomies, consolidation of two incommensurate genders, and emergence of subcultures and stigmatized identities based on erotic difference (for instance, the transvestite molly, the sapphist, the tommy). What confluence of social, technological, epistemological, and representational factors contributed to this shift in modes of intelligibility? Might these paral-

lel developments in racial, gender, and erotic ideologies usefully be viewed as inter-
secting?

One form of textual production can provide a mode of access into such an
inquiry. The atlases and maps produced by northwestern European mapmakers of
the late sixteenth and early seventeenth centuries often deploy depictions of human
bodies to visually augment their navigational and geographical information. With
the publishing efforts of Pieter Van den Keere and Willem Blaeu in the Netherlands,
Georg Braun and Franz Hogenberg in Germany, and John Speed in England, car-
tographic bodies become a crucial spur to the commercial boom in the map trade.
Within the history of European cartography, it is usual to view the use of bodies as
an ornamental embellishment which adds interest and flavor to—and sometimes de-
tracts from—the more scientific business of cartographic representation. However, I
want to propose that what seems to be a superfluous aesthetic convention conveys a
strategy of spatialization that brings significantly new ethnographic, racial, and gen-
dered relations of knowledge into view.

In reading maps for their social effects I am not alone. In 1983, J. B. Harley, a
historian of cartography, called for a semantic and historically contextualized analy-
sis of Tudor maps, premised on their unity of decorative and geographical image—a
theoretical program he amplified in influential articles on the ideology of early mod-
ern maps published in *Imago Mundi* and *Cartographica*.[5] More recently, early modern
mapmaking has been analyzed by literary critics and historians in terms of its cultural
poetics and its role in expressing and enabling new forms of subjectivity. John Gillies
and Tom Conley, for instance, have demonstrated the extent to which a geographic
imagination influenced the early modern literatures of England and France.[6] Richard
Helgerson has described the emergence of "a cartographically and chorographically
shaped consciousness of national power" during Elizabeth I's reign, wherein the de-
velopment of surveying and mapmaking allowed the English to take conceptual pos-
session of their kingdom for the first time.[7] Walter Mignolo has analyzed both the
emergence of the "Americas" in the European cartographic consciousness and the co-
existence of indigenous traditions of mapmaking among the Amerindians of Mexico
and Peru.[8] And, whereas it might be expected that maps figure importantly in discus-
sions of New World conquest and resistance, it is perhaps less predictable that John
Hale gives maps pride of place in his opening chapter on the Renaissance "discovery"
of "Europe."[9] Together, these attempts to analyze the politics and poetics of space
give us a fascinating portrait of the role of early modern cartography in the making
of subjects, nations, and world.

Yet, although each of these works focuses, in varying degrees, on alterity and
otherness, none of them examine in any detailed fashion the "work of gender," to in-
voke Louis Montrose, on the cartographic imagination or the work of maps on gen-

dered embodiment.[10] This essay examines the function of the cartographic body in the making of nations, and in so doing, reframes nationality as an implicitly gendered and erotic, as well as incipiently racial, phenomenon.[11] I argue that along with the inauguration of new forms of subjectivity and the growth of national consciousness came new terms of intelligibility for the body. Coincident with western Europeans' expanding perception of the world and the extension of their colonial grasp is a new spatial orientation toward bodies, an orientation that both reflects and enables widespread changes in the epistemology of the body.[12]

In focusing on gender, however, I do not scrutinize those dominant ideological hierarchies that position the female body as inferior or subordinate to the male, or, as others have done, examine the association of uncharted land with femininity and virginity.[13] It is true that since the classical age, the female body has been employed to personify abstract materiality—hence, in the self-consciously classical iconography of atlas frontispieces initiated by Abraham Ortelius in 1570, the continents are personified as female (Figure 7). And, with the publication of Gerard Mercator's *Tabulae Geographicae* of 1578, navigators, astronomers, and geographers—and soon thereafter, rulers, explorers, and soldiers—would be represented on atlas title pages and maps in all their specificity as male. However, despite the stable binary of a feminized personification of territory contrasted to the particular men who chart and conquer it, the strategies used to spatialize male *and* female bodies undergo a shift over the course of the late sixteenth and early seventeenth centuries. In thus linking spatializing strategies with historical change, I hope to illustrate the synchronic coordinates within which terms of embodiment are articulated, while charting the diachronic process whereby these terms alter under the pressure of new ideological exigencies.

* * *

In the late sixteenth and early seventeenth centuries, bodies on maps proliferate; particularly on world, continent, and country maps, there are simply more bodies taking up more space. At the same time, bodies that on medieval and early Renaissance maps had been located within geographic interiors—filling the blank space of Brazil, the vast northern expanse of America, and the *terra incognita* of Australia—are generally shifted to the margins, creating the distinctive ornamental borders associated with the great era of Dutch mapmaking (Figure 8). Neither the impulse nor the effects of this framing strategy are adequately accounted for by the wide-scale transformations in the mode of cartographic production over the course of the fifteenth and sixteenth centuries. Historians of cartography emphasize the amount of new information to be cartographically conveyed during this era of exploration, as geographic and ethnographic data were relayed and required by lucrative colonial and mercantile

THEA
TRVM
ORBIS
TERRA
RVM

Opus nunc denuò ab ipso Auctore recognitum, multisque locis castigatum, & quamplurimis
nouis Tabulis atque Commentarijs auctum.

7. Title page from Abraham Ortelius, *Theatrum Orbis Terrarum* (Antwerp, 1574). Clements Library, University of Michigan.

8. Pieter van den Keere, wall map of world. 1611. Sutro Library, San Francisco.

ventures. Simultaneously, developments in practical geometry and linear perspective altered the technique of projection and the ability to accurately delineate spatial orientation through the use of visual coordinates.[14] The center of map and atlas production shifted from France and the Mediterranean to the Netherlands, where artists and engravers were plentiful, printing technology advanced, and the seafaring demand for up-to-date charts high. The effects of these changes on maps themselves were indeed significant. By the late sixteenth century, portolan navigational charts, which focused on delineating accurate rhumb lines and the location of coastal harbors, were supplemented by world and continent maps that inscribed an increasingly detailed geography.[15] Manuscript charts, often beautifully embellished with gold and colored inks, were commercially supplanted, first by woodcuts and then by copperplate engravings, many with finely etched and colored illustrations. And with the ability to mass produce detailed maps and large-scale atlases, more and more provinces, cities, and towns were subjected to the surveyor's instruments and gaze.

Such changes provide a variety of motives for excising bodies from the interior spaces of maps. But bodies were not so much removed (as they would be under the rationalist regime of the eighteenth century) as resituated along the margins. Far from ideologically marginalizing anthropomorphic images, this movement of bodies to the

periphery gave new import and meaning to the human form. Indeed, it appears that a combination of technical innovations, aesthetic conventions, and ideological pressures enabled a mode of visual representation that brought a new *system* to the cartographic body. In addition to imparting a sense of human dimensionality and perspective to large spatial abstractions, the placement of bodies alongside the edges of maps tends to follow a specific pattern. Abstracted from their environmental context, figures are suspended along a grid of regularly measured, reticular space.[16] Yet, as "homogeneous" as the bordered graticule (the network of parallels and meridians in maps) is, its interior content is arranged by an implicit order of hierarchy and difference. Miming the grammar of latitude and longitude that organizes the cartographic idiom itself, maps in this period begin to imply that bodies themselves may be terrain to be charted.

Although the concept of using an equidistant, perpendicular network to delineate geography was first proposed in the thirteenth century, it was not until the translation into Latin of Ptolemy's *Geography* in the fifteenth century that "abstract, geometric and homogeneous space began to be used for mapping."[17] Historian of cartography David Woodward suggests that this development indicates an "emergence from the medieval center/periphery frame of mind, in which places in the world were accorded widely different levels of importance," to "the more abstract notion . . . that space could be referenced to a geometrical net of lines of longitude and latitude and could thus everywhere be accorded the same importance." Expanding on Woodward's insight that "[s]uch an image of the whole earth allowed the idea of a finite world over which systematic dominance was possible, and provided a powerful framework for political expansion and control," I want to suggest that such a "rationalization" of *bodies* in space took place under the auspices of maps.[18]

There are exceptions to both the proliferation and marginalization of bodies, of course. Individual throwbacks to previous design formats throughout the seventeenth century sometimes locate bodies—usually African and American ones—within a geographical setting. And two of the most widely used atlases of the late sixteenth and early seventeenth centuries, Ortelius's *Theatrum Orbis Terrarum* and Mercator's *Atlas Sive Cosmographicae*, make relatively little use of bodies in their comprehensive mapping of the world, beyond depicting personified female continents on their title pages. But the Dutch and English maps and atlases that followed (and which came to dominate the northwestern European map trade), while clearly imitative of the geography of their Flemish forebears, supplant the restrained decorative idioms of Ortelius and Mercator. Their exuberant deployment of cartographic bodies along map edges enabled two related changes. On the one hand, it made possible a more pronounced differentiation of skin color and clothing, as peoples across the globe are placed according to their physical location and displayed so as to represent a particular culture. On the other hand, it inaugurated a shift away from portraying the world's peoples

as generically male, engaged in activities of labor and warfare, and toward a dyadic composition of the earth's population as pairs of men and women, often captured in static poses that emphasize both their domesticity and representativeness.

In the late sixteenth century, the depiction of native inhabitants on maps became prevalent enough to constitute a separate genre, the *cartes á figures*. In *Shakespeare and the Geography of Difference*, John Gillies posits that "the inhabitants of the *cartes á figures* are almost certainly based on the voyage illustrations" from which developed a "repertoire of exotics." [19] In a footnote, Gillies remarks that whereas the union between geographic and chorographic imagery represented by this separate genre is not generally present in the sixteenth century, the figures can be found in the *Civitates Orbis Terrarum* (Towns of the World) of Georg Braun and Franz Hogenberg, the first volume of which was published in 1572. He suggests that the representation of local inhabitants was a logical element of the city atlas which was, by definition, chorographical. [20] Yet, as befits a footnote to his larger discussion, Gillies does not ask why this genre of maps multiplies or how the chorographic function of human figures affects the meaning of the maps on which they appear.

I will return to Braun and Hogenberg later in this essay, for their six-volume opus enacts over its forty-five year publication release the process of spatialization that I will be describing. Before examining specific maps, however, some basic cartographic conventions require explanation. On world and continent maps, differences of climate, flora and fauna, skin color, manner of life and dress tend to divide the inhabitants of the globe into four (and sometimes six) distinct ethnographic groups. Country and city maps, on the other hand, tend to reflect the ubiquitous western European obsession with status and rank hierarchy. Registered through formal arrangements such as the placement of status-marked bodies on vertical axes, as well as the itemization of social difference through sumptuary codes, such images articulate gradations of status and rank from the top to the bottom of the social scale. [21]

It is of course unremarkable that bodies that are divided and ranked by race and status are also gendered. But the arrangement of male and female bodies along the border of many early seventeenth-century maps deserves wider comment than it has yet received, for it represents a significant departure from earlier cartographic conventions. Sometimes positioned singly, less often grouped in small vignettes, figures are most often placed in male-female pairs. It is the obviousness that attends such gender representations that I want to call into question; for despite the naturalizing claims of reproductive biology, there is nothing self-evident about representing the world's peoples as mature adults and in terms that explicitly situate them (and these are the terms actually inscribed on many maps) as "man and wife." Despite alternative possibilities—male and male, female and female, old and young, master and servant, parent and child, children together (or, given known patterns of polygamy in the Levant

and the New World, a man with several wives)—one pattern predominates: that of husband and wife, with the addition of an occasional infant accentuating the marital pattern.

Through such racial, class, and gendered coordinates, the human form is placed on a conceptual grid, localized not only by the land it inhabits, but by what the early moderns called *habit*. Derived from the Latin for "holding, having, 'havior," *habit* in this period signified "the way in which one holds or has oneself . . . a) externally; hence demeanor, outward appearance, fashion of body, mode of clothing oneself, dress, habitation; [and] b) in mind, character, or life; hence, mental constitution, character, disposition, way of acting, comporting oneself." *Habit* thus synthesizes the separate, yet closely related concepts, *costume* and *custom*, *manners* and *morals*.[22]

Recent scholarship on European sumptuary laws and the transnational phenomena of fashion demonstrates that clothing, particularly in urban locales, was a dynamic, and for some authorities, a disturbing social force by the late sixteenth century. Popular costume books such as Abraham de Bruyn's *Omnium Pene Europae, Asiae, Aphricae atque Americae Gentium Habitus* (1577) and Cesare Vecellio's *Habiti Antichi et Moderni di tutto il Mondo* (1590) depict a range of fashion, usually by employing single figures or single-gender groups to represent different social hierarchies (virgin, bride, and matron, for instance) (Figure 9). Vecellio, in particular, evinces what Diane Owen Hughes calls a "bricolage of fashion" that celebrates and encourages the cross-cultural contact of clothes, a "miscegenation" that mirrors the aesthetic intermingling of clothing styles promoted by the fashion industry itself.[23] Just as publishers of costume books pirated images from voyage illustrations for their collections, mapmakers copied images from costume books for map borders.[24] However, in so doing, cartographers reconstituted the dynamism of the clothing trade into a stable iconography of national dress.[25] On maps, *habit* functions as a static metonym for national character, status hierarchies, and gender and erotic relations. As an emblem of fixed identity, *habit* works in much the same way as Peter Stallybrass and Ann Jones argue does *livery*: marking and impressing subjects into signifiers of larger social relations.[26]

* * *

Gillies has drawn our attention to the overwhelmingly classical idiom of Flemish and Dutch atlas frontispieces and world maps, as expressed in the pervasive personification of the four (or sometimes six) continents, the four seasons, and the four elements.[27] But the relatively static hierarchies of gender and race inscribed by this classical idiom have yet to be analyzed in terms of their relation to alternative tropes that originated on maps themselves. The frontispiece of Ortelius's *Theatrum Orbis Terrarum* inaugurated a monumentalizing idiom for atlas title pages that quickly be-

DONNA DEL CAIRO.

9. "Donna del Cairo," from Cesare Vecellio, *Habiti Antichi et Moderni di tutto il Mondo* (Venice, 1590), p. 481v. Newberry Library, Chicago.

came generic; variations of his Anverian pageant-stage and personified female continents appear in many subsequent frontispieces (see Figure 7).[28] The crowned queen of Europe—holding a scepter in one hand and in the other, a Christianized T-in-O globe[29]—lords over her supposedly less civilized sisters. Asia with her censer is on the left; Africa, her head surrounded by a fiery halo, is on the right; and America reclines below with her hammock and bow and arrow, brandishing a severed head. At her feet, a bust of the fabled continent of Magellanica suggests the possibility of yet another new world. In the spatial iconography of Ortelius's title page, Europe enthroned contrasts explicitly to the cannibalistic America lolling on the ground, while Asia and Africa provide subservient if statuesque support to the edifice of European dominion.

Whereas Mercator's *Atlas Sive Cosmographicae* swayed the nomenclature away from Ortelius's theatrical metaphor and gave birth to the lasting title of *atlas*, the visual iconography of the frontispieces adorning his many editions remained theatrical, monumental, imperial, and gendered. In the first edition, a dynamic, muscular Atlas, legs spread and arms taut, grasps a celestial globe while a terrestrial globe lays at his feet. In the second edition of 1607, the same Atlas is surrounded by six female statues accoutred with the animals and attributes of their lands, gazing impassively at the distance; their various states of dress and colored skin tones (evident in colored editions) enhance their racialized status (Figure 10). The title page of the 1635 English translation of *Mercator's Atlas* depicts a less classical, more vernacular Atlas, flanked by "grave HISTORIE and renown'd GEOGRAPHY," holding the globe aloft while trampling on the forces of Riot, Sloth, and Oblivion (Figure 11). In the four corners, the female continents are captured in emblematic poses, with the sumptuously clothed Europe and Asia positioned above the naked Africa and America.[30] And, in Peter Heylyn's *Cosmographie* of 1652, both stage and Atlas are gone, but the female continents linger, kneeling in a slightly recessed background and holding their respective gifts to the world, as male representatives of military prowess stand in the foreground (Figure 12).

In several frontispieces issued by the Blaeu firm, a rare variation in the personification of continents occurs, with America appearing as a man wearing a feathered headdress and skirt.[31] Perhaps inspired by a world map of 1617 by Claes Janszoon Visscher, which personifies the continents of Peru and Africa as male, this frontispiece, filled with a myriad of human figures, suggests an urge to push beyond already clichéd conventions, even as its elaborate coloring further differentiates pale Europe and Asia, tawny Amerindians, and black Africa and Magellanica.

This brief yet representative survey demonstrates that, despite some aesthetic changes, the bodily hierarchies embedded in Flemish, Dutch, and English frontispieces remain fairly consistent throughout this period, suggesting that a classical idiom meshed easily with broad concepts of natural social hierarchy well into the seventeenth century. But beyond the proliferation of flora and fauna associated with

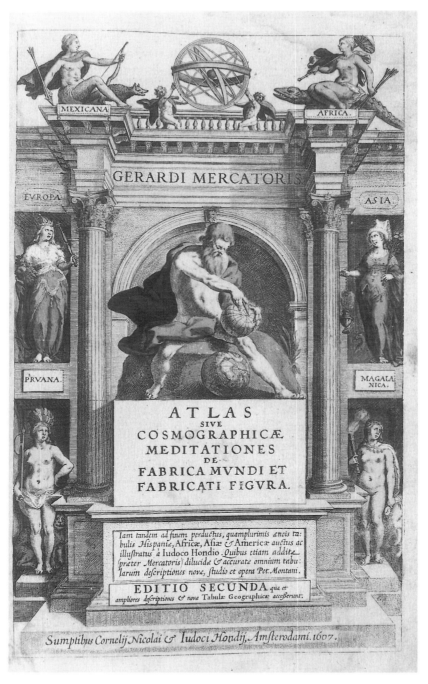

10. Title page from Gerard Mercator, *Atlas sive Cosmographicae*, second edition (Amsterdam, 1607). Clements Library, University of Michigan.

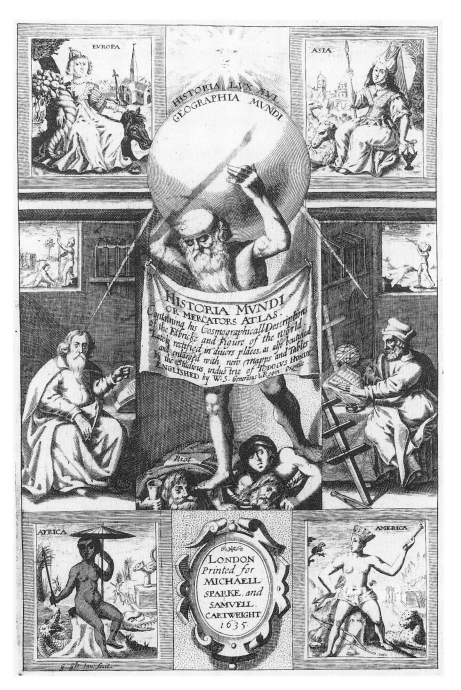

11. Title page from Gerard Mercator, *Historia Mundi or Mercators Atlas Englished* (London, 1635). Newberry Library, Chicago.

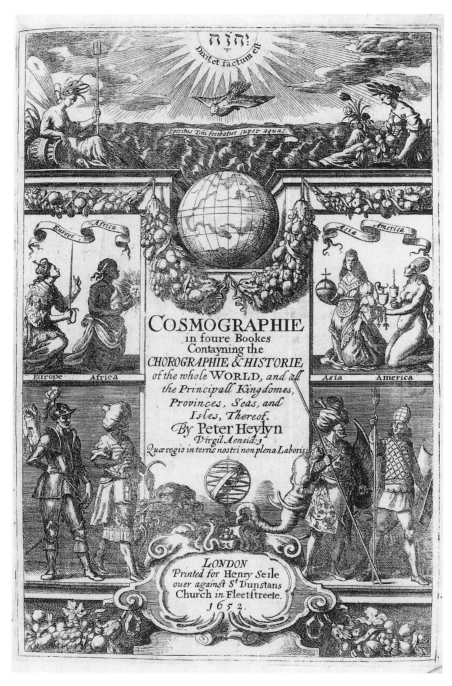

12. Title page from Peter Heylyn, *Cosmographie* (London, 1652). Clements Library, University of Michigan.

each continent, and variations in skin tone made possible by coloring copperplate en-
gravings, classical visual topoi were not particularly well suited to the further speci-
fication of cultural difference. Thus, while the preeminence of the classical motif is
unmistakable in frontispieces, this dominance is challenged by a competing idiom on
maps themselves. In the early years of the seventeenth century, an ethnographic idiom
emerges that accords more fully with the "scientific" pretensions of the new geogra-
phy; it supplements, and in some instances supplants, the use of classicism. By ethno-
graphic idiom, I mean not only the further specification of ethnic and racial differences
through the depiction of skin color, costume, and custom, but the location of bodies
on a geometrically proportioned graticule which offers them for comparative viewing
and potential categorization. Spatialized on hierarchical coordinates, ordered accord-
ing to physical and cultural differences, bodies on maps become available as objects
of protoscientific inquiry.

That is, the abstraction of bodies from a landscape correlates with their geo-
metric rationalization; and both accord with an increasing tendency to view bodies
as potentially classifiable objects of an epistemology organized according to ethno-
graphic and gendered imperatives. In making this claim, I am aware that many schol-
ars eschew what they believe to be an anachronistic terminology of "race" when ana-
lyzing early modern representations of otherness. In her book on early anthropology,
Margaret Hodgen, for instance, argues that "cultural divisions were never associated
with 'racial' divisions. Any effort to distinguish among the 'races' of mankind on either
anatomical, physiological, or cultural ground was relatively negligible."[32] In accord
with Hodgen's contention that it was essentially religious difference that troubled
Europeans, Kwame Anthony Appiah argues that Moors and Jews were understood
not as racially or ethnically different, but as simply existing beyond the Christian
fold.[33] Ivan Hannaford suggests that *ecclesia* and *polis* governed conceptions of other-
ness, and that sixteenth-century "attempts to establish anatomical, physiological, geo-
graphical, and astrological relationships between man and man, and man and beast,
did not produce a fully developed idea of race, since there was no proper anthro-
pology, natural history, or biology to support it."[34] And Gillies likewise suggests that
"the sharper, more elaborately differentiated and more hierarchical character of post-
Elizabethan constructions of racial difference are inappropriate to the problems posed
by the Elizabethan other."[35] Ethnic typology, Gillies implies, is irrelevant to a geo-
graphical imagination that consistently blurs racial outlines, telescopes one form of
ethnicity into another, and subsumes all ethnicities under the rubric of exoticism.

If "race" is foreign to early modern modes of conceptualization, according to one
historical view, then another school of thinkers neglects to historicize race at all, in-
stead assuming that current configurations of race and racism correspond unproblem-
atically to early modern modes of being and behavior. Neither approach, the work of
an increasingly vocal group of scholars has made clear, is adequate to the complexity

of relations accompanying a growing consciousness of differently hued beings inhabiting divergent territories and possessing various modes of cultural identification and religious affiliation. In their work on visual images, Kim Hall and Peter Erickson, for instance, have shown that even apparently aesthetic phenomena such as tropes of light and dark figure barbarism and civility through the colors of the world's peoples.[36] Rather than idealizing the Renaissance as a period untouched by race, or condemning it as a mirror of our own culture, we need to analyze the multiple processes and strategies by which race was constructed in this period, even as we acknowledge the numerous ways in which its incipience precluded certain forms of racism.

For it is certainly true that the concepts that would be consolidated by the nineteenth century are inchoate, unstable, and malleable in the early seventeenth century. The preeminent compiler of travel narratives in England, Richard Hakluyt, for instance, paints Africans with a broad brush, sometimes conflating, and only inconsistently differentiating between Africans, Negroes, Moors, Black Moors, and Ethiopes.[37] And it is likewise true that the Christian belief that all men were potentially "brethren in the family of God" mediated (and to some extent moderated) European attempts to differentiate themselves from the alien peoples they encountered.[38] *Race* was associated variously with lineage, genealogy, and civility, often referring to a tribe, people, or nation,[39] while *ethnick* was used largely to describe "heathens" outside of Christendom.[40] *Complexion* did not refer directly or solely to skin tone, but to the combination of the qualities of the four elements that governed the humoral body; in the words of Thomas Elyot, author of the best-selling health manual *The Castel of Helthe*, *complexion* refers to "a combynation of two dyvers qualities of the four elements in one body, as hotte and drye of the fyre: hotte and moyste of the Ayre, colde and moyst of the Water, colde and dry of the Earth."[41] Skin color thus was an external manifestation of basic humoral qualities, which were themselves affected by climatological variations around the globe.

In arguing that early seventeenth-century maps and frontispieces develop an ethnographic idiom, then, I am not suggesting that we are witnessing the emergence of a full-fledged taxonomy, much less scientific racism with its focus on phenotypic skin color and its noxious justifications drawn from biology. I do contend, however, that the spatial plotting of cartographic bodies in the early seventeenth century depended on and fostered a delineation of difference not wholly circumscribed by notions of true and false religion, civility and barbarism. Other concepts, themselves equally unstable, infringe upon and complicate such binaries. Ideas of lineage bleed into notions of nation; ideas of nation evolve out of complexion and clime. Through such convergences, the specification of difference begins to take on an increasingly racialized cast. In Juan Huarte's popular health manual *The Examination of Men's Wits* (1594), for instance, climatological explanations of the state of men's souls, originally derived from Galenic medicine, morph seamlessly into nationalist and racialized meanings:

Galen writ a booke, wherein he prooveth, That the maners of the soule, follow the temperature
of the body [*Quod animi mores*], in which it keeps residence, and that by reason of the heat,
the coldnesse, the moisture, and the drouth, of the territorie where men inhabit, of the meates
which they feed on, of the waters which they drinke, and of the aire which they breath: some
are blockish, and some wise: some of woorth, and some base: some cruel, and some merciful
. . . And to proove this, he cites many places of Hippocrates, Plato, and Aristotle, who affirme,
that the difference of nations, as well in composition of the body, as in the conditions of the
soule, springeth from the varietie of this temperature: and experience it selfe evidently sheweth
this, how far are different Greeks from Tartarians: Frenchmen from Spaniards: Indians from
Dutch: and Aethiopians from English.[42]

"And experience it selfe evidently sheweth this." With Europeans' increasing experi-
ence and expectation of global variation, concepts of nation, region, religion, lineage,
genealogy, skin tone, complexion, mode of dress and living all begin to jostle and re-
assemble. If phenotype is a concept based on visible characteristics, then what devel-
oped in the early modern period was not a phenotype based on the privileging of skin
color, but a strategy of marking differences and similarities through a visual mime-
sis of nation, religion, lineage, costume, as well as skin color—in a word, *habit*. As
will become clear from the evidence of maps, the habits of the populace of continents,
countries, and towns were profoundly amenable to geometric rationalization.

＊　＊　＊

Before cartographic bodies were plotted on perpendicular axes along map mar-
gins, they tended to be represented in geographic context. Medieval and early Re-
naissance maps sometimes used human figures to denote the rulers of realms, as in
the *Catalan Atlas* of 1375, which dots the terrain with sultans, moguls, kings, and
queens.[43] Other maps depicted the topography of foreign lands as highly fantastical,
with both figure and landscape overwritten by the repertoire of the mythical and the
marvelous. Modified through the medium of medieval Christianity, monstrous types
known as the "fabulous races of men"—hybridized beasts, headless men, Amazons,
cannibals—map the extremes of bodily form onto the extremes of geographical place;
indeed, the monstrous or grotesque on maps generally marks the site of geographical
liminality, even when geography and ethnography moved toward greater specificity
and accuracy.[44] In a Renaissance French map by Le Testu (1556), for instance, two
Amerindians battle a dragon and an oversized dog while a dog-headed man (cyno-
cephalus) apparently comes to the Indians' aid (Figure 13). The map of the New World
in Sebastian Münster's influential edition of *Ptolemy* (1540) shows limbs and a head
dangling from a cannibalistic pyre in Brazil—a popular trope that gained some cre-
dence through the use of ritual cannibalism among the Tupinamba.[45]

Not all early Renaissance maps, however, were devoted to depictions of mon-

13. Portolan Chart of Florida from Guillaume Le Testu, *Cosmographie Universelle*, 1556. MS DLZ 14, fol. 53. Bibliothèque du Service historique de l'Armée de terre, Vincennes.

strosity or savagery. In a map by Portuguese cartographer Lopo Homem (1519), a group of Amerindians harvest brazilwood while monkeys, parrots, and macaws look on (Figure 14). And a portolan chart from the French Dieppe school (1538) shows very pale Amerindians engaged in a variety of activities: waging war, carrying brazilwood toward a Portuguese ship off the coast, and interacting with Portuguese traders. Such maps, depicting the commercial activity that justified colonial ventures, represent, albeit in a schematic way, Amerindians living, producing, acting within a particular environment.

The *Boke of Idrography*, a manuscript atlas presented in 1542 to Henry VIII by French cartographer Jean Rotz, is an important attempt to depict foreign bodies in specific geographical settings devoid of monstrous tropes (Figure 15). Rotz's portolan charts are concerned above all with mapping coastlines; thus, they render the geographic interior of continents with nowhere near the precision given over to rhumblines radiating out from compass roses. Nonetheless, Rotz registers the diversity of the world's population through figures recognizable by their dress, skin tone, modes of habitation and locomotion (Figure 16). Although Rotz depicts the geography of northern Europe in his map of the Mediterranean, he neglects to include northern European figures; only as we move south toward the Mediterranean do bodies come into view. Despite its pretensions to be a world atlas, Rotz's representation of bodies is governed by an impulse to depict alterity, not to provide a comprehensive global itemization: what is already known does not require delineation; what is foreign or unfamiliar demands specification. At the same time, Rotz's peoples—all of them male, as is true for the bulk of early Renaissance maps—are coterminous with, and intrinsic to, the landscape they inhabit.[46]

* * *

The relation of figures to space, as well as their normative gendering, begins to change as voyage illustration makes available a more detailed specification of native bodies and modes of dress and life on the interior of non-European continents. Theodor de Bry's two series of illustrated *Voyages* (1590–1634) marks this transition: some of the plates offer fully animated vignettes, as in "The manner of makinge their boates" from the first book of *America*, while others capture the native subject in an objectifying anterior and posterior pose, as in the depiction of "Proceres Roanoack" (Figure 17). Both the dramatized scene and the static pose convey ethnographic information as part of a colonialist project. However, those illustrations that place native bodies within a lived context—fishing, cooking, eating, praying—incur less of a systematizing effect than those that extricate the body from a detailed landscape and submit it to an anterior and posterior gaze.

De Bry's oft-noted Europeanization of the features and postures of the Algon-

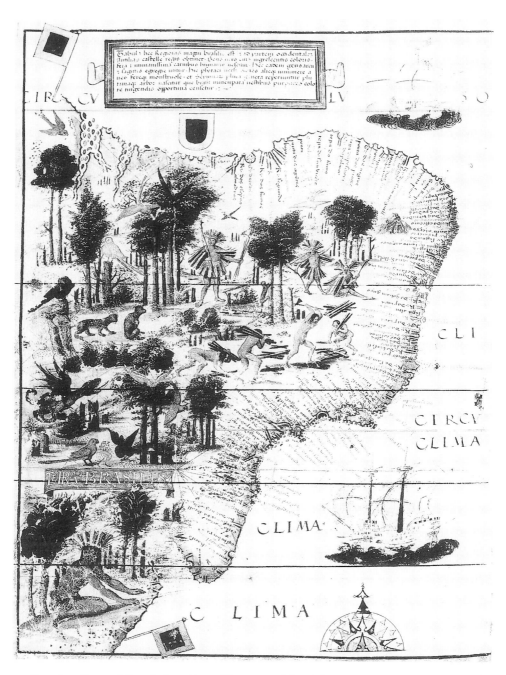

14. Portolan Chart of Brazil, from Lopo Homem, *Miller Atlas*, ca. 1519. Cartes et Plans, Rés. Ge DD 683, leaf 4r. Bibliothèque Nationale, Paris.

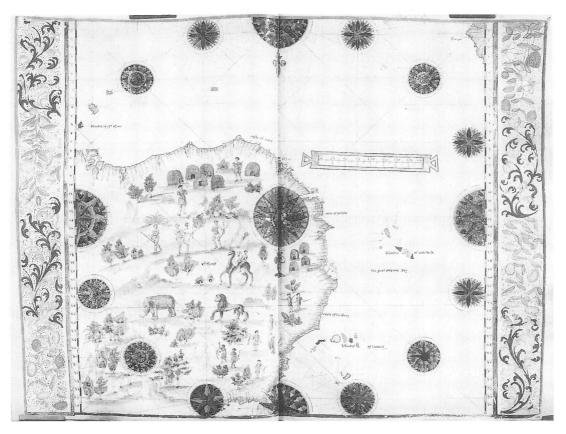

15. Map of Africa (Barbary Coast), from Jean Rotz, *The Boke of Idrography*, 1542. MS Royal 20 E IX, pp. 15v–16r. By permission of the British Library.

quians drawn by John White during his governorship of the Roanoke settlement has been criticized for erasing the alterity of native bodies in order to make them more familiar, and aesthetically pleasing, to European viewers (Figure 18).[47] But what this critique ignores is the extent to which de Bry and those he influenced maximize the potential of White's "natural history" technique of drawing a single object against a blank background and supplementing the visual information with a textual caption. Even as they sometimes add diminutive flora and fauna, de Bry and his followers further rationalize White's native subjects through a spatializing idiom that has much in common with both costume books and anatomical illustration.[48] Consistency of scale, stable orientation, and isolation of a single or double figure in a static pose against a minimal background produce the body as a rationalized object of knowledge—as in an ethnographic insert from Samuel de Champlain's map of the Saint Lawrence River (1612), which depicts two sets of male-female pairs from neighboring tribes

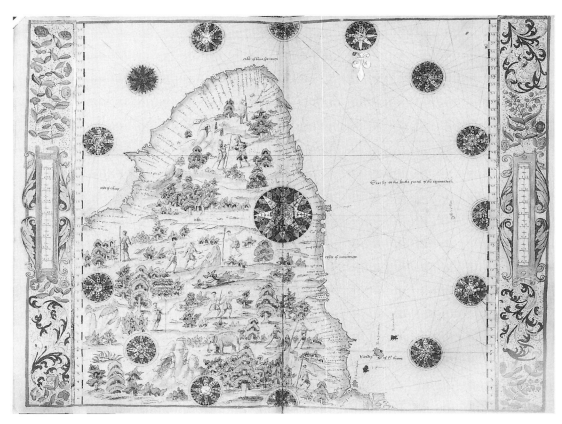

16. Map of Africa (Cape of Good Hope), from Jean Rotz, *The Boke of Idrography*, 1542. MS Royal 20 E IX, pp. 17v–18r. By permission of the British Library.

(Figure 19). The marital couple is isolated in the foreground, the background reduced to a sparse landscape. Extricated from a lived environment and submitted to a viewpoint that emphasizes corporeal singularity, these figures, like similar ones in a host of early seventeenth-century maps of the New World, appear to float in space and time, located only by the labels and captions that denote their representativeness of an entire people. Presenting the native subject as a standard type, these voyage illustrations translate European colonialists' experiences of human diversity into an orderly, systematizing uniformity, while constructing a rationalized measure that encourages classification and comparison.[49]

In 1587, Rumold Mercator solved the crisis in representation that had plagued mapmakers since the discovery of the New World by dividing the globe along a prime meridian, flattening the rotundity of the earth by artificially cutting it in half. His technical innovation of a "double hemisphere map" created not only a new geography, but the possibility of a new aesthetic format. In 1594 Petrus Plancius situated the six alle-

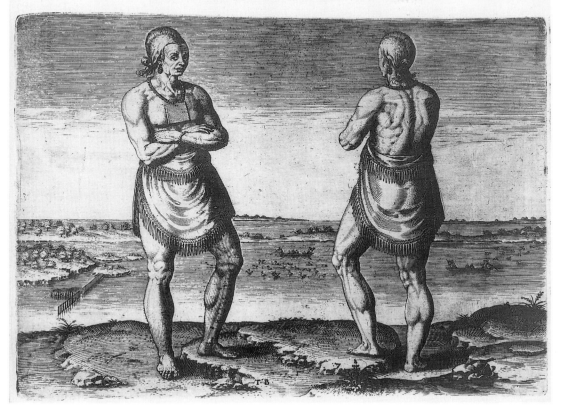

17. "Proceres Roanoack" ("A Chief Lorde of Roanoke"), from Theodor de Bry, *America*, plate VII (Frankfort, 1590). Newberry Library, Chicago.

gorical continents, familiar from Ortelius's and Gerard Mercator's atlas title pages, in the corners and central interstices of his own double-hemisphere map (Figure 20).[50] Europe, holding a cornucopia and surrounded by emblems of science, is accompanied by her continental sisters who, in various states of dress and nudity, sit astride beasts of transport. Alluding to the wealth to be gained by commerce and colonization, Asia's feet rest atop a jeweled box while the feet of Mexicana and Peruana dangle over piles of gold; Europe marks her domination over all with her foot atop a Christianized T-in-O globe.

Plancius's design made expert use of the blank space that had been opened up within the map's rectangular frame. But rather than satisfy the desire for thematic adornment, his map seems to have whetted it. In 1611 Pieter van den Keere augmented

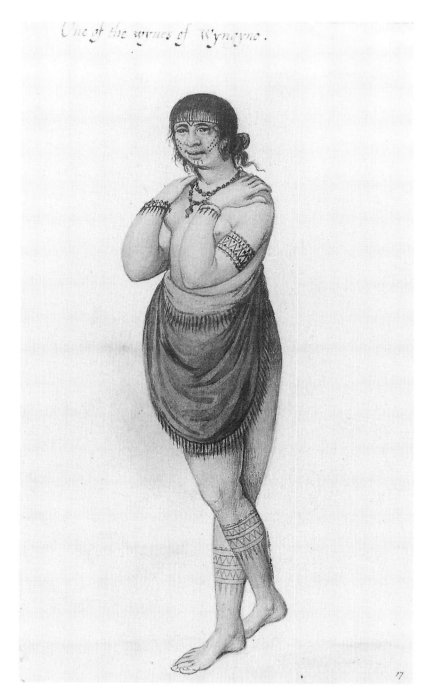

One of the wyues of Wyngyno.

18. John White. *One of the wyves of Wyngyno.* 1585. Watercolor. © The British Museum, London.

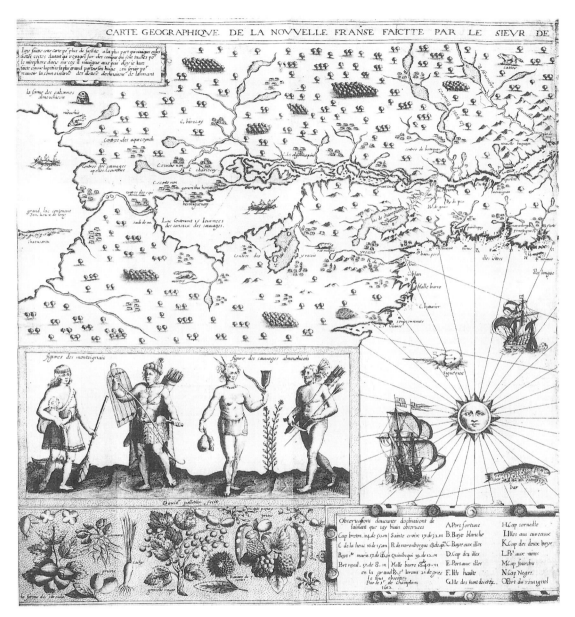

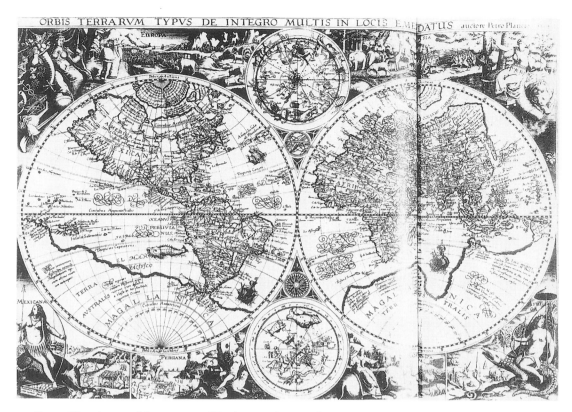

20. Petrus Plancius, world map. 1594. Newberry Library, Chicago.

Plancius's format with ornamental borders filled with bodies (see Figure 8).[51] Along with elaborate depictions of the six allegorical continents in its interior interstices, this map is framed by fourteen cities, rulers of seven nations, and eighteen pairs of human figures, all of them paratactically rubbing up against one another.[52] As Günter Schilder and James Welu remark, "This kaleidoscope of images take the viewer to all known parts of the world."[53] What they don't mention, however, is that the social relations of this world are governed by a precise logic of hierarchy and analogy. For instance, the allegorized continent of Mexicana is bordered at the top, left to right, by a scene of Philip III, king of Spain, and his queen; a Spanish couple; a view of Rome; and an Italian couple—all conveying the dominance of Roman Catholicism via Spanish rule over colonial Mexico (Figure 21). Next along the top border is a view of Frankfurt, a German couple, and, holding pride of place in the center of the frame, the Holy Roman Emperor, Rudolf II. Ensconced below the imperial figure of Christian authority in the central interstice is Europe, wearing a papal crown and receiving homage from the other continents. Along the border, Van den Keere situates Euro-

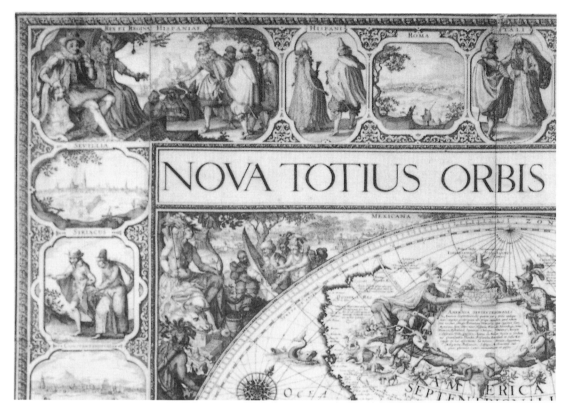

21. "Hispaniae, Rome, with Mexicana." Detail of Pieter van den Keere, wall map of world. 1611. Sutro Library, San Francisco.

pean nations on the top, New World natives on the bottom, the inhabitants of the Middle East and Africa on the right, and the peoples of the Far East on the left. Twelve out of the eighteen pairs in his borders are male-female couples. All of the Europeans on the top border compose such pairs, while along the left and right borders, Turkey, Poland, Denmark, and Hamburg prove to be exceptions.

Van den Keere's design was influenced by Willem Blaeu's large wall map of the world, first issued in 1605. An immense twenty-sheet map, only one poorly preserved copy still exists; it has been reconstituted in facsimile as it appeared in a 1624 edition published by Jodocus Hondius (Figure 22).[54] Blaeu's wall map alternates views of cities with views of people, all of them spatialized according to a continental hierarchy: the cities and inhabitants on the top border are European, while the lower border is populated by non-Europeans. Most of the figures in these twenty-eight vignettes compose male-female pairs, linked by their shared age and status. However, some of the figures constitute triads or foursomes. Again, this difference seems to cor-

22. Jodocus Hondius after Willem Blaeu. Wall map of world. 1624. Clements Library, University of Michigan.

respond to a division between European and non-European: with the exception of the Danes, all of the figures on the top border compose adult male-female pairs, while most of those in threesomes or groups are non-European, positioned along the bottom border. Occasionally joining within one circular frame depictions of two non-European peoples—quite unexpectedly, for instance, a Floridean and Greenlander pose in animated discussion—this map suggests that what was seemingly becoming the fundamental strategy of spatially ordering bodies in northwestern Europe, the male-female pair, had not yet taken firm hold on representations of non-Europeans.

For it appears that later maps are more consistent in their deployment of male-female couples. The engraver responsible for Blaeu's border etchings, Claes Janszoon Visscher, for instance, depicts sixteen male-female pairs in top and bottom margins (with twenty cities along the sides) in one of his earliest maps, "Orbis terrarum typus de integro" (1614), while in a later map he mixes the four elements with national couples: Spanish, French, Italian, German, English, and Belgian along the top, and Greenland, China, Java, Guinea, Peru, and Magellanica along the bottom.

Indeed, it is when maps *fail* to employ male-female dyads that it becomes evident

that such couples are not merely the natural, most obvious or suitable way to organize bodies in space. Other options were clearly available. Vecellio's costume plates, for instance, depict *single* bodies in their effort to detail slight alterations of dress from one region and status to the next. De Bry's Amerindians are represented both singly and in groups. The city atlas of Braun and Hogenberg, as we shall see, mixes male-female pairs with single figures, single-gender pairs, and group tableaus. The yoking of male-female pairs with a European status in Blaeu and Van den Keere suggests that more is at work in these maps than expediency or aesthetics. And while it is certainly the case that the positioning of men and women together does not inevitably imply a marital union, I would maintain that these maps imply marriage through portraying their figures in complimentary, status-appropriate dress and positioning them in poses suggestive of domestic intimacy—arms draped around one another, clasping hands, talking with considerable animation, women gazing up at their male companions. Within each vignette, there is little to suggest national or ethnic variations in what male-female contact might *mean*. What motivates and emerges from such images, I want to suggest, is not merely a recognition of biological reproduction, but a specifically *heterosexual* idiom, one that reflects and enforces an emerging discourse of "domestic heterosexuality."

I will say more about "domestic heterosexuality" shortly. For now, I simply want to note that with one exception, the continent maps in Blaeu's multivolume folio *Novvel Atlas* all follow a pattern similar to that of his world map: five male-female pairs on either side, topped with city views (Figure 23).[55] The exception is his map of Europe, where Venice is represented by two men—whether in reference to the Venetian republic or the Italian reputation for sodomy, one can only surmise. As in the world maps, couples and cities serve as an agent of boundary, implying a conceptual analogy between the inhabitants of the earth and the cities they inhabit: the marital body and the land domesticated by it together connote the essence and boundary of nation.

Within twenty years, the ornamental designs inaugurated by cartographers in the Netherlands established conventions of embodiment that were to last through the late seventeenth century and would influence map production throughout western Europe. These conventions were utilized in several kinds of cartographic production: large wall maps intended to decorate a nobleman's study, single sheet maps to be used by statesmen, mercantilists, and military commanders, multivolume folio atlases to be treasured in gentlemen's libraries, and, to a lesser extent, quarto atlases available to anyone able to purchase them.[56] With copperplates moving from one publishing house to another, with images pirated, bought, reproduced, and updated, the Dutch cartographers cornered the profitable market in maps while spreading their images of the body into the halls of state, the gentleman's library, the mercantilist's shop, and, as Vermeer's paintings of Dutch domestic interiors attest, the bourgeois parlor.[57] Whereas multisheet wall maps and folio atlases were expensive and thus limited to an

23. "Africa," from Willem Blaeu, *Le Theatre du Monde, or, Novvel Atlas* (Amsterdam, 1635), p. 60. Newberry Library, Chicago.

elite stratum, single-sheet maps and quarto atlases were less costly, no doubt making their way into a more popular domain.[58] Paraphrasing the report of a seventeenth-century traveler to Holland, Svetlana Alpers remarks that "even the houses of shoe-makers and tailors displayed wall-maps of Dutch seafarers."[59]

Although the Dutch dominated the market, cartographers from other countries produced their own maps and atlases, capitalizing on their competitors' successful formats. In John Speed's *Theatre of the Empire of Great Britaine* (1611), the spatial gridding of marital bodies is given a native English cast. In "The Kingdome of England," for instance, the figures on the left, captioned as "A Lady," "A Gentleman," "A Citizens Wife," "A Countryman," are yoked to their spouses on the right as the viewer's eye moves across the land (Figure 24). Separated by the gulf of the kingdom, yet joined through their shared rank and marital union, these figures frame the kingdom in an explicit marriage of nation and heterosexuality. In "The Kingdome of Ir[e]land" the inset shows couples already linked, as the more usual class hierarchy is replaced with

24. "The Kingdome of England," from John Speed, *The Theatre of the Empire of Great Britaine* (London, 1611). Clements Library, University of Michigan.

the English preoccupations with, as the captions suggest, the "gentle Irish," the "civill Irish," and the "wilde Irish" (Figure 25). No classical iconography here, but rather the political problems vexing the emerging "Empire of Great Britaine."[60]

In 1627 Speed published *A Prospect of the Most Famous Parts of the World* wherein the continent maps repeat the general format developed for his native England. With cities placed horizontally along the top, and single figures arranged vertically, Speed momentarily forgoes the conjugal pair, focusing instead on ethnic and national differences overwhelmingly represented by men. In all but two of the many country maps, however, the marital idiom is reasserted, with heterosexual spouses divided from one another by the geography of nation or empire. To give only a few examples, "A New Mappe of the Roman Empire" shows, top to bottom, Spanish, Italian, Turkish, Egyptian, and Moorish couples. The map of Germany shows a gentleman, a merchant, a Bohemian, a Helvetian, a country man, and their wives. France proceeds with king,

25. "The Kingdome of Irland," from John Speed, *The Theatre of the Empire of Great Britaine* (London, 1611). Clements Library, University of Michigan.

nobleman, merchant, country man, and, at the bottom, a lawyer—and their wives. The Turkish Empire is represented by a Grecian, Egyptian, Assyrian, Arabian, Persian, and, as the captions clearly state, "His Wife," "His Wife," "His Wife," "His Wife," "His Wife"—accomplishing, in its insistence on the singular, a silent elision of the Turkish practice of polygamy (Figure 26).

* * *

The shift of the cartographic body to the margins and the body's attendant abstraction from environmental context are encapsulated by the six-volume *Civitates Orbis Terrarum*, published by Georg Braun and Franz Hogenberg.[61] The first volume of this atlas of town plans was published in 1572; four more books were released before the turn of the century, and a final book appeared in 1617. The focus of *The Towns*

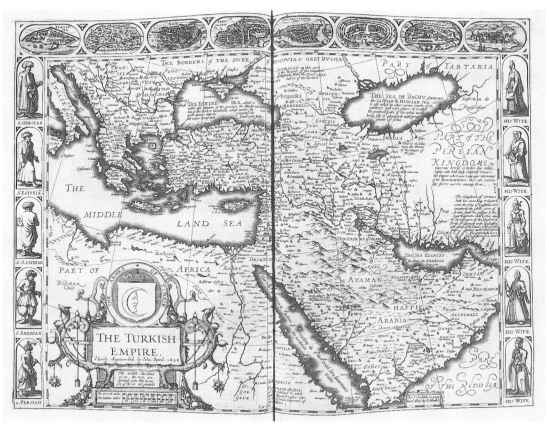

26. "The Turkish Empire," from John Speed, *A Prospect of the Most Famous Parts of the World* (London, 1627, 1646). Clements Library, University of Michigan.

of the World is Europe, and although most of the figures are represented in male-female pairs, this pattern is by no means the only one: numbers of plates present groups of three and four, as well as pairs of men or women. Some plates depict several small vignettes simultaneously while others portray what appears to be the entire population of a village. Positioned for the most part either off to the side or in the lower foreground, these figures, while perspectivally large in proportion to the town itself, are nonetheless presented as attached to it (Figure 27). In the consistent linking of inhabitants to landscape, these figures undoubtedly provide models for the *cartes á figures*, as Gillies noted. However, whereas the vast majority of the plates locate figures in a particular scene, performing a recognizable and often quite animated set of activities, over the course of the atlas's publication, figures increasingly are extricated from the landscape, first through a strategy of captioning, then through explicit spatial gridding.

In volume 1, figures abstracted from such a context are limited to depictions of rulers of church and state—as in the view of Venice, which provides captions identifying ecclesiastical figures situated along the bottom border inset, and the view of Constantinople, adorned along the lower margin with twelve small medallion portraits of Turkish emperors. The tendency to label, however, is confined to these two plates until volume 3, published in 1581, when a few more plates show figures arrayed in various native costumes. A detailed plate depicting Basques, for instance, highlights women's social roles, from the noble matron and virgin to the saint and rustic.

By 1617, what seems to have begun as an impulse to caption has given way to the logic of the grid, as images lifted from Speed's *Theatre* find their way into the final volume. In the reconstitution of Speed's frontispiece and marginal figures, the towns of Yorke, Shrowesbury, Lancaster, and Richmont are surrounded by the ethnic groups that comprise England (Britannus, Romanus, Saxo, Danus), while the typical status hierarchy is laid out in heterosexual pairs (Figure 28).[62] Ethnic differentiation and the

27. "Cracovia," from Georg Braun and Franz Hogenberg, *Civitatis Orbis Terrarum*, vol. 6 (Cologne, 1618), pp. 44 b–c. Newberry Library, Chicago.

28. "England," from Georg Braun and Franz Hogenberg, *Civitatis Orbis Terrarum*, vol. 6 (Cologne, 1618), pp. 2 b–c. Newberry Library, Chicago.

marital unit mutually frame English urban space. A slightly different gridding occurs in the representation of Ireland, as the towns of Galway, Dubline, Lymericke, and Corcke are bordered by nobles, citizens, and rustics—husbands on the left, wives on the right.

As these examples demonstrate, the spatial plotting of northwestern European mapmakers altered the orientation toward the cartographical body. Extracted from the landscape and resituated as a vital element in ornamental borders, human figures were relegated to a framing function whose formal status as "marginalia" belies their importance to the map totality. From the margins, the body continues to speak to and with the geography depicted within. Enhancing the map's geometric rationalization of space, these images of embodiment evoke and reveal the power of submitting social relations to a spatializing grid.

Such representations, however, were not forever relegated to the borders; by the 1660s, depictions of the familial unit infiltrate the interior frame, filling the interstitial

spaces previously monopolized by the female personifications of continents. In Frederick de Wit's *Nova Totius Terrarum Orbis Tabula* (Amsterdam, c. 1660) representatives of the nuclear family supplant the single woman while retaining her continental attributes. On the top left, Europe is represented by a fashionable gentleman holding the arm of his elegant wife; two children (or a child and his young governess) are in attendance, while a horse, being pacified by an attendant, rears in the background. On the top right, Asia is represented by an imposing Turk holding the hand of his regal wife; two children (or possibly, a child and a servant) complete the family unit, which is chaperoned by a camel. On the bottom left, America is represented by a husband, wife, and child, all adorned in feathered costumes and escorted by a crocodile. On the bottom right, the African husband holds a staff, while his wife carries the ubiquitous parasol; their child (and an elephant) follow behind. Each heterosexual dyad is accompanied by at least one child, and the figures are physically linked through affectionate (or proprietary) gestures: while husbands and wives hold hands, children cling to the mother's hand or hold a parent's robe. (The difficulty of discerning between children and servants only adds to the overall effect of a patriarchal household.) In de Wit's map of the world, domestic heterosexuality and the bourgeois household have supplanted utterly the idiom of imperial classicism.

De Wit's decorative scheme is copied and revised for the English consumer by Robert Greene in his *New Mapp of the World* (Figure 29). Greene retains the familial figures, excises much of de Wit's baroque decoration, and clarifies and strengthens the ideological import of the background scenes. It is in reference to this map that Rodney Shirley refers to the accompaniment of each family with "local background" which he describes as "rustic scenes of hunting or (in the case of America) of cannibalism."[63] The implications, however, extend beyond an innocent rusticity. On Greene's map, the Asian figures on horseback clearly are fighting one another; and in Africa, one of the equestrian archers is actually a centaur. The background activities thus are differentiated along an axis of civility: genteel European equestrians, accompanied by hounds, chase a stag; an Asian cavalry battles its foe in violent warfare; hostile Americans engage in their seemingly timeless enjoyment of cannibalism; and Africans either pursue mythological beasts, or are mythological beasts themselves. Patterns of civility and domestic heterosexuality simultaneously create and differentiate the four corners of the world.

For western Europeans accustomed to traditions of the Christian *mappaemundi* and the late medieval concept of the body politic, the analogy between body, land, and kingdom would have been a familiar enough trope. In several examples of the medieval *mappaemundi*—the Ebstorf map is a well-known example—Christ's body becomes a T-in-O sphere, with his head, hands, and feet marking the four cardinal directions, and the kingdom of heaven and earth encompassed within his bodily em-

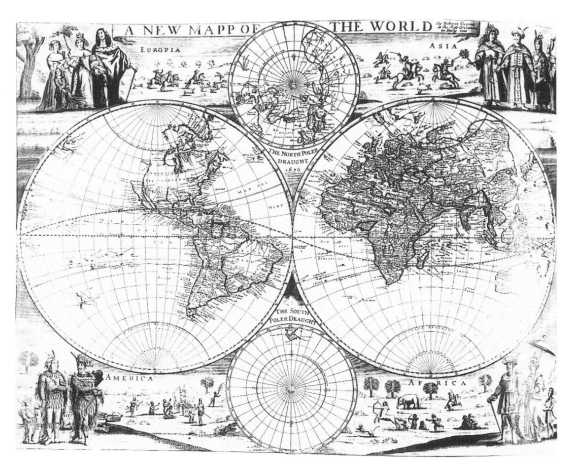

29. Robert Greene, *A New Mapp of the World* (London, 1676). Newberry Library, Chicago.

brace. And, from the fifteenth through the early seventeenth century, the conflation of land and ruler was a frequent resource in articulations of monarchical power—as in the Armada and Ditchley portraits of Elizabeth I, which present the queen laying imperial claim to the entire globe or standing atop Saxton's map of England and Wales, or in the title page of Samuel Purchas's collection of travel narratives, *Hakluytus Posthumus* (1625), where, in the upper left corner, James I and Prince Charles are regally arrayed in front of a scrolled map of Scotland, England, and Ireland.[64] By the early seventeenth century, however, the analogy between body, nation, and land increasingly is appropriated by and reformulated on maps themselves. Instead of representing the monarch embodying, or taking imaginative possession of, the kingdom or globe, maps fragment the nation (or continent) into its constituent parts: subjects,

citizens, or natives, linked together under totalizing paradigms of geopolitical space (continent, empire, nation, kingdom, country), yet nonetheless differentiated by ethnicity, religion, status, and gender.

* * *

The future direction of this new cartographical orientation is implied by a book engraving from the mid-eighteenth century. The frontispiece of Thomas Osborne's *Collection of Voyages and Travels* (1745) literally has lifted eighteen pairs of figures off of maps and rearranged them under the title "A Description of the *Habits* of most COUNTRIES in the WORLD" (Figure 30). Insofar as *habit* conflated clothing and manners, costume and custom, the engraving's reference to habits extends beyond a catalog of what is often referred to as "native garb." Whereas clothing style encodes cultural specificity—the elaborate costume of the Muscovite, for instance, contrasting to the bare skin of the Virginian—the concept of habit also works to homogenize difference. For, from the Laplander to the Hottentot, the visual depiction of bodily and behavioral habits presents heterosexual coupling as holding sway over national, ethnic, and religious difference.

Since at least the late sixteenth century, travel narratives had included tales of gender disorder. Indeed, Kim Hall argues that "What cultural chaos the early travelers saw, they perceived primarily in terms of gender."[65] When European travelers turn their eyes away from battles, land formations, and commodities toward social practices, they typically describe courtship and marriage rituals, note the presence of polygamy and divorce, and bemoan the incidence of sodomy and female lasciviousness. Certainly, the global diversity of erotic practices looms as a troubling issue in the travel narratives included in Osborne's two-volume collection. In *A Voyage into the Levant*, by Henry Blount, for instance, Turkish men not only have multiple wives, but "each basha hath as many, or likely more, Catamites, which are their serious loves; for their wives are used (as the Turks themselves told me) but to dress their meat, to laundress, and for reputation."[66] *A True Relation of the Travels and most miserable Captivity of William Davis* repeats the commonplace that Turks, although "goodly people of person" are "very villains in mind, for they are altogether sodomies [*sic*], and do all things contrary to a Christian."[67] The same author views the women of Naples as "very audacious, especially in the sinful use of their bodies," while the women of the West Indian island of Morria are described as separatist Amazons: "One month in the year, the Men from each side of the main land come in their canoes over to the island, every man matching himself with a woman, living there a month; and what men children they find there, they carry away with them, and the women children they leave behind with the mothers."[68] Nicholas de Nicholay describes the sultan's sodomitical

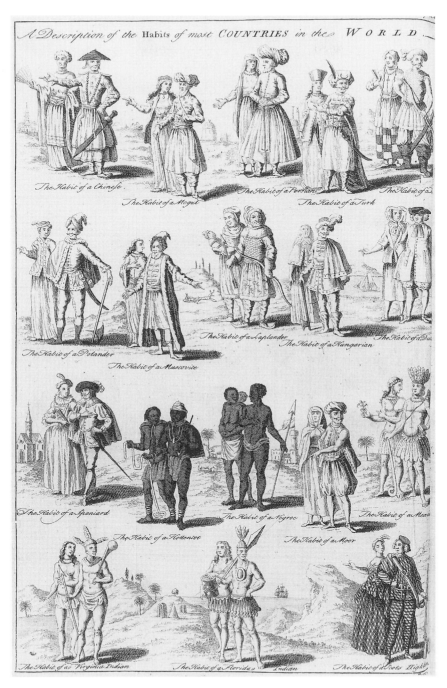

30. Title page from Thomas Osborne, *Collection of Voyages and Travels* (London, 1745). Newberry Library, Chicago.

treatment of Christian slaves, his seraglio (which houses his two hundred wives and concubines), as well as "the very great amity" among Turkish women "proceding only through the frequentation & resort to the bathes: yea & sometimes [these women] become so fervently in love the one of the other . . . they wil not ceasse until they have found means to bath with them, & to handle & grope them every where at their pleasures."[69]

Such narratives of exoticized erotic practices are contradicted by Osborne's engraving, which transmutes this lively diversity into a monotonous repetition of heterosexual marriage. Given that the tales—most of them written in the late sixteenth and seventeenth centuries[70]—bank on the conflation of eroticism and exoticism, we need to ask why the illustration does not. I believe that one answer lies in the growing importance of heterosexual desire as a national, indeed, *nationalist*, project.[71] In contrast to the classical idiom of earlier atlas frontispieces, Osborne's engraving functions not as a monumental *theater*, but as a global *index* and rationalized *cartography* of nations. Extricated from their native homes and reassembled according to a geometric logic, these bodies of the world are plotted as if on a coordinate space of parallels and meridians. In accord with the genre of travel narration, they have displaced topography and become themselves terrain to be charted. And despite their varied ethnic costumes, they are joined together by the imagined affinity of their affective and erotic habits, the custom of heterosexual coupling. Indeed, the marital union here signifies the force linking and homogenizing nations, with companionate dyads seemingly offered as the harmonious resolution to the threat of ethnic, racial, and national difference. Through the repetition of erotic sameness, the naturalness of heterosexual monogamy is enforced at the same time that its cultural specificity is erased. As a global erotic normativity literally is installed by the deployment of images from maps, national identity and heterosexual marriage are shown to go hand in hand.

* * *

As a culmination of the conventions I have been exploring, Osborne's engraving lays bare the ideological effects of the implementation of the grid. As Gillies remarks, through the construction of parallels and meridians, the geometric grid allows "a scientific sense of orientation, distance, and proportion."[72] On early modern maps, as Gillies' work shows, rectangular coordinates exert an axiological force of symmetry, balance, and parity—whereby, for instance, representations of continents line up according to the counterbalancing of eastern and western, northern and southern hemispheres. Similar to the way the geometric graticule exerts an axiological force on land masses, a conceptual grid exerts order, system, and hierarchy on the world's populace. The new geography and the new ethnography thus mirror one another in their

attempts to spatially plot, and thereby render more precise knowledges of, bodies in space. What emerges from the historical implementation of the grid is the possibility of a representative conceptual model, both geographic and somatic, which implicitly confers a concept of the normative by exploiting the exhibition of alterity. That much of the known world had by 1745 already been colonized only underscores the ideological import of the display of otherness—and underscores as well its function in producing the concept of bodily normativity which would prove to be a significant precondition for Enlightenment schemes of scientific racism.

At the same time, the movement toward an ethnographic differentiation of race (and the uninterrupted specification of status and rank hierarchy) exists in tension with, indeed is contradicted by, the function of gender and eroticism on maps. As racial difference threatens to fragment and ramify the globe, and class status demarcates ever more precisely local economies (even as those economies become increasingly mobile), the combined forces of normative gender relations and erotic practices function to glue the globe together. Despite (or perhaps because of) differences in dress and skin color, cartographic bodies come to represent, like the animals in Noah's ark, the natural order of a world composed of male-female pairs.

The representation of this coupled world order correlates with the emergence in western Europe of two discourses crucial to the organization of sexuality: the anatomical construction of two incommensurate genders, with their corresponding biological "natures"; and an ideology of domestic heterosexuality, whereby the affective nuclear family was idealized as an explicit union of emotion and eroticism. Prior to the seventeenth century, marriage in northwestern Europe primarily was a reproductive, dynastic process of social affiliation, offering to family and kin the opportunity to consolidate labor and land. With the Reformation emphasis on marriage as an affective affair, as well as economic and demographic changes that altered the average age of first marriage and the division of household labor, the conjugal unit was posited as the uniquely appropriate site of erotic interest and activity for both women and men. This form of marriage did not merely privilege emotional connections, a sense of privacy, and the separation of the domestic from the public sphere, as historians of companionate marriage claim; it also intensified the *erotic* relation between spouses.[73] Desire for an erotic partner, in addition to desire for a reproductive, status-appropriate mate, became a requirement for, not just a happy by-product of, the bonds between husband and wife. Within the discourse of domestic heterosexuality, desire and emotional commitment not only became the guarantor of happiness and erotic fulfillment, but became a means of articulating the "natural" arrangement of bodies in space.[74]

The cultural production of domestic heterosexuality also contributed to the hardening of both gender and racial lines. For Osborne's marital pairs, it must be noted, are segregated from one another by race. Precisely at the moment when erotic prac-

tices were more likely to take a cross-cultural form, when racialized bodies might cross borders, mingle, and touch in unprecedented ways, Osborne's engraving silently elides interracial sexuality from the global picture.[75] Just as the instability of the gender binary fosters a disavowal of diverse erotic practices, so too the instability of racial divisions enables a disavowal of interracial sexuality. The naturalization of heterosexuality and the unnaturalness of miscegenation emerge simultaneously, as two sides of the same global body. Thus, the production of two ways of constructing race: the ethnographic, which depends on the notion of habit, and the biological, which depends on the concept of reproduction. On seventeenth-century maps, we can begin to glimpse these two modes of construction articulating themselves in terms of one another. It is almost as if domestic heterosexuality serves as an enabling condition of modern racialization, while race gives order and support to domestic heterosexuality.

Obviously, images on maps cannot bear the burden of this argument alone. Further work will need to place the construction of race, gender, and eroticism within the material conditions of mapmaking, including the role of maps in promoting commerce and colonization, and the relation of maps to the revolution in print, with the social and technical possibilities of fixity and circulation analyzed by Elizabeth Eisenstein, Bruno Latour, and Adrian Johns.[76] Changes in the methods and aims of empirical science, including geometry, optics, astronomy, and anatomy, and how these innovations drew from and contributed to the techniques and conventions of mapmaking need, obviously, to be brought more fully into the picture.[77] And both maps and their material conditions must be viewed in relation to the competition among European powers for colonial supremacy, the ongoing New World conquests and resistances to them, the global slave trade, the development of capitalism, and the emergence of nation-states and republicanism following England's model.

Nonetheless, Osborne's eighteenth-century index of bodies suggests that, in the midst of enormous cultural shifts, what people across the globe potentially have in common—at least from a northwestern European perspective—is the reassuring fantasy of stable gender binaries, clear racial divisions, and their "natural" correlative, heterosexual coupling. To invoke Gillies' book once more, by the mid-seventeenth century we seem to have moved from a geography of *difference* to a geography in which certain kinds of differences (racial, ethnic, regional, national) are articulated in tension with an overarching sameness—that is, a worldwide fraternity of gender roles and erotic practices.[78] Increasingly classifiable according to race and ethnicity, yet nonetheless unified by normative gender and erotic arrangements, the fantasy of a new global body had come into being.

The composition of this fantasized global body was, from the beginning, riven with contradictions, and never possessed the secure status of the Real. Not only did northwestern Europeans project onto the peoples of other nations the repressed form

of their own desires, but different populations *did*, in fact, embody a variety of gender and erotic arrangements.[79] Just as important, by the late seventeenth century there was growing awareness of the practice of "unnatural acts" *within* Europe, evinced by the rise of transvestite molly houses in urban centers, periodic trials and violent purges of sodomites (particularly in England and the Netherlands), and medical and popular accounts of tribades, female husbands, and sapphists.[80] The fantasy of global erotic normativity was unattainable even within "civilized" Europe. Thus, to the image of Osborne's eighteen marital pairs, we might append these the words of Jonathan Goldberg: "the law is a regulatory device that installs compulsory heterosexuality only through its compulsion to repeat: thus every performance of the social bond is necessarily subject to failure since the need for repetition is the sign of its completion and imperfection."[81]

Yet, however fantastical and unstable its initial emanation, it is crucial to recognize that from the seventeenth century on, the concept of a global body enacted a powerful universalizing logic, the implications of which trouble many of the premises of current feminist and anticolonialist histories of imperialism and science. For the spatializing strategies of cartography did not focus only on the body of the *other*; no matter their status, gender, or race, *every* individual was submitted to the logic of the grid. No simple dichotomy—religious/irreligious, civil/ uncivil, black/white, self/other—provides a master key for unlocking the grid's terms of intelligibility. Rather, in the rationalization of the body that maps helped to instantiate, the ongoing plotting of gradated *degrees of difference* authorizes each body's subjection to universalizing norms. With the ability to chart such differences and plot their degrees came a corresponding ability to construct racial, gender, and erotic typologies—eventually paving the way for the ideological congruence of natural history, political theory, anthropology, biological science, and their elaborations of, and justifications for, scientific racism and compulsory "romantic" heterosexuality.

* * *

In attempting to "juggle," in the words of Margaret Ferguson, multiple axes of difference, my essay has composed a broad, inclusive framework.[82] The danger of such an approach is the neglect of cultural specificity (of differences of racial and gender organization, for instance) and the implicit privileging of northwestern Europe as the center of cultural production. I therefore want to conclude by describing three possible directions for future investigation that would nuance and perhaps alter my account.

One such direction would respond to the need to localize different European mapmaking traditions—to attend to the differences between Spanish, Portuguese,

French, German, English, and Netherlandish representations, for instance, and to analyze their images in relation to intra-European conflict and the contest for colonial supremacy.[83] Such a study would delineate the strategic differences and similarities that inform representations of cultures mapped by western Europeans and detail the iconography and ideology permeating maps of Africa, Asia, and the New World. Another direction would attend to the self-descriptions of Africans, Asians, and Amerindians, describing how each culture elaborates its own conventions of depicting the body and space. Close readings that contextualize maps within indigenous traditions no doubt will generate additional questions about race, ethnicity, gender, and eroticism. A third path would address the cross-cultural contact among mapmaking cultures, whereby hybrid maps were generated out of conflicting, even warring, countries and traditions.[84] Informed by the "pluritopic hermeneutics" advocated by Walter Mignolo, such a study would further our understanding of the ongoing colonial interactions that were, and remain, the cause and result of mapping the global body.[85]

Notes

I am indebted to Richard Helgerson for gently suggesting that I look at maps, to Margo Hendricks for stimulating discussions on early modern formations of race, to Peter Erickson for useful suggestions for revision, to Elise Frasier for careful research assistance, and to Brian Dunnigan of the Clements Library, University of Michigan, for gracious help in locating and reproducing map images. Clark Hulse provided exceptional assistance in tracking down illustrations and permissions. Patricia Simons offered a rigorous critique of an early version of this essay and suggestions for further reading. I am also grateful to the organizers of, and auditors to, presentations of this essay at conferences at the University of Michigan, California State University-Stanislaus, Queen Mary and Westfield College, and Florida State University at Tallahassee, particularly Bernhard Klein, Andrew Gordan, Arnold Schmidt, Patricia Parker, and Domna Stanton. I profited as well from the astute criticism of the Newberry Library Fellows of 1998–99, particularly that of Ken Alder, and am grateful to the National Endowment for the Humanities for a Newberry Library fellowship. Ray Clemens did much to make those eight months collegial, and Art Holtzheimer shared his enthusiasm for maps. Finally, to the Chicago Map Society and the Herbert Dunlap Smith Center for Cartography at the Newberry Library, most particularly Bob Karrow and Jim Ackerman, I give my thanks for their warm welcome into their field, as well as for their bibliographic and interpretive expertise.

1. See *Women, "Race," and Writing in the Early Modern Period*, ed. Margo Hendricks and Patricia Parker (London: Routledge, 1994); *Race, Ethnicity, and Power in the Renaissance*, ed. Joyce Green MacDonald (Madison, N.J.: Fairleigh Dickinson University Press, 1997); *The William and Mary Quarterly*, 3rd series, 54:1 (January 1997), a special issue on "Constructing Race: Differentiating Peoples in the Early Modern World"; and *Shakespeare Studies* 26 (1998), which presents a forum on "Race and the Study of Shakespeare." The introductions to all four volumes emphasize the lability and multiplicity of meanings of race, as well as how it is implicated in understandings of region, nationality, and gender.

2. See Thomas Laqueur, *Making Sex: Body and Gender from the Greeks to Freud* (Cambridge, Mass.: Harvard University Press, 1990).

3. See Alan Bray, *Homosexuality in Renaissance England* (London: Gay Men's Press, 1985).

4. See Alan Bray, "Homosexuality and the Signs of Male Friendship in Elizabethan England," *History Workshop Journal* 29 (1990): 1–19; Jonathan Goldberg, *Sodometries: Renaissance Texts, Modern Sexualities* (Stanford: Stanford University Press, 1992); Mario DiGangi, *The Homoerotics of Early Modern Drama* (Cambridge: Cambridge University Press, 1997); and Jeffrey Masten, *Textual Intercourse: Collaboration, Authorship, and Sexualities in Renaissance Drama* (Cambridge: Cambridge University Press, 1997).

5. J. B. Harley, "Meaning and Ambiguity in Tudor Cartography," in *English Map-Making 1500–1650: Historical Essays*, ed. Sarah Tyacke (London: British Library, 1983), pp. 22–40. See also Harley, "Maps, Knowledge, and Power," in *The Iconography of Landscape: Essays on the Symbolic Representation, Design, and Use of Past Environments*, ed. Denis Cosgrove and Stephen Daniels (Cambridge: Cambridge University Press, 1988), pp. 277–312; "Silences and Secrecy: The Hidden Agenda of Cartography in Early Modern Europe," *Imago Mundi* 40 (1988): 57–76; "Deconstructing the Map," *Cartographica* 26:2 (1989): 1–20; and "Cartography, Ethics and Social Theory," *Cartographica* 27:2 (1990): 1–23. Harley's indispensable work continued in editing, with David Woodward, the multivolume *The History of Cartography*. The introduction to vol. 1, *Cartography in Prehistoric, Ancient, and Medieval Europe and the Mediterranean* (Chicago and London: University of Chicago Press, 1987), entitled "The Map and the Development of the History of Cartography," charts the divergence, by 1980, in the history of cartography between "its traditional work in the interpretation of the content of early maps as documents and its more recently clarified aims to study maps as artifacts in their own right and as a graphic language that has functioned as a force for change in history" (p. 39). This emphasis within the history of cartography on maps as a language and an agent of change has both drawn from and fostered the work of scholars outside of geographic disciplines and belies any easy divide between cartographical and textual analysis. For the debate about the impact of critical theory on the history of cartography, see the multiauthored conference discussion "Theoretical Aspects of the History of Cartography: A Discussion of Concepts, Approaches and New Directions," *Imago Mundi* 48 (1996): 185–205. Preceding Harley's emphasis on the relation between decorative and geographical image was the more formally oriented but nonetheless extremely useful *Decorative Printed Maps of the Fifteenth to the Eighteenth Centuries* by R. A. Skelton (New York and London: Staples Press, 1952). With an emphasis on the map as a work of art, Skelton avoided ideological readings of cartographical content.

6. John Gillies, *Shakespeare and the Geography of Difference* (Cambridge: Cambridge University Press, 1994); Tom Conley, *The Self-Made Map: Cartographic Writing in Early Modern France* (Minneapolis and London: University of Minnesota Press, 1996).

7. Richard Helgerson, *Forms of Nationhood: The Elizabethan Writing of England* (Chicago and London: University of Chicago Press, 1992), p. 108.

8. Walter Mignolo, *The Darker Side of the Renaissance: Literacy, Territoriality, and Colonization* (Ann Arbor: University of Michigan Press, 1995).

9. John Hale, *The Civilization of Europe in the Renaissance* (New York: Atheneum, 1994).

10. Louis Montrose, "The Work of Gender in the Discourse of Discovery," *Representations* 33 (Winter 1991): 1–41. As far as I know, little of the new work within the history of cartography on the semiotics of maps has concerned itself with the representation of bodies.

11. It is not my purpose to enter the debate about the emergence of nationality, except to

acknowledge that its definition, origin, and subsequent development are contested. In addition, nationhood came unevenly to even western European countries, and only England formally emerged as a nation in this period. See Liah Greenfeld, *Nationalism: Five Roads to Modernity* (Cambridge, Mass.: Harvard University Press, 1992); Benedict Anderson, *Imagined Communities: Reflections on the Origin and Spread of Nationalism* (London: Verso, 1983); Ernest Gellner, *Nations and Nationalism* (Oxford: Basil Blackwell, 1983); Brendan Bradshaw and John Morrill, *The British Problem, c. 1534–1707: State Formation in the Atlantic Archipelago* (London: Macmillan, 1996); David J. Baker, *Between Nations: Shakespeare, Spenser, Marvell, and the Question of Britain* (Stanford: Stanford University Press, 1997); and the critique of Greenfeld in Carla Hesse and Thomas Laqueur, eds., introduction to *Representations* 47 (Summer 1994): 1–12.

12. My ideas about spatialization have been influenced by the work of Barbara Maria Stafford, *Body Criticism: Imaging the Unseen in Enlightenment Art and Medicine* (Cambridge, Mass.: MIT Press, 1991), and Philip Armstrong, "Spheres of Influence: Cartography and the Gaze in Shakespearean Tragedy and History," *Shakespeare Studies* 23 (1995): 39–70.

13. Several scholars, including Helgerson and Montrose, above, have noted the association of the land—particularly America—with the feminine and specifically with virginity. See Peter Hulme, "Polytropic Man: Tropes of Sexuality and Mobility in Early Colonial Discourse," in *Europe and Its Others: Proceedings of the Essex Conference on the Sociology of Literature, July 1984*, vol. 2, ed. Francis Barker, et al. (Colchester: University of Essex, 1985), pp. 1–15. Others have analyzed the ways the female body itself is "mapped." See Joan DeJean's analysis of *la carte chi tendre* in *Tender Geographies: Women and the Origins of the Novel in France* (New York: Columbia University Press, 1991) and Sumathi Ramaswamy, "Maps and Mother Goddesses in Modern India" (forthcoming).

14. The influence of linear perspective on cartography is actually a matter of some debate. See Samuel Edgerton, *The Renaissance Rediscovery of Linear Perspective* (New York: Basic Books, 1975); "From Mental Matrix to Mappamundi to Christian Empire: The Heritage of Ptolemaic Cartography in the Renaissance," in *Art and Cartography: Six Historical Essays*, ed. David Woodward (Chicago: University of Chicago Press, 1987), pp. 10–50; and *The Heritage of Giotto's Geometry: Art and Science on the Eve of the Scientific Revolution* (Ithaca: Cornell University Press, 1991). Svetlana Alpers challenges the influence of Albertian perspective in *The Art of Describing: Dutch Art in the Seventeenth Century* (Chicago: University of Chicago Press, 1983), and "The Mapping Impulse in Dutch Art," in Woodward, *Art and Cartography*, pp. 51–96, arguing instead that Dutch (rather than Italian) art shared with maps a mutually supportive impulse of description rather than narrative. The "coincidence between mapping and picturing" (p. 119) in Dutch visual culture suggests that "it is in the north, not in Italy, that maps and pictures are reconciled," as evinced by "the great and unprecedented production of mapped pictures . . . landscapes and city views" (p. 137).

15. The portolan/portulan chart, first developed for navigating the Mediterranean in the thirteenth century, is a surprisingly accurate maritime chart based on firsthand navigational measurements of distance and direction (rather than, as in later maps, projection, coordinate geometry, and perspective). The charting of coastal outlines preceded the application of the rhumb network (radiating directional lines) which was later added with the appearance of the magnetic compass. Although Mercator's projection appeared in 1569, mariners continued to use portolan charts well into the seventeenth century. See Tony Campbell, "Portolan Charts

from the Late Thirteenth Century to 1500," in *The History of Cartography*, vol. 1, pp. 371–463, and Robert Putnam, *Early Sea Charts* (New York: Abbeville Press, 1983).

16. I am not suggesting that anthropomorphic images were new to maps, or that bodies never appeared in the margins of medieval maps or manuscripts. The "fabulous races" were often portrayed on the edge of medieval texts, as in the woodcuts of the *Nuremberg Chronicle* (Hartmann Schedel, *Liber chronicarum*, 1493), an illustrated history of the world, or in vertical columns, as within the *Liber de naturis rerum creatarum* (1492), a Flemish medieval bestiary (both reproduced in *Circa 1492: Art in the Age of Exploration*, ed. Jay A. Levenson [New Haven and London: Yale University Press and the National Gallery of Art, Washington, D.C.], pp. 124–25). As these images, as well as the *Catalan Atlas*, attest, the notion of organizing figures along a general grid or series of compartments was not new to the Renaissance. Nonetheless, it seems important that medieval texts generally grid *mythic* creatures, while the systematic positioning of the world's populace along graticuled borders in the early years of the seventeenth century achieves a higher degree of ordering, accompanied by implicit gender and racial constructions.

It is instructive to consider the differences between seventeenth-century map borders and the marginal images of Gothic manuscripts analyzed by Michael Camille in *Image on the Edge: The Margins of Medieval Art* (Cambridge, Mass.: Harvard University Press, 1992). Arguing that "[t]he centre is . . . dependent upon the margins for its continued existence" (p. 10), Camille views the often profane images "exiled into the unruled empty space of the margins" (p. 20) as "marginal mayhem" (p. 22), witty inversions of orthodoxy which nonetheless reinforce the status of the "center." His final words regarding the demise of marginal illustration are somewhat apocalyptic: "Gothic marginal art flourished from the late twelfth to the late fourteenth century by virtue of the absolute hegemony of the system it sought to subvert. Once that system was seriously questioned, art collapsed inwards, to create a more literal and myopic deadcentre, taking with it edges and all" (p. 159).

17. David Woodward, "Maps and the Rationalization of Geographic Space," in *Circa 1492*, pp. 83–87; quote, p. 84.

18. Ibid., p. 87.

19. Gillies, *Shakespeare and the Geography of Difference*, pp. 98 and 97.

20. Ibid., p. 214, note 67. In "Political Maps: The Production of Cartography and Chorography in Early Modern England," a chapter of *Narrative and Meaning in Early Modern England: Browne's Skull and Other Histories* (Cambridge: Cambridge University Press, 1997), Howard Marchitello argues that, as an essentially narrative genre, chorography is a rival countertradition to cartography, which tends to repress its own narratological and diachronic impulses in favor of a synchronic, timeless mode of representation.

21. Whereas within each country the extent to which costume reflects status and degree is clear, more research is required to analyze the variation of national costume within a given continent. That is, the dress worn by a French nobleman may do more to mark him as European than to mark him as explicitly French.

22. The concept of *custom* as a habitual or usual practice predates *costume* by at least four centuries. *Custom* derives from the Roman *costumne* in the eleventh or twelfth century, while *costume* as manner of dress doesn't appear in England until the mid-eighteenth century. *Costume* is derived from the Italian sense of guise or habit in artistic representation. The significance of custom as a matter of national identity is signified by the sense of paying a duty or toll when

passing through a custom house, with the guarding of borders through financial transactions. The OED records the first use of custom as toll in 1494 and the first use of bestowing one's custom (frequenting as a customer) in 1605. *Manner* is defined as "customary mode of acting or behaviour, whether of an individual or a community" for as early as 1225. It is linked to morality at the same early date: "A person's habitual behaviour or conduct, esp. in reference to its moral aspect; moral character, morals."

23. Vecellio's first edition was published under a slightly different name in Venice in 1590. The second edition, published in Venice in 1598, is what has come to be known as *Habiti Antichi et Moderni di tutto il Mondo* (Costumes, Ancient and Modern). The first Italian edition printed 420 illustrations; focused on Italy, it also included plates of other European countries, Africa, and Asia; the second edition, written in both Italian and Latin, increased the plates to 522, adding coverage of America. A third edition was published in 1664. According to Annette Dixon and Monika Schmitter in *Venice: Practitioners and Patrons* (exhibition catalog for the University of Michigan Museum of Art, 1997), over the course of publication, "the heavily descriptive text of the first edition gradually decreased" (p. 49). An English translation, *Vecellio's Renaissance Costume Book* (New York: Dover, 1977), reprints the 1598 edition. For Diane Owen Hughes's work on Vecellio's "fashion bricolage" and "sartorial miscegenation" see *Distinction and Display in Renaissance Italy* (New Haven: Yale University Press, forthcoming).

24. See William C. Sturtevant, "The Sources for European Imagery of Native Americans," in *New World of Wonders: European Images of the Americas 1492–1700*, ed. Rachel Dogget (Washington, D.C.: Folger Shakespeare Library, 1992), pp. 25–33.

25. As Hughes notes, this emblematizing of national dress is a primary impulse of many costume books as well.

26. For an analysis of fashion and livery, see Peter Stallybrass and Ann Rosalind Jones, *Renaissance Clothing and the Materials of Memory* (Cambridge: Cambridge University Press, 2000).

27. Gillies focuses on "the paradox of a geography conscious of its novelty, confident of its superiority to the ancient geography, energetically generating a new poetry to make sense of its radically incongruous world-image, yet still enthralled to the imagery of the past" (*Shakespeare and the Geography of Difference*, p. 188). The contradiction between the new geography and a classical iconography—what Gillies calls the "powerful archaism of the decorative frame" (p. 170)—creates a cartography fascinatingly at odds with itself.

28. I do not mean to imply that the pageant-stage is in any way limited to cartographic representations; it is clearly a pervasive visual strategy for title pages of all sorts.

29. Prior to the incorporation of the New World, the medieval globe was split into three continents, Asia, Africa, and Europe. In the T-in-O map, the T represents the division of Africa from Europe and Asia by the Mediterranean, while the O signifies the globe itself. Derived from Roman sources, this concept was adapted by Christian cartographers to accommodate the world as divided among the three sons of Noah, and thus the three races of the world: Semitic, Hamitic, and Japhetic.

30. Mignolo suggests that in a culture of alphabetic writing that proceeds from left to right and top to bottom, the ostensible equality of the four corners is undermined, for whenever Europe is not centered above the other continents, she is positioned in the upper left quadrant, the privileged point of origination (*The Darker Side of the Renaissance*, p. 279).

31. See Willem Blaeu, *Appendix Theatri A. Ortelii et Atlantis G. Mercatoris* (1631) and vol. 2 of *Le Theatre du Monde or Novvel Atlas* (1635).

32. Margaret T. Hodgen, *Early Anthropology in the Sixteenth and Seventeenth Centuries*

(Philadelphia: University of Pennsylvania Press, 1964), p. 213. "People were differentiated from one another as 'nations,' while the term 'race' carried a zoological connotation properly applicable only to animals. As long as man—even pigmented man—was regarded as monogenetic in origin and homogeneous in descent, he could not be submitted to zoological divisions, or to the terms used to designate them . . . it was rather difference in language and religion which touched the Renaissance European to the quick" (p. 214).

33. Kwame Anthony Appiah, "Race," in *Critical Terms for Literary Study*, ed. Frank Lentricchia and Thomas McLaughlin, 2nd ed. (Chicago: University of Chicago Press, 1995), pp. 277–78.

34. Ivan Hannaford, *Race: The History of an Idea in the West* (Baltimore and London: Johns Hopkins University Press, 1996), p. 183. "It is unhistorical to perceive the concept of race before the appearance of physical anthropology proper, because the human body, as portrayed up to the time of the Renaissance and Reformation, could not be detached from the ideas of *polis* and *ecclesia*. Membership in both was inextricably bound to political theory and Christian theology" (p. 147).

35. Gillies, *Shakespeare and the Geography of Difference*, p. 32. He argues that Elizabethan otherness is more a function of the combination of "a generic exoticism or exteriority with an inherent transgressiveness" (p. 25) and is most often played out in terms of a "fatal attraction" toward some aspect of the excluded polity that leads to miscegenation (p. 100).

36. Kim F. Hall, *Things of Darkness: Economies of Race and Gender in Early Modern England* (Ithaca: Cornell University Press, 1995), focuses primarily on tropes of black and white. In more recent work, she maintains that a focus on religious differences in discourses of blackness hide an anxiety about a fundamental *similarity* between black and white; see " 'Troubling Doubles': Apes, Africans, and Blackface in *Mr. Moore's Revels*," in *Race, Ethnicity, and Power in the Renaissance*, pp. 120–44, and "Object into Object? Some Thoughts on the Presence of Black Women in Early Modern Culture," this volume. In "Representations of Blacks and Blackness in the Renaissance," *Criticism* 35:4 (Fall 1993): 499–527, and "The Moment of Race in Renaissance Studies," *Shakespeare Studies* 26 (1998): 27–36, Peter Erickson helpfully charts the different possible critical positions on race. See also Margo Hendricks, " 'Obscured by Dreams': Race, Empire, and Shakespeare's *A Midsummer Night's Dream*," *Shakespeare Quarterly* 47:1 (1996): 37–60, and "The Philology of Race," unpublished paper; as well as Alden T. Vaughan and Virginia Mason Vaughan, "Before Othello: Elizabethan Representations of Sub-Saharan Africans," *The William and Mary Quarterly*, 3rd series, 54:1 (January 1997): 19–44.

37. See Emily C. Bartels, "Imperialist Beginnings: Richard Hakluyt and the Construction of Africa," *Criticism* 34:4 (Fall 1992): 517–38. Bartels argues that such inconsistencies were a strategic attempt to "retain the unfamiliarity of the native subject and so create a critical boundary between Africa and England." By obscuring the individuality of the native subject and amplifying alterity, "the impression that persists is one of undifferentiated darkness" (p. 523).

38. In this, I disagree with Stephen Greenblatt's contention that wonder is "the central figure in the initial European response to the New World, the decisive emotional and intellectual experience in the presence of radical difference," *Marvelous Possessions: The Wonder of the New World* (Chicago: University of Chicago Press, 1991), p. 14. As Adriane Stewart points out in her dissertation *Body Phantoms: Ontological Instability, Compensation, and Drama in Early Modern England* (Vanderbilt University, 1996), whereas "wonder may have been the quintessential European response to the difference of the new world and its flora and fauna . . . it was [not] the defining figure in the European response to the new world peoples and their bodies" (p. 47).

39. In *Black Athena: The Afroasiatic Roots of Classical Civilization*, vol. 1 (New Brunswick: Rutgers University Press, 1987), Martin Bernal suggests that "it is generally accepted that a more clear-cut racism grew up after 1650 and that this was greatly intensified by the increased colonization of North America, with its twin policies of exterminating the Native Americans and enslavement of Africans" (pp. 201–2). To the contrary, there is no such general acceptance. Writing against the idea that the slave trade led directly to doctrines of racial inferiority, Michael Banton, in *The Idea of Race* (London: Tavistock, 1977), advances the thesis that the concept of race was born out of nineteenth-century historical writing concerned primarily with making sense of European lines of descent. Having first racialized western Europe, later thinkers turned to the construction of racial typologies for the rest of the world. Hannaford's laudable attempt to historicize contemporary racial thinking is, unfortunately, untouched by recent scholarship that would challenge his heavy emphasis on political theory as the sine qua non of racial construction. While recognizing the importance of Hermetic, Cabalist, and medical thinking to the development of human "types," Hannaford downplays material practices such as colonial ventures and wars of conquest. Indeed, the studies of both Hannaford and Banton are flawed by their overreliance on the construction of coherent, consistent, and consciously racialized political theories to the neglect of material evidence of racial modes of thinking and racialized social structures.

40. The term *ethnic*, according to the OED, pertained in this period first to "*nations* not Christian or Jewish; Gentile, heathen, pagan," and secondarily, to non-Christian and non-Judaic *persons* (emphasis mine). Ethnicity, then, is primarily a function of religious nationality—the two are not separated. Ethnic personhood was a function of nationality, while nationhood was described recursively through the religion, manners, dress, and physical characteristics of inhabitants.

41. Sir Thomas Elyot, *The Castel of Helthe (1541)*, ed. Samuel A. Tannenbaum (New York: Scholars' Facsimiles and Reprints, 1937), p. 2. See Michael Schoenfeldt, *Bodies and Selves in Early Modern England* (Cambridge: Cambridge University Press, 1999), whom I thank for this and the next reference.

42. Juan Huarte, *Examen de ingenios: The Examination of Men's Wits (1594)*, trans. Richard Carew, ed. Carmen Rogers (Gainesville, Fla.: Scholars' Facsimiles and Reprints, 1959), pp. 21–22.

43. See Jean Michel Massing, "Observations and Beliefs: The World of the *Catalan Atlas*," in *Circa 1492*, pp. 27–33 and 120–21.

44. Some of the sources for the fabulous races of mankind were Pliny, Saint Augustine, and Isidore of Seville. On the use of the marvelous in maps and narratives, see John Block Friedman, *The Monstrous Races in Medieval Art and Thought* (Cambridge, Mass., and London: Harvard University Press, 1981); Mary Campbell, *The Witness and the Other World: Exotic European Travel Writing, 400–1600* (Ithaca and London: Cornell University Press, 1988); and Lorraine Daston and Katharine Park, *Wonders and the Order of Nature* (New York: Zone, 1998).

45. Images of cannibalism continued to animate maps of South and North America well into the seventeenth century.

46. *The Maps and Text of the Boke of Idrography, Presented by Jean Rotz to Henry VIII*, ed. Helen Wallis (Oxford: Oxford University Press, 1981). Wallis ascribes to these illustrations an ethnographic intention: the representations of people scattered over maps, she argues, "differ in systematic ways in different regions of the same map. . . . While the precise geographic locales

indicated may be vague or incorrect, the regional distinctions often conform in a general way to the culture areas or regional culture types recognized by nineteenth- and twentieth-century anthropologists" (p. 67). Wallis bases her claim that racial differences were not salient on the observation that "Physical differences between the inhabitants of major world areas are often not shown at all, and even when they are, the skin and hair colours and hair forms that are obvious to modern observers are frequently not the ones chosen. The cultural details emphasized are principally male clothing and weapons, secondarily houses, occasionally activities . . . and sometimes a few modes of transport." If these miniature vignettes are ethnographic, however, the terms by which they specify diversity differ from later map illustration, for Rotz seems more intent on recording cultural details than in marking human types.

47. The drawings are reproduced by Paul Hulton, *America 1585: The Complete Drawings of John White* (Durham and London: University of North Carolina Press and British Museum, 1984), who notes that de Bry and his craftsmen "tended sometimes to idealize and to Europeanize the Indian figure and features. They would often make the female Indian face accord more than did White's drawings with European ideas of beauty and attractiveness, introducing Mannerist stylistic characteristics then in fashion." Hulton, however, considers these changes "trivial departures from White's record which merely serve to emphasize how closely De Bry generally kept to his models" (p. 18). In addition to Native Americans, White also drew several Eskimos (possibly while accompanying Martin Frobisher) and Middle Eastern figures, most probably copying from someone else's original. See also Bernadette Bucher, *Icon and Conquest: A Structural Analysis of the Illustrations of de Bry's Great Voyages*, trans. Basia Miller Gulati (Chicago and London: University of Chicago Press, 1981).

48. In her comparison of de Bry's engravings to the original watercolors by John White, Adriane Stewart argues that de Bry "Europeanized Indian features and, utilizing what is perhaps the quintessential normalizing discourse about bodies, produced a number of schematic anatomical representations, especially of the male Indian body," *Body Phantoms* (pp. 60–61). While some of the plates depict horrific images and thereby convey an undeniably dehumanizing intention, I am more interested in the ways anatomy and cartography make use of one another's spatial strategies for schematizing the body, a question I pursue in an essay, "Anatomy, Cartography, and the New World Body."

49. This is the only time Champlain used human figures in maps of the New France—his later maps are populated by no ethnographic bodies.

50. Rodney Shirley, in *The Mapping of the World: Early Printed World Maps, 1472–1700* (London: Holland Press Limited, 1983), p. 207, attributes the inspiration of Plancius's pictorial borders to the drawings in de Bry.

51. Günter Schilder and James Welu, *The World Map of 1611 by Pieter Van den Keere* (Amsterdam: Nico Israel, 1980).

52. In addition to bodies, city views are the most common image surrounding early seventeenth-century maps, followed by coats of arms and portraits of rulers.

53. Schilder and Welu, *World Map of 1611*, pp. 17–18.

54. Günter Schilder, *The World Map of 1624 by Willem Jansz. Blaeu and Jodocus Hondius* (Amsterdam: Nico Israel, 1977). This map, according to Rodney Shirley's *The Mapping of the World*, "was universally recognized as the outstanding prototype for nearly all successor world maps on the stereographic or double-hemisphere projection" (p. 268). According to R. A. Skelton, it was Jodocus Hondius who initiated the use of ornamental borders; his format was

quickly copied by the rival house of Blaeu, whose engraver Visscher brought the design to its most accomplished state. Visscher worked for both Bleau and other houses, and after 1611 published maps under his own imprint.

55. Most of the Dutch cartographers occasionally mixed a classical with an ethnological idiom. The world map of Blaeu—engraved by Josua Van den Ende and originally published as a single sheet in 1606 and used to open his *Novvel Atlas*—is decorated by allegorical representations of the cosmos, the elements, the seasons, and the seven wonders of the world, as if to say, no humans frame the boundaries of the entire globe. Blaeu's atlas was enlarged and reissued in various languages by his son, Johann. Their output culminated in an eleven-volume folio atlas, first issued in 1662 and translated into several languages.

56. The biobibliography of maps from this period is vast. In tracing the intertextuality of images, I have found most helpful Shirley's *The Mapping of the World* which provides many examples of the cartographic idiom I argue became dominant, as well as Philip D. Burden's *Mapping of North America: A List of Printed Maps, 1511–1670* (Rickmansworth, Hertfordshire: Raleigh Publications, 1996). The extent of publication of atlases is indirectly attested by Peter Van der Krogt, "Amsterdam Atlas Production in the 1630s: A Bibliographer's Nightmare," *Imago Mundi* 48 (1996): 149–59, who reports that 10,000 Dutch atlases are currently held by about 750 libraries throughout the world, of which 2,275 are the combined Mercator-Hondius-Janssonius atlases (published in Latin, Dutch, German, French, and English) and 1,479 are from the publishing house of Blaeu.

57. Not incidentally, Vermeer uses wall maps not only as signifier of scientific inquiry (augmented by a globe in *The Geographer* and *The Astronomer*), but as a background to scenes of heterosexual seduction. Maps are prominent in his *Art of Painting*, *Woman in Blue Reading a Letter*, *Young Woman with a Water Pitcher*, and *Woman with a Lute*.

58. One quarto edition of Mercator's atlas, entitled *Atlas Minor* (1595), includes a decorative title page scaled down to size but nonetheless still peopled by allegorical continents.

59. Alpers, *The Art of Describing*, p. 159.

60. I am grateful to Chris Ivic for sharing a chapter of his dissertation "Mapping the Celtic Fringe in Early Modern Britain" (University of Western Ontario, 1998), on John Speed's *Theatre of the Empire of Great Britaine*.

61. *Civitates Orbis Terrarum: The Towns of the World, 1572–1618*, ed. R. A. Skelton, 3 vols. (Cleveland: World Publishing Co., 1966).

62. The original frontispiece to Speed's *Theatre* was engraved by Jodocus Hondius.

63. Shirley, *Mapping of the World*, p. 492.

64. Samuel Purchas, *Hakluytus Posthumus, or Purchas His Pilgrimes* (London, 1625). For readings of the relationship between gender and nationalism articulated in Elizabeth's monarchical portraits, see Louis Montrose, "The Elizabethan Subject and the Spenserian Text," in *Literary Theory/Renaissance Texts*, ed. Patricia Parker and David Quint (Baltimore: Johns Hopkins University Press, 1986), pp. 303–40; Andrew Belsey and Catherine Belsey, "Icons of Divinity: Portraits of Queen Elizabeth I," in *Renaissance Bodies: The Human Figure in English Culture, c. 1540–1660*, ed. Lucy Gent and Nigel Llewellyn (London: Reaktion Books, 1990), pp. 11–35; Elizabeth Pomeroy, *Reading the Portraits of Queen Elizabeth I* (Hamden, Conn.: Archon, 1989); and Roy Strong, *Gloriana: The Portraits of Queen Elizabeth I* (London: Thames and Hudson, 1987). For my interpretation of the link between eroticism and nationalism in Elizabeth's portraits, see my chapter, "The Politics of Pleasure; Or, Queering Queen Elizabeth," in *The Renais-*

sance of Lesbianism in Early Modern England (Cambridge: Cambridge University Press, forthcoming).

65. Hall, *Things of Darkness*, p. 25.

66. Thomas Osborne, *Collection of Voyages and Travels* (1745), p. 517.

67. Ibid., p. 477.

68. Ibid., pp. 482 and 487.

69. Ibid., p. 60.

70. Robert Wither's *The Grand Signiors Serraglio* was published in London in 1590 and reprinted in Samuel Purchas's *Purchas His Pilgrimes*, vol. 2 (London, 1625). Nicholas de Nicholay's *Navigations, Peregrinations, and Voyages, Made into Turky* was first published in French in 1567 and translated into English in 1585 by T. Washington. Henry Blount's *Voyage into the Levant* was published in London in 1637.

71. For support for my contention with a view to the eighteenth century, see Susan Lanser, "Singular Politics: The Rise of the British Nation and the Production of the Old Maid," in *Singlewomen in the European Past*, ed. Judith M. Bennett and Amy M. Froide (Philadelphia: University of Pennsylvania Press, 1999), pp. 297–323; Felicity Nussbaum, *Torrid Zones: Maternity, Sexuality, and Empire in Eighteenth-Century English Narratives* (Baltimore: Johns Hopkins University Press, 1995); and Laura Brown, *Ends of Empire: Women and Ideology in Early Eighteenth Century English Literature* (Ithaca: Cornell University Press, 1993).

72. Gillies, *Shakespeare and the Geography of Difference*, p. 172.

73. The scholarship on companionate marriage is vast. See Lawrence Stone, *The Family, Sex, and Marriage in England, 1500–1800* (New York: Harper and Row, 1977) and *The Road to Divorce: England, 1530–1987* (Oxford: Clarendon Press, 1990); Keith Wrightson, *English Society, 1580–1680* (New Brunswick, N.J.: Rutgers University Press, 1982); John R. Gillis, *For Better for Worse: British Marriages, 1600 to the Present* (New York and Oxford: Oxford University Press, 1985); Martin Ingram, *Church Courts, Sex and Marriage in England, 1570–1640* (Cambridge: Cambridge University Press, 1987); Alan Macfarlane, *Marriage and Love in England: Modes of Reproduction, 1300–1840* (London and New York: Blackwell, 1986); Ralph Houlbrooke, *The English Family, 1450–1700* (London and New York: Longman, 1984); Michael Anderson, *Approaches to the History of the Western Family, 1500–1914* (London and Basingstoke: Macmillan, 1980); Joel Harrington, *Reordering Marriage and Society in Reformation Germany* (Cambridge and New York: Cambridge University Press, 1995); Constance Jordan, *Renaissance Feminism: Literary Texts and Political Models* (Ithaca: Cornell University Press, 1990); Lyndal Roper, *The Holy Household: Women and Morals in Reformation Augsburg* (Oxford: Clarendon Press, 1989). For analysis of the relation between companionate marriage and homoerotic relations in England, see Valerie Traub, "The Perversion of 'Lesbian' Desire," *History Workshop Journal* 41 (Spring 1996): 23–49; for further explanation of the concept of "domestic heterosexuality," see my forthcoming *The Renaissance of Lesbianism in Early Modern England* (Cambridge: Cambridge University Press).

74. It is worth noting that Osborne's illustration depicts only two children. Later in the century, maternity, fertility, and nationalism would be more intertwined. See Nussbaum, *Torrid Zones*, and Lanser, "Singular Politics."

75. In an unfortunately heterosexist analysis, the early-sixteenth-century cross-cultural erotic contact of Portuguese sailors and colonists in West Africa is explored by Ivana Elbl in " 'Men without Wives': Sexual Arrangements in the Early Portuguese Expansion in West

Africa," in *Desire and Discipline: Sex and Sexuality in the Premodern West*, ed. Jacqueline Murray and Konrad Eisenbichler (Toronto: University of Toronto Press, 1996), pp. 61–86. In "'The Getting of a Lawful Race': Racial Discourse in Early Modern England and the Unrepresentable Black Woman," in *Women, "Race," and Writing in the Early Modern Period*, pp. 35–54, Lynda Boose argues that miscegenation is the primary anxiety constituting racial relations in the late sixteenth century. Gillies likewise sees fear of miscegenation as definitive in the construction of Renaissance categories of difference. On the incidence of interracial sexuality in colonial Virginia, see Kathleen Brown, *Good Wives, Nasty Wenches, and Anxious Patriarchs: Gender, Race, and Power in Colonial Virginia* (Chapel Hill: University of North Carolina Press, 1996).

76. Elizabeth Eisenstein, *The Printing Press as an Agent of Change: Communications and Cultural Transformation in Early Modern Europe*, 2 vols. (Cambridge: Cambridge University Press, 1979); Bruno Latour, "Drawing Things Together," in *Representation in Scientific Practice*, ed. Michael Lynch and Steve Woolgar (Cambridge, Mass.: MIT Press, 1990), pp. 19–68; and Adrian Johns, *The Nature of the Book: Print and Knowledge in the Making* (Chicago and London: University of Chicago Press, 1998). Latour in particular is indebted to an earlier work on perspective, William Ivins, *On the Rationalization of Sight, with an Examination of Three Renaissance Texts on Perspective* (New York: Metropolitan Museum of Art, 1938), who calls "the rationalization of sight . . . the most important event of the Renaissance." Ivins argues that European pictorial representation since the fourteenth century, as well as the modern scientific culture it engendered, depends on "the development and pervasion of methods which have provided symbols, repeatable in invariant form, for representation of visual awarenesses, and a grammar of perspective which made it possible to establish logical relations not only within the system of symbols but between that system and the forms and locations of the objects that it symbolizes" (pp. 12–13). The "rationalization of sight," in other words, brings "visual recognition and measurement," as well as "logical symbolization" to thought and analysis.

77. See the 1999 dissertation of Robert Karrow, "Intellectual Foundations of the Cartographic Revolution (Maps)" (Loyola University of Chicago), especially his chapter "The Mathematical Model: A World of Calculation." I thank Bob for generously sharing his work in progress. See also Margarita Bowen, *Empiricism and Geographical Thought: From Francis Bacon to Alexander von Humboldt* (Cambridge: Cambridge University Press, 1981).

78. I am indebted to Richard Helgerson for this formulation.

79. A breathtaking analysis of this mechanism of projection is performed by Goldberg's *Sodometries*.

80. See also Tim Hitchcock, *English Sexualities, 1700–1800* (New York: St. Martin's Press, 1997); and Susan Lanser, "Befriending the Body: Female Intimacies as Class Acts," *Eighteenth Century Studies* 31 (1998–99): 179–98, and "'Queer to Queer': The Sapphic Body as Transgressive Text," in *Lewd and Notorious: Female Transgression in the Eighteenth Century*, ed. Katharine Kittredge (forthcoming).

81. Jonathan Goldberg, "The History That Will Be," p. 6, in *Premodern Sexualities*, ed. Louise Fradenburg and Carla Freccero (Durham and Chapel Hill: Duke University Press, 1996), pp. 1–22.

82. Margaret Ferguson, "Juggling the Categories of Race, Class, and Gender: Aphra Behn's *Oroonoko*," in *Women, "Race," and Writing in the Early Modern Period*, pp. 209–24.

83. To a certain extent, such a requirement is offset by the widespread dissemination of European maps from the mapmaking centers of the Netherlands, combined with the intertextualization (plagiarism) of maps themselves.

84. For an analysis of hybridity in New World mapmaking, see Dana Leibsohn, "Mapping Metaphors: Figuring the Ground of Sixteenth-Century New Spain," *Journal of Medieval and Early Modern Studies* 26:3 (Fall 1996): 497–523; and "Colony and Cartography: Shifting Signs on Indigenous Maps of New Spain," in Claire Farago, ed. *Reframing the Renaissance: Visual Culture in Europe and Latin America, 1450–1650* (New Haven: Yale University Press, 1995), pp. 264–81.

85. Mignolo, "On Describing Ourselves Describing Ourselves: Comparitism, Differences, and Pluritopic Hermeneutics," in *Darker Side*, pp. 1–25.

3. SECOND-WORLD PROSTHETICS

Supplying Deficiencies of Nature in Renaissance Italy

HARRY BERGER, JR.

During the 1960s I spent a lot of time worrying in public about a concept of representation that had become prominent in the early modern period. Following the usage of authors as diverse as Leonardo, Sidney, and Traherne, who wrote of a second nature or an other nature constructed by the mind or imagination, I called it the second world. Renaissance authors considered it second in two senses: it both followed, or imitated, and improved on, or idealized, the actual world they lived in and inherited from the past.[1] The clearest and simplest example of this double relation, the one I fastened on when I was working the distinction out, is the relation of actual to imaginary space graphically produced by the system of monocular perspective.[2]

Though the distinction between second-world fiction and first-world actuality resembled the one Aristotle made between poetry and history, it was more radical because it had ontological force. I didn't intend it merely as a distinction, or *paragone*, between genres of writing but as a binary relation between two representational constructs: imaginary or counterfactual worlds and the (f)actual world that was first because in the beginning it was created by God even if subsquently embellished by human art and blemished by human sin. I was well aware that both these constructs, and the relation between them, belonged to the sphere of cultural production that would today be designated (after Althusser) as the Imaginary.[3] But I was less interested at that time in the imaginariness of the real than in the increasing (if always virtual) reality of the imaginary. My reading of early modern texts in literature, art, and science suggested to me that the crucial feature of the second-world was its expressly fictive, artificial, or hypothetical status. Of those three partially overlapping attributes, "hypothetical" was probably the most useful because it allowed me to include in the set of second world constructions not only visual, dramatic, and literary artifacts but also the models produced by scientific method and cosmology.[4]

This, roughly, was the line I took in unpacking the idea of the second world in the 1960s, and it was a line I was never very happy with. There were a lot of bugs both in the theory itself (if you can call it a theory) and in the way I tried to relate it to specific texts, practices, and discourses.[5] For reasons I won't go into here, I was unable to solve the problems that bothered me, and so I ended up abandoning the project. But the main reason I start with this pathetic little memoir is that I have recently become interested in some features of second-world discourse and constructions that I completely overlooked. In the 1960s I romanticized the new and positive role played by the discourse in Renaissance culture. I distinguished second-world

from green-world representations on ethical grounds, construing the latter as escap-
ist and misanthropic performances, and I tried to show how, in different genres and
media, Renaissance authors and visual artists (Leonardo da Vinci, Vermeer, Erasmus,
More, Spenser, Shakespeare, Milton, and Marvell) made the same distinction when
they deployed complex second-world constructions to critique or parody—and re-
sist—the pleasurable surrender to bitterness, victimization, and resentment encoded
in green-world idyllicism. What my current retrospect makes most clear to me is the
extent to which this distinction whitewashed the notion of second world, purged it
of dangers inhering in its very structure as a representation that parades some kind of
superiority—of coherence, clarification, complexity, ethical insight, demystification,
and so on—to both the actual and the idyllic worlds it depicts. I now, for example,
find second-world discourse complicit in producing the misanthropy it critiques, and
I am struck by its subtly corrosive influence on attitudes toward the first world. So I
want to make amends for the Pollyanna view I blame on my green or golden youth
by exploring that bad influence. My sense of its negative features is directly indebted
to contemporary critiques of the way cyberdiscourse uses virtual reality, which is in
some respects conceptually—if not technologically—similar to Renaissance notions
of imaginary second worlds produced by art.

* * *

A standard theme expressed in the contemporary discourse of technophobia is
that the so-called improvements of technology degrade the environment, endanger
the natural order, and—according to some versions of the discourse—diminish human
nature. A standard dream expressed in the contemporary discourse of technophilia is
that the second nature of technology will enable humans to slough off the sorry skin
of their first, or natural-born, nature. This elicits from critics of technophilia the claim
that its discourse gives aid and comfort to the ideological degradation of natural-
born nature. Thus the critics attribute to technophilic discourse the same effect on
nature in the sphere of ideology that technophobes attribute to technology in the
sphere of practice. Technophilia posits—that is, it presupposes and preconstitutes—
the unhappy state of nature that the compensations or enhancements of technology
must overcome. From the standpoint of technophilia, nature is always already de-
graded, but this standpoint conceals or mystifies the role of technophilia in the ideo-
logical production of degraded nature. From the standpoint of its critics, technophilia
poses a more serious risk than technology to our constructions of and dealings with
and responses to the environments—human as well as physical—that we represent as
natural.

In their more hysterical moments, cybernauts pixelated by the prospect of en-
sconcing the species in a second world of virtual reality write as if they believe post-

modern technology will eventually help us transcend the limits imposed on human life and nature by material bodily existence. Translated into cybertalk, the idea is that if we can morph ourselves into information and download it into a computer, we may be able to abject the meat and wetware that's been holding us back from hard-wired heaven ever since we crawled out from under a stray piece of Martian rock. Critics of technological idealism claim that this sort of visionary bluster gives aid and comfort to the ideological degradation of natural-born nature.[6] Here, for example, is Kathleen Woodward's synopsis of the New Age narrative she calls a delusion: "Over hundreds of thousands of years the body, with the aid of various tools and technologies, has multiplied in strength and increased its capacities to extend itself in space and over time. According to this logic, the process culminates in the very immateriality of the body itself. In this view technology serves fundamentally as a prosthesis of the human body, one that ultimately displaces the material body." The narrative is deluded, Woodward writes, because it "has 'lost touch' with the very material and mortal body that grounds its imagination and imagery of transcendence."[7] Note that in her paraphrase the delusion equates technology with prosthesis; this is something I'll come back to later. Critics like Woodward fix on the way the idealism of visionary desire and misanthropic aversion to the embodied human condition seem in New Age narrative and research projects to be bound together in a kind of perverse codependency: misanthropy and idealism mutually exacerbate each other. The critique also picks out the related strains of misogyny and gynephobia inextricable from the genetic and gendered fantasy that underwrites those projects—the fantasy of modes of production and reproduction dominated by androgenesis or male parthenogenesis.

The only new thing in the New Age narrative is the form, the structure, and the reach of its technology. One of the purposes of this essay is to show that the correlates of the technology, its ideological fallout in misanthropy, idealism, and the other factors I just mentioned, go back a long way, as do critiques of the fallout.[8] They go back at least as far as Plato. The dialogues not only represent the performative technologies that dominated Athenian public life—the political, poetic, rhapsodic, rhetorical, logographic, and dramatic arts—but also critique them. The critique extends to the ideological aid and comfort the defenses of these technologies get from the myth of androgenesis. In the *Symposium* Plato has Socrates pretend he was instructed or rather commanded by a very un-Socratic and professorial dominatrix named Diotima to believe that men should copulate in the soul rather than in the flesh, with boys rather than with girls, so as to give birth to poems and laws and ideas rather than to babies and bodies.[9] Though this passage is a crown jewel in the display case of Platonic idealism, it's made of paste. (I add parenthetically that Plato is one of Platonic idealism's severest critics.)[10] The androgenetic rhapsody Socrates pipes through the mask of Diotima is a critique of the preceding speeches in the dialogue. It exposes their praises of boy-love as self-serving performances that slander the proper peda-

gogical functions of pederasty. Socrates uses Diotima's account of the androgenetic upward path, the anabasis to beauty, to show how easy it is to misrepresent a pseudo-idealistic and insidiously misanthropic elitism as the genuine ethical praxis Foucault calls the care or technology of the self.

Androgenesis is not only a major trope of cyberdiscourse. It is used to legitimize the strategies of homosocial control you find at work in the ritual and discursive practices of genealogy, initiation, craft organization, and pedagogy all over the world. The rhetoric of unassisted paternity characterizes the institutional polemics of masculine identity formation. No doubt some of our contemporaries would say it is all about family values. And others would say it is all about castration. Whatever. The motives for claiming androgenesis are rooted in the sexual and generational division of labor, in conflicts over rights in children, in the perennial friction between domestic and extradomestic modes of production and recruitment. The motives are thus implicated in the whole range of social, economic, political, and representational technologies. Whether as hyperbole or as metonymy, the trope of androgenesis has always been operative in the fictions and technologies of idealization.

So this is how things stand. Critics of New Age cyberdiscourse have turned up a set of disturbing ideological motifs and motives actively at work in its narratives about transcendence from the natural to the virtual bodily state. These motives and motifs are not confined to that discourse but are embedded in what I think of as a recurrent diachronic pattern, a dynamic model, in which technology and ideology mutually act on and alter each other. In this essay I shall explore the influence of the model on some examples from the Italian Renaissance; examples focused on technologies of representation in two fields of discourse and practice, visual art, including anatomy, and conduct. But before doing that, I want to outline and comment on the model itself. What I called its diachronic pattern has four basic moments.

First, technology enhances life; machines do better what we used to do for ourselves. They encourage fantasies of self-transcendence and idealization, the flip side of which is the abjection (in Kristeva's sense) of the body.

Second, the price of enhancement is the alienation of control that occurs because machines have their own structure and logic.

Third, when we become dependent on our machines, when usage converts technological enhancements into necessities, they come to feel less like enhancements and more like compensatory or prosthetic supplements, that is, things we can't seem to do without.

Fourth, in the backwash produced by the interplay of these factors, a tendency arises to disparage residual cultural constructions of nature and human nature, as well as of the body.

In this dialectic, the critical problem arises from the ironic interplay between the first two moments. That is, in any technological enhancement of human functions,

the function can't be extended from bodily agency without being abstracted from it. And by "abstracted" I mean "alienated." To free the function and its power from the corporeal limits of productive agency is to alienate it to the forms, the forces, the logic, of instrument or medium. I call this *cybernetic alienation* because it involves the transfer of command functions from bodily to extra-bodily mechanisms. Think of the anxieties built into the transfer of economic function and power from human hands in situated markets to the invisible (and severed) hand of an abstract market process. Or think of the effects of the printing press and the Internet, and the symptom of the problem in the anxiety of censorship. The superimposition of writing on speech, of printing on writing, and of the electronic medium on the print medium progressively broadens the range of communication and extends its power, but at the same time it progressively abstracts the means of production from the control of the authorial body and thus alienates the production of meaning—alienates it not simply to the forces of the medium but to whoever is in the position to profit from and control those forces. Enhancement and alienation are the manifest and latent consequences of the same process; you can't have one without the other.

I have elsewhere discussed this ironic dialectic under the rubric of the *abstraction rule*, and will here repeat only two points made in that discussion.[11] The first is that although the operation of this dialectic can be observed across the historical board, it should by no means be granted the autonomy postulated by proponents of technological determinism. It has, let us say, relative autonomy only when the means or media of production are considered apart from the mode, the social forces, the apparatus, of production.[12] This holds true, of course, for cultural production. And it also holds true for the means or media and the modes of representation and self-representation.

The second point is that the dialectic produces a context that activates a specific distinction between the terms *art* and *technique*. Our word *art* comes from Latin *ars*, which was a general term used to denote any skill, craft, or profession, and also the know-how, or knowledge, or theory, or method, required to practice any of these. Since Latin *ars* is the equivalent of Greek *techne*, *art* and *technique* are often used interchangeably. But the following statements suggest a situation in which they can do the work of antonyms: "At the outset, the development of all technologies reflects . . . human intelligence, inventiveness, and concern. But beyond a certain point . . . these qualities begin to have less and less influence upon the final outcome; intelligence, inventiveness, and concern effectively cease to have any real impact on the ways in which technology shapes the world."[13]

In the long run, "technique sharply reduces the role of human invention" because it "poses primarily technical problems which consequently can be resolved only by technique. . . . Technical elements combine among themselves, and they do so more and more spontaneously."[14] These statements describe an ironic and dialectical force,

a process of alienation, that structures the interplay between (1) *art*, the sum total
of intentions, desires, guided practices, and objectives that account for production of
any sort, and (2) *technique* and *technology*, those mechanisms, procedures, instrumen-
talities, and agencies that are initiated by art but break free of its control.[15]

I return now to the third moment in the model, in order to explore the impact
of the alienation effect on the relation between the two resonant terms that appeared
together there as they did in my earlier quotation from Kathleen Woodward: *techno-
logical* and *prosthetic*. Though the two terms signify different forms of activity, they are
often treated as interchangeable, and this confusion involves both a profound error
and a profound truth, as I shall try to show after providing a little background.

In the middle of the fourteenth century, Petrarch praised the dignity and inge-
nuity of the creature he called man for its ability to invent remedies that correct im-
perfections in its body: thus, he writes, man "learns to make wooden feet, iron hands,
[and] wax noses, . . . erects failing health by medicines, excites weakened taste by fla-
vor, and restores ailing sight by eyeglasses." These remarks occur in a treatise that aims
in part to counter the arguments put forth in a powerful strain of Christian discourse
focused on contempt of the world and the misery of the human condition.[16] Petrarch
praises prosthetic remedies among other arts and skills both as antidotes to the natural
ills of the human body and as testimonies to human ingenuity and dignity. This kind
of praise became a topos, a commonplace, in humanist writing, and it is still going
strong. Almost six hundred years later, Freud gave similar sentiments a more ironic
turn by embedding them in his argument for the repression hypothesis. "With every
tool," he wrote in *Civilization and Its Discontents*, "man is perfecting his own organs
. . . or is removing the limits to their functioning"; and after listing a few examples—
motor power, ship and aircraft, eyeglasses and the telescope and microscope—he con-
cludes that the (obviously male) creature he calls man has "become a kind of prosthetic
god. When he puts on all his auxiliary organs he is truly magnificent." Freud immedi-
ately reminds his readers that "those organs have not grown on to him and . . . still
give him much trouble," and that "present-day man does not feel happy in his Godlike
character."[17]

Three comments on this passage will serve to introduce my own argument. First,
Freud's description of the man-god all dressed up in his prosthetic finery prompts me
to wonder how this creature feels, how he evaluates himself, when he strips off his
auxiliary organs and stands naked before the mirror. And I suspect he feels discon-
tented. But not necessarily because repression is the price he pays for civilization. I
am less concerned—and this is my second point—with the renunciation or repression
of instinct (sexual or otherwise) than with its devaluation; a devaluation produced
by many of the remedies and improvements mentioned above because their very suc-
cess in restoring or enhancing specific bodily functions creates a more pervasive sense
of the natural defectiveness of those functions. Third, when Freud lumps eyeglasses

together with the microscope and telescope he stretches the term "prosthetic" in a way that obscures an important distinction. Strictly speaking, eyeglasses do but the others do not qualify as prosthetic devices.

This is because the term "prosthesis" taken in its narrow sense designates compensatory devices in the area of medical technology as opposed to more general technological achievements. We distinguish artificial legs from automobiles, hearing aids from audio systems, and eyeglasses from microscopes and telescopes. It just doesn't feel right to apply the label "prosthesis" to the enhancements of power or function produced by the move from speech to writing to printing to word processing; from manual labor to machines; from walking to riding and driving; and from physiologically based perception to telescopes, amplifiers, and computers. Such changes are not merely compensatory; they are additive; they increase the power of human functions by extending them from the limits of the organic body to the instruments or media of communication, labor, transportation, perception, and representation.

That seems to me to be a pretty clear and simple distinction. But, as I said, in contemporary discourses the two terms are often treated as if interchangeable. It's easy enough to chalk that up to sloppy thinking, or else to enthusiasm and deconstruction. Dozens of cybernuts have pounded the term "prosthesis" to airy thinness. *Prosthesis* is the title of a recent book in which David Wills tries his best, and at length, and with appalling rhetorical sophistication, to make its meanings proliferate.[18] And yet, in spite of my skepticism, those who confuse technology with prosthesis have a point. There happens to be a good reason why the distinction between the additive and the compensatory is sometimes hard to uphold.

To start at the level of trivia, think of the sense of disability often expressed by people temporarily without a computer or a telephone or a car. What was once an enhancement becomes a necessity lacking which they feel, relatively speaking, "crippled." This of course is one of the minor unintended consequences of technological advance and cybernetic alienation. But to shift to a level of less trivial trivia, think of the effect intended by the strategies for marketing the so-called natural look that have become standard operating procedure in the culture of cosmetics.[19] They try to give aesthetic enhancements the utilitarian value of necessities without which consumers would be inadequate; they offer compensation for the shortcomings they persuade you that you have and should do something about.[20] The health of economic regimes depends on the finesse with which they inject into the cultural imaginary the virus of misanthropic self-understanding, the suspicion or fear that without the alienated enhancements they provide, human life would be solitary, poor, nasty, brutish, and short. (Hobbes attributes this miserable state, the state he calls Warre, to the absence of government, commerce, and technology; I suggest that on the contrary the state of Warre may be one consequence of their functioning presence.)

To the extent that cybernetic alienation produces not only diminishing control but also discursive awareness of diminution, what is culturally represented as merely natural and bodily tends to be devalued. Thus it is in part the decrease of control over the increase of power that unsettles the distinction between technological enhancement and prosthetic compensation. But there is also another factor that contributes to devaluation. Consider the common precondition of Albertian perspective, the camera obscura, and the camera: all involve the abstraction and alienation of a monocular system of vision from the binocular organic system. The increase and refinement of visual power is consequent on its being freed, alienated, from the limits of the body. In *On Painting* Alberti shows himself fully aware that he is proposing a hypothetical method in which seeing is described on the model of picture-making and geometry, an abstractive model that "requires the mathematics, but not the physics or physiology, of vision."[21] It is nevertheless the case that Alberti arbitrarily assigns the vertex of the geometrical system—the distance point—the value of an eye, the eye of a virtual observer, a cyclopean robot, constructed and controlled by the system. Having been abstracted from the body, Alberti's virtual system of vision is then reincorporated in an imaginary body, an idealized geometrical phantasm that any empirical viewer may incarnate by standing in the right place.

"Pre-cybernetic machines could be haunted; there was always the specter of the ghost in the machine."[22] As Beth Pittenger has suggested, Donna Haraway's statement can be turned around: precybernetic humans could be haunted by the specter of the machine in the body, an idea-producing machine, a mathetic or mathematical *dianoia*, trapped in the *morbidezza* of the body and its senses.[23] And one can readily imagine that the epistemological anxiety about the limits of the senses given expression from the time of Copernicus on would already be a specter haunting Alberti's project. Jean-Louis Comolli notes that "when the invention of photography . . . perfected the *camera obscura* and thereby achieved what generations of painters had for centuries demanded from the technique of artificial perspective—the possibility of copying nature faithfully"—at that point "the human eye was abruptly seen as neither altogether unique, nor quite irreplaceable, nor very perfect."[24] Again, it is imaginable that a specter of this anxiety cast its shadow over the Quattrocento neighborhood of perspective experiment and magic-working. For Comolli's terms are as applicable to perspective as to photography: "a strengthening of confidence in a perspective and analogous representation of the world" is offset by "a crisis of confidence in the organ of vision" in which the human eye was "devalorized and deposed from its central place by the eye" of perspective's cyclopean observer (52).[25] The conventional wisdom that stronger glasses can weaken the eyes may be no more than a myth, but in the present context it can stand as an allegory of the prosthetic backlash that occurs when the enhancements of bodily power or appearance produced by art and technology engen-

der—and I mean engender—a kind of idealism in the wake of which the going cultural representations of bodily and human nature become targets of dissatisfaction, contempt, aversion, or disgust.

Technophiles may exalt the benefits of enhancement and technophobes lament the costs of alienation, but within the structure of technical change there is a motivated skew toward representing the body as a diminished thing. The alienation and dependency that diminish the value of unimproved human nature, life, and the body retroactively transform enhancement into compensation. Confronting the fallen state to which it has reduced humankind, technology is reduced by its own logic to doing the restorative work of prosthesis. What begins as a surplus enriching nature, adding to it, turns into a substitute that "adds only to replace," that "fills . . . as . . . one fills a void," that replaces what has been lost.

These phrases from *Grammatology* are cited to remind you that the logic of the slippage from enhancement to compensation accords with what Derrida has described as the logic of the supplement.[26] The ambivalent or even contradictory structure of this logic finds its way into an idiom sometimes used in sentences about prosthesis, and centered on a verb that's cognate with the word supplement. Here, for example, is Montaigne: "she was hanged for using illicit devices to supply her defect in sex."[27] Here is the 1634 English translation of one of Ambroise Paré's chapter titles: "Of the Meanes and Manner to repaire or supply the Naturall or accidentall defects or wants in mans body."[28] Here, at the turn of the twentieth century, is S. H. Butcher pausing in his commentary on the *Poetics* to paraphrase Aristotle's view of the art/nature relation: "the function . . . of the useful arts is in all cases 'to supply the deficiencies of nature.'"[29] Here is Peter Stallybrass, writing in 1992 about transvestism in the English Renaissance theater: "all efforts to fix gender are necessarily prosthetic" in that "they suggest the attempt to supply an imagined deficiency" by the exchange of clothes or other means.[30]

"To supply a deficiency" is a way of saying "to fill a gap," but the words also mean "to *create* a deficiency." Suppose someone who wants to tell you that art improves nature expresses it this way: "the forms of art supply deficiencies in the forms of life." The expression perversely delivers two contradictory messages, for it also says "art adds deficiencies to life and thus diminishes nature." It simultaneously announces the positive objective of technology and acknowledges the negative and unintended consequences, the prosthetic backlash, built into its structure. When Kaja Silverman observes that the relation between the camera and the eye is "prosthetic: the camera promises to make good the deficiencies of the eye," "make good" seems unambiguously to deliver the straightforward meaning of "supply." Yet the context of the statement reinstates the ambiguity, for Silverman has just endorsed Jonathan Crary's argument that new optical and scopic technologies work to "diminish belief in . . . [the eye's] supposed objectivity and authority."[31]

In the history of arts and technologies we should expect this dilemma to take different forms depending on the relative degree of alienation. For example, chirography is less alienated from the body than typographic and electronic forms of reproduction and communication. In any electronic operation the hand does less and the machine does more than in a corresponding typographic or chirographic operation. Of course, in focusing on the means or media and ignoring the mode, the sociopolitical context, of production, I am simplifying to make my point. Jonathan Goldberg, for example, has brilliantly shown in *Writing Matter* how the forces of alienation were intensified in Elizabethan England by the politics of graphic technology, that is, by the impact of the teaching and styles of handwriting on the formation of docile subjects and class differences:

The writing manuals write the body within a scriptive organization and retrospectively secure the body within the regiment of what counts for the health of the scriptively remade body. . . . The illustrations depicting penhold [isolate the writing hand and arm and dispense with the rest of] . . . the body. Yet both written and visual representations of penhold carry the same implication: that the body and its natural life are menaced by writing, that a different body (a socialized and civilized body) is produced by writing. . . . In these discussions of penhold [in the manuals] the violence of writing comes to produce the writer as the instrumental hand.[32]

Goldberg's study contributes to the more general understanding of the way changes in pedagogy and schooling interact with new developments in graphic mediation to alienate behavioral technology from the two traditional sources of primary socialization, the household or family and the church.

If we construe the root -*graphy* literally and liberally, we can make chirography include not only handwriting but the whole range of manually executed representations in the literary, dramatic, and visual arts, in geometry, algebra, and calculus, in cartography, accounting, and anatomy. The period from roughly the thirteenth through the seventeenth centuries saw the emergence of a graphic revolution based on inventions and improvements that affected signifying practices in all media. The resulting innovations in notational and symbol systems produced growing awareness that by altering the materials, methods, and means (media) of representation, one could alter whatever it is one's representation stands for, signifies, refers to, or imitates. This includes one's representation of oneself—the second nature associated with "Renaissance self-fashioning"—as well as one's representation of the world.[33] It includes both together in the orientation toward Enframing (*Gestell*) Heidegger calls the Age of the World Picture, an orientation the credo of which might be—to vary Descartes's cogito—"I represent myself, therefore I am." An orientation in which imaginary or hypothetical second-world and second-nature constructions begin to take on the more insistent and aggressively interventionist qualities of virtual reality.[34]

An important example of these constructions occurs in the two-phase develop-

ment of new techniques for analyzing and representing the human body: first, dissection was conjoined with increasingly sophisticated techniques of visual illustration, and second, the mimetic emphasis motivated by the desire for accuracy was qualified or challenged by classicizing norms of idealization expressed in demands for symmetry and proportion. These norms and demands moved the graphic record of dissected cadavers into a realm of visual fantasy that nevertheless laid claim to accurate realization—the realization, however, not of dead bodies but of myological and visceral slices of idealized life (or art).

Such hypothetical constructions of world and self were developed during a time when many features formerly ascribed to nature and God were being reattributed to the Aristotelian tradition and made the targets of critique. The basis of the critique was the revival of the skeptical denigration of sense perception associated in antiquity with epicurean and atomistic theories, and now reinforced by the Copernican hypothesis along with seventeenth-century discourses of atomism and mechanism:

To excite in us tastes, odors, and sounds I believe nothing is required in external bodies except shapes, numbers and slow or rapid movements. I think that if ears, tongues, and noses were removed, shapes and numbers and motions would remain, but not odors or tastes or sounds. The latter, I believe, are nothing more than names when separated from living beings, just as tickling and titillation are nothing but names in the absence of such things as noses and armpits. . . . [M]any sensations that are supposed to be qualities residing in external objects have no real existence save in us, and outside us are mere names.[35]

Natural philosophers of the seventeenth century departed from Aristotle far more radically [than did their medieval precursors], coming gradually as the century progressed to an appreciation of the hypothetical status of scientific claims, the potency of experiment as a technique of confirmation and disconfirmation, and the broad utility of mathematics as an instrument of measurement and analysis. . . . [When] we shift our focus from methodology to worldview and metaphysics [the major developments we find] are the rejection . . . of Aristotle's metaphysics of nature, form and matter, substance, actuality and potentiality, the four qualities, and the four causes; and the resuscitation and reformulation of the corpuscular philosophy of the ancient atomists. . . . [These developments] stripped away the sensible qualities so central to Aristotelian natural philosophy, offering them second-class citizenship, as secondary qualities, or even reducing them to the status of sensory illusions. For the explanatory capabilities of form and matter, it offered the size, shape, and motion of invisible corpuscles. . . . [The changes in worldview or metaphysics that led to] the abandonment of the essential natures of Aristotelian natural philosophy (which are to be discovered only by an examination of things in their natural, unfettered state) encouraged a more manipulative or experimental approach to natural phenomena. Moreover, there can be no doubt that stress on invisible corpuscular mechanisms compelled serious thought about hyptheses and their epistemological status. And finally, the shift of emphasis from Aristotelian qualities to the geometrical properties of corpuscles (shape, size, and motion) surely encouraged the application of mathematics to nature.[36]

Let me observe parenthetically that historical and philosophical accounts of this new orientation need to be correlated with the burgeoning literature on what some

have called a culture of self-fashioning, and others a culture of internalization—just as, for example, Charles Taylor's account of internalization in *Sources of the Self* should be correlated with Norbert Elias's thesis in *The Civilizing Process*. I'm suggesting, in other words, that there may be cross-relations and homologies between the kind of model-building we find in conduct books like *The Book of the Courtier* and the kind we find in the hypothetical world models imagined by Galileo, Descartes, and others. One point of contact between these widely disparate projects is their common tendency to generate distrust in human capabilities—behavioral and moral in one case, perceptual and epistemological in the other—and thus to mutate into prosthetic remedies. Despite the differences between early modern and modern or postmodern technology, the former graphic and the latter electronic, the former analog and the latter digital (ironic word), we encounter the prosthetic backlash effect as much in the spatializations and embodiments of the graphic revolution as we do in the despatializing and disembodying technologies of the electronic revolution. Indeed, the misanthropic, misogynist, and somatophobic symptoms of the prosthetic desire to transcend or escape nature surface in the literary and artistic culture of classical antiquity. I shall illustrate this with three examples, three old stories, selected in part because they had afterlives influential enough to give them the status of charter myths, and in part because, like cartoons, they depict the symptoms graphically, simplistically, melodramatically, which perhaps explains why they have healthy intertextual careers.

My first old story is the anecdote told by Pliny and Cicero, among others, of the painter Zeuxis. Preparing to paint a Hera (or Helen), he asked who the most beautiful virgins in town were, had them all rounded up, picked five, and selected from each the best body part. The reason for this procedure was that he didn't "believe that it was possible to find in one body all the things he looked for in beauty, since nature has not refined to perfection any single object in all its parts."[37] The kicker in this anecdote comes out in Cicero's version, in which we are told that Zeuxis was first taken to the palaestra, where, marveling at the bodies of the boys at play, he asked to see their sisters.[38] The Zeuxis story was picked up by Alberti, who uses it in his treatise on painting as a piece of practical advice,[39] and in subsequent writing on art and conduct we often find it stated as a general principle of idealization, sometimes—but not always—associated with Zeuxis. Like the blazon in poetry, the anecdote seems to found the idealizing process on a fantasy of dismemberment or amputation, but the causality is of course reversible since the violence of that fantasy is an effect of some prior imagined idealization.

My second old story, from Ovid's *Metamorphoses*, is the tale of Marsyas the satyr, who challenged Apollo to a flute contest and lost, and whom Apollo thereupon skinned alive for his chutzpah. "Who is it," Ovid's Marsyas cries, "that tears me from myself?" (6.385). This myth has often had its skin peeled off by readers in search of deeper meanings. In recent years it has been seriously flayed by Claude Gandelman

and Jonathan Sawday.[40] Sawday uses various readings of the myth to critique the cultural practices surrounding anatomy in early modern Europe, and both mention the appearance of the motif in the historiated initial V that appears in the 1555 edition of Vesalius's anatomy. They make the obvious identification of Apollo with Vesalius and Marsyas with the cadaver, and though Sawday judges this to be an "appropriate" connection, I find it strange. Why should the actual or graphic analysis of corpses be depicted as the violent and punitive revenge taken by a god against a hybristic satyr? There is nothing obviously Apollonian in the anatomist who repelled many people because he skulked about sacrilegiously in cemeteries aiming to steal and dismember the remains of human images of God. But in sixteenth-century Scotland and England, when public dissection was added to execution as a punishment for crime and became an extension of "the law's revenge," the anatomist became implicated in "the re-assertion of the rights of sovereign power over the body of the condemned criminal." It is this complicity that leads Sawday, whose words I just quoted, to activate his mythic analogy.[41] The only problem is that Marsyas was flayed alive. Why should *dis*section be associated with *vivi*section?[42]

Sawday and Gandelman discuss a tradition running from Plato to the Italian Neoplatonists that reads the flaying of Marsyas as "a Dionysian rite, a tragic ordeal of purification by which the ugliness of the outward person was thrown off and the beauty of the inward self revealed."[43] In the beginning of the *Paradiso*, when Dante prays to Apollo as god of poetry for the extra shot of inspiration he needs to express the self-transcending experience of the highest heaven, he implores him to "enter my breast, and breathe there / as you did when you tore Marsyas from the cover of his limbs."[44] The vengeance of the god is justified as the violence of grace. Paul Barolsky has made much of this myth in his studies of Michelangelo. On the basis of a free-wheeling conflation of Condivi, Vasari, and Michelangelo's poetry, he argues that the sculptor compared himself to Socrates, whom Alcibiades in the *Symposium* called a Marsyas and a Silenus, ugly on the outside but filled with images of the gods within, analogies with which he represented the pathos of his corporeal imprisonment and his desire to find and release—through flaying or sculpting—"the trembling soul / hidden beneath the excess mass of its own flesh."[45] According to the evidence assembled by Samuel Edgerton, Michelangelo's attitude reflected a more general contemporary interpretation of the Marsyas legend as prefiguring "the Last Judgment. The victim's skin represented his evil humors and sin. By removing it, he is purgated and redeemed; his skinless body symbolizes truth revealed."[46]

These mystical and mystifying appropriations of the myth tend to gloss over the horror Ovid harps on: as Marsyas screams, his skin is stripped off and he becomes "all one wound; blood flows down every side, the sinews lie bare, the veins throb and quiver, and you could count the entrails as they palpitate."[47] Now, if I can excoriate the remains of poor Marsyas one more time, it seems to me that when fantasies

of artistic and spiritual self-transcendence are represented by the spectacle of a satyr
being skinned alive, they make him a figure of the human self to be transcended, and
they assume the value of a punishment inflicted on a defective and unruly nature. But
within the context of Sawday's culture of dissection, the transcendence is not from
body to spirit, or outside to inside, or self to god; it is from nature to art. The title
of Sawday's book, *The Body Emblazoned*, aptly expresses the body's predicament: to
"blazon" a body is to embellish it "through art and poetry" but also, as the Zeuxis
anecdote suggests, "to hack it into pieces, in order to flourish fragments of men and
women as trophies."[48]

My third example is also from *Metamorphoses*. Ovid begins the tenth book by
telling how Orpheus loses his wife in the underworld. The effect of this tragedy is to
make him reject the love of women, institute pederasty in Thrace, and start plinking
his lyre in an open field. The promise of a Thracian Woodstock pulls in an audience
of shade trees, birds, and wild animals, and Orpheus sings to them of boys loved by
the gods and girls inflamed by forbidden lust. These are the stories we read during the
rest of the book. They are bound together by misogynist, antierotic, and gynephobic
themes that reflect the bitterness of the narrator, and that throw a strange light on the
story I want to single out, the story of the sculptor Pygmalion, who makes a statue
of a woman and then falls in love with it.[49]

This episode is the turning point of an exchange supervised by Venus. When the
Cyprian women, the Propoetides, deny her divinity, she turns them first into prosti-
tutes and then into stones. Pygmalion's disgust at their shamelessness is quickly gener-
alized to "the faults that nature had so lavishly bestowed on woman's mind" (10.244–
45). He remains celibate while carving his ivory dream virgin, who is both the product
and the symbol of his misogyny. But not of misogyny only. Since he falls in love with
his own fantasy and his own creation, his desire is both autoerotic and incestuous.
In rejecting women and withdrawing to art he becomes a placeholder for Orpheus,
which makes the episode another refraction of the narrator's embittered homoeroti-
cism. Finally, Venus reverses the trick she played on the Propoetides by bringing the
statue to life in response to Pygmalion's prayer, and Orpheus drops clues suggesting
that she would have done better to butt out and let Pygmalion continue investing his
desire in his ivory doll. For what makes the ivory semblance seductive is that although
it appears to be alive it is uncontaminated by life or otherness. It is better than nature.

In *The Romance of the Rose*, as Michael Camille and others have argued, the Pyg-
malion and Zeuxis myths are used to reiterate "the common medieval notion" of the
"insufficiency" and "secondariness" of art, and the primacy of nature.[50] If I can re-
iterate an equally common modern notion, this valuation will have changed by the
sixteenth century. Camille reiterates it when he refers to a shift of emphasis in which
fiction moves from its marginal and secondary status to the center of discourse, and
in which the artist becomes empowered as the maker of a second world.[51] As I noted

at the beginning of this essay, in my green years I was so romanced by the idea of second-world discourse, so deeply and unsuspiciously entranced by it, that I ignored the corrosive complicity of technology with idealism and androgenesis—ignored the imaginary violence that accompanies the power of art to produce a second and better nature. The Zeuxis myth illustrates this complicity, and *Metamorphoses* focalizes its misogynous antinaturalism in showing that the arts of Orpheus and Pygmalion are motivated by the desire to escape not only from the power of Mother Nature and her daughters, but also from their flaws and failings. To be for art is to be against nature and against woman.

The common ground, the common theme, toward which I am—admittedly—nudging our three anecdotes is a rejection of what is misleadingly called the "natural state"; a misanthropic and somatophobic construal of human nature and the body coupled with the desire to punish the latter and transcend the former. This construal and desire are of course found in many forms in many cultures. What distinguishes them in the early modern figural and discursive practices I now turn to is that the devaluation of human nature and the body is the complement, the logical consequence, the prosthetic backlash, of developments made possible by the enhanced representational power of new graphic technologies. The technophile's desire to find salvation and resurrection in a virtual world is inscribed in the work of many early modern practitioners and theorists in anatomy and the visual arts. The next two sections briefly consider the manifestation of this desire in the work of Alberti, Leonardo, and Vesalius, and then explore it at greater length in Vasari's *Lives of the Artists*.

* * *

In the second book of his treatise on painting, Alberti distinguishes and interrelates two of painting's major divisions, composition, "that rule [*ragione*] in painting by which the parts fit together," and circumscription, "a certain rule for drawing [*ragione di segniare*] the outline of the planes." Between these two definitions he introduces *istoria* as "the greatest work of the painter," and immediately proceeds to disarticulate it: "Bodies are parts of the *istoria*, members are parts of the bodies, planes part of the members."[52] A few paragraphs later he repeats this dissection and adds that "The primary parts of painting, therefore, are the planes. That grace in bodies which we call beauty is born from the composition of the planes."[53] Here the anatomy of *istoria* turns into a genealogy of artistic resurrection, for what is exposed is not a skeleton but the embryo fathered by *disegno*, that is, the outlines engendered by the painter who would say that he was "guiding an outline with line" (Mallè 81).

Alberti goes on to describe the birth of beauty by reversing his course and moving from composition of planes to that of members to that of bodies and finally to

their harmonious integration in "what is happening in the *istoria*." The praiseworthy
istoria, he continues, is one in which the aesthetic appeal to delight in "copia et va-
rietà" is tempered by moral qualities: "moderate and grave with dignity and mod-
esty."[54] This caveat is soon extended to the body reborn in art so as to safeguard it
from natural defects: "The parts of the body ugly to see and in the same way others
which give little pleasure should be covered." A few sentences later, the conflict in-
herent in the norms of mimetic idealism briefly surfaces when Alberti cites Plutarch's
observation "that when the ancient painters depicted the kings, if there were some
flaw in them which they did not wish to leave unnoticed, they 'corrected' it as much
as they could while still keeping a likeness."[55]

If the project of mimetic idealism is to make art's resurrected body transcend its
natural referent, it is already the case in Alberti that this objective is extended from
the content of representation to its effect on the observer. Invoking the pathognomic
credo that the movements of the body are—or should be—the index of those of the
soul, he insists that the praiseworthy *istoria* will capture the observer's eye and homeo-
pathically "move his soul" because each painted figure "clearly shows the movement
of his own soul" ("we weep with the weeping, laugh with the laughing, grieve with
the grieving"), movement "made known by the movements of the body" (Spencer
75, 76). The regimen imposed by the painter on painted figures—insuring that "each
member performs its function" and "all bodies . . . harmonize . . . [with] the *istoria*"
(Spencer 74, 75)—is to be reimposed on living figures. The hegemonic reach of this
aesthetic ideal has been described by Graham Hammill and Mark Jarzombek:

While istoria explains to the painter how to compose a body on the surface of the canvas, it also
becomes a model for an idealized version of aesthetic reception in which the spectator properly
imitates the grace, beauty, and elegant harmony of the [depicted] bodies.

The perspective order, by which all "random confusion" and "tumultuous appearances" have
been deleted, . . . guides the spectator from the vacillating to the stable. *Società natura e vera
religione*, instead of disappearing at the vanishing point, will issue forth from the picture plane
into the real world. The spectator becomes an extension of the *istoria* which, since it has been
ordered in the soul of the humanist painter, orders the spectator's soul (or so it is hoped).[56]

It is within the context of this resurrective and missionary project that Alberti
advises the painter to follow nature by designing human figures from the inside out:
"Before dressing a man we first draw him nude, then we enfold him in draperies. So,
in painting the nude we place first his bones and muscles which we then cover with
flesh so that it is not difficult to understand where each muscle is beneath" (Spencer
73). He then goes on to insist, as we saw, that all members, bodies, and movements
should be graceful and functional, and later, in book 3, he adds that the painter should
not only follow but also surpass nature as Zeuxis did by taking, or robbing, or seizing

("pilliare," "torre"—Mallè 107–8) "from every beautiful body . . . whatever beauty is praised" so as to combine into one figure these choice body parts that in nature are always "dispersed in many bodies" (Spencer 92–93).[57]

Alberti's instructions in book 2 for painting the nude describe a reversal or inversion of the practice of anatomy. They presuppose a prior act of dissection, or at least of its graphic record, and they outline a method of reconstruction that will produce not only better images of bodies but also images of better bodies. Though Alberti repeatedly states that in following this advice the artist will be following nature,[58] in fact—as his clothing/body analogy suggests—he is prescribing a kind of imaginary prosthetics in which the defects of nature will be corrected by mentally undoing and graphically redoing the body. The artist here displaces *la natura* as the creator of the second world of art. But he will also do God's work. "Since the patristic period," Caroline Walker Bynum observes, "theologians had asserted that God could reassemble—even recreate—any body." Bynum is discussing Christian defenses of the doctrine of resurrection, particularly the resurrection and restoration of the broken bodies of martyrs. This divine art will be imitated by such artists as Signorelli, whose "Resurrection of the Dead" in the *Last Judgment* fresco at Orvieto (1499–1504) is, in Bynum's words, "a famous Renaissance depiction of resurrection as the enfleshing of skeletons." Among the motifs Bynum lists in her comments on artistic depictions of the resurrection is "the reclothing of skeletons."[59]

The displacement of the motif from the divine to the human artist and, in Alberti, from actual dissected bodies to reconstructed ideal bodies is oddly illuminated by an earlier passage in the second book of *Della Pittura*. There Alberti proclaims that whoever is a master of painting will see his works admired and feel himself to be another God. This is because the architect, the stonemason, the sculptor, "and all the workshops and crafts of artificers are guided by the rule and art of the painter." Thus "whatever beauty is found can be said to be born of painting. . . . For this reason, I say . . . that Narcissus who was changed into a flower, according to the poets, was the inventor of painting. Since painting is already the flower of every art, the story of Narcissus is most to the point. What else can you call painting but a similar embracing with art of the surface of the pool?"[60]

This is so conspicuously bland an appropriation of the myth that it makes people scratch their heads and produce interpretations. In one of the more interesting responses, John Lyons suggests that Alberti means to draw attention "to an image in which the subject is its own object and discovers in the act of representation its own destruction."[61] And in the most persuasive analysis I have encountered, Jarzombek shows that when the Narcissus allusion is read in the light of all of Alberti's writings, it hints at the danger of "simulative obsession," which Alberti personifies in the figure of the human being as artist.[62] "In simulating," Alberti writes, "we [aspire to] become what we want to appear," and thus to escape from what we think, or fear,

we are.⁶³ According to Jarzombek, the futility of this desire is inscribed in the fate of the artist-figure, Narcissus. Its transgressiveness is inscribed in the crime of Prometheus. In his Lucianic satire, *Momus*, Alberti associates Prometheus with Narcissus by making the fire stolen from the gods—the fire that gives birth to technology—symbolize the power and "art of simulation."⁶⁴ Jarzombek's interpretation of this figural complex brings it very close to a standard psychoanalytic characterization of narcissism, which I cite in François Roustang's version: "narcissism is the impossible effort of the subject to reunite with himself in his own objectified image . . . within the register of representation," and the consequent "alternation between self-deprecation and pretension."⁶⁵

Notice that in Alberti's reference to Narcissus it is not the object in the pool that is desired and embraced but the surface of the pool itself, the medium of representation. So if there is a destructive lure, it includes the whole surface on which art imagines and inscribes its illusion. And for Alberti this means that it also includes the art-making process in which the design and desire transmitted through the hand prepares the surface to receive the reflection that is no reflection. It is not a reflection because—and here Alberti departs from the Narcissus myth—under the pretense of reflecting an original, painting discards it for the idealized "beauty" of a purged image.⁶⁶

The implied passage from actual dissected bodies to reconstructed ideal bodies may remind one of Bakhtin's account of the emergence of a "new bodily canon" from "the grotesque image of the body," the former promoting the ideal of a "strictly completed, finished product," smooth, impenetrable, "isolated, alone, fenced off from all other bodies," the latter emphasizing the openness of the perpetually changing organic body to all the metabolic processes "through which the world enters the body or emerges from it."⁶⁷ The desire to escape into the second world of art and embrace its smooth body engenders a desire that participates in the same imaginary violence I mentioned at the beginning of this essay, the violence of the desire to abject what cyberpunk calls the "meat" and "wetware" of the natural body. The invention of painting was the moment of metamorphosis, and the enduring flower commemorates the cost of the invention, the sacrificial desire of the inventor to plunge into the graphic imaginary, thereby losing, destroying, the rough body of the real self and world. The anatomical and geometrical dissection of the rough body is the precondition for the fantastic reversal and resurrection that transforms it into the smooth body. The desire for purgative lustration is fulfilled in *illustration*.

The medical and graphic surgeries that mediate the passage from the natural to the idealized body have been described and justified in terms of technical motives and praised for their contributions to science and art. Common to the convergent discourses of anatomy and painting was a positive objective: by performing actual or imaginary dissections in order to learn how bodies are built, you would learn to build them better than nature. But the hard edges of these discourses are smudged

with punitive fantasies that betray *le dessous*, the underneath or seamy underside of the project of idealization: fantasies of actual or imaginary violence expressed in the rituals of dissection and dismemberment the body has to undergo in order to be resurrected and glorified.

Alberti's anatomical inversion, the double procedure of dissection and graphic reconstruction, is by no means peculiar to him. It finds its way into Leonardo's comments on anatomy.[68] Here, for example, are four entries from the notebooks:

1. It is difficult to learn anatomy from watching a dissection because of "the very great confusion that must result from the combination of tissues, with veins, arteries, nerves, sinews, muscles, bones, and [the] blood which . . . tinges every part the same color. . . . Moreover, integrity of the tissues, in the process of investigating the parts within them, is inevitably destroyed. . . . Hence some further anatomy drawings become necessary."[69]

2. "Remove by degrees all the parts of the body of a man in making your dissection, till you come to the bones" (R 807).

3a. "First draw the spine of the back; then clothe it by degrees, one after the other, with each of its muscles" (R 809), or again,

3b. "First draw the bones . . . [and then lay on] those muscles which lie close to the said bones, without confusion of other muscles" (R 799).

4. "When you have finished building up [*di crescere*] the man, you will make the statue with all its surface measurements" (R 802).

Jean-Paul Richter finds the Italian both rhetorically and lexically ambiguous; he suggests that "di crescere" ("building up") must refer to modeling in clay, and then adds that the passage was originally inserted in the anatomy series "under the impression that *di crescere* should be read [as] *descrivere*."[70] But within the discourse of reversal or resurrection, both terms work together to connote not merely reconstruction but imaginary renovation, the *poiesis* of the glorified corpse replacing the cadaver's flayed and dismembered and stinking remains.

Leonardo frequently insists that knowledge of anatomy is indispensable to art because it enables the painter of the human figure "to become a varied and comprehensive demonstrator of the muscles according to their various effects in the figure."[71] Of course, knowing anatomy doesn't require the actual practice of dissection. He recognizes that the painters among his readers may not be able to stand the sight of corpses, and that they may lack the patience, the graphic expertise, and the knowledge of perspective and geometry, accurately to record the results of dissection. But he consoles them with the happy news that they will have the benefit of his 120 books on anatomy (R 796). Elsewhere he counsels painters "to disclose only those muscles which are involved in the motion and action" of the figure and he reminds them that whatever is not so involved "remains slack and limp."[72] But "slack and limp" describes *all* the muscles of a cadaver, which gives no direct information about their various effects in

a living moving figure. In the case of Michelangelo, for example, James Elkins has
demonstrated that although the knowledge gained from dissection may have helped
him simplify his forms, for most of his surface contours the artist relied much more
heavily on observation of living figures.[73] Elkins cites examples of life studies in which
"the muscles are strained and violently active to such an extent that they have little
resemblance to their appearance in dissection" (178–79) (Figure 31).

Ironically, the same holds true for several of Leonardo's graphic representations
of partially flayed or dissected bodies (Figure 32).[74] They look like cutaways of active
figures posing for anatomical studies. Purified fictions, animated idealizations, of the
dissected body, their tensed muscles seem extrapolated from the observation of living
bodies to the graphic analysis of anatomy. In these cases, anatomy appears to owe
more to the imitation of life than imitation owes to anatomy. That is what makes the
claim that knowledge of anatomy is essential to representation feel arbitrary or gratu-
itous. How much help do you think Leonardo got from his studies of flayed shoulders
when he was painting the weirdly mischievous, or mischievously weird, gesture en-
titled *St. John the Baptist* (Figure 33).[75] No doubt the claim about anatomy supports
and expresses the pretension of art to the status of science. But the graphic forms, the
texts and images, in which we find the claim articulated convey another message: they
represent anatomy as a constituent of the resurrective gesture that entails undoing
nature and redoing it as art. This gesture gets its effect from the conspicuousness with
which the images that depict the work of anatomy conceal its actual character. The
truth of nature expressed by the blood and guts of the decaying cadaver doesn't simply
disappear from the images; its absence, its exclusion, is part of what they convey.

Leonardo constantly praises nature and insists that we ought to make it our
model, internalize its reason, observe it, imitate it, and store it in memory, all with
utmost care and precision. In many entries, however, he invokes the Zeuxis principle,
and in some he writes as if there is a *paragone* between nature and painting, and as if
the painter's second nature is better than the one it imitates. Furthermore, when one
looks closely at his verbal accounts of both landscape and the proper way to depict
it, one sees that many of the former are more prescriptive than descriptive, that they
too are organized on Zeuxis's principle of selectivity, and that in effect they replace
nature because they are offered as models for the painter to copy; and this in spite
of Leonardo's express opinion that painting is better and closer to nature than verbal
discourse.

Like his resurrective view of anatomy, this revisionary tendency is closely con-
nected to the more general misanthropic strain that emerges from even a casual read-
ing of the Notebooks' rhetorical negotiations with their readers. The speaker con-
structed by the author's addresses to readers is often by turns defensive, aggressive,
impatient, cynical. He insists that he will be scorned, misunderstood, underappreci-
ated, by a readership most members of which are fools or knaves.[76] This misanthropic

31. Michelangelo Buonarroti. Study for *The Battle of Cascina*. Ca. 1504. Black chalk on paper. Teylersmuseum, Haarlem.

32. Leonardo da Vinci. Anatomical Studies of a Man's Neck and Shoulders. 1510–1511. Pen and ink with wash. The Royal Collection ©2000 Her Majesty Queen Elizabeth II.

view of his fellow humans is inscribed in many of the fables and allegories, and it may also be read into or out of the series of verbal and visual depictions of the deluge, where the savagely exuberant energy of his rhetoric in one medium and his hand in the other overscribbles and blots out the world. But this voice is inextricable from that of the other speaker in the Notebooks, who—absorbed in observation and speculation, in creative and technological projects—sits secure and alone at the center of the second world he continuously generates around himself.

33. Leonardo da Vinci. *St. John the Baptist.* Ca. 1515. Oil on panel. Musée national du Louvre, Paris. (Photo: Scala/Art Resource, NY.)

The link between these two voices may be illuminated by the utopian misanthropy More and Erasmus parodically represent, and by later passages in which such writers as Descartes and Hobbes perform and recommend an originary space-clearing act of violence, an imaginary destruction of the actual world, as the precondition to starting over and building it better.[77] The author constructed by the text of Leonardo's Notebooks manifests Hythlodaean tendencies: misanthropic episodes ranging from impatience through skepticism to bitterness, episodes that seem connected to his serious interest in what Louis Marin punningly calls *utopics* and to a preference for clarity and distinctness (and distinct*ion*) founded in the possibilities generated by his command of new graphic technologies of representation—a preference that, as a painter, he interrogates and rejects in the ambiguating practice of *sfumato*.[78]

The representational strategy that informs Leonardo's approach to anatomy—conspicuous exclusion coupled with idealization—also informs some of the plates for Vesalius's *Fabric of the Human Body* (published 1543). I refer of course to the famous series of musclemen depicted in the second book. Attributed to an artist in Titian's workshop, these are not figures with the flaccid, inactive muscles of cadavers. Most of them are flayed early modern Schwarzeneggers—pumped-up, active, oversized, and hypermale, the muscles they are progressively being deprived of are those of the idealized and classicizing bodies of high Renaissance art. One of their more striking and oft-noted aspects is the way they cooperate with the anatomist by rhetorically performing the pathos of their progressive disarticulation, even when, in the seventh plate of the series of anterior views, nothing is left but a ragged, staggering, partially covered skeleton held up by a noose threaded through its eyeholes (Figures 34, 35).

Vesalius writes that "when administering the dissection of a man" he suspends the cadaver by a cord, and he adds that "the cadaver was suspended in this way during the delineation of all the plates of muscles, just as it is displayed in the Seventh plate."[79] Thus, of the sixteen plates detailing the unraveling of the musculature, only the one he mentions—Figure 35—reproduces that procedure. Its presence together with Vesalius's comment dramatizes the extent to which the other plates elide both the actual process of dissection and the actual condition of the human specimen. The graphic record of dissection is expressly, conspicuously, a fantasy that denies—and in denying, rejects—the true nature of the corpses on which the anatomist operates. Describing these as "criminals, worn-out paupers, and bodies wasted by disease," the historian of science Charles Singer effuses that for Vesalius they were nevertheless "worthy of . . . attention as showing forth, however distantly, the design of Man in the mind of the Godhead. To reach closer than these poor corpses to that grand design was the real aim of the anatomist."[80] Singer's rhetoric betrays the androcentric and androgenetic basis of Vesalius's myological fantasy even as it suggests the motive for rejecting the natural state of the objects to which the illustrations refer. The

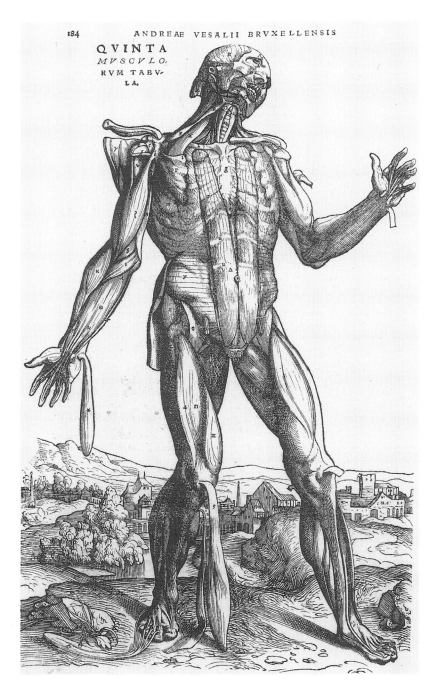

QVINTA
MVSCVLO,
RVM TABV-
LA.

34. Andraeas Vesalius, *De Humani Corporis Fabrica* (Basel, 1543), book 2, plate 5. Newberry Library, Chicago.

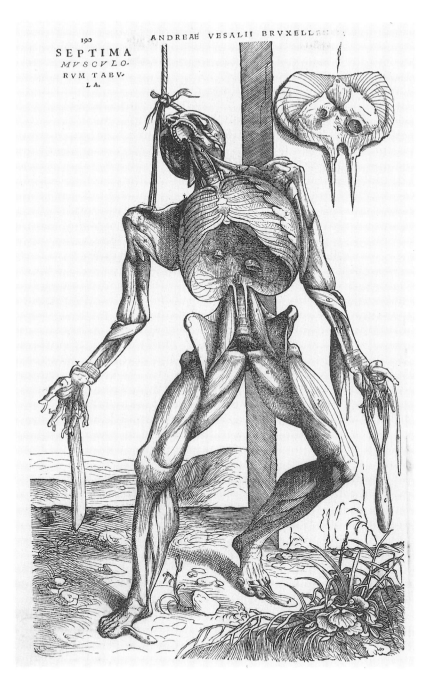

SEPTIMA
MVSCVLO-
RVM TABV-
LA.

35. Andraeas Vesalius, *De Humani Corporis Fabrica* (Basel, 1543), book 2, plate 7. Newberry Library, Chicago.

Vesalian artist gives birth to a golden race, an elite, of perfect male bodies resurrected from their cadavers so that they may heroically stage a more glorious dismantling, the assisted suicide they perform in bringing on their second death in art or science. And these figures are not only borrowed *from* painting, they are also, as Vesalius himself writes, models *for* painting—images "such as only painters and sculptors are wont to consider."[81] It is just such a rescue and resurrection of the body—rescue from nature, resurrection in art—that gave Giorgio Vasari his master plot in *The Lives of the Most Excellent Painters, Sculptors, and Architects*, which first appeared in 1550 and was reprinted in 1568 in a greatly expanded edition.

* * *

Among the comments on the logic of technology and culture change with which I began this essay was the proposition that in the backwash of technological advances, and as a result of the awareness of a corresponding diminution in control, a tendency arises to devalue what is considered merely natural and bodily. That this devaluation is often positively coded as the desire for an art that transcends nature gives us our link to Vasari's *Lives*. The *Lives* has been called "the first and still the most influential of all narrative and critical histories of art."[82] Art historians praise Vasari for being among the first to develop "a vocabulary of critical appraisal" and stylistic differentiation, and his many judgments of style are still valued for their historical if not their aesthetic significance. He was the first writer on art to treat sculpture, architecture, and painting as members of a single family—the children, as he put it, of one father, Design (he doesn't say who their mother is). Finally, he is still appreciated for the comprehensive technical knowledge evident especially in his long introductory account of the materials, procedures, standards, and types of artistic production.

To organize his narrative, Vasari took an idea common in his time, the idea of the rebirth—*la rinascita*—of art, and made it the basis of a historical scheme modeled in part on the human life cycle. He argued that classical and modern art had each gone through a three-stage career of improvement; that classical art and culture were destroyed by the combined forces of barbarian invasion and Christian zeal; and that after almost a thousand years of dark ages the arts were reborn and began their second cycle. Panofsky describes this cycle as

an evolution unfolding itself in three phases (*età*), each corresponding to a stage of human life and starting, roughly, with the beginning of a new century. The first phase, comparable to infancy, was ushered in by Cimabue and Giotto and his contemporaries; the second, comparable to adolescence, received its imprint from Masaccio, Brunelleschi, and Donatello; and the third, comparable to maturity, began with Leonardo da Vinci and culminated in Michelangelo. Vasari thus divides his *Lives* into three parts, and in the general preface of this triad . . . as well as in

the individual prefaces placed at the head of each part he tries to define the stages of the whole *rinascita*.[83]

This general scheme is easy enough to criticize; the evolutionist fantasy of progress and the biological analogy are particularly vulnerable. It is easy to show that the three-stage model has no organizing power in the 1568 edition most people use, because Vasari shifts from a qualitative to a chronological criterion: when he adds the lives of his contemporaries to those in the 1550 edition, he puts them all in part 3, simply because they are contemporaries. So one is tempted to assume that neither he nor his readers took his narrative patterns too seriously, tempted also to extend this assumption to his rhetorical habits, for example, his tendency to invoke divine forces and describe artistic agency in religious terms. We might conclude from this that his real interest was in providing information about—and judgments of—art and artists, and that this gives the book its enduring value. And in fact the *Lives* is often read as a collection of biographies that delivers a good picture of the age even if the information is unreliable.

But this is too reductive a response. I reject the idea that the superficial three-stage model brought to grief in the 1568 edition is the real narrative motor of the book. In my view, the *Lives* is driven, even if only intermittently, by another project, one to which the religious rhetoric is strategically important. I should note in passing that, although my focus is on Vasari's *Lives*, I am also more generally concerned with the structural dynamics of early modern discourses and technologies of representation. The problems and contradictions I find in the *Lives* are the same as those I find in the larger context. They center on the tension between the increasing capability of the techniques of representation and the constraints imposed by the politics of representation. For example, if you were a painter, you took pleasure in modeling figures in the round and suggesting what the bones and muscles were up to under the figure's clothes and skin; and as to the skin itself, you could—thanks to slower-drying oil paint—have a field day showing every wrinkle, wen, and zit. But if you were a patron, you were likely to insist on wenless and zitless portraits, and you were interested in having the painter display other things under the skin besides muscles and bones: greatness of soul, for example, distinction of mind, force of personality, or nobility of birth. It was the need to resolve this conflict between the claims of imitation and idealization that influenced the structure of Vasari's narrative machine.

What I propose to do, then, is demonstrate that the real motor driving the machine has only two gears, not three. Low gear drives the first two styles toward one kind of conquest of nature; high gear drives the third style toward another. Starting slowly in Giotto's century and picking up speed in Masaccio's, the painters and sculptors in low gear gradually perfect the means that enable them to produce accurate

likenesses. But with Leonardo art shifts into high gear and transcends imitation. The artists of the third style draw forth from the mind forms that surpass any to be found in nature, and with Michelangelo, as Patricia Rubin phrases it, "the conquest of nature is complete."[84]

The low gear that drives the first two styles or stages is the gear of imitation, or *mimesis*, and the high gear that drives the third style is the gear of *idealization*. Mimesis covers the improvements in the graphic technology of representation. Among these Vasari himself discusses the elements of geometry, perspective, proportion, foreshortening, and anatomy, the use of color and shading, and the "movements of the mind and gestures of the body." Although he praises these accomplishments of the two low-gear styles, he finds the naturalism of the second style too meticulous and labored: its artists "copied what they saw in nature, nothing more"; the shift into high gear releases a level of facility, grace, and freedom that surpasses not only the second style but also nature herself: the sculpture and painting of the third style are at once more lifelike and "more beautiful than in real life." In this connection it is interesting—as my colleague Karen Bassi has pointed out—that in the *Poetics* Aristotle claims that we learn our *earliest* lessons through mimesis.[85]

From Aristotle to the present day, the prevailing view of the relation between mimesis and idealization tends to stress their harmonious and cooperative interplay. Even when—as in the case of Quattrocento art—scholars acknowledge the tension between the novel appeal of naturalistic detail and the demand for idealized likenesses, they insist that the tension gets nicely resolved by the artists who transmit the torque upward into the so-called High Renaissance. The juncture of mimesis with idealization was encoded in the coupling of anatomy with proportion discussed from the time of Alberti and Ghiberti on, and highlighted in modern scholarship.[86] On this development, Wölfflin, Panofsky, Gombrich, and the standard art-historical textbooks all agree, and, in doing so, they follow Vasari's lead. They accept and privilege the aesthetic technophilia of an early modern ideology that Gombrich, in the course of supporting Vasari's position, expresses as follows: "in the age of the High Renaissance the conquest of natural appearances went hand in hand with the realization of a human ideal of Beauty," and an ideal that Gombrich, like Vasari, essentializes as objectively true.[87] It makes sense to call this ideology *mimetic idealism*.

In this ideology, formulas like "the conquest of natural appearances" gesture benignly both toward improved representational skills and toward idealization. Art is "true to nature, but nature idealized."[88] Yet even here, as more explicitly in Rubin's phrase quoted above, "the conquest of nature," "conquest" is an edgily ambiguous term. "To conquer nature." Four senses of this phrase come to mind: (1) to master the representation of natural forms; (2) to master and appropriate or improve on nature's productive processes, as in Aristotle's "art completes what nature cannot bring to

a finish" (*Physics* 199a15–17); (3) to make convincingly natural or realistic images of forms better than those found in nature; (4) to encounter nature as an obstacle to be removed, an enemy to be defeated, in the drive toward idealization. Vasari's narrative scheme expressly privileges the first three senses of the relation. But in a variety of ways, Vasari's text betrays the insistent and subversive pressure of the fourth sense, the pressure of a counterargument that upsets the easy accommodation of mimesis with idealization.

Mimetic idealism is the position I argue against in this essay. Not that I think it is wrong: mimetic idealism is "right" in the sense that orthodoxy or correct belief is right. Since patrons, like artists, imitated and emulated each other, their competition resulted in the privileging of certain stylistic norms, the visual rhetoric of exemplarity that Gombrich and Vasari speak of as an "ideal of Beauty." Those for whom the control of the resources of self-representation was an important political asset invested in the new science of art in order to stimulate the production of images that persuasively expressed the ideal. They also encouraged the efforts of humanists, Neoplatonists, and writers on art to rationalize or mythologize this system of patronage and production. From this collaboration emerges the euphoric harmony of mimetic idealism, the picture of a system in which the shift from mimesis to idealization is smooth and effortless. In fact the analogy of the organic lifecycle encouraged by Vasari and emphasized by Panofsky gives a misleadingly naturalized picture of the book's narrative machine, which in my view has more in common with fluid-drive transmission and other chimeras of the automotive imaginary.

Vasari's *Lives* both reflects and participates in this fluid drive system, and so my attempt to present an alternate view that will more or less strip his narrative gears is also aimed at the broader discursive context. The nub of the alternative is this: Early modern developments in the technology of representation not only increase mimetic skills and encourage their deployment in the service of idealization; the virtuality of the fantasies of idealization they make possible produces dissatisfaction with the unidealized referent of representation. What is perceived and imaged as *there*, before representation, falls short of the ideal, and is reinscribed in discourse as mere nature. The ability to represent idealized form reorients desire, and produces within it subtle currents of aversion to mere nature, and along with it, bad conscience about this aversion. This is an example of the logic of the supplement, the effect of technological enhancement, I discussed earlier. Its impact on the text of Vasari's *Lives* is demonstrable, and I now turn to explore it in three different contexts.

First, in the prefaces to parts 2 and 3, the critical passages that negotiate the shift from low to high gear.

Second, in the frequently repeated formulas of praise in which Vasari writes that painted or sculpted figures appear to be made of flesh rather than paint or stone, that

they seem to move and breathe, their flesh seems to quiver, their pulses to beat, and so forth.

And third, in the way Vasari works his major narrative trope of *rinascita*, rebirth, or—as I prefer to call it—resurrection.

1. The shift to high gear. In the preface to part 2 Vasari praises the accomplishments of the artists of the second age or period, their greater mastery of design, proportion, anatomy, color, perspective, and foreshortening. As a result the sculptors of that period could make their statues seem to move and to have "anima," while the painters could produce figures with such lifelike "movements of the mind and gestures of the body" that they fully resemble their originals. That praise, however, is carefully if unemphatically qualified: though the second-age artists got rid of the awkwardness and disproportion caused by the crudeness of their predecessors, they sought to make only what they saw in the natural state ("nel naturale") and nothing more.[89]

The preface to part 3 intensifies this criticism. The artists of the second period lacked "the perfection of finish [gli estremi del fine suo]" in their *disegno* because

> although they made an arm round and a leg straight, the muscles in
> these were not explored with that graceful and sweet facility that
> appears between the seen and the unseen, as is the case with the
> flesh of living figures; but they were crude and flayed, which made
> for difficulty to the eye and hardness of manner; missing from that
> manner was the delicacy that comes from making all the figures
> supple and graceful, particularly those of women and children, with
> the limbs true to nature in the case of men, but [in the former]
> covered with plumpness and fleshiness that should not be awkward,
> as they are in nature, but refined by design and judgment.[90]

> sebbene e' facevano un braccio tondo ed una gamba diritta, non era
> ricerca con muscoli, con quella facilità graziosa e dolce, che
> apparisce fra 'l vedi e non vedi, come fanno la carne e le cose vive;
> ma elle erano crude e scorticate, che faceva difficoltà agli occhi e
> durezza nella maniera: alla quale mancava una leggiadra di fare svelte
> e graziose tutte le figure, e massimamente le femmine ed i putti con
> le membra naturali come agli uomini, ma ricoperte di quelle
> grassezze e carnosità, che non siano goffe come le naturali, ma
> arteficiate dal disegno e dal giudizio. (M 4.9)

Vasari's Italian is condensed here, but as I read it this is what it says: the artists should have made "the limbs true to nature in the case of men," whose limbs were already supple and graceful, but they should have "covered" (*ricoperte*) the limbs

of women and children "with plumpness and fleshiness" so that they wouldn't "be awkward, as they are in nature, but refined [*arteficiate*] by design and judgment." "*Ricoperte*" actually means "re-covered," "covered again," and carries an intensive sense of "covered over," "hidden" (thus "ricoperta" means "pretext," "excuse"). When you put the reiterative and intensive senses together, you get the impression, first, that the artists graphically flayed their figures and were then obliged to re-cover them, and second, that the purpose of this exercise—at least in the case of women and children—was to resurrect the body in a glorified form. And this was where the second-age artists failed. Having profited from their knowledge or practice of anatomy, they left its marks on the bodies they made. They lacked the skill or judgment to represent these figures in a manner that both concealed the anatomical violence and justified it by improving on nature. Also, they needed to learn that in the matter of comparative body parts, those of women and children are inferior to male members, and thus require the equivalent of hormonal injections before being dressed and brought to *la tavola*. The artists of the third period were distinguished by the *sprezzatura* enabling them to hide the evidence of the laborious skills of dismemberment that their predecessors developed and passed on to them and that they, of course, or at least the best of them, diligently studied and exercised.

Vasari singles out excavation as the major factor in bringing on the third age: its artists had the advantage of

veder cavar fuora di terra certe anticaglie citate da Plinio delle piu famose; il Lacoonte, l'Ercole ed il Torso grosso di Belvedere; cosi la Venere, la Cleopatra, lo Apollo, ed infinite altre; le quali nella lor dolcezza e nelle lor asprezze, con termini carnosi e cavate dalle maggior bellezze del vivo, con certi atti che non in tutto si storcono, ma si vanno in certe parti movendo, e si mostrano con una graziosissima grazia, e'furono cagione di levar via una certa maniera secca e cruda e tagliente. (M 4.10)

seeing drawn out of the earth certain antiquities cited by Pliny as among the most famous; the Laocoon, the Hercules, and the great torso of the Belvedere; the Venus, the Cleopatra, the Apollo, and countless others; these in their sweetness and in their severity, with contours fleshy [or fleshlike—or muscular] and drawn from the greatest beauties in nature, and with certain attitudes that involve no distortion of the whole figure but only a movement of certain parts, and are revealed with a most graceful grace—it was owing to these that a certain dry and crude and sharp manner was taken away. (V 1.619, much altered)

These statues, extracted from the earth, exhumed like corpses, reborn like spirits delivered from nature, had themselves been originally extracted, reintegrated, and reborn in accordance with the Zeuxis principle; and many, broken or torn apart by time's violence and human force, awaited the Aesculapian ministrations of the new wave of artists.

I find something disturbing, the erotics of an obscene connoisseurship, in the ver-

bal caresses of such phrases as "grassezze e carnosità" and "termini carnosi e cavate dalle maggior bellezze del vivo."[91] The desire to exhume the fragments of antiquity mingles with the desire to resurrect the life of human flesh in stone or pigment and with the desire to remove, *levare*, and re-cover, *ricoprire*, the raw traces produced by the *tagliente* probes of a too careful, penetrating, dissective, and graphic imitation of nature. In this connection, it may be noted that the phrase "via del levare" contains within itself an ambiguity that gives it the potential valency of the now famous *aufheben*, "to sublate," for it means not only to take away, subtract, deliver from, but also to raise up, as in resurrection. To save or salvage nature by delivering her from her imperfections entails a passage through the violence that *levare* and *scorticare*, the subtractive work of the sculptor and the anatomist, have in common. In Vasari's story, this equivalence makes it possible for the harshness of flaying to be lightened or relieved (*rilevato*) by augmenting the imitation of dead and living body parts with the imitation of ancient statues. But there is no getting around the necessity of violence—whether actual, graphic, or imaginary—fundamental to the project of mimetic idealism, in which nature is transcended, the natural body destroyed and resurrected, because they don't meet the standards of a divinely fathered *disegno*.

In several passages of the *Lives*, however, there are hints of an alternative fantasy of resurrection in which Mother Nature is bypassed and art is magically, androgenetically, brought to life. The obvious model for this is the myth of Pygmalion, which Vasari first mentions in the preface to the whole work among the examples of wicked love falsely cited as "proof of the nobility of art" (M 1.98); this is a response to the argument of sculptors that the superiority of their art was proved by the high prices for which "the loves caused by the marvelous beauty of certain statues" were responsible (M 1.94). In the preface to the *Lives* Vasari briefly summarizes the story, but this time in the positive context of praise for ancient sculptors (M 1.218–19). Bronzino's painting of the myth is mentioned in the life of Pontormo (M 6.275), and in the life of Titian there is an obvious allusion in lines written by a patron in praise of a portrait of "una gentildonna" he loved: "Ben vegg'io, Tiziano, in forme nove / L'idolo mio, che i begli occhi apre e gira" (M 7.456). As we saw earlier, in Ovid the movement from the Propoetides to Pygmalion's living statue traces a fantasy of death and resurrection that slanders both nature and woman, but the critical irony central to Ovid's performance is ignored or repressed by the Vasarian narrator. It remains trapped in the underwriting, from which it sends an occasional tremor of bad conscience up to the surface.

One such tremor appears in the life of Mantegna, a passage of which is so closely linked to the comments on excavation cited above that it merits fairly extensive quotation. Mantegna's former master, Squarcione, acting partly from personal motives, publicly criticized some of his paintings

because in making them he had imitated the ancient works in marble, from which it is not possible to learn painting perfectly, for the reason that stone is ever from its very essence hard, and never has that tender softness that is found in flesh and in things of nature . . . ; adding that . . . they would have been more perfect, if he had given them the color of marble . . . because his pictures resembled not living figures but ancient statues of marble. . . . This censure piqued the mind of Andrea; but, on the other hand, it was of great service to him, for recognizing that Squarcione was in great measure speaking the truth, he set himself to portray living people, and . . . showed that he could wrest [cavare] the good from living and natural objects no less than from those wrought by art. But for all this, *Andrea was ever of the opinion* that the good ancient statues were more perfect and had greater beauty in their various parts than is shown by nature, since, *as he judged and seemed to see* from those statues, the excellent masters of old had wrested [cavato] from living people all the perfection of nature, which rarely assembles and unites all possible beauty into one single body, so that it is necessary to take [pigliarne] one part from one body and another part from another. In addition to this, *it appeared to him* that the statues were more complete and more thorough in the muscles, veins, nerves, and other particulars, which nature, covering their sharpness somewhat with the tenderness and softness of flesh, sometimes makes less evident, save perchance in the body of an old man or in one greatly emaciated; but such bodies, for other reasons, are avoided by craftsmen. And that he was greatly enamored of this opinion is recognized from his works, in which, in truth, the manner is seen to be somewhat hard and sometimes suggesting stone rather than living flesh. (V 1.559–60, my emphasis; M 3.389–90)

The sustained meditation attributed to Mantegna occurs near the end of part 2 and clearly anticipates the references to the Zeuxis principle and ancient statues in the preface to part 3. I am therefore tempted to substitute "Giorgio" for "Andrea" in the first italicized phrase and read all that follows until the last sentence—or perhaps until the cryptic clause that concludes the penultimate sentence—as an opinion being entertained and explored *in altera persona* by the author of Vasari's text. We know, from what he says here and elsewhere, that it is not an opinion he subscribes to without reservation. Copying from life, as he notes in the technical introduction to painting, succeeds copying from immobile statues as the capstone of the painter's training (M 1.170–71). And in the introduction to the life of Mino da Fiesole he states that artists who imitate only the works of their predecessors, and not nature, are unable "to make them so similar that they shall be like nature herself, or even, by selecting the best, to compose a body so perfect as to make art excel nature" (V 1.476; M 3.115). Though Mantegna observed the Zeuxis principle, he failed to respect the Pygmalion principle. Yet the view that the ancient sculptors did the modern painters' dirty work for them has a certain escapist appeal: they saved the moderns from having to "wrest"—de Vere's excellent rendering of *cavare*—outstanding body parts from living models, from having to suffer the inconvenience of the living body, with its internal structure obscured by the veil of flesh, and also, perhaps, from having to flay and dissect the dead body to wrest from it the secrets of its inner life. Mantegna becomes

the mouthpiece for a pastoral fantasy in which the discourse of art is purged of the imaginary violence—or the violent Imaginary—inscribed in its language, its exemplary anecdotes, its procedures, and its ideals.

2. The praise formulas. Vasari's formulas of praise are so frequent and so obviously hyperbolic that it is easy to dismiss them or pass them by. The notion that art can produce a second nature better than nature, and the notion that art can dissimulate and pass itself off as nature—these are among the commonplaces of early modern aesthetics. But if we pause before one of his more famous descriptions, the searching intensity of the narrator's gaze produces a weird effect. Here is what he writes about the *Mona Lisa*:

In this head, whoever wants to can easily see how art is able to imitate nature, for in it were counterfeited all the details that can with subtlety be painted; the eyes had that luster and moistness that are always seen in life, and around them were all those rosy pale tones, and the lashes, which can't be represented without the greatest subtlety. The eyebrows, through his having shown the manner in which the hairs spring from the flesh, more thickly there, more thinly here, and follow the pores of the skin, could not be more natural. The nose with its beautiful nostrils rosy and delicate, appeared to be alive. The mouth, with its parted [lips], and with its corners united by the red of the lips to the flesh tints of the face, seemed in truth to be no colors but flesh. Whoever looked most intently at the pit of the throat could see the pulses beating.[92]

This doesn't need much comment. It evokes thoughts of the fetishism of the male gaze or the dissective connoisseurship of the Petrarchan sonneteer. The aesthetics of artistic judgment and of voyeuristic fascination converge. What complicates the passage is that Vasari isn't likely to have seen this portrait because Leonardo took it to France, which is where Vasari—who never went to France—says it was. It has been pointed out that the description doesn't accurately reflect the painting as we have it today. Had he described what he saw, he would be like Pygmalion investing his desire in a work of art to make it come alive. Instead, while pretending to give us an ekphrasis—a verbal imitation of visual art—he spins out the fantasy of an idealized portrait to which he attributes the seductiveness of the idealized form of woman—woman, that is, as a man's work of art.

Vasari's express attitude toward woman and women differs from his figurative use of gender categories, but influences it enough to call for some comment. In discussing Michelangelo's early *Pietà* in the Vatican, he mentions those fools who complain that the Virgin looks too young to have such a grown corpse, and he zaps them with the following nugget from his profound knowledge of female physiology: "They fail to see that virgins who haven't been contaminated maintain and preserve their freshness of countenance unstained for a long time" (M 7.152, my trans.). This accords with his other comments on women who have been contaminated by—or who have contaminated—their husbands, lovers, and clients. Such comments are relatively rare in

the *Lives*, but they reflect a consistent pattern. Except when positioned as model, sitter, or patron, woman is the artist's curse. Her major function is to take the blame for man's weakness and for the domestic obligations that obstruct his career. Given this attitude, we can understand Vasari's respect for the immaculate marble motherhood of Michelangelo's Mary, and for the permissible seductiveness of Mona Lisa's painted flesh, or fleshly paint.

The women Vasari most admires are those whose lifelike but idealized forms pass into marble or pigment from a male source of conception that aspires to be immaculate and androgenetic—what Vasari calls *disegno*, the father of the arts. This source is embodied by Vasari in his attention to artistic genealogies in which the parent/child relation is subordinated or displaced to the master/pupil relation, and the workshop replaces the household. The production of artistic manhood entails something like abduction from the natural family and induction—or initiation—into the patrilineages of art. Like all such initiatory and pedagogical practices, as I noted above, the specialized mobilization of male resources aspires to androgenesis; it involves an alienation of power from natural to artificial families, and a corresponding intensification of homosociality and misogyny. I don't mean to suggest that gender is a primary concern or structuring principle of the *Lives*. On the contrary, gender differences are taken for granted and embedded in other categories, which allows them to exert pressure from below even as they are reaffirmed and revitalized by their repetitive appearances in displaced form. This pressure is diffused through the shadowy personification of *la natura*, who is feminized more by grammatical accident and traditional function than by rhetorical emphasis. Because nature is the mother of generation and corruption, she is also, by extension, the mother or stepmother or grandmother of imitation—that is, of those images constructed as faithful representations of her creatures.

(Before going on, let me pause just long enough to demythologize *nature* and expose my own strategically crude and fuzzy use of that term. In my lexicon, "nature" signifies whatever was there before art for art to imitate; this can include not only the organic and inorganic world but also the so-called second nature of human artifacts and culture. "Nature" in this construal simply denotes the referential raw material art works with.)

Though Vasari's critique of low-gear mimesis is articulated in aesthetic categories of style, its force apprehends the defects, the coarseness, awkwardness, and lack of grace, of most living bodies, and the harsh, offensive appearance of the excoriated cadavers that are supposedly essential to the mimetic reconstruction. In this respect, his injunction to conquer and transcend nature implicates more than a stylistic imperative; embedded within it is a vaguely matricidal impulse. His express desire for art is that it pass through and beyond nature, *ultra naturam*. But hooked onto this is the impulse to act *contra naturam*. The impulse surfaces in casual details, peripheral comments, anecdotal juxtapositions, aesthetic evaluations, and accounts of practices

essential to the science of art: hints of violence; dismemberment; fear or contempt of the natural body—its imperfections, attachments, diversions—that is essentially gender-coded; and a preference for the signs of life exhibited by dead images whose pigment the observer's desire transforms into flesh. Behind Vasari's obscene verbal caresses of Mona Lisa and the other beautiful undead creatures that materialize in his verbal descriptions lurks the rejection of nature as mother of the ills that flesh is heir to.

In the larger register of the master narrative, nature is not so much violated as elided out. At the beginning of the *Lives* Vasari celebrates the creativity of God, the first architect, sculptor, and painter. At the end of the life of Michelangelo he closes the circle of androgenesis by performing an extended literary resurrection of the homoerotic divine artist. Early in the life Vasari reports Michelangelo saying that when he was young he sucked in the hammer and chisels of his art with his mother's milk. But near the end of the story he corrects that figure with the remark that "when he wanted to bring forth Minerva from the head of Jove, he had to use Vulcan's hammers" to achieve a *grazia* "that isn't seen in nature." *Disegno*, father of the arts, aspires to be the sole parent of art's master race.

Vasari assimilates both the pattern of his history and its culmination to the art by which Michelangelo delivers/extracts/excavates the form enwombed/entombed in the natural matrix, and brings it to perfection. In the long run, deliverance from woman signifies deliverance from nature. But perfection is attainable only by passing through the period of mimesis in which nature is conquered by those who aspire merely to reproduce her, and reaching the third age of idealization in which to conquer nature means both to transcend her and to sublate mimesis. In Vasari's judgment, then, the artists of the third period were distinguished by their ability to hide the evidence of the laborious skills of dissection their predecessors developed and passed on to them. The critique of the second period is superficially directed toward the aesthetic disability that results from too conspicuous a display of the science of art and too fussy an attempt to imitate nature. But since the desire for a glorified representation of the body encodes the desire for a glorified body, the critique of naturalism amounts to a critique of nature. There can be no resurrection of the body in art without the sacrifice of the body in nature.

3. Resurrection. Resurrection is one of the major organizing tropes of Vasari's narrative. The engraving on the 1568 title page shows Fame waking up the dead with a three-horned trumpet worthy of Dizzy Gillespie; the inscription reads, "with this breath I shall proclaim that these men have never perished nor been conquered by death" (Figure 36). A few times in the dedications and general preface Vasari comes on as a kind of judge and hell-harrier, as if he imagines himself playing Christ in Michelangelo's *Last Judgment*, saving artists from what he calls the second death—not damnation, but oblivion. His many references to this function have the effect of hooking

LE
VITE DE' PIV ECCELLENTI
PITTORI, SCVLTORI, ET ARCHITETTORI,
Scritte, & di nuouo Ampliate da M.
GIORGIO VASARI PIT. ET ARCHIT. ARETINO.

HAC SOSPITE NVNQVAM HOS PERIISSE

VIROS, VICTOS AVT MORTE FATEBOR.

CO' RITRATTI LORO
Et con le nuoue vite dal 1550. insino al 1567
Con Tauole copiosissime De' nomi, Dell'opere,
E de' luoghi ou' elle sono.

IN FIORENZA APPRESSO I GIVNTI 1568.
Con Licenza, e Priuilegio.

36. Title page from Giorgio Vasari, *Vite de' piú eccelenti pittori, scultori, ed architettori* (Florence, 1568). Newberry Library, Chicago.

together the rebirth of the arts Vasari writes about and the rebirth of that rebirth in his writing. When the rhetoric of salvation filters into the general theory of dual-drive transmission, it reinforces the Good News—or possibly the Bad News—most fully revealed in the third preface. First the spirit of art has to incarnate itself in the body of nature, then it has to resurrect its body from nature.

I want to emphasize that the causal form of this proposition reverses the one Vasari and his contemporaries usually focus on. The standard message is that because of the death-dealing powers of nature, time, and oblivion, art bestows a sort of second-best immortality. But the message I draw from the Vasari text is that in the relation of visual art to its natural referent, the triumph of the visual sign entails the sacrifice of the referent. Resurrection presupposes death. If something ain't broke and you want to fix it, you have to break it; if it ain't dead and you want to resurrect it, you have to kill it. This may be a merely ritual sacrifice, merely symbolic, merely (with certain exceptions) imaginary. But like all sacrifices it is vibrant with traces of lethal violence to the bodies nature produces. If the body is to be resurrected in the transcendence of art, it first has to be encrypted and dissected, inhumed and exhumed, so that it may be repositioned, consumed, assimilated, and reborn in the beautiful sarcophagus or flesheater of art. "Sarcophagus" is from a Greek word meaning carnivorous; a carnivore; a cannibal; a kind of limestone remarkable for consuming the flesh of corpses laid inside it. I conclude with an example of the sarcophagous qualities of Vasari's text.

At the end of his life of Masaccio, Vasari cites an epitaph in which Annibale Caro puts these words in the dead painter's mouth:

> I painted, and my picture was like life;
> I gave my figures movement, passion, soul:
> They breathed. Thus, all others
> Buonarroti taught; he learnt from me.[93]

At the end of his life of Filippo Lippi he quotes another example of this genre, composed by Poliziano and cut into Lippi's tomb in antique letters. Poliziano has the dead painter tell passersby that his touch could make artificial colors come to life and deceive minds into hoping they could speak, and that nature herself, rendered visible in his figures, was amazed, and acknowledged that he had equaled her in her arts (M 2.630). Note that in making the dead speak, the writers represent themselves as doing precisely what they pretend their painters claim to have done: bring life to inanimate substances. Anything Masaccio and Lippi intended to "say" when they "spoke" through their art is encrypted in their "remains," a term that euphemistically denotes the empty site of former life and nature, the space that makes it possible for others to resurrect the two painters' intended meanings in a different form, but one now

common to them both. The fictiveness of antique lettering flags this pathos. And in citing these epitaphic performances, Vasari assimilates them into his new version of the continuing discourse of art. If he enlists Caro and Poliziano as his assistants in this project, he also goes beyond them by making their messages yield and contribute to the larger theme of the mimesis that characterizes the second age, the theme Vasari puts in Masaccio's mind, if not his mouth: "desirous of acquiring fame, he considered that (as painting is nothing else but the counterfeiting of all the things of nature, simply with design and colors as they are produced by her) he who more perfectly follows her can be called excellent" (M 2.288). This passage vividly exemplifies Vasari's resurrective method. He has helped Masaccio pass from his own life through the first death and beyond nature to the better life he receives in the book called *Lives*. There his first life is emptied out so that he may live in perpetuity as Vasari's mouthpiece. In this way, biography is founded on thanatography, and the *Lives* is like a sequence of images adorning a sarcophagus.

Vasari's vision of the progress of art from the Dark Ages to its culmination in Michelangelo is meant to enhance the new dignity accorded both the work of art and the work of the artist. At the same time, his elaboration of this claim is beset by a series of subversive themes and narratives that trouble his vision of progress and, more generally, prowl the depths of the idealizing fantasies inscribed in his book. They include

the uneasy marriage between Mother Nature and Father Art;
the equally uneasy marriage of imitation to idealization;
graphic violence: dissection, dismemberment, and other fantasies of idealization;
misogyny, homoerotics, androgenesis, and other techniques for assuring the progress
of art.

The common feature of these motifs is their contribution to the disparagement of the natural, the bodily, the maternal, and the female. Devaluation of the natural body emerges in the *Lives* as the by-product of a narrative structured to demonstrate that art can and should—and indeed did—transcend nature.

Vasari was himself a practicing architect and painter, and the *Lives* begins with a long, knowledgeable introduction to current techniques and workshop practices in architecture, sculpture, and painting. A strange affinity lurks between the fascination with technique, the commitment to idealization and transcendence, and a conception of the plastic arts already infiltrated by the dream of plastic surgery. It is as if the artist should train himself not only to represent the human body but also to reconstruct it—after he has mentally disassembled it. Bernard Schultz observes that "the theory of artistic anatomy as founded by Alberti and Ghiberti . . . provided a practical foundation for the correct articulation of the human figure,"[94] but his ensuing discussion raises a question he doesn't consider: what relation subsists between the correct ar-

ticulation of the human figure and the articulation of the correct human figure, especially when the notion of correctness is skewed toward idealization by the revival and revision of the classical theory of proportion? According to Vasari, the artist who has seen bodies dissected and knows "the order and conditions of anatomy" will make better pictures of bodies. Will these also be pictures of better bodies?

To judge from their written statements, Alberti, Leonardo, Vasari, and their contemporaries seem to take it for granted that knowledge of anatomy along with some hands-on practice in dissection is either essential or extremely useful to the artist who wishes to acquire competence in representing the living body; and many modern scholars back them up in this claim. But is it true? Can't competent images of the living body be produced without the benefit of the anatomical knowledge and practice focused on dead bodies? Then what's the point of the claim, apart from the assertion of more than artisanal status? I think the claim is motivated not merely by the desire to transcend nature but by the desire to imagine what it would be like if second-world discourses and figures could be projected beyond their imaginariness, beyond their secondness, so as to supply the deficiencies of nature. This is a cybernetic fantasy *avant la lettre*. In the first section of this essay I remarked that cyberdiscourse uses the notion of virtual reality in a manner that is in some respects conceptually—if not technologically—similar to Renaissance notions of imaginary second worlds produced by art. Yet there is at least a normative difference, for in the value system of the version of Renaissance poetics unpacked by Philip Sidney's "An Apology for Poetry" it is a gesture of weakness, a failure of the imagination, to thrust beyond the containment of the second world toward the facticity—that is, the factitious and fetishistic semblance— of truth-claims about the real.[95] Nevertheless, the proto-cybernetic fantasy of the authors I have considered nudges the second world toward the status of virtual reality. "Virtual" in that phrase is etymologically a loaded term. It doesn't simply mean "as if." It is related not to the virtue branch of *virtus* and *virtù* but to their androcentric power branch, and its force derives from the overlap of *vir* with *vires* (*vis*). In idiomatic usage its adverbial form, "virtually," means "almost but not quite," or "nearly."

Coda. From Nudity to Nakedness: Kenneth Clark on Prosthetic Backlash

"To be naked is to be deprived of our clothes, and the word implies some of the embarrassment most of us feel in that condition." So Kenneth Clark proclaimed in the second sentence of *The Nude*, leaving us to wonder who the unembarrassed and uncivilized minority might be.[96] *The Nude* appeared in 1956, and Clark went on to serve as High Civilization's *arbiter elegantiae*, which placed him directly—and in my opinion justifiably—in the post-1960s line of cultural fire. In the nearly fifty years since its

publication, the elitism and sexism that maculate this and such later studies as Clark's two Rembrandt books have made him an easy target. As Margaret Miles has shown, when he identifies nakedness with "a huddled and defenseless body" (23) or with "the shapeless, pitiful model that the students [in art school] are industriously drawing" (25), "the embarrassment most of us feel" is directed not merely toward nakedness per se but toward the naked truth of the female body.[97] The point of view constructed by Clark's rhetoric is signified by a "we" that fluctuates between the connoisseurial authority of a royal plural and a democratically inclusive appeal to common human sentiment: "A mass of naked figures does not move us to empathy, but to disillusion and dismay. We do not wish to imitate; we wish to perfect."[98]

The tonal hint of condescension and the frequent identification of the "we" with the position of a privileged male gazer have made it hard for Clark's critics to appreciate the strength of the basic idea that informs *The Nude*. This idea is one of the sources of the concept of prosthetic backlash I develop in the present essay, and so I would like to redirect attention to it, beginning with Miles's paraphrase:

In Clark's distinction between "nakedness" and "nudity" the nude body is a representation of a naked body from which subjectivity, along with moles and lumps, has been elided. At the same moment when the naked body was "re-formed" to render it pleasingly balanced and proportioned and without blemishes, it lost its ability to express the personal character of the person whose body it is. . . . In Clark's description, the naked body becomes "a nude" by having its feeling ("embarrassment") removed along with the visible symbols of its individuality and personality ("wrinkles, pouches and other small imperfections"). The nude achieves universality at the expense of particularity. The subject of a nude painting has been deleted, replaced by the role the nude plays in representing "a far wider and more civilizing experience." (14)[99]

This account accentuates Clark's emphasis on the abstraction of nudity from nakedness in order to highlight what has been sacrificed in the process of reformation. And although that is surely one way to formulate and critique the Clark thesis, it doesn't quite do justice to a variant reading of the naked/nude relation occasionally discernible in *The Nude*—a subordinate argument the causal logic of which runs counter to that of the thesis Miles picks out. The variant is perhaps most concisely stated in a comment on Rembrandt: "Rembrandt's male models are as miserably thin as his women are embarrassingly fat. By a paradox, the academic search for perfection of form through a study of the nude has become a means of showing the humiliating *im*perfection to which our species is usually condemned."[100] In other words, our unhappiness with the naked body is a backlash produced by our experience of its artistic metamorphosis into the ideal form of the nude body, the "balanced, prosperous, and confident . . . body re-formed" that is the most durable of "those inheritances of Greece which were revived at the Renaissance."[101]

In the light of this argument Clark's casual opening reference to privation—"To be naked is to be deprived of our clothes"—glances beyond itself toward the more deeply embedded consequence of artistic achievement and inheritance: to be naked is to be deprived of our nudity. If we didn't have clothes and representations of nudity to begin with we wouldn't be embarrassed by our bodies in their "natural state." Like clothes, then, the nude may be given the ambivalent value of a supplement that supplies the body's deficiency: a consequence of art or technology that manifestly improves on the naked body and therefore latently disparages it; initially an enhancement and ultimately a compensation. In the preposterous perspective of genealogical interpretation, nudity came first and provides the Edenic vision of innocent perfection from which we fell and always fall into the sin of nakedness. Thus Clark notes that photographers of the nude, "in spite of all their taste and skill," cannot satisfy "those whose eyes have grown accustomed to the harmonious simplifications of antiquity. We are immediately disturbed by wrinkles, pouches, and other small imperfections, which, in the classical scheme, are eliminated. . . . In almost every detail the body is not the shape that art had led us to believe it should be" (27). The emergence or reemergence of artistic and idealized canons of nudity during the Renaissance, the depiction of better bodies than the bodies we have, accentuates the defectiveness of mere nakedness, and makes the body a victim of prosthetic backlash. Clark attributes this effect to forms of cultural production that have broad but nevertheless specific historical provenance in the art of classical antiquity and its Renaissance revisions.

The shape this art had led us to believe the body should have was determined by the now familiar elements of early modern representational technology that characterized revivals and revisions of antique canons and practices. Innovations in visual arts, anatomy, and medical discourse were closely linked to improvements in the media through which representations in word or image were produced and disseminated. In Italy during the Quattrocento, the transformation from nakedness to nudity took place within the career of visual art itself: the more effective and accurate techniques of imitation that marked earlier fifteenth-century visual practice initially conflicted but eventually combined with norms of idealization based on principles of proportion, symmetry, and harmony. For my purposes, what is most important about the nude that emerges from these changing representational protocols is that it is not only an abstraction from the actuality of naked bodies but also an expressly fictive construction. If mimesis makes the represented body a reflection and possible model of the naked actuality, idealization and fictionalization work together to produce the nude as both an exemplary and a counterfactual supplement that supplies the deficiencies of nakedness.

I would like to thank Peter Erickson, Karen Bassi, and Patricia Reilly for perceptive and constructive critiques that helped me enormously in the course of revising and expanding early drafts of this essay. Thanks also to the patience and helpful comments of the audience to whom an earlier version was delivered at the October 12, 1996, meeting of the Bay Area PEMS Group.

1. Most of the essays I published on this topic were subsequently included in *Second World and Green World: Studies in Renaissance Fiction-Making*, ed. John Patrick Lynch (Berkeley: University of California Press, 1988). Abbreviated to *SW* in subsequent citations.

2. See *SW* 17–25 and 373–408.

3. See, for example, "The Ecology of the Mind," in *SW* 41–62. Were I to entertain these notions today I would characterize the first world not by "factuality" but by "facticity" because of the latter's etymological and semantic connections to "factitious" and so, by extension, to "fetishistic" and "fictitious."

4. Examples: the hypothetical space, place, and time of an epic or pastoral or novel, a utopian narrative, a lyric utterance, a play, a painting, an experiment, an alternative cosmology.

5. Among the more troubling weaknesses was my habit of writing about second worlds *tout court* rather than about instances of second-world discourse—thus reifying them as independent entities.

6. "Hans Moravec has a dream," writes one acerb critic of Moravec's research in robotic transformation. "[He] wants to download the information stored in the human brain and transfer it to a computer. Once the transfer is complete, the body becomes disposable. . . . 'If you're tired of the ills of the flesh, then *get rid of the flesh*; we can *do* that now'. . . .[T]he point is not merely to leave the body but to reconstitute it as a technical object under human control" (N. Katherine Hayles, "The Seductions of Cyberspace," in *Rethinking Technologies*, ed. Verena Andermatt Conley [Minneapolis: University of Minnesota Press, 1993], 173). Hayles's quotation is from Ed Regis, *Great Mambo Chicken and the Transhuman Condition: Science Slightly over the Edge* [Reading, Mass.: Addison-Wesley, 1990], p. 7). For a characteristic sampling of cyber-discourse and its critics, see the special issue of *Body & Society* 1, 3–4 (November 1995) entitled *Cyberspace/Cyberbodies/Cyberpunk: Cultures of Technological Embodiment*, ed. Mike Featherstone and Roger Burrows. See also *Flame Wars: The Discourse of Cyberculture*, ed. Mark Dery, special issue of *South Atlantic Quarterly* 92 (1993): 559–857.

7. Kathleen Woodward, "From Virtual Cyborgs to Biological Time Bombs: Technocriticism and the Material Body," in *Culture on the Brink: Ideologies of Technology*, ed. Gretchen Bender and Timothy Druckrey (Seattle: Bay Press, 1994), 50, 51.

8. For premodern examples, see *SW* 189–228 and passim. See also my "Facing Sophists: Socrates' Charismatic Bondage in *Protagoras*," *Representations* 5 (1984): 66–91, especially 89–90, and "Plato's Flying Philosopher," *Philosophical Forum* 13 (1982): 385–407.

9. Since the name "Diotima" means "Zeus' honor (or gift or reward)," it evokes a fleeting thought of Athene.

10. On this view of Plato, see "Plato's Flying Philosopher" and "Facing Sophists." See also my "Levels of Discourse in Plato," in *New Directions in Philosophy and Literature*, ed. Anthony Cascardi (Baltimore: Johns Hopkins University Press, 1987), 77–100, and "*Phaedrus* and the Politics of Inscription," in *Plato and Postmodernism*, ed. Steven Shankman (Glenside, Pa.: Aldine Press, 1994), pp. 76–114.

11. "Bodies and Texts," *Representations* 17 (1987): 149–50; "From Body to Cosmos: The

Dynamics of Representation in Precapitalist Society," *South Atlantic Quarterly* 91 (1992): 591–96.

12. On the myopia of technological determinism see the enlightening discussion by Carla Hesse, "Books in Time," in *The Future of the Book*, ed. Geoffrey Nunberg (Berkeley: University of California Press, 1996), pp. 21–36.

13. Langdon Winner, *Autonomous Technology* (Cambridge, Mass.: MIT Press, 1977), pp. 313–14.

14. Jacques Ellul, *The Technological Society*, trans. John Wilkinson (New York: Vintage Books, 1964), pp. 86, 93.

15. Here I follow Raymond Williams's commonsense distinction between "*technique* as a particular construction or method, and *technology* as a system of such means and methods": Raymond Williams, *Keywords: A Vocabulary of Culture and Society* (New York: Oxford University Press, 1983), p. 315. The structural homology between the generation of technologies and of ideas is suggested in the following comment by Umberto Eco on Ioan Culianu's thought: "He took the view that there is a universe of ideas, which develop almost autonomously through an abstract ars combinatoria—these combinations interfere with history, with material events, in often unpredictable ways" (*New York Review of Books* 14, 6 [April 10, 1997], 7).

16. Francesco Petrarca, *De remediis utriusque fortunae libri II*, Bibl. Vatic., Cod. Urb. lat. 334, II, 93, f. 231r; trans. Charles Trinkaus, *In Our Image and Likeness: Humanity and Divinity in Italian Humanist Thought* (1970; rpt. Notre Dame, Ind.: University of Notre Dame Press, 1995), 1: 194.

17. Sigmund Freud, *Civilization and its Discontents*, trans. James Strachey (New York: W. W. Norton, 1962), pp. 37–39. The key phrase, "a kind of prosthetic god," translates "einer Art Prothesengott": Freud, *Gesammelte Werke*, vol. 14 (1948; rpt. London: Imago Publishing, 1955), p. 451.

18. David Wills, *Prosthesis* (Stanford, Calif.: Stanford University Press, 1995).

19. Thanks to Margo Hendricks and Jeffry Fawcett for suggesting this example.

20. I mention the culture of cosmetics because it has special relevance to one of the central issues in the first text to be discussed, Vasari's *Lives*: the issue of enhancement in visual representation. For a trenchant account of the ambivalence and backlash produced by early modern techniques of enhancement and idealization, see Gail Kern Paster, *The Body Embarrassed: Drama and the Disciplines of Shame in Early Modern England* (Ithaca, N.Y.: Cornell University Press, 1993), especially chap. 4, pp. 163–214. A relevant example: "if breast and nipples can be made more beautiful through cosmetics, then breast and nipple au naturel become plain and less erotic" (p. 207).

21. David C. Lindberg, *Theories of Vision from Al-Kindi to Kepler* (Chicago: University of Chicago Press, 1976), 149. See also my "L. B. Alberti on Painting: Art and Actuality in Humanist Perspective" (1965) in *SW* 374–75.

22. Donna J. Haraway, "A Cyborg Manifesto," in *Simians, Cyborgs, and Women: The Reincarnation of Nature* (New York: Routledge, 1991), p. 152.

23. Elizabeth Pittenger, "Aliens in the Corpus: Books in the Age of the Cyborg," in *Prosthetic Territories: Politics and Hypertechnology*, ed. Gabriel Brahm and Mark Driscoll (Boulder, Colo.: Westview Press, 1995), pp. 204–18.

24. Jean-Louis Comolli, "Technique and Ideology: Camera, Perspective, Depth of Field," in *Movies and Methods*, ed. Bill Nichols (Berkeley: University of California Press, 1985), 2: 52.

25. Ibid.

26. See Jacques Derrida, *Of Grammatology*, trans. Gayatri Chakravorty Spivak (Baltimore: Johns Hopkins University Press, 1976), pp. 141–64.

27. From the *Travel Journal* for September 5–28, 1580, in *The Complete Works of Montaigne*, trans. Donald M. Frame (Stanford, Calif.: Stanford University Press, 1957), p. 870. The idiom is the same in French: "Et fut pendere purs des inventions illicites a *supplier au defaut* de son sexe." I am grateful to Catherine Newman for supplying this example.

28. David Wills, "1553: Putting a First Foot Forward (Ramus, Wilson, Paré)," in *Human, All Too Human*, ed. Diana Fuss (New York: Routledge, 1996), p. 162.

29. S. H. Butcher, *Aristotle's Theory of Poetry and Fine Art*, 4th ed. (1907; rpt. New York: Dover, 1951), p. 119. Butcher is quoting from *Politics* 1337a1–3—"prosleipon . . . anapleroun," to fill up or supply what is lacking.

30. Peter Stallybrass, "Transvestism and the 'Body Beneath': Speculating on the Boy Actor," in *Erotic Politics: Desire on the Renaissance Stage*, ed. Susan Zimmerman (New York: Routledge, 1992), p. 77.

31. Kaja Silverman, *The Threshold of the Visible World* (New York: Routledge, 1996), pp. 129–30.

32. Jonathan Goldberg, *Writing Matter: From the Hands of the English Renaissance* (Stanford, Calif.: Stanford University Press, 1990), pp. 97–98. See more generally chaps. 2, 3.

33. For a critique of the concept of self-fashioning, see my review essay of H. Perry Chapman's *Rembrandt's Self-Portraits* in *Clio* 23 (1994): 285–94.

34. Without undertaking a genealogy of the term "virtual," which I first encountered in the Cassirerian work of Susanne Langer, I take this opportunity only to observe that the etymologically reinforced sense of the term that seems most relevant to its current usage in the phrase "virtual reality" is "almost [real]," "with the virtue and power of the real."

Heidegger's attempt to integrate and historicize the concept of representation in "The Age of the World Picture" has been critiqued by Jacques Derrida in "Sending: On Representation," trans. Peter Caws and Mary Ann Caws, *Social Research* 49 (1982): 294–326.

35. Galileo, "The Assayer," in *Discoveries and Opinions of Galileo*, trans. Stillman Drake (Garden City, N.Y.: Doubleday Anchor Books, 1957), pp. 276–77.

36. David C. Lindberg, *The Beginnings of Western Science: The European Scientific Tradition in Philosophical, Religious, and Institutional Context, 600 B.C. to A.D. 1450* (Chicago: University of Chicago Press, 1992), pp. 361–62.

37. Pliny, *Natural History* 35.61.

38. Cicero, *De Inventione* 2.1.1.

39. See below.

40. Claude Gandelman, *Reading Pictures, Viewing Texts* (Bloomington: Indiana University Press, 1991), pp. 131–40; Jonathan Sawday, "The Fate of Marsyas: Dissecting the Renaissance Body," in *Renaissance Bodies: The Human Figure in English Culture c.1540–1660*, ed. Lucy Gent and Nigel Llewellyn (London: Reaktion Books, 1990), pp. 111–35.

41. Sawday, "Fate of Marsyas," 116. See also Ruth Richardson, *Death, Dissection and the Destitute* (London: Routledge and Kegan Paul, 1987), p. 32.

42. On the fear and allegations of vivisection see the measured opinion of Katharine Park, "The Criminal and the Saintly Body: Autopsy and Dissection in Renaissance Italy," *Renaissance Quarterly* 47 (1994): 19–20.

43. The words are those of Edgar Wind, whom both authors cite: *Pagan Mysteries in the Renaissance* (New Haven, Conn.: Yale University Press, 1958), 143.

44. "Entra nel petto mio, e spira tue / sì come quando Marsia traesti / della vagina delle membre sue" (*Par.* 1.19–21).

45. Paul Barolsky, *Michelangelo's Nose: A Myth and Its Maker* (University Park: Pennsylvania State University Press, 1990), pp. 19–26. The quoted passage is from Michelangelo's now canonical statement of this pathos, the madrigal "Sì come per levar." See, for example, James Saslow, trans., *The Poetry of Michelangelo* (New Haven, Conn.: Yale University Press, 1991), p. 305.

46. Samuel Y. Edgerton, Jr., *Pictures and Punishment: Art and Criminal Prosecution During the Florentine Renaissance* (Ithaca, N.Y.: Cornell University Press, 1985), pp. 206–7, especially note 38.

47. Clamanti cutis est summos direpta per artus, / nec quicquam nisi vulnus erat; cruor undique manat, / detectique patent nervi, trepidaeque sine ulla / pelle micant venae; salientia viscera possis / . . . numerare. . . . (*Met.* 6.387–91, trans. Frank Justus Miller, 2 vols. (Cambridge, Mass.: Harvard University Press, 1944), 1: 315.

48. Jonathan Sawday, *The Body Emblazoned: Dissection and the Human Body in Renaissance Culture* (New York: Routledge, 1995), p. ix.

49. For a more detailed discussion, see my "Orpheus, Pan, and the Poetics of Misogyny: Spenser's Critique of Pastoral Love and Art," *English Literary History* 50 (1983): 27–34.

50. Michael Camille, *The Gothic Idol: Ideology and Image-Making in Medieval Art* (Cambridge: Cambridge University Press, 1989), p. 317.

51. Ibid., 337. See also Camille's epilogue, pp. 338–45.

52. Leon Battista Alberti, *On Painting*, trans. John R. Spencer, rev. ed. (New Haven, Conn.: Yale University Press, 1966), p. 70, slightly altered; Italian text from Luigi Mallè's edition of *Della Pittura* (Florence: Sansone, 1950), p. 85. Subsequent references to these texts will be cited as Spencer or Mallè, followed by the page number. On the structural correspondence in Alberti between verbal and visual composition, see Michael Baxandall, *Giotto and the Orators: Humanist Observers of Painting in Italy and the Discovery of Pictorial Composition, 1350–1450* (Oxford: Oxford University Press, 1971), 130–35.

53. Spencer 72. "Nascie della compositione della superficie quella gratia ne corpi quale dicono bellezza" (Mallè 87).

54. Spencer 75, substituting "modesty" for Spencer's "truth," since the original reads "verecundia," and the doublet "dignità et verecundia" (Mallè 92) seems to articulate a gender distinction.

55. Spencer 76–77. There is a touch of mischief in the last phrase: "servando la similitudine" (Mallè 93) refers to the likeness of the flaw as well as of the sitter, and thus glances at a potential conflict between the painter's and the sitter's representational preferences.

56. Graham Hammill, "Caravaggio's Sexual Aesthetic," unpublished manuscript, p. 12; Mark Jarzombek, *On Leon Baptista Alberti: His Literary and Aesthetic Theories* (Cambridge, Mass.: MIT Press, 1989), pp. 107–8. I am grateful to Professor Hammill for permission to quote from his stimulating essay.

57. In *Idea*, Panofsky oddly quotes this passage as "a sharp attack against those who believe that they can produce something beautiful without any study of nature," where "study" takes on euphemistic force to any reader who interprets the Zeuxis passage as a sharp attack on

nature: Erwin Panofsky, *Idea: A Concept in Art Theory*, trans. J. J. S. Peake (Columbia: University of South Carolina Press, 1968), pp. 57–58.

58. As instanced above, the Italian wording is more aggressive: artists "pillino dalla natura" (Mallè 89)—take. rob, pill, as from a victim on a battlefield, and bring the trophies back.

59. Caroline Walker Bynum, *Fragmentation and Redemption: Essays on Gender and the Human Body in Medieval Religion* (New York: Zone Books, 1992), pp. 267, 292, 284.

60. Emending Spencer's pleonastic "embracing with art of *what is presented on* the surface" (64, my italics) to conform with the Italian, "abbraciare con arte quella ivi superficie del fonte" (Mallè 78). There is a difference between embracing a particular image on the reflecting surface and embracing the reflecting surface itself, and as I note below, the latter alternative has more radical implications. Compare Cecil Grayson's version and translation of the Latin text: "Quid est enim aliud pingere quam arte superficiem illam fontis amplecti"; "What is painting but the act of embracing by means of art the surface of the pool?" (Leon Battista Alberti, On painting *and* On Sculpture: *The Latin Texts of* De Pictura *and* De Statua, ed. and trans. Cecil Grayson [London: Phaidon Press, 1972], pp. 62–63.

61. John D. Lyons, "Speaking in Pictures, Speaking of Pictures: Problems of Representation in the Seventeenth Century," in *Mimesis: From Mirror to Method, Augustine to Descartes*, ed. Lyons and Stephen G. Nichols (Hanover, N.H.: University Press of New England, 1982), p. 167.

62. Jarzombek, *On Leon Baptista Alberti*, p. 85.

63. Ibid., quoted from Cecil Grayson, *Leon Baptista Alberti: Opera Volgari* (Bari: Gius, Laterza, and Figli, 1966), 2: 131: "simulando diventerremo quali vorremo parere." My interpolation and addition are intended to inject into the quoted statement Jarzombek's general reading of the Albertian problematic.

64. Jarzombek, *On Leon Baptista Alberti*, p. 159.

65. François Roustang, "A Philosophy for Psychoanalysis?" trans. Terry Thomas, *Stanford Literature Review* 6 (1989): 175. I take it that this is intended to apply to subjects of any sex or gender.

66. This reading differs from that of Grayson, for whom "the implied sense" of Alberti's "imprecise" expression is "that painting is representing Nature faithfully through artistic means on a flat surface, just as Nature (Narcissus) is reflected truly in the flat mirror of the pool. In this sense the painter is, as it were, an imitator of reflections, and holds a mirror up to Nature" (On Painting *and* On Sculpture, p. 114).

67. Mikhail Bakhtin, *Rabelais and His World*, trans. Hélène Iswolsky (Cambridge, Mass.: MIT Press, 1968), pp. 29, 26, 317–22.

68. For some comments on Leonardo's attitude toward the body that could have been written about Alberti, see A. Richard Turner, *Inventing Leonardo* (Berkeley: University of California Press, 1992), pp. 192–94.

69. *The Notebooks of Leonardo da Vinci*, ed. Jean-Paul Richter, trans. R. C. Bell with E. J. Poynter, two vols. (1880; rpt. New York: Dover, 1970), entry no. 798. Subsequent references to this text will be cited as R followed by the entry number.

70. *Notebooks of Leonardo da Vinci*, 2:112.

71. R489, but from the more faithful translation published in Martin Kemp, ed., *Leonardo on Painting*, trans. Kemp and Margaret Walker (New Haven, Conn.: Yale University Press, 1989), 130.

72. Kemp, *Leonardo on Painting*, p. 121.

73. James Elkins, "Michelangelo and the Human Form: His Knowledge and Use of Anatomy," *Art History* 7 (1984): 176–86.

74. See the examples in *The Drawings of Leonardo da Vinci*, ed. A. E. Popham (New York: Reynal and Hitchcock, 1945), pp. 243–46.

75. And if it is Saint John, note that his famous world-class *dito indice* is aimed in a direction indicative not of crucifixion but of resurrection.

76. See, for example, R 1, 3, 9, 10, 11.

77. See my "Utopian Folly: Erasmus and More on the Perils of Misanthropy," *SW* 229–48; Descartes, *Discourse on Method*, part 5, second paragraph; Hobbes, *De Corpore* 7.1.

78. Louis Marin, *Utopics: Spatial Play*, trans. Robert A. Vollrath (Atlantic Highlands, N.J.: Humanities Press, 1984). See, for example, p. 53: "The whole is offered for inspection, without hidden surfaces or secrets. . . . Utopic description is, at bottom, nothing but the construction of the multiple figure destined to satisfy the desire to know . . . and the omnipresent gaze of the viewer contemplating Utopia's harmonious spaces is in fact the image, in the form of text, of a will to total knowledge."

79. Andreas Vesalius, *De humani corporis fabrica libri septem* (Basel, 1543), p. 266. Quoted by C. D. O'Malley, *Andreas Vesalius of Brussels, 1514–1564* (Berkeley: University of California Press, 1964), pp. 126–27.

80. Charles Singer, *A Short History of Anatomy and Physiology from the Greeks to Harvey* (New York: Dover, 1957), p. 116.

81. Andreas Vesalius, *De Humani Corporis Fabrica*, book 2, plate 24, in *The Illustrations from the Works of Andreas Vesalius of Brussels*, ed. and trans. J. B. deC. M. Saunders and Charles D. O'Malley (New York: Dover, 1950), p. 92.

82. J. R. Hale, in Hale, ed., *A Concise Encyclopaedia of the Italian Renaissance* (New York: Oxford University Press, 1981), p. 327.

83. Erwin Panofsky, *Renaissance and Renascences in Western Art* (1960; rpt. New York: Harper and Row, 1969), p. 31.

84. Patricia Rubin, *Giorgio Vasari: Art and History* (New Haven, Conn.: Yale University Press, 1995), 2.

85. Personal communication.

86. See, for example, the discussion in Bernard Schultz, *Art and Anatomy in Renaissance Italy* (Ann Arbor, Mich.: UMI Research Press, 1985), pp. 38–44.

87. See E. H. Gombrich, *New Light on Old Masters* (Chicago: University of Chicago Press, 1986), pp. 119, 124.

88. Rubin, *Giorgio Vasari*, 412.

89. *Le opere di Giorgio Vasari*, ed. Gaetano Milanesi (1878–85, rpt. Florence: Sansoni, 1906, 1981), 2: 105–6. Referred to as M in subsequent citations.

90. Loosely based on the 1912 translation by Gaston du C. de Vere reprinted in Everyman's Library: Giorgio Vasari, *Lives of the Painters, Sculptors and Architects*, intro. David Ekserdjian, 2 vols. (New York: Knopf, 1996), 1: 618. Cited as V in subsequent references. Though here and subsequently I have used the de Vere translation, I have not hesitated to alter it when, as in this passage, it seemed to me to miss the essential sense of the Italian. On the few occasions in which no translator is listed, the translation is mine.

91. "It is . . . in part the promise of a newly technically powerful homosociality that inspires the Renaissance's way of admiring its 'self' through communication with the beautiful

antique dead": Louise Fradenburg and Carla Freccero, introduction to *Premodern Sexualities*, ed. Fradenburg and Freccero (New York: Routledge, 1996), p. xx.

92. V 1.I.635–36, seriously altered. Other examples of the Art-as-Nature Trope: Leonardo gave his figures "motion and breath" (M 4.11); Raphael surpassed nature in his use of color (M 4.12); the hair Correggio painted looked like gold, more beautiful than real hair (M 4.12); Parmigianino painted figures in which one could see the pulses beat (M 4.12), and so did Leonardo (M 4.40) and Raphael (M 4.350); Raphael painted children that seemed to be of living flesh rather than worked up by colors and *disegno* (M 4.321), and the same is true of the figures in the Canigiani *Holy Family* (M 4.326); his portrait of Julius II was so lifelike that all who saw it trembled at the image as if it were the man himself (M 4.338).

93. From George Bull's Penguin translation: Giorgio Vasari, *The Lives of the Artists*, rev. ed. (Harmondsworth: Penguin, 1971), p. 132. The original: "Pinsi, e la mia pittura al ver fu pari; / L'atteggiai, l'avvivai, le diedi il moto, / Le diedi affetto. Insegni il Bonarroto / A tutti gli altri, e da me solo impari" (M 2.301).

94. Schultz, *Art and Anatomy*, p. 38.

95. According to Sidney, the poet differs from the astronomer, geometrician, physician, rhetorician, and historian in that "he nothing affirmes, and therefore never lyeth" (Sir Philip Sidney, "An Apology for Poetry," in *Elizabethan Critical Essays*, ed. G. Gregory Smith, 2 vols. [London: Oxford University Press, 1904], 1: 184. But as Margaret Ferguson wryly observes, in borrowing this defense of the poet from Plutarch Sidney adds bite to it: he "subverts Plutarch by suggesting that all kinds of discourse are as false as poetry and deceive, unlike poetry, precisely because they lead the reader to expect truth from them." Margaret W. Ferguson, *Trials of Desire: Renaissance Defenses of Poetry* (New Haven, Conn.: Yale University Press, 1983), p. 149.

96. Kenneth Clark, *The Nude: A Study in Ideal Form* (1956; rpt. Garden City, N.Y.: Doubleday Anchor, 1959), p. 23.

97. Margaret Miles, *Carnal Knowing: Female Nakedness and Religious Meaning in the Christian West* (1989; rpt. New York: Vintage Books, 1991), pp. 13–14.

98. Clark, *The Nude*, p. 26.

99. Miles, *Carnal Knowing*, p. 14.

100. Clark, *The Nude*, p. 439.

101. Ibid., pp. 23–24.

4. READING PAINTING

Holbein, Cromwell, Wyatt

CLARK HULSE

Reading Painting

The goal of this essay is to read a portrait. My subject—or rather my suspect—is Hans Holbein's *Sir Thomas Cromwell* (Figure 37), painted in 1532 or 1533 and now in the Frick Collection in New York City.

But what does it mean to "read" a portrait, or, for that matter, to read a painting of any kind? How might we unfold the phrase "reading painting" into the full analogy that it implies: *reading* is to *writing* as *viewing* is to *painting*?

In the long era of representational art, the making of a painting—whether a portrait, a historical painting, or a genre painting—can be understood as the construction of imitative bodies arranged in space, where both the bodies and the space are made of pigments and plaster, wood, or canvas. A painted second body is clearly a defective copy of its original, lacking animate speech and motion. Yet it is set before the eyes of its audience with an intent that it be recognized as superior: better-looking, no doubt, than its model, for all of its oily or wooden qualities, repairing the blemishes and ravages of the living person. Hence, in the terms introduced by Harry Berger in the preceding essay, a portrait is both aesthetic and prosthetic. It is a substitute body that aspires toward perfection in two contradictory ways: first, in its lifelike resemblance to the person whom it depicts, and second, in the ways it supplements that person through its tendency toward an ideal image of the face and body.

Portraiture thus involves intertwined processes of creation and recognition—call them painting and reading—which may be linked to the other processes of mirroring, mapping, and anatomizing outlined by Mullaney, Traub, and Berger. Each may be considered a technology, in the sense in which Raymond Williams used the word (and the sense adopted by Berger) as "a system of . . . means and methods."[1] But in this series of premechanical visual technologies, one term seems anomalous, like a breed of dog in a list of felines: "reading" seems categorically different from, say, mapping. Reading is surely a technology, a system of means and methods, but in what sense can it be made, like the others, a specifically *visual* technology? When we recognize the subject of a painting, refer it to a thing or things in the world, pursue a narrative within it, recognize the delineation of an ideal, construe a moral statement, or otherwise interpret it, are we engaging in a visual interpretation that unwinds from the visual nature of the object, or, as the word "reading" suggests, invoking a verbal technology that operates in some parasitic relation to the artifact which is its host?

In *Past Looking*, Michael Ann Holly argues that the rhetoric of a painting "very largely engenders the rhetorical strategies of its subsequent interpreters."[2] The historicity of the work is projective, establishing interpretable patterns that can be caught up into meaning, just as the modern work of interpretation is historically retrospective, invoking the materiality of an artifact from the past through its readings. In the case of medieval and early modern artifacts, the historically apposite interpretive systems for images are largely verbal. From the subjugation of image to divine word in church decoration to the construction of humanistic allegorical systems among

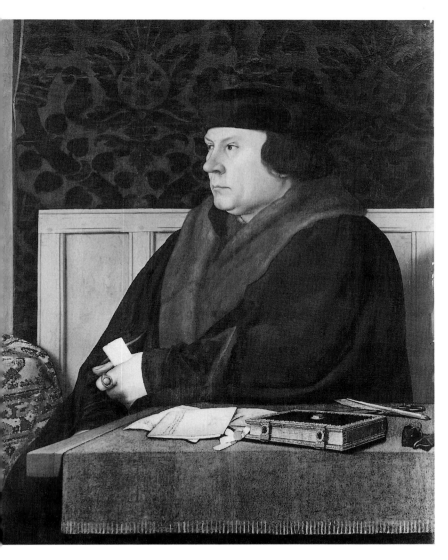

37. Hans Holbein the Younger. *Sir Thomas Cromwell*. 1532–33. Oil on oak panel. Copyright The Frick Collection, New York.

the Florentine Neoplatonists to the emblematics of the sixteenth and seventeenth centuries, images are construed through, and as, linguistic systems. Alberti invented modern pictorial composition through its analogy to Ciceronian sentence structure, assembling its limbs into a coherent body of significance.[3] Following out Harry Berger's logic in the preceding essay, we may see the early modern technology of visual "reading" as itself a prosthetic action, repairing the deficiency of the merely visual by adding that immaterial verbal essence called meaning that has been demanded but left incomplete through the compositional history of the artifact.

Hence Holly's argument provides a way to break down the dichotomy we initially faced, between appropriately visual and parasitically verbal interpretations, precisely to the extent that verbal interpretation—reading—is already embedded historically within the matrix of the visual work at the time of its production. But adopting a premodern system of reading, on the basis of its historical specificity to the premodern visual artifact, addresses only one side of Holly's prescription for historical adequation. While such readings are historically licensed, to the extent that they are consciously available to a premodern viewer, they are also historically limited in two ways. First, they internalize the censorship or constraints upon meaning that operate on the same premodern viewer, all the ways that potential meanings are ruled out as inappropriate, subversive, lewd, insulting, outlandish, punishable, or simply unfundable. Second, neither the original system of restraint nor the original system of meaning is necessarily binding upon later readers operating within different social systems. Indeed, any modern reading that wishes to interpret the artifact as a representation of its historically distant culture will inevitably do so by making visible both systems, those that license meaning and those that constrain it. Or, in visual terms, every technology for making some things visible is equally a technology for making other things invisible or opaque, and "reading" must attend to both.

Meyer Schapiro has pursued such doubled readings of images in his examination of how script itself is represented in painting. He finds in medieval art a set of characteristics by which "language determines some pictorial features; painting, then, is like language in its sequential narrative order, its literalness, and its submission to symbolism."[4] The historical technology leads to the general question of "whether the requirement of a strictly unified, homogeneous visual language is inherent or necessary in art" (p. 187). Is there, in effect, a "semiotics of visual language"? The answer that Schapiro finds in his images of writing is equivocal: the visualization of writing alternately obscures the text and makes it legible, or offers it to the view only of a reader inside the painting. Similarly, in *To Destroy Painting*, Louis Marin teases out the linguistic structures of Poussin's *Arcadian Shepherds* in the Louvre, based on Poussin's own assertion that "just as the twenty-four letters of the alphabet are used to form our words and to express our thoughts, so the forms of the human body are used to express the various passions of the soul and to make visible what is in the mind."[5]

In each case, semiotic analysis cannot produce a machine of meaning adequate to the subtle and powerful acts of viewing performed by a Schapiro or a Marin: it produces instead a set of visual conditions, such as spatial arrangement, the postures of bodies, and the display of texts, upon which interpretation then acts.

It appears, then, that the specifically visual dimension to "reading" involves more than a "visual semiotics," in that it continually invites resistances to the verbal, either as content (words represented within painting) or as form (bodies and spatial arrangements construed as words and sentences). This must not be understood as the denial of the possibility of reading; on the contrary, it is an extension both of the project of reading and of its itinerary. We may imagine that reading a portrait proceeds toward the making of verbal meaning but does not stop there. It proceeds from significance to the aesthetic, from the aesthetic to the prosthetic, that is, from the body to its significance, from the significance to the recognition that when meaning is joined to the body it becomes more beautiful; then to the scorn for the unperfected body which needed such verbal additions; and then to the realization that the verbal addition of meaning is itself "merely" a technology, which leads at last to a revulsion against reading, a return to the body. The technology of reading may begin in the semiotic impulse, but it ends in a reversal of semiotics; its movement is cyclical, from the body as word to the word as body.

Reading Portraits

To return to the body at hand: Holbein's portrait of Thomas Cromwell, who became earl of Essex and chancellor of the Exchequer before dying on the scaffold. This particular painting is, I must say from the outset, an inauspicious choice for reading. First of all, as a portrait it is tied to a specific, factual, and determinate referent, born 1485, died 1540. As in the case of a proper noun, the factuality of the referent can be seen as a weight or drag on the metaphoricity of the painting, reducing or eliminating the play of invention, fictionality, or indeterminacy whose disclosure has been the ultimate goal of reading, in the advanced literary sense of that word, for most of the past century. Even if I were to promise that my reading would disclose interesting things about patronage, power, ideology, and the constitution of the self in the early sixteenth century (and I will indeed try to disclose those things), the portrait is still tied to a realm of the "real," of the "out there" and beyond itself, however cleverly I might reinscribe those externalities within the structure of the painting or argue for the outside being the inside or for the essentially constructed nature of the "real."

Furthermore, this particular portrait has a certain minimalist air about it that might be said to form a resistance reading: the figure is not quite in profile nor quite in the more familiar three-quarter view. It is a peculiarly low-information format, hiding

most of the right side, especially the right eye. He is somewhere in an interior and seems to be looking out a window whose frame is just visible at the left edge, but why or what he looks at is not clear. His left hand clutches some paper, but otherwise he does nothing definable. There is little here on the basis of which to construct a narrative or an allegory, little here beyond the words written in the form of a salutation on the top sheet of paper on the table: "To our trusty and right well biloved Counsaillor Thomas Cromwell, Maister of o[u]r Jewell House."

The minimalist qualities of Holbein's *Cromwell* stand in contrast to another painting, Rembrandt's famous *Aristotle Contemplating the Bust of Homer* (Figure 38), for which I do not propose to offer a reading, although it might seem a more auspicious candidate. This is in some sense also a portrait, albeit a fictional one. The bust on the left is Homer, though no one claims that Rembrandt, or Aristotle for that matter, knew what Homer looked like, but the bust seems to show a blind and antique person, and so can stand for Homer. The figure on the right, who might similarly be read as a figure or metaphor for Aristotle, is recognizable as a model that Rembrandt used elsewhere, but his biological identity here is subjugated to the fiction of the portrayal, making him Aristotle-enough for us. In the words of Richard Brilliant, "freed from any dependency on an original subject, the artist has created an imaginary Aristotle, or what passes for Aristotle, looking at a bust of Homer, derived from a Hellenistic portrait type of Homer, and thinking about him."[6]

Ironically, this identification of the figures and of the relationship between them has not always been apparent. Guercino, for instance, looking at a drawing showing the two figures together and the touch of the fingers to the head, saw a physiognomist reading character in the bumps of the skull.[7] Guercino is wrong, overruled by early documentation, but his error points to the unanchored identity of the figures, an unanchoring that constitutes an independence from an absolute "out there" that rules true portraits, and constitutes in its place a dependence upon the interpretive conventions of a community of readers. And Guercino can be said to be quite right in his reading of the ethos of the painting, as Svetlana Alpers has demonstrated in a powerful reading of her own in her book *Rembrandt's Enterprise*.[8] That gaze and touch are the means by which the philosopher indeed reads character, gaining access to knowledge about Homer. The gaze and touch are, she argues, essentially parallel routes to knowledge, as is demonstrated by Descartes's theory of vision acting as a kind of sight-stick by which we touch an object. The hand of Aristotle is an implement not just of sense but of reason; indeed, it is the most specifically human instrument of reason. The painting, a creation of the hand and the eye, seeks access to an understanding of character and of the world through vision and touch, through the painter's gaze upon the world and the touch of the brush on the canvas. "Aristotle," then, is a stand-in for Rembrandt himself, and the painting as a whole is an allegory of painting, or more specifically of Rembrandt's painting, and the famous rough tex-

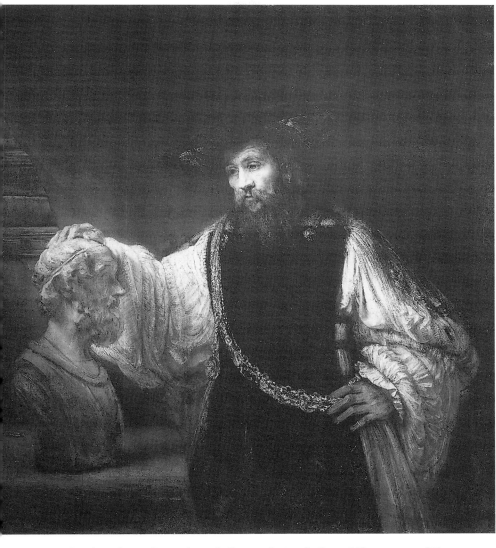

38. Rembrandt van Rijn. *Aristotle Contemplating the Bust of Homer*. 1653. Oil on canvas. Metropolitan Museum of Art, New York. (Purchase, special contributions and funds given or bequeathed by friends of the Museum, 1961.)

ture of the painting is the process by which Rembrandt makes that allegory especially visible by making the paint itself visible, by stressing, in effect, that the thing-in-the-world, the essential being-out-there that anchors the meaning of this painting and drives the reading of it is the nature of painting itself in its doubly material and referential nature.

Alpers's reading of Rembrandt painting Aristotle reading Homer adds impor-

tant dimensions to our understanding of what is implied in the enterprise of "reading" a painting. If paint is assumed to be, in some way or other, semiotic as words are semiotic, then they are alike the seeds of meaning. Reading painting is then, to use a phrase made current by Donald Preziosi and others, making the visible legible.[9] This assertion of legibility requires an initial denial of the material nature of the medium, followed by the affirmation of meanings within an interpretive situation—thus the figures on the canvas are Homer and Aristotle, or a physiognomist, or whatever. The resulting system of legibility is then reimposed upon the world "out there," so that the legibility of the artwork absorbs its referent and its material, permitting the internal play of the visual signifier to be thematized and projected onto that world as the constructing or deciphering of its nature or its ideology. This process of making the visible legible is quite fully represented in Alpers's reading of the painting as an allegory of painting. This is especially so when that reading neatly recapitulates the repressed initial term, the material medium of paint, restoring it at a sublime level, so that the action of touching by Aristotle/Rembrandt turns or closes the artifact in upon itself, allowing it to make statements about the world without returning to it.

It is time, however, to observe that this particular exploration of "reading painting" has continually invoked an extra term, that of "touching," to mark its boundary points of initiation and closure. The touch is the direct encounter with the "out there," the "real," in whatever bracketed sense one prefers to understand those terms. But it will be quickly apparent that touching is a dangerous element in painting or in reading, and that the touch may as likely be disruptive as it is affirming. As such, the touch of the "real" is both the initiatory moment of artistic creation and, I would say, the moment of the hand upon our shoulder which starts us out of our absorption in dream or artwork, the moment when the reader or viewer believes again that the real is *still* out there, still excluded from the writing and the reading, still illegible or invisible to sight.

It has been remarked that the real is that to which we always return, that which is always there when we open our eyes. In writing and painting what is always there, what the artist always returns to for confirmation, is the graphic touch, the hand holding the brush or the pen as it approaches the writing/drawing surface. And so the touch has a double nature, just as the real has the double nature of actuality or delusion. Touch in painting may be the swirling, orbicular motions of the brush in the hand that are the mark of the master as the hand reaches through the density of the medium to grasp the object and to bring the object to view. This touch has the certainty of grasp, contact, legibility. Or the touch may go on swirling, locked in the medium and in the organics and mechanics of the hand, creating a ghostly snare for the eye that makes visible only its refusal to reveal the actual. Likewise verbal metaphor, if it does not reach across to the real, recoils in self-touching, automatic, obsessive, always doubling and redoubling by a logic of its own. Hence our fundamental

enterprise of visual reading—the making of the visible legible—once again confronts its opposite, the rendering of invisibility and illegibility, and, especially, those places where the legible and illegible, visible and invisible, touch.

Indeed, one may already discern two different forms of touching in Rembrandt's painting, the touch of Aristotle's right hand on the bust (Figure 39), and that of his left hand on his own hip (Figure 40), the fingers twined among the rings of the golden chain. The left hand makes visible the knowledge of the body to itself, the closed loop of subjective self-identity as one simultaneously feels oneself touching and feels oneself being touched, and feels the two selves as one without thinking about it.[10] There is certainty at the cost of solipsism. The right hand on the head, by contrast, is less certain but more venturesome. It may not be the touch of mastery and knowledge that Alpers proposes but instead, or also, its opposite, the touch of exploration, the encounter with the other. For it is a touch between the seer and the blind, the living and the dead.

Homer, even more than Plato, is the philosophic teacher whom Aristotle supplants. Like Aristotle, his philosophy is a knowledge of the world gained through reason and touch, but there the similarity ends. If, to Rembrandt's Aristotle, the hand touching is an organ of reason and an extension of sight, to blind Homer it is the instrument that substitutes for sight in his knowledge of the physical world. Homer's touch is radically unlike Aristotle's, and Aristotle, confronting that blind touch, may seek to incorporate it only at some peril or may see it as beyond his reach. Homer is in this sense a spectral, atavistic figure of the unconscious to Aristotle's particular and empirical form of consciousness. Are we so sure that his hand will continue to rest there, to gain, as Guercino proposes, a knowledge of what is inside that blank, illegible head? Or will it draw back in failure?

Reading, then, might be described as the grasping of metaphor if we understand "metaphor" in its root sense of "carrying over" between here and there, this and that, the thing and the not-thing. This distantiation "within" the structure of metaphor, this difference of itself from itself, may ordinarily be understood as the condition of metaphor's legibility, justifying in particular those deconstructive modes of reading that focus primarily upon that internal distantiation and infolding. But more dangerous than such readings is a reading that registers the touch of the real, whose sharp pressure marks or scars the reading. The mark of the touch is, in the text or painting, the most intense mark of pleasure or, more likely, of pain.

Reading Cromwell, Reading Wyatt

So I turn again to Holbein's painting of Thomas Cromwell precisely because those things that seemed to impoverish it and make reading difficult—its realism and its

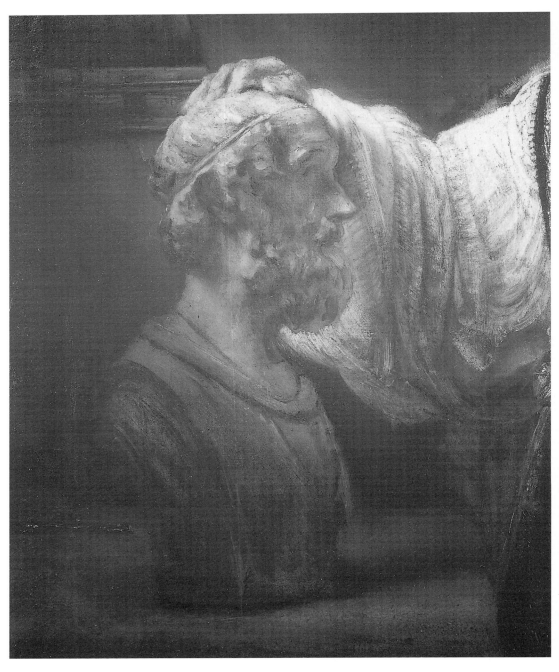

39. Rembrandt van Rijn. *Aristotle Contemplating the Bust of Homer* (detail). 1653. Oil on canvas. Metropolitan Museum of Art, New York.

40. Rembrandt van Rijn. *Aristotle Contemplating the Bust of Homer* (detail). 1653. Oil on canvas. Metropolitan Museum of Art, New York.

minimalism—can be precisely what point us toward a reading. Whereas Rembrandt's picture celebrates painting and viewing, which, like reading and writing, can provide an illusion or fiction that masters the so-called reality outside the studio, Holbein's portrait seems mastered by its subject. The narrowed, beady eyes, the averted face, the grasping action of the hand around the piece of paper suggest at the outset that our reading of this painting is subjugated by the being to whom the painting refers, and this person may be named and identified but remains untouched or unmodified by the act of naming.

The constructing and construing of the painting's metaphor must therefore begin with a certain delicacy and deference. If, as Aristotle claims, a metaphor is a noun standing for another noun,[11] and if nouns are the names of things, then this painting is a visual noun, a metaphor standing for Thomas Cromwell. It is no revelation

41. Hans Holbein the Younger. *Sir Thomas Cromwell* (detail). 1532–33. Oil on oak panel. The
Frick Collection, New York.

to suggest that Renaissance people were obsessed with the metaphors of self, with
the objects, whether verbal or material, that stood for people, collectively and indi-
vidually. Perhaps this obsession accounts for a curious doubling and redoubling of the
metaphor, in which Holbein twice paints words on the painting, words that name or
stand in for what the painting stands for.

First, on the table in front of Cromwell is the letter I have already mentioned,
on the outside of which is written, "To our trusty and right well biloved Counsaillor
Thomas Cromwell, Maister of o[u]r Jewell House" (Figure 41). This pinpoints the
date of the portrait between April 12, 1532, when Cromwell was appointed master of
the Jewel House, and April 12, 1533, when he was elevated to the chancellorship of the
exchequer.

More important, the address on the letter transforms the portrait into a form of
address, or rather the whole portrait becomes the letter addressed to its audience to
read. Holbein was paid by Cromwell, perhaps to make a portrait, or perhaps a pattern
drawing from which this and other portraits could be produced. This particular por-
trait almost certainly belonged to Sir Thomas Pope,[12] a political ally of Cromwell's,
who either would have commissioned it from Holbein or would have received it as
a present from Cromwell himself. Hence the painting is a statement, spoken in the
voices of Pope and Holbein, declaring their dependence on Cromwell. It is likewise
spoken in the voice of Cromwell, declaring to his associates, clients, and rivals his spe-
cial favor with the king and—since the letter is carefully folded with its contents con-
cealed from us—intimating his craft and discretion in the king's affairs. And finally it

42. Hans Holbein the Younger. *Sir Thomas Cromwell* (detail). 1532–33. Oil on oak panel. The Frick Collection, New York.

presumes to speak for the king himself, who openly proclaims the trust and love that give title and identity to Cromwell.

Paul Ricoeur observes that all discourse, including the discourse of metaphor, "occurs as an event, but is to be understood as meaning."[13] I would contend first of all that this process of meaning is visible in Holbein's portrait of Cromwell. The substitution of oak and oil for a particular person unveils a complex set of political and social relationships. But we may instantly extend and reverse Ricoeur's formula and say that metaphor occurs as a meaning and is understood as an event. For the portrait itself, composed of a represented person and represented writing, is a set of meanings which becomes an utterance, and the very fact of that utterance in all its phases—in the commissioning of it, the execution, the presentation, the display, the viewing of the portrait—conjures those political and social relationships into being. If the portrait depicts Cromwell as a man in a certain position, it is itself one of the ways he acquires and maintains that position. The portrait does not simply reflect or make visible a historical occasion external to itself. By instantly insisting upon its own legibility, it brings that reality into being. Yet by the same act it becomes autogenetic, giving life to its own metaphor.

But a further aspect of the metaphoric process of the painting is legible in a second inscription that marks the portrait of Cromwell. On the blue-green damask background above the sitter was a scroll that, like the letter, named Cromwell and describes his situation. It was in Latin, and can be roughly translated as: "Good and prudent minister both to Christ and to his king; seldom is born a man who, in his heart, in his face, or in [the deeds of] his hand, is so loyal and resolute in friendship; seldom is born a man of eminence more faithful to his country, or more loving of piety."[14]

On the background of the painting as it hangs today in the Frick, however, no such inscription is visible or legible. If we look at a detail of this area (Figure 42) we

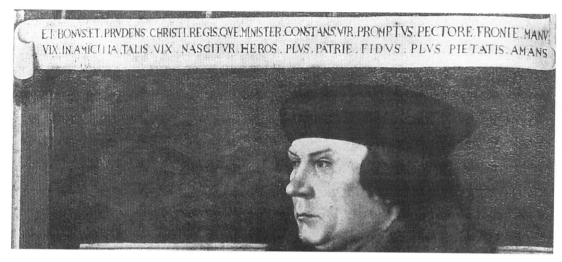

ET BONVS ET PRVDENS CHRISTI REGIS QVE MINISTER CONSTANS VIR PROMPTVS PECTORE FRONTE MANV
VIX IN AMICITIA TALIS VIX NASCITVR HEROS PLVS PATRIE FIDVS PLVS PIETATIS AMANS

43. Hans Holbein the Younger. *Sir Thomas Cromwell* (detail before cleaning). 1532–33. Oil on oak panel. The Frick Collection, New York.

see that indeed the wall behind Cromwell is finely figured but devoid of writing. One might imagine a reading of those arabesques, revealing them as a secret code legible only to the initiated. Indeed, Roy Strong has noticed that the pattern directly over Cromwell's head takes on the shape of a crown, as if Holbein were covertly commenting on his client's overweening ambition. I am uncertain about this reading, not because the crown shape isn't there—it visibly is—but because the intention attributed to Holbein would require that he see it and Cromwell not, or that Cromwell see it somehow as a sign of his dedication to the crown. One or the other of these acts of interpretation would require an absorptive, inward-turning spiral of reading that can be shaken out of its trance only by the touch of the real.

For the inscription is simply gone. It can be made visible now only in photographs (Figure 43) taken shortly before the inscription was removed by a restorer when the painting went on the art market in 1915. He was concerned with modern aesthetic values, which were preoccupied with notions of originality and were upset about people scribbling on painted surfaces.

My point right now is not to say that the conservator was wrong, but that his action marked a change in the statement of the painting, in its meaning and its metaphoric nature. If the inscription is original, then it proclaims once again that Holbein and Pope are clients of Cromwell and perhaps are bound by genuine friendship and admiration as well as self-interest. If it is added after Cromwell's death, then it is an astonishing denunciation of the injustice of his death, especially astonishing given the dangers in an absolutist state of being a true friend to any man judged to be a false traitor. The subsequent erasure of the inscription marks the final turning of the painting

from political and emotional values to aesthetic values. The erasure marks the interstice between collecting as a part of clientage and family lineage and collecting as modern accumulation from a ruptured past. In the process, the sitter for the portrait becomes less important than the body of wood and oil that makes it, and the eulogy of the king's minister is erased because it has become far less important than the name "Holbein," which is inscribed discreetly on a plaque affixed to the frame. The painting now appears to us as an address from the restorer, in the voices of the artist, the dealer, and the collector, declaring the genius of Holbein, the acumen of Sir Hugh Lane, and the taste and munificence of Henry Clay Frick.

This bit of confusion over the inscription leads to a further problem. The painted body and the painted words are locked together in a circuit of mutual definition, each standing for the other, together standing for a name, the originary noun "Cromwell," and all standing for the living person. But when the externally "real" from which the painting claims to originate is altered—when the person dies, and in this case dies violently—does the metaphor die as well? In the case of the painted body in the Frick Cromwell, the answer is no. There is no question that this represents Thomas Cromwell, and most people feel, with no corroborating evidence, that the portrait is lifelike. The second metaphor, inscribed on the letter, is meant as a kind of explication of the painted metaphor, describing a set of political relationships that have disappeared, leaving the inscription as an empty husk no longer adequate to the painted body, and used now only as a means for dating the panel and placing it in Holbein's *oeuvre*. It is a coin that has passed from the hands of the politicians to the pockets of the art historians. The third metaphor, the words that appear and disappear again on the back wall, is a redundancy that can neither obscure nor further reveal the identity of Cromwell beyond what the king has done on the folded letter. But it speaks of an occasion in which someone other than the king—whether Holbein or someone else, the patron, the customer, the consumer—names Cromwell, speaks aloud and in public the syllables of praise, conjures the presence and mourns the loss of the patron, protector, and friend. When the shock of death and the moment of defiance are past, when Cromwell can no longer protect himself, much less a client, the obsession to speak his name at all, especially aloud and in public, miraculously vanishes. The portrait is removed and put away quietly in the back room, just in case, after a few years, Cromwell is rehabilitated, or until its aesthetic value comes to outweigh its political danger. The touch of the painter's hand in making the inscription and of the conservator's in removing it are those points of the origin and death of the metaphor, the points of pain and scarring that a reading must recognize.

If these points of touching are visible or legible, in their invisible or illegible way, in the inscriptions on the painting, we might equally look for them in an event and a poem closely connected to the painting and closely connected to a person who is perhaps more familiar to modern audiences than Cromwell, the courtier and poet Sir

Thomas Wyatt. The early accounts agree that Cromwell himself conjured Wyatt when he stood on the scaffold on July 28, 1540, and called out, "Farewell Wyat," and "gentell Wiat praye for me." [15]

It is clear that the brusk and outspoken Wyatt was, like Sir Thomas Pope, a friend and political dependent of the wily Cromwell. But is it possible that the astute Cromwell would remind Wyatt of that association at such a perilous moment? Is it possible that Cromwell—who dissolved the English monasteries, pensioned off the monks and nuns, forbade English men and women to pray monthly for their dead, and, through his peculiar mixture of Lutheran conviction and bureaucratic efficiency, hounded the ideas of purgatory and saintly intercession from the English consciousness—is it possible that this man, even in the depths of extreme despair, cried out, "Pray for me, Master Wyatt"? And is it possible that Wyatt, who acknowledged himself to be inclined to Lutheranism, did so?

Since one account of the words comes from the draft of a government broadside defending the execution,[16] it might seem to be simply a cruel joke of Cromwell's enemies to put these words in the mouth of a man who became vicar-general of the Church in order to purge and dismember it. The words, then, would not come from him, but would be aimed at him. They would be not a prayer but a condemnation, damning him to the hell to which he has consigned others by forbidding for them the prayers that he begs for himself.

But the words appear in a second source, the commonplace book of Richard Cox, chaplain to the king, a Lutheran, an ally of Cromwell, and later a Marian exile.[17] There is not likely to be any mockery here, but rather an injunction to Wyatt, and indeed to Cox, to pray not to any saint or icon but to Christ himself. And they are an injunction not to turn away too quickly from their tainted comrade, not to scurry for cover with too unseemly a haste, or deny him at the crowing of the cock. The words then are metaphoric, meaning instead to remember Cromwell, to remember that he was a friend and benefactor in his time of prosperity, and should not be deserted in his time of distress. Like the anonymous hand who painted the words in the now-erased inscription at the top of the Holbein portrait, they utter his name at the time of his death. And so, metaphorically, they pray for themselves, pray that they may act honorably in the face of the death that comes to others, and pray to avert that death from themselves.

If Cromwell actually did say the words, his own meaning may have been close to Richard Cox's meaning. When he asks Wyatt to pray for him, he is asking Wyatt to remember him to Christ, asking Christ to remember him, asking, in effect, for Christ's dead body in place of his own, asking for a sacramental, not a metaphoric, substitution of life for death and death for life. As vicar-general, Cromwell negotiated the narrow path that Luther traced between the Roman Church's insistence on the real—and hence nonmetaphoric—presence of the body of Christ in the Eucharist, and the

Zwinglian insistence on a purely metaphoric understanding of it as a meal of communion and commemoration, a collective spiritual remembering of Christ's incarnation. As he spoke to Wyatt, Cromwell stood at a precipice, not only in his own life, but also in the sacramental power of metaphor in his culture. Which substitution of words and objects would genuinely lead to the resurrection of the souls and bodies of the faithful, including the dismembered body of Cromwell?

Did Wyatt pray for Cromwell? Did he in a commemorative sense remember, or in a sacramental sense re-member him? The question, as an issue of fact, is unanswerable. It is possible that Wyatt wept openly at Cromwell's plea. The accounts differ over the point, however, so it is apparent that either someone embellished the facts here or that someone else tried to suppress them. Indeed, a Spanish chronicle records both actions of embellishment and suppression, saying that the witnesses "marvelled to see how deeply Master Wyatt was moved. And as Cromwell was a very wise man, he reflected on it, and said out loud, 'Oh, Wyatt, do not weep; for if I were no more guilty than you were when you were arrested, I should not have come to this!' All the gentlemen loved Wyatt well, so they dissembled; otherwise he might have been arrested to find out if he knew of any treason that Cromwell had plotted." [18] Wyatt's tears appear and disappear in response to the same forces that ruled over Holbein's inscription. They flow as a sign of an emotional state and a political allegiance, and they are dried by the specter of death, transformed into signs of discretion and compassion, and of higher allegiances to royal power and to self-interest.

Did Wyatt pray for Cromwell? Did he in a commemorative sense remember, or in a sacramental sense re-member him? If he did, then a single poem stands as the visible evidence. The poem goes like this:

The pillar perished is whereto I leant,
The strongest stay of mine unquiet mind;
The like of it no man again can find—
From east to west still seeking though he went—
To mine unhap, for hap away hath rent
Of all my joy the very bark and rind,
And I, alas, by chance am thus assigned
Daily to mourn till death do it relent.
But since that thus it is by destiny,
What can I more but have a woeful heart,
My pen in plaint, my voice in woeful cry,
My mind in woe, my body full of smart,
And I myself myself always to hate
Till dreadful death do cease my doleful state? [19]

The case that the poem refers to Cromwell's execution is venerable but in the usual way perfectly circular. If we assume that that is what it means, then the poem makes sense. If we don't, it doesn't. The crucial phrase is "pillar," which must be taken as a metaphor unless we assume that the poem is about the stresses of home repair. No, for any number of reasons we assume that "pillar" is indeed a metaphor and we try to reach through the matter of the poem to touch its referent, the broken body of Thomas Cromwell.

When we dig under the crust of the poem, though, what we find is not the body of the dead minister of state but that of a dead poet, Francesco Petrarca. Wyatt's first lines are a conflation of the openings of two different Petrarchan sonnets:

Rotta è l'alta colonna, e 'l verde lauro,
Che facean ombra al mio stanco pensero;

(Broken the column and the green bay tree
That lent a shade to my exhausted thought)

Gloriosa Columna, in cui s'appoggia
Nostra speranza e 'l gran nome latino,

(O glorious column against which does lean
Our highest hope and the great Latin name . . .)[20]

In both sonnets, Petrarch's "columna" or "colonna" is his patron, Cardinal Giovanni Colonna. The name is just barely a metaphor; it is almost a pun, playing on two different meanings of the same sound. Only a kind of infection from the surrounding words gives the pun the power of a metaphor, making the column appear as a visual object behind which Colonna flits like a ghost.

What is the point of this chain of substitutions, in which a pillar stands for Cromwell, a column for Colonna, a pillar for a column—or rather not stands for, but stands in for momentarily, only to break, crumble, and perish? Surely this is not a very efficient way of talking about Cromwell, nor, as Harold Mason observes, is it a very good job if the purpose is to translate Petrarch. Mason offers the explanation that well-trained students of Renaissance literature habitually used to offer, supposing that "under the stress of the sorrow he felt, Wyatt . . . looked into his Petrarch to find an analogy to his own position, and chose the sonnet in which Petrarch was lamenting the death of his protector and friend."[21] This is no doubt true, as far as it goes, but the theory of creative imitation is too relentlessly affirmative. Here imitation is not just a way to find words, it is also a way of avoiding them, a way of shunting our at-

tention and Wyatt's own from Cromwell off to Colonna and Petrarch, from political and emotional immediacy to poetry. Wyatt has not praised Cromwell, he has buried him and placed the body on the soft bed of Petrarchan sentimentality.

As the pillar perishes, as the stay against disquiet is removed, the mind slides away from death into repetitive, obsessive actions. The poem enacts the very betrayal that its writing was supposed to prevent, the betrayal of the unfortunate by the fortunate. Wyatt spoke of this betrayal in another poem, also usually dated (and by the same logic) to 1540–41:

> Lucks, my fair falcon, and your fellows all,
> How well pleasant it were your liberty!
> Ye not forsake me that fair might ye befall,
> But they that sometime liked my company
> Like lice away from dead bodies they crawl:
> Lo what a proof in light adversity!
> But ye, my birds, I swear by all your bells
> Ye be my friends, and so be but few else.[22]

"Lucks" in a sense inverts the action of "The pillar perished": there Wyatt is the betrayer, here he is betrayed. But the metaphoric action of the two poems is strangely identical. Confronted with the dead body, Wyatt oddly cannot bear to touch or even to name it, either as Cromwell or as himself. His words turn into lice and crawl away, until his mind can return to its obsessive theme, which is itself a self that he cannot imagine having within itself a center or stable prop. The action of recoiling from the dead body, like the action of recoiling from the self, produces loathing and disgust— disgust at others, loathing for himself. And so "The pillar perished" ends at a point that is suggested neither by its occasion nor by its poetic model; it ends in a neurotic and obsessive action of self-loathing that can only be terminated by the very thing that is the unnameable object of its loathing, the body in death:

> My mind in woe, my body full of smart,
> And I myself myself always to hate
> Till dreadful death do ease my doleful state.

The concluding line of the poem as I have just cited it is, however, slightly at variance with the line as I cited it earlier. As with Cromwell's inscription, we find ourselves reading something invisible. For the word "cease" which appeared in the version cited earlier, and which appears in all modern editions, is in fact a modern editorial conjecture. The best early manuscript authority for the poem, the Arundel-Harington

manuscript, dating from the mid-1550s, gives "cause," while the first printed edition, Richard Tottel's Miscellany of 1554, gives "ease":

$$
\text{Till dreadful death do}
\left\{
\begin{array}{l}
\text{ease} \\
\text{cease} \\
\text{cause}
\end{array}
\right\}
\text{my doleful state.}
\left\{
\begin{array}{l}
\text{Tottel} \\
\text{modern} \\
\text{Arundel-Harington}
\end{array}
\right.
$$

Tottel's reading at first sight seems right, but modern editors are suspicious of Tottel. After all, he gives the poem the title of "The louer lamentes the death of his loue." In a certain sense of the word "love" the title describes the Cromwell situation, but it is obviously misleading, or rather acts like a good diversion to lead us off the scent, down the Petrarchan trail toward poeticality, and toward another death, the death of Petrarch's beloved, Laura. That is the way indeed toward ease, toward sweet forgetfulness. If we look to the Arundel-Harington manuscript for What Wyatt Really Meant, we find death *causes* his doleful state. But that seems too much what he meant, too uncomfortably direct. It is the repressed ceaselessly returning, for death is here both cause and ease. Better to put it aside again, and settle on "cease." It is a fine conjecture, since it makes perfect sense and could be misread in a copytext in two different ways. And precisely what it does is to cause the anxiety of the poem—both the textual and the emotional anxiety—to cease.

The textual crux is a metaphor for what Wyatt must and cannot bury in the poem. Like the inscription that appears and disappears in the background of Holbein's portrait of Cromwell, it is a metaphor whose value is neither caused nor fixed once and for all by poet, political occasion, or poetic model—or needless to say, by a modern editor or reader. The text is, like the face, a surface on which meanings are written, through which words pass, across which emotions flicker. Words, emotions, meanings come and go, and the mind may try to forget them. But the face can never fully forget what has touched it, can never fully disavow what has passed, for each felt word leaves its line or furrow.

In deference to Wyatt, I will call them scars. In a poem addressed to Sir Francis Bryan the following year, when Wyatt himself was in the Tower on charges arising from Cromwell's fall, he wrote:

> Sure I am, Brian, this wound shall heal again
> But yet, alas, the scar shall still remain.[23]

And again in the speech he prepared for his trial, he uses the same figure: "These men thynkethe yt inoughe to accuse and as all these sclaunderers vse for a generall rule—whome thou lovest not, accuse. For tho he hele the wounde yet the scharre shall remayne."[24] Each attempt to read a metaphor, to transform it into meaning or

value, leaves its mark on the surface of the text, the painting, the drawing. If we study Holbein's superb though very worn drawing of Wyatt (Figure 44), we must ask if those are scars high on his left cheek (Figure 45), or if the drawing is stained from use. Each attempt at exegesis is an accusation: "We don't believe your story. Stop the diversions, the evasions, the lies. What's the truth under all this cover?" Our suspect may clear himself, proclaim his innocence, but the accusation of meaning always lingers, like the scar marking the point where the blow fell. The action is always double: the wound is opened from without, the scar forms from within. If bodily scars are the writing of emotional experience on the body, then the touches of use left on paintings so feared by curators, the textual variants and corruptions so troubling to editors, are the scars of meaning. They show the continuous process by which works of art are, by reading them, converted to use, converted to value, converted, for that matter, into works of art, and undergo at each step the stripping away of previous reading, previous use, previous value, and previous art.

So we must turn back to Holbein's portrait of Cromwell and ask whether the strange moments of illegibility in it must, like the illegibility of Wyatt's poem, be read as a sign for the haunting fear of betrayal, either the painter's fear for himself, or, more likely, the fear that in making this painting he has in some way betrayed his own benefactor, Thomas Cromwell.

On his first visit to England in 1526, Holbein had received a limited number of commissions, largely from Thomas More or people connected to the More-Erasmus humanist network. Upon his return in 1528, however, he quickly received more important patronage from an ever-widening circle of city merchants, diplomats, and court officials, especially those connected with Cromwell. His portrait of Cromwell marks the moment when Cromwell himself emerged as the Protestant counterweight to More in the Privy Council. After the fall of Anne Boleyn and the first imprisonment of Wyatt, Cromwell was instrumental both in managing Wyatt's escape from peril and in bringing Holbein forward to direct royal patronage, which reached its zenith in the famous Whitehall frescoes. And yet, out of all the portraits that Holbein did at the English court, the portrait of Cromwell has always seemed the least flattering to its subject, the most viciously mocking.

Even in its composition, the portrait is remarkable and unusual in several ways. The figure of Cromwell is set deep and low in the frame, making him look small and distant from the viewer. Holbein experimented endlessly in his portraits with the framing of the single figure, setting it high or low, forward or back, behind a sill or a table, bulking large or small. In only one other portrait is the combination of low, small, back, and behind so forceful, the exquisite portrait painted in the same year of the Steelyard merchant Georg Gisze (Figure 46). But here the effect is totally different. The table is raked so that it comes toward the viewer and touches the picture frame. The open spaces around the figure are filled with a clutter of symbolic objects that we

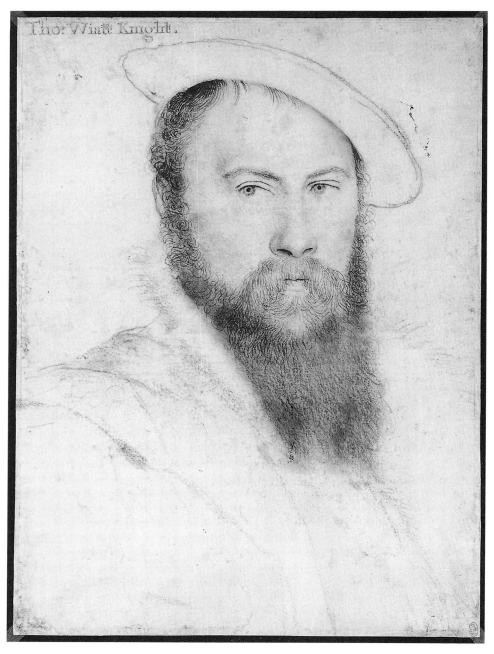

44. Hans Holbein the Younger. *Sir Thomas Wyatt*. Ca. 1537. Chalk on paper. The Royal Collection ©2000 Her Majesty Queen Elizabeth II.

45. Hans Holbein the Younger. *Sir Thomas Wyatt* (detail). Ca. 1537. Chalk on paper. The Royal Collection ©2000 Her Majesty Queen Elizabeth II.

are invited to read as projections or reflections of his character. The writing on the back wall, one of several identifying the sitter, faces us directly and legibly, and Gisze's hand shows us a letter. Above all, Gisze himself turns to the viewer with a slightly shy, accommodating look. Everything here speaks of openness and contact.

In contrast, the formal qualities of Cromwell, the posing of the figure, the averted face and narrow eyes, the blocking table, the surrounding spaces filled with arabesques, the illegible writings, the hand closed in on the paper, have come to be read as suggesting aloof distance, coldness, even a murderous nature. The words of the now-erased inscription praising Cromwell seem wildly inappropriate to the visual evidence. This is exacerbated by the present location of the painting in the Living Room of the Frick Collection where their subjects seem to face each other across a mantel. The almost universal reaction is incisively summarized in a letter to Sidney Cockerell written by the painter Charles Ricketts, who visited the Frick mansion in 1919, shortly after Henry Clay Frick acquired the painting: "Imagine Sir Thomas More, the beautiful saint, and Cromwell, the monster, united in history, art and tragedy, now facing each other, united by Holbein and time and chance."[25]

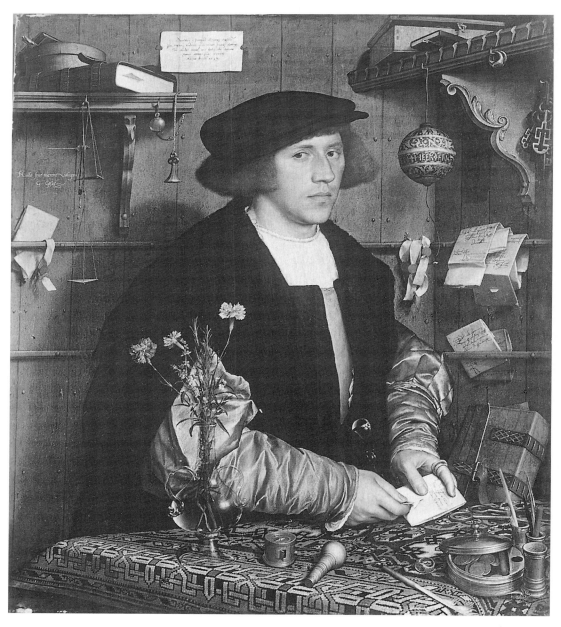

46. Hans Holbein the Younger. *The Merchant Georg Gisze*. 1532–33. Oil on oak panel. Staatliche Museen, Berlin. (Photo: Foto Marburg Art Resource, NY)

Can we—should we—avoid this reading of the painting, or if we cannot, what are we to think of Holbein? Rather than accept right off that Cromwell is simply gazing pitilessly at his intended victim, I can imagine two other readings of the portrait. One is if the scroll at the top is part of the original composition (even if the known contents of the inscription came later). This would have the effect of lowering the top of the composition, or conversely, of raising the figure of Cromwell in the frame to a more typical position, so that we seem not to look down on a diminished figure but to look up at him. Indeed, the vantage point is in any case unusually low.

Alternatively, one may accept this composition as Holbein's and presume that the unusual format is in some way significant, above all in its aversion and resistance to legibility. In contrast to Georg Gisze, whose selfhood bleeds continually back and forth between his own figure and the symbolically legible objects above, behind, around, and even in front of him, Cromwell appears to hold himself apart from the figural. With the exception of the single salutation naming him, a salutation and naming imposed by the hand of the king, the obsessive graphic marking of the picture produces nothing readable—not in the other letters on the table, in his hand, or on the second table to the left, not in the arabesques on the wallpaper, not in the patterns of the Turkish carpet, nor in the book clasped shut so prominently in the foreground. At the upper left, the edge of the wallpaper curls back ever so slightly and teasingly, but the thin strip of wall beneath is blank. Surfaces which open out angularly in the Gisze portrait here are flat and overlapped, self-occluding (Figure 47): the wainscoting covers the lower reach of wallpaper, the carpet on the table, again, folded over itself, the left plane of Cromwell's face closes off the right. Color is displayed in large, relatively unmodulated patches: green, brown, red, blue, and the black silhouette at the center, blocking the eye. If Gisze is enveloped by the symbolic, Cromwell holds himself forcibly aloof from the realm of painting and writing, and gazes steadily out his window.

Holbein's faces are sometimes half-shadowed, or more often fully illuminated from unspecified sources. The window almost visible at the left (Figure 48) is unique in Holbein's oeuvre both as a source of light and as the object of the sitter's gaze. We do not see what he sees, only we see his eyes exploring it, without pleasure.[26] Indeed, his eyes may be narrowed down at the harshness of the light, and it is that illumination that deprives his face of the softening, slightly irresolute inwardness that so often characterizes Holbein's figures, including Gisze and More. The touching of the real with the sight-sticks of vision through that window, which so distracts Cromwell from the figural realm, or which he achieves only by his abstraction from that realm, belongs to him alone, not to us, not to Holbein, who can only see and paint the fact that Cromwell sees. This may not be a man whom you like, but it is a man whom you can in a way trust. He may betray you, but it will not be the betrayal Wyatt feared in himself

47. Hans Holbein the Younger. *Sir Thomas Cromwell* (detail). 1532–33. Oil on oak panel. The Frick Collection, New York.

48. Hans Holbein the Younger. *Sir Thomas Cromwell* (detail). 1532–33. Oil on oak panel. The Frick Collection, New York.

and for himself, the betrayal of weakness, inadvertence, or the sheer blundering folly of those who mistake reality. It will be clear and deliberate, or not at all.

Whatever happened with More, Cromwell did not betray either Wyatt or Holbein. But the question remains whether, in portraying Cromwell, Holbein betrayed Cromwell. In a political sense, Holbein, as an alien, a stranger, an outsider, was also a noncombatant, wholly without the power to harm or help Cromwell. The cultural work of his paintings is the property of his patrons. Holbein's self-inscription within his English works could remain, in effect, his own secret, but that is the secret we demand to know. Has Holbein betrayed him, or betrayed the secret of his grasp? Or does the portrait, like Wyatt's poem, in some way recoil from its putative subject in order to focus obsessively on the artist's "myself, myself"?

If so, it is in a way directly opposite to Wyatt's—not by refusing to name Cromwell, but by so directly naming him. If the illegibilities of the painting, the frustration of Holbein's indecipherable figurations, define Cromwell precisely as he-who-resists-and-escapes-figuration, then Holbein can succeed, can lay bare Cromwell's ability to confront the real, only by imitating Cromwell, that is, by confronting the reality of Cromwell with equal directness. If Homer was the atavistic figure of the Aristotelian and Rembrandtian unconscious, then Cromwell is the inverted double of Holbein. He is not Holbein's simple mirror image, like Gisze, who returns the painter's look and whose hand reaches forward as if to touch the painter's as it works. He is Holbein's opposite, who doesn't care if the painter looks or not, does not submit to the painter's work, but commands more powerfully the real source of the painter's own power.

Whether there is any validity in this reading, whether there is some form of simultaneous portrayal and betrayal, some form that belongs to the artist's own touch

49. Hans Holbein the Younger. *Sir Thomas Cromwell* (detail). 1532–33. Oil on oak panel. The Frick Collection, New York.

rather than to the touch of the externally real, some particular, persistent and obsessive characteristic of Holbein's hand as it moved the brush loaded with paint across the figural arabesques of the panel, we cannot—for quite objective reasons—ever know. Holbein's touch is characteristically rendered invisible in his paintings by their high level of finish—this in stark contrast to Rembrandt's touch, or to Dürer's,[27] or to Holbein's own practice in his drawings. In addition, this particular painting has been subjected to, in John Rowlands's concise phrase, "ruthless cleaning," which "has erased from its surface much of the subtlety of execution that it doubtless at one time possessed."[28] So totally has Holbein's touch been erased from the surface that the painting has for decades been regarded as only the best extant copy of the original, and only the revelation in X rays of artistic revisions to the position of the sitter's left hand, *pen-*

timenti or repentances invisible to the unaided eye, confirm its derivation as a "badly preserved original" from Holbein's own hand.

In the face of such facts, of such a reality of the object, one must conclude with an acknowledgment of a limited defeat in any attempt to read this painting, followed by a strategic withdrawal. This is not simply to say that reading is always already impossible or something softly relativistic like that—quite the opposite. There is no doubt a universal and inherent slippage of all metaphors toward phenomenological vacancy and death; but insofar as it is universal it is no more than a potential, offset at each moment by the million potentials for meaning. What holds the act of reading with a stronger grasp is the historically contingent making and unmaking of metaphoric reference, even through biological death and the corruption or destruction of artifacts, so long as we register as precisely as possible the pleasure, or more often the pain, of those encounters.

If reading and seeing, or painting and writing, are both similar to touching and yet brought up short by the encounter or the touch, then they are after all like Aristotle's two hands, the right one exploring the ghostly artistic head in front of him, the left one unconsciously feeling his own hip. Of course it is always hard to know if one's reading feels right. Those moments when one feels most surely the encounter with the real object out there may just be those moments when one is left most powerfully in the snare of one's own persistent delusions. Yet in that neat dichotomy of right and left, Aristotle's hands may once again describe things too simply, as compared to the small allegory of reading visible in the way Cromwell's hands are arranged. The right one is present but invisible. The left hand we are able to see (Figure 49), doing not one but two things, simultaneously curling around the paper and turning in on itself, both exploring the objective world and unself-consciously present to itself, as Cromwell looks out primarily with the left eye, as here painted by the brush of the left-handed artist, Holbein.

Notes

1. Raymond Williams, *Keywords: A Vocabulary of Culture and Society* (New York: Oxford University Press, 1983), p. 315.

2. Michael Ann Holly, *Past Looking: Historical Imagination and the Rhetoric of the Image* (Ithaca: Cornell University Press, 1996), p. 24.

3. See Michael Baxandall, *Giotto and the Orators: Humanist Obervers of Painting in Italy and the Discovery of Pictorial Composition, 1350–1450* (London: Oxford University Press, 1971), pp. 130–35, and Clark Hulse, *The Rule of Art: Literature and Painting in the Renaissance* (Chicago: University of Chicago Press, 1990), pp. 60–65.

4. Meyer Schapiro, "Script in Pictures: Semiotics of Visual Language," in *Words, Script, and Pictures: Semiotics of Visual Language* (New York: Braziller, 1996), p. 181.

5. Quoted in Louis Marin, *To Destroy Painting*, trans. Mette Hjort (Chicago: University of Chicago Press, 1995), p. 39.

6. Richard Brilliant, *Portraiture* (Cambridge: Harvard University Press, 1991), p. 80.

7. Julius Held, *Rembrandt Studies* (Princeton: Princeton University Press, 1991), p. 20.

8. Svetlana Alpers, *Rembrandt's Enterprise: The Studio and the Market* (Chicago: University of Chicago Press, 1988), pp. 25–26.

9. Donald Preziosi, *Rethinking Art History: Meditations on a Coy Science* (New Haven: Yale University Press, 1989), chap. 3.

10. I am indebted here to Edward Snow's reading of the body's experience in itself in relation to Velázquez's *Rokeby Venus*, in "Theorizing the Male Gaze: Some Problems," *Representations* 25 (Winter 1989): 30–41.

11. Aristotle, *Poetics* 1457b6–9.

12. Roy Strong, "Holbein in England: I: Thomas Cromwell," *Burlington Magazine* 109 (1967): 276–78.

13. Paul Ricoeur, *La métaphore vive* (1975); English translation as *The Rule of Metaphor: Multi-Disciplinary Studies of the Creation of Meaning in Language*, trans. Robert Czerny (Toronto: University of Toronto Press, 1977), p. 70.

14. "ET.BONUS.ET.PRUDENS.CHRISTI.REGIS.QUE.MINISTER.CONSTANS.VIR.PROMPTUS. PECTORE.FRONTE.MANU.VIX.IN.AMICITIA.VIX.NASCITUR.HEROS.PLUS.PATRIE.FIDUS.PLUS. PIETATIS. AMANS." In the translation I have attempted to unpack the implications of the Latin. Text from Paul Ganz, *Hans Holbein der Jüngere des Meisters Gemälde, Klassiker der Kunst*, vol. 20 (Stuttgart, 1912), p. 106.

15. Accounts appear in Corpus Christi College, Cambridge, Parker MS 168; BL Harleian MS 3362, fol. 79r; El Marqués de Molins, *Crónica del Rey Enrico Otavo de Ingalaterra* (Madrid, 1874), trans. M. A. S. Hume (1889). See also H. A. Mason, *Sir Thomas Wyatt: A Literary Portrait* (Bristol: Bristol Classical Press, 1986), pp. 247–248; R. B. Merriman, *Life and Letters of Sir Thomas Cromwell*, 2 vols. (Oxford, 1902).

16. Mason, *Portrait*, p. 247.

17. Corpus Christi College, Cambridge, Parker MS 168, fol. 118r–v. The manuscript was given to the college by the son of Richard Cox. Some poems by Wyatt appear on ff. 110r–11v, but ff. 118–19, containing the account of Cromwell's execution, are on a different paper from the rest of the volume. See Richard Harrier, *The Canon of Sir Thomas Wyatt's Poetry* (Cambridge: Harvard University Press, 1975), pp. 78–79; H. A. Mason, *Editing Wyatt* (Cambridge: Cambridge Quarterly, 1972).

18. Kenneth Muir, *Life and Letters of Sir Thomas Wyatt* (Liverpool: Liverpool University Press, 1963), p. 173.

19. Sir Thomas Wyatt, *The Complete Poems*, ed. R. A. Rebholz (New Haven: Yale University Press, 1981), no. 29, p. 86; from Arundel-Harington MS and Tottel. Textual variants: Line 8, *Dearly* (Arundel), *Daily* (Tottel); 11, *woeful* (Arundel), *carefull* (Tottel); 14, *cease* (modern conjecture [Nott?]), *cause* (Arundel), *ease* (Tottel). I follow Tottel in line 8. See Ruth Hughey, ed., *The Arundel-Harington Manuscript*; Mason, *Editing*.

20. Petrarch, *Sonnets and Songs*, trans. Anna Maria Armi (New York: Grosset & Dunlap, 1968), pp. 10–11, 386–387.

21. H. A. Mason, *Humanism and Poetry in the Early Tudor Period: An Essay* (London: Routledge, 1959), p. 196.

22. Rebholz, *Complete Poems*, no. 68, p. 101; from BL Hill MS 36529 and Tottel.

23. Rebholz, *Complete Poems*, no. 62; from BL MS Harley 78 and Tottel.

24. Muir, *Life and Letters of Sir Thomas Wyatt*, p. 193; text from BL MS Harley 78.

25. Stanley Morison, *The Likeness of Thomas More: An Iconographical Survey of Three Centuries*, edited and supplemented by Nicholas Barker (New York: Fordham University Press, 1963), p. 10.

26. See, by comparison, Meyer Schapiro's analysis of the contrast between profile and frontal figures in medieval painting in "Words and Pictures: On the Literal and the Symbolic in the Illustration of a Text," in *Words, Script, and Pictures*, pp. 69–95. The profile format, Schapiro argues, denotes separation from the viewer and engagement in the historical time of the painting, in contrast to the frontal figure, which engages the viewer in timeless, repeated, even ritual action. In a semiotic extension, Schapiro equates profile with the third person pronouns "he" or "she," and frontal with the complementary pair "I-thou."

27. See in this regard Joseph Koerner's remarkable exposition of Dürer's touch as signature in *The Moment of Self-Portraiture in German Renaissance Art* (Chicago: University of Chicago Press, 1993), especially pp. 3–32.

28. John Rowlands, *Holbein: The Paintings of Hans Holbein the Younger* (London: Phaidon, 1985), p. 138.

5. ART FOR THE SAKE OF DYNASTY

The Black Emperor in the Drake Jewel and Elizabethan Imperial Imagery

KAREN C. C. DALTON

> These pictures . . . are not art for art's sake; still less art for God's sake; they are rather art for the sake of power, wealth, and lineage—for the sake of dynasty.

Portraiture occupied a central role in the creation and dissemination of royal imagery as practiced by the Habsburg, Tudor, and Valois rulers during the second half of the sixteenth century. These monarchs—Philip II of Spain, Elizabeth I of England, and Henry III and Henry IV of France—elaborated over time visual and verbal metaphors that made manifest their power and status, asserted their claims to illustrious and often mythical lineages,[1] and put forward their imperial ambitions in both the temporal and the sacred realms. Each of these Renaissance princes reigned in an era of transition between the medieval and the modern world: an era when rulers could, without contradiction, be depicted as classical deities, biblical figures, and Roman emperors; an era when astrology was not yet distinct from astronomy, chemistry was only beginning to separate from alchemy, and mathematics was still linked to magic; an era when explorers set off in search of Atlantis, the kingdom of Prester John, and the Northwest Passage, while establishing settlements in the Americas. This world in which the mythical and the empirical overlapped and at times interpenetrated made for a rich and deep pool of images from which an artist could draw. Further, it made for images which could be multivalent, depending on the context in which they were used.[2]

In the context of Elizabethan England, portraits of the queen and the evolution of her iconography assumed particular importance. Due to the destruction and suppression of religious imagery by Henry VIII and Edward VI after the former's rupture with the Church of Rome, portraiture came to preponderate in the country's visual production. Elizabeth's exceptional popularity among her subjects created a large demand for her likeness.[3] This demand increased even further when, in the mid-1580s as a sign of loyalty to their sovereign, individuals from across the social spectrum began wearing images of the queen. Some of these badges bearing Elizabeth's portrait appeared in the form of medallions struck in base materials, while others were cameos set in intricate jewels.[4] Numerous portraits of prominent individuals displaying such cameos survive, including Elizabeth's lord chancellor, Sir Christopher Hatton (Figure 50),[5] and her secretary of state, Sir Francis Walsingham.[6] The queen herself

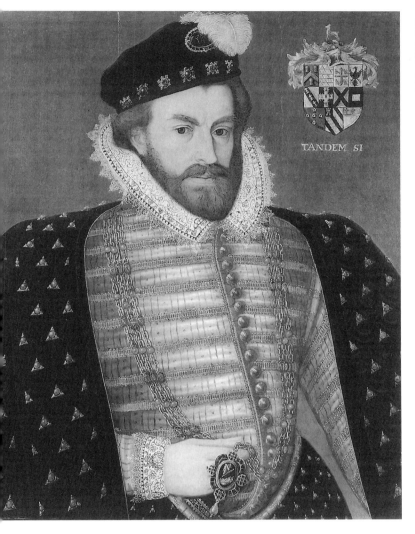

TANDEM SI

50. Anonymous. *Sir Christopher Hatton*. Ca. 1585 (date of 1589 added later). Oil on panel. By courtesy of the National Portrait Gallery, London.

bestowed jewels containing her image on deserving subjects as rewards for services rendered to the Crown.[7] Such was the purpose of the so-called Drake Jewel which Elizabeth gave to Sir Francis Drake, most probably in recognition of his role in the defeat of the Spanish Armada in 1588. Individuals who received jewels from Elizabeth I wore them both to confirm their devotion to her and to proclaim their favorable standing in the queen's eyes. The jewels themselves were conceived not as commentaries on their recipients but as paeans to the glory and virtue of the ruler who presented them as gifts.

The Drake Jewel consists of a gold case enameled in red, white, blues, and greens and set with table-cut rubies and diamonds, from which is suspended a cluster of small

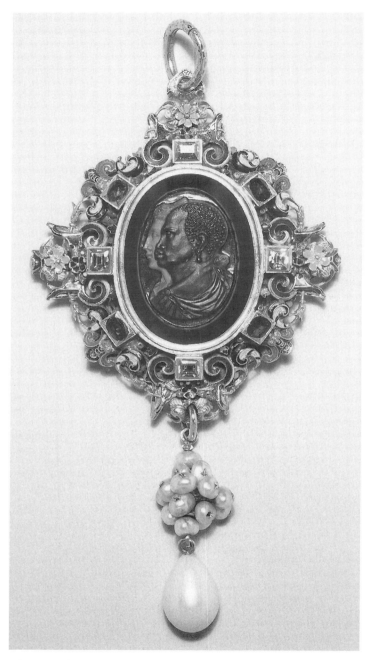

51. The Drake Jewel (front). 1588. Gold and enamel with sardonyx, rubies, and diamonds. Collection of Lt. Col. Sir George Meyrick, Bart., on loan to Victoria and Albert Museum, London.

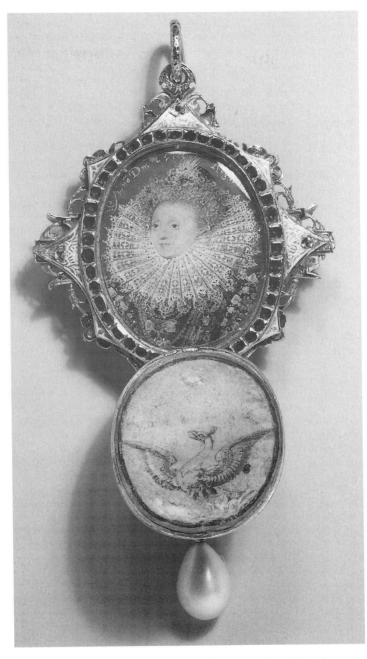

52. Miniature by Nicholas Hilliard. The Drake Jewel (inside). 1588.
Painting on parchment. Collection of Lt. Col. Sir George Meyrick,
Bart., on loan to Victoria and Albert Museum, London.

pearls and a larger pearl. The front of the jewel (Figure 51) presents a two-layer, sardonyx cameo in which a black emperor and a white woman are carved in left profile.[8] The reverse (Figure 52) opens to reveal a miniature of Queen Elizabeth painted by Nicholas Hilliard, opposite which is the painting of a phoenix on parchment.[9] This jewel appears prominently in several portraits of Sir Francis Drake.[10]

In 1591, and again in 1594, Drake had his portrait painted, probably by the Flemish painter Marcus Gheeraerts the Younger (Figure 53).[11] In both pictures Drake's three-quarter-length figure stands beside a table on which rests a globe turned to reveal Africa and Brazil. Clad in a black doublet with a white ruff at his neck, Drake wears a sword and the Drake Jewel. At upper left is the sitter's coat of arms, granted in 1581 when he was knighted by Queen Elizabeth on board the *Golden Hinde*, the vessel in which Drake had circumnavigated the globe. In the 1591 portrait, Drake's gloved right hand is seen planted on his right hip beneath a black cloak, and his left hand holds a black velvet hat. The cloak is absent from the 1594 portrait in which the sitter's right hand rests on the globe, and his gloved left hand holds his other glove.

The Drake Jewel, and particularly its cameo with the profiles of a black emperor and a white woman, presents an excellent example of the multiple meanings an Elizabethan work can convey. Further, it encapsulates in miniature the development of Elizabethan imperial imagery in the late 1580s. This essay will interpret individually and as an ensemble the images that comprise the Drake Jewel, while situating the Drake Jewel within the broader framework of the elaboration and functions of Elizabethan iconography.

Queen Elizabeth I and the Notion of Empire

By the late 1580s numerous symbols emblematic of Queen Elizabeth as a ruler and of her ambitions figure in her portraits. The imagery is borrowed from many different sources, including the Bible, English history, Roman history, classical mythology, Virgil, Petrarch, navigation, and, I suggest, alchemy. The central idea around which this complicated imagery orbited was that of the sacred ruler and the return of the Golden Age, as envisioned in the imperial revival of Emperor Charles V. This return to the universal harmony of the Age of Saturn was prophesied in Virgil's Fourth "Messianic" Eclogue:

> Now the last age of Cumae's prophecy has come;
> The great succession of centuries is born afresh.
> Now too returns the Virgin; Saturn's rule returns;
> A new begetting now descends from heaven's height.
> O chaste Lucina, look with blessing on the boy

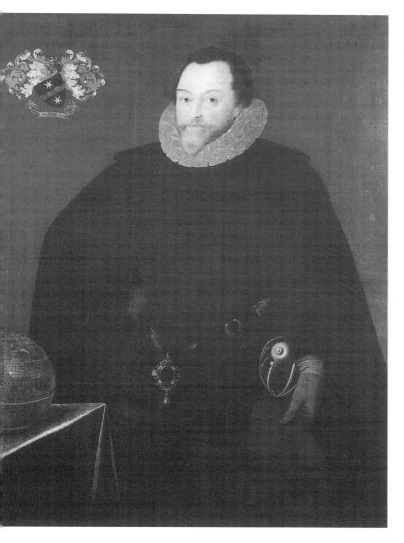

53. Manner of Marcus Gheeraerts the Younger. *Sir Francis Drake*. Dated 1591. Oil on canvas. National Maritime Museum, London (Greenwich).

> Whose birth will end the iron race at last and raise
> A golden through the world: . . .[12]

For Charles V, and the Renaissance princes who inherited his vision, including Elizabeth I, the new Golden Age would be both religious and nationalist in nature. One of the symbols used to express this *renovatio* or rebirth was the phoenix,[13] a mythical creature that personified both things cyclical and recurrent and things eternal. According to classical authors, this fabulous bird lived for five hundred years, was consumed in the flames of an altar fire, and rose again to life from its own ashes. For Christians it

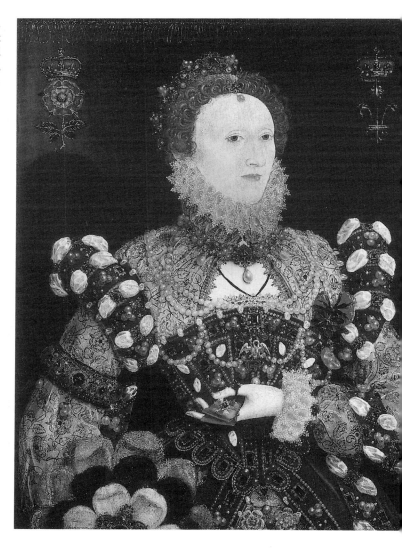

54. Nicholas Hilliard. *Elizabeth I* ("Phoenix Portrait"). Ca. 1572–76. Oil on panel. Walker Art Gallery, Liverpool.

came to symbolize the life, death, and resurrection of Christ, as well as chastity. Elizabeth first associates herself with the characteristics of the phoenix in a portrait painted by Nicholas Hilliard in the early 1570s (Figure 54),[14] in which she wears a jewel in the form of a phoenix at her breast. During those same years Hilliard painted a second and very similar portrait of the queen wearing another jewel (Figure 55),[15] this time a pelican, symbol of redemption and charity, plucking its own breast to shed blood to save its young. Taken together, these two emblems characterize different aspects of Elizabeth's reign: the phoenix identifies her as a ruler by divine right and affirms the validity of her dynastic claims, while the pelican emphasizes her relationship

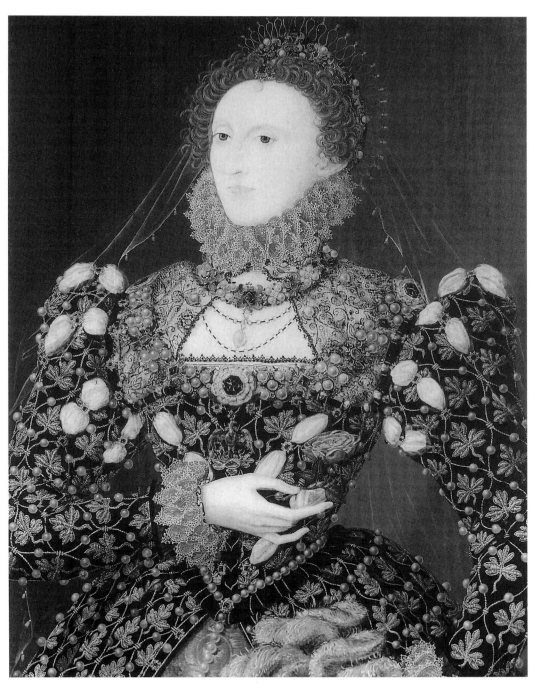

55. Nicholas Hilliard. *Elizabeth I* ("Pelican Portrait"). Ca. 1572–76. Oil on panel. By courtesy of the National Portrait Gallery, London.

to her subjects. Later in her rule, in an engraving by Crispin van de Passe the Elder dated 1596 (Figure 56),[16] Elizabeth appears with both the phoenix and the pelican, as well as numerous other symbols identifying her as the incarnation of the return of the Golden Age.

Of all the symbols deployed by the artists and writers who portrayed Elizabeth, the one that identified her most cogently as the incarnation of the *renovatio* was the just, imperial virgin Astraea.[17] With Astraea the Virgin returns the reign of Saturn, eternal peace, purified religion, and endless well-being and wealth for her subjects. The symbol was used by poets to characterize the queen from the beginning of her reign. However, it does not appear in her portraits until 1579, at which time it is coupled with another symbol of Elizabeth's imperial aspirations, the world globe. In George Gower's three-quarter-length portrait of the queen, she holds a sieve, attribute of the Roman vestal virgin Tuccia. In reproof of those who falsely accused her of unchasteness, Tuccia fetched water from the River Tiber in a sieve and transported every drop of it to the temple. To the left behind Elizabeth glows a terrestrial globe, an attribute of the emperors of antiquity, and the motto "TUTTO VEDO & MOLTO MANCHA" ("I see everything, but much is missing"), an allusion to England's quest for territorial expansion.[18]

The introduction of these two symbols—the Virgin Astraea and the world globe —into Elizabeth's iconography in 1579 takes place against the backdrop of three important occurrences: (1) the publication in 1577 of John Dee's *General and Rare Memorials Pertayning to the Perfect Arte of Navigation*; (2) Sir Francis Drake's successful plundering of Spanish holdings in Central and South America in 1572–73 and again in 1577–80 when he circumnavigated the globe; and (3) the protracted marriage negotiations between Elizabeth and Francis, duke of Anjou.

John Dee was an Elizabethan scholar of immense erudition whose thinking and writing encompassed such disparate subjects as alchemy, pure and applied mathematics, history, especially so-called British history, navigation, politics, law, medicine, astrology, astronomy, religion, and occult sciences. His circle of correspondents and friends was international in scope: in 1548 Dee traveled to Louvain where he studied with and established lasting rapports with Europe's leading cosmographers, including Gemma Frisius, Pedro Nuñez, Abraham Ortelius, and Gerard Mercator. In 1550 Dee was in Paris lecturing on Euclid and engaging in exchanges with the foremost intellectuals of France. Later in his career he was present at the courts of Emperor Rudolf II and of the king of Poland. His circle of patrons and friends at home was impressive— including Queen Elizabeth herself, her chief minister William Cecil, baron of Burghley, Robert Dudley, earl of Leicester, Sir Henry Sidney, Sir Christopher Hatton, and Sir Francis Walsingham—and these and other members of Elizabeth's court were the audience for Dee's *General and Rare Memorials*.[19]

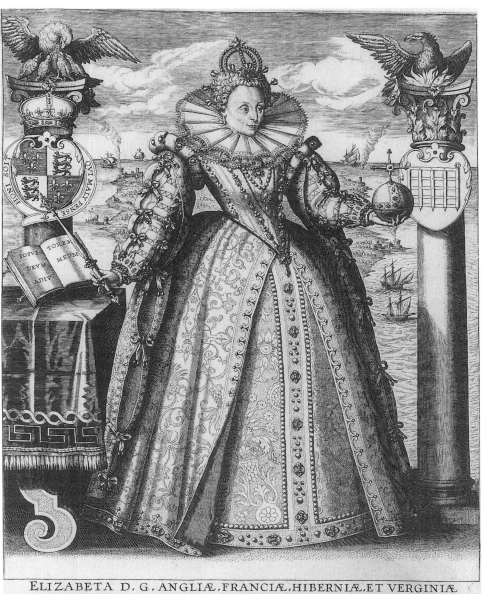

ELIZABETA D. G. ANGLIÆ. FRANCIÆ. HIBERNIÆ. ET VERGINIÆ
REGINA CHRISTIANAE FIDEI VNICVM PROPVGNACVLVM.

Jmmortalis honos Regum, cui non tulit ætas Queis ipsæ tantum superant reliqua omnia regna,
 Ulla prior, veniens nec feret vlla parem. Quantum tu maior Regibus es. reliquis,
Sospite quo nunquam terras habitare Britannas Viue precor felix tanti in moderamine regni,
 Desinet alma Quies, Iustitia atque Fides, Dum tibi Rex Regum cælica regna paret.

In honorem serenissimæ Suæ Maiestatis hanc effigiem fieri curabat Ioannes Woutnelius belga. Anno 1596.

56. Crispin van de Passe the Elder. *Elizabeta D. G. Angliae, Franciae, Hiberniae, et Verginiae/
Regina Christianae Fidei Vnicvm Propvgnacvlvm.* Dated 1596. Engraving. © The British
Museum, London.

Dee's treatise was written and published at a time when England's perennial fear of invasion by Spain was heightened by war in the Netherlands and by Spain's anger over raids on its treasure ships by English privateers. This eighty-page document was the first section of a four-part work: the second part is lost, the third was burned, and the fourth survives in the manuscript at the British Museum, *Of Famous and Rich Discoveries*.[20] Dee advocated in *General and Rare Memorials*—and his drawing for its title page illustrated (Figure 57)[21]—a vision of the country's future as the "British Impire" with Elizabeth "Sitting at the HELM}of this Imperiall Monarchy: or, rather, at the Helm of the IMPERIALL SHIP, of the most parte of Christendome."[22] The policy Dee proposed for achieving this state had two principal components: first, securing the country's maritime defenses by establishing and maintaining a Petty Navy Royal, and, second, expanding Britain's sphere of influence and actual territorial holdings by two means, "discovery of new lands and recovery of territories that once arguably belonged to the British crown."[23] Citing historians such as Geoffrey of Monmouth, Dee not only traced Britain's founding to Arthur's ancestor, the Trojan Brutus,[24] but also buttressed Britain's prior claim to virtually all of North America (which he called Atlantis), Greenland, Estetiland, and Friseland by citing earlier voyages of discovery and conquest made by Arthur and "the Lord Madoc, Sonne to Owen Gwynedd Prynce of Northwales."[25] A measure of the favorable reception of Dee's imperial vision at court can be found in his dedication of *General and Rare Memorials* to Sir Christopher Hatton. The latter opposed Elizabeth's marriage to the duke of Anjou, and he actively supported the voyages of exploration (and potential expansion) by Drake and others.

The very effective handmaidens of John Dee's blueprint for a "British Impire" were England's enterprising mariners and privateers, of whom the most audacious and successful was Sir Francis Drake.[26] In 1570 and 1571 Drake made two voyages to the West Indies during which he gathered intelligence on Spain's funneling of treasure and goods from South America and the Far East into Central America, and then transshipping them to Spain. During the second voyage he also learned of the growing boldness of the *cimarrones*, escaped African slaves who were intercepting Spanish shipments of gold and silver from Panama on the Pacific side of the Isthmus of Panama to Nombre de Dios on the Caribbean side. On a return voyage in 1572–73, Drake capitalized on the reconnoitering he had done earlier. With daring and determination that became part of his legend, Drake and a handful of men attacked Spain's storehouse in Nombre de Dios. He then formed an alliance with the *cimarrones* and some French Huguenots to ambush a Spanish mule train laden with three hundred pounds of silver and some gold.[27] Drake's share of that raid amounted to £20,000 and made him a man of substantial means. More important for England's imperial ambitions was the moment when the *cimarrones* guided Drake to a tree from which both the Atlantic and the Pacific were visible. Upon seeing the Pacific Ocean, Drake "be-

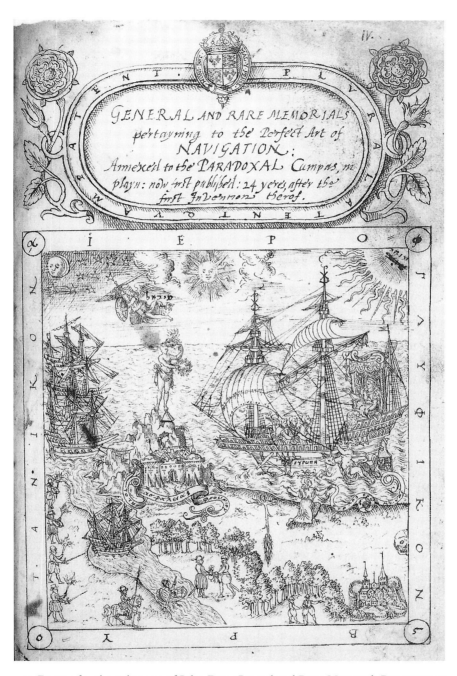

57. Design for the title page of John Dee, *General and Rare Memorials Pertayning to the Perfect Arte of Navigation*. Ca. 1577. Ink on paper. MS Ashmole 1789, fol. 50. Bodleian Library, Oxford.

sought God of his goodnesse to give him leave and life to sayle once in an English ship in that sea."[28] The sight of the "Great South Sea" and Drake's prayer were harbingers of the glory that would accrue to England and to Drake when, on his next voyage, he circumnavigated the globe.

In November 1577 in a ship called the *Pelican*, recalling one of Elizabeth's symbols, Drake again set sail for the Americas. This time he had the financial backing of some very powerful individuals, including the queen herself. The purpose of this venture and even the voyage itself were carefully concealed secrets. In general, all involved were seeking ways to reduce the considerable advantage of Spain and Portugal in the arena of world trade. All involved were also eager to realize a handsome return on their investment. Drake himself was keen on sailing through the Strait of Magellan and establishing an English colony on the west coast of South America. Some of his backers, among whom Sir Christopher Hatton, Robert Dudley, earl of Leicester, and Sir Francis Walsingham, favored John Dee's plan of discovering a Northwest Passage, called the Strait of Anian, linking the Atlantic and the Pacific across the north of America. (Martin Frobisher's three failed attempts to locate this passage notwithstanding, the English still hoped to find a route to the riches of the Far East without encroaching on Spain's and Portugal's turfs.) Drake passed through the Strait of Magellan between August 23 and September 6, 1578, and began what became his most profitable series of raids. *El Draque* ("the dragon"), as Spaniards came to call Drake, swooped down on Spain's wealthy, but ill-defended outposts along the coasts of Chile and Peru, increasing his booty and his reputation for bravery, daring, and seamanship as he went. His ships laden with plunder, Drake proceeded north along the coast of Central America and past California, where he did not discover, nor apparently did he spend much time trying to discover, a Northwest Passage. Drake began the voyage home on July 23, 1579. Rather than retrace his steps and run the risk of encountering Spanish ships seeking revenge for his depredations, Drake sailed westward through the Molucca Islands and around the Cape of Good Hope, arriving at Plymouth, England, on September 26, 1580. The *Pelican*, since renamed the *Golden Hinde* (the white hind was the cognizance of Sir Christopher Hatton), thus became the first English ship to sail around the world, and Drake the first person of any nation to command through the entirety of such a voyage. (Magellan died before completing his circumnavigation.) Drake's success, for which he was awarded a knighthood by Queen Elizabeth on April 4, 1581, aboard the battered *Golden Hinde*, signaled the beginning of the maritime mastery John Dee and others were urging England to develop.

Contemporaneous with Dee's advocacy of a British Empire and with Drake's maritime exploits were Elizabeth's spasmodic matrimonial negotiations with Francis, duke of Alençon (later duke of Anjou and of Brabant).[29] A dynastic alliance with the brother of King Henry III of France would provide England an ally against Spain's ever-increasing might, and it offered the desirable promise of halting French interven-

tion and expansion in the Netherlands. In the hope of accomplishing these two goals, Elizabeth reversed six years (mid-1572 to late 1578) of what Susan Doran has called "a masterpiece of protracted dalliance."[30] In May 1578 she sought to reopen the matrimonial project with the duke of Anjou. Ultimately, these negotations were bound to founder on the profound opposition emanating from all levels of English Society—from Elizabeth's Privy Council to Parliament to the Protestant clergy—against the queen wedding a Catholic, and especially a French one. Perhaps equally significant in solidifying the disapproval of this match were concerns about the monarch's ability to conceive a child (by the time the negotiations were abandoned in February 1582, Elizabeth was forty-nine years old) and about the dangers of childbirth should she become pregnant. Consequently, during this period the image of Elizabeth as the Virgin Queen recurred in numerous court entertainments, constantly reminding the queen that "her chastity was part of her special mystique and that her marriage to the French prince was therefore out of the question."[31]

Mindful of John Dee's articulated plan for the creation of a "British Impire," of Drake's successful voyages and raids, of the failure of Elizabeth's negotiations for a dynastic alliance with Francis, duke of Anjou, and of England's deteriorating relations with Spain, we return to the "Sieve" portraits of Elizabeth I. The 1579 "Sieve" portraits have been interpreted by Roy Strong as the earliest pictures of the queen "to include a programme of imperial aspirations" and as explicit statements of opposition against her marriage. Strong states further: "In the 'Sieve' portrait of 1579 we witness John Dee's vision of a British Empire founded on sea power made part of the iconography of monarchy. One may well speculate as to whether Dee, whose ability to compose visual allegories is amply demonstrated by his frontispiece, might have had a hand in composing this programme."[32]

A second series of "Sieve" portraits was painted in 1583, the most accomplished and iconographically elaborate by Quentin Metsys the Younger (Figure 58).[33] In this picture the symbolism introduced in Elizabeth's "Sieve" portraits from 1579 is developed further and expanded. Elizabeth again holds the sieve identifying her as the chaste Virgin Queen. And again the terrestrial globe appears with the motto "TUTTO VEDO E MOLTO [MANCHA]," but this time the surface of the globe is enlivened with ships sailing westward, images of England's developing sea power and her pursuit of new lands in the New World. Further additions to the arsenal of imperial imagery are the jasper column at left with the crown of the Holy Roman Empire at its base, and the historiated medallions carved into the column's surface.

The jewellike medallions relate the story of Dido and Aeneas in which, because he resists the temptations of remaining with Dido, Aeneas fulfills his destiny of founding the Roman Empire.[34] The identification of Elizabeth with Aeneas not only underscores her Trojan descent so painstakingly established by John Dee, it also emphasizes that in forgoing marriage and therefore eschewing human passion, Elizabeth is assum-

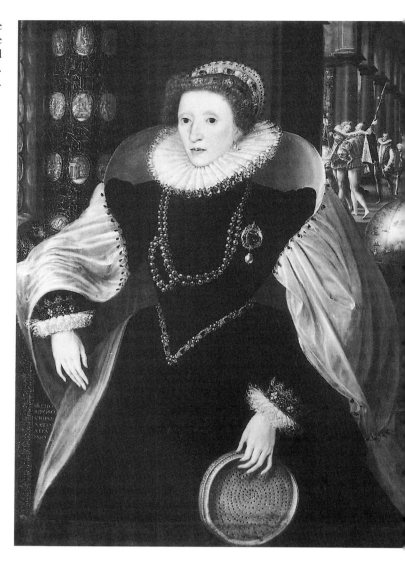

58. Quentin Metsys the Younger. *Elizabeth I* ("Sieve Portrait"). Signed and dated 1583. Oil on canvas. Pinacoteca Nazionale, Siena.

ing her destiny as chaste empress of an expanding British Empire. She will not marry the duke of Anjou or any other. Nor will she produce heirs from her body through whose dynastic marriages she could have hoped to extend England's territory and influence, a technique used to such advantage by the Habsburgs. Rather, in what seems to be a visual statement of a change in policy, the future of England lies in acquiring distant lands through discovery and in enhancing the queen's mystique as the Virgin Astraea who ushers in the New Golden Age.

The development of Elizabeth's imperial imagery reached its apogee in the buildup to and aftermath of England's defeat of the Spanish Armada in 1588. The

routing of Spain's invasion fleet of 130 ships prompted Elizabeth to sit for George Gower for a new portrait celebrating the victory. The queen poses in imperial triumph. She rests her hand on the terrestrial globe, repeating the gesture of Roman emperors. Her fingers indicate, as Tabitha Barber has observed, "England's dominion of the seas and plans for imperialist expansion in the New World." Carefully situated above the globe and beside Elizabeth is an imperial crown.[35]

From this same period date numerous medals and cameos bearing portraits of Elizabeth in profile, in imitation of Roman emperors. Following the precedent established in antiquity and revived by monarchs during the Renaissance, the image on the reverse of the portrait depicted some virtue, characteristic, or deity with which the ruler should be associated.[36] One of the most notable examples is the Phoenix Jewel. The obverse of this pendant features a gold bust-length portrait of Elizabeth in left profile while the reverse (Figure 59) presents the relief of a phoenix in flames under the royal monogram.[37] (The phoenix, as I mentioned earlier, connoted the divine nature of Elizabeth's reign and her constancy as a ruler.) In a work known as the Armada Jewel, which dates from about 1585 to 1590, another gold bust of Elizabeth in profile appears on the front of a locket. On the reverse is the device of the Ark of the English Church tossed on a stormy sea with the inscription "SAEVAS TRANQVILLA. PER. VNDAS" ("Peaceful through the stormy seas"), alluding to her role as its protector.[38] Taking into account both the orchestration of devices, symbols, and inscriptions in praise of Elizabeth, which is characteristic of these multi-image jewels, and the increased emphasis on Elizabethan imperial imagery in the late 1580s may offer some insight into the iconography of the Drake Jewel.

Black Emperors

The striking double cameo mounted in the center of the Drake Jewel combines two subjects especially favored for late sixteenth-century jewels: Roman emperors and blacks, both male and female. Of the nearly fifty cameos carved with the heads or busts of Africans inventoried by the Image of the Black in Western Art Research Project and Photo Archive, Harvard University, half of them are men represented as Roman emperors. Some are laureate; some wear the cuirass of the Roman military; almost all are cloaked in a *paludamentum*, the mantle worn by rulers and chief military officers in Rome.[39] Of this group, four cameos, including the one in the Drake Jewel, juxtapose a black emperor and a white woman. Remarkably similar to the Drake cameo is one centered among several other cameos and carved stones in a candleholder that was given by the state of Venice to Henry IV of France and Marie de' Medici on the occasion of their wedding in 1600 (Figure 60).[40] Two other cameos place back-to-back a black emperor and a white emperor.[41] Who is this black emperor?

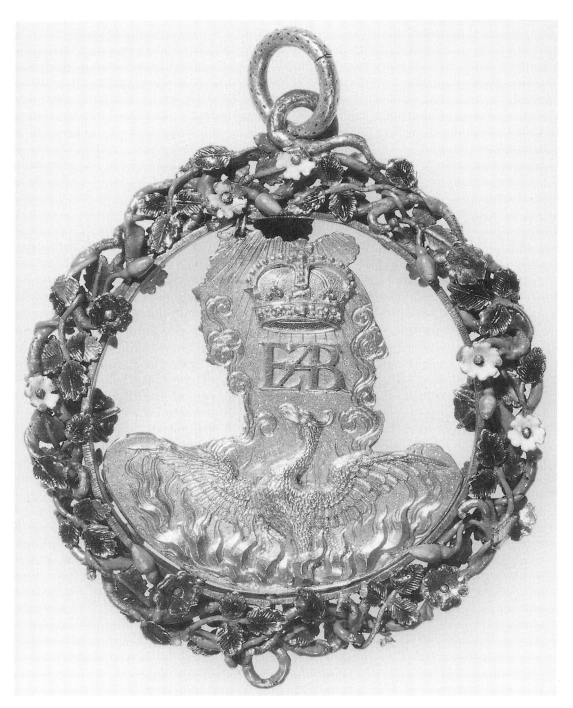

59. Anonymous. Phoenix Jewel (reverse). 1570–80. Gold and enamel. © The British Museum, London.

60. Anonymous. Candleholder given to Henry IV of France and Marie de'
Medici by the state of Venice on the occasion of their marriage. 1600.
Polished and carved sardonyx and agate. Musée national du Louvre, Paris.

Later in this essay I will offer a response, but for the moment I will survey the identities other authors have suggested in the past. To my knowledge, Ernst Kris is the only scholar to have identified any of these emperors as a specific person. He proposed that the black emperor on the reverse of a cameo representing an unidentified Roman emperor was Philip the Arab (r. 244–49).[42] Kris's assumption that images associated in this manner would represent figures of equal stature seems sound. However, it is improbable that Philip is the correct identification since he was from Macedonia not Africa, and other depictions of him neither bear any resemblance to the visage on the cameo nor do they portray a person with Negroid features.[43] Ernest Babelon speculates that these black figures have only been "crowned" in jest,[44] even though none is treated in a caricatural manner. The plausibility of this interpretation appears questionable when one considers the improbability of a person of noble rank wearing anything that would cast a negative or ridiculous light on himself.

Alternatively, Babelon conjectures that the African figures on these cameos refer to the black king represented frequently in Adoration of the Magi scenes.[45] It is striking that during the sixteenth century in certain geographical areas—namely, Flanders, the Netherlands, and Germany—the black king in several works depicting the Adoration of the Magi is represented as a Roman emperor.[46] As in the painting by Marten de Vos (Figure 61), the black king—and he alone among the Three Kings—wears the Roman cuirass and the *paludamentum* or some sort of mantle that approximates it.[47] Usually he is either bareheaded or crowned although in some instances his head is covered with a turban or a helmet. This iconography was introduced and flourished during the sixteenth century and then virtually disappeared in the seventeenth.[48] It is also pertinent to note that during the years 1530–1630 a large number of artists working in England were from the Low Countries, including John de Critz the Elder, Marcus Gheeraerts the Younger, and Quentin Metsys the Younger.[49]

The meaning of the black emperor in the Drake Jewel, and perhaps in other contexts as well, lies in two seemingly unrelated areas: in Elizabeth's particular development of the idea and imagery of empire and in the imagery of alchemy. Both were rooted in the idea of the return of a Golden Age, also known as the Age of Saturn. For Elizabeth the realization of that ideal would result in her being recognized as the Sacred Empress or the Una; in alchemy it signified successful pursuit of the Philosopher's Stone.

Imagery of Alchemy

In his valuable study of the history of alchemical art, Jacques van Lennep describes alchemy as the art of transmutation, specifically of converting base metals into silver or gold. However, in order for the alchemist to succeed in this undertaking, he first

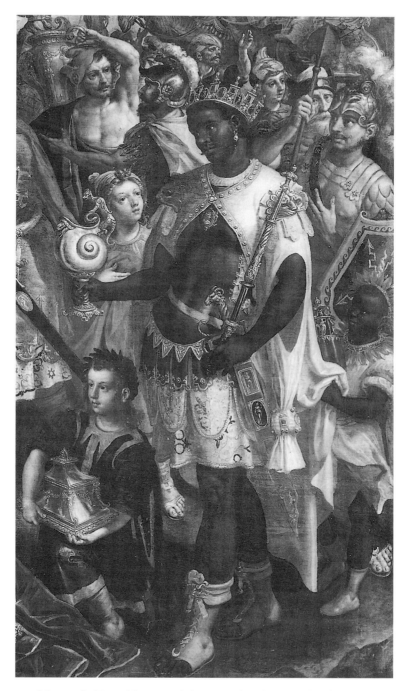

61. Marten de Vos. *Adoration of the Magi* (detail). Signed and dated 1599.
Oil on canvas. Musée des Beaux-Arts, Valenciennes.

had to discover the "Philosopher's Stone." These two sides of alchemy—the practical or operative, and the speculative—are inherent to its nature. The first, Lennep continues, relates to metallurgy and primitive chemistry while the second partakes of a mystical research.[50]

This basic duality is evident in alchemical language and in the visual imagery that accompanies alchemical treatises, whether in manuscript or printed form. Addressing the complexity of alchemy's verbal expression, which F. Sherwood Taylor characterized as "the expression of the perfecting of matter in terms of human experience," Gareth Roberts notes that this is a language which "discloses discourses where the material and metaphorical worlds had not yet parted company, and in which both a metal and a human being had body, soul and spirit."[51] Similarly, the images deployed to illustrate the process of transmutation ranged from the specific—including the various stills, vessels, and furnaces common to the alchemist's laboratory—to the highly allusive and metaphorical. In the latter category, depictions of cycles of death, decomposition, and resurrection, whether drawn from religious sources, nature, or classical mythology, were favored. Thus, in a late fourteenth-century alchemical manuscript the resurrection of Christ is interpreted as the moment when the Philosopher's Stone appears, heralding the success of the operation.[52] The analogy between the alchemical process and the cycle of agricultural generation—of seeds being sown, germinating underground, and sprouting—is first illustrated in the *Opera chemica*, which dates from about 1470 to 1475 and is attributed to Raymond Lull.[53] Similarly, human generation resulting from coitus between the royal couple, the sun and the moon, gestation of the fertilized egg in a dark womb, and the eventual birth of their offspring, often a hermaphrodite, also paralleled the stages through which base metals must pass before becoming silver or gold.[54] Alchemy's adaptation of the mythology of classical antiquity to its own interpretations finds special favor after the fifteenth century.[55] Particularly pertinent to this essay is the verbal and visual imagery developed in alchemy around the myth of Saturn.

Saturn, a Roman god of agriculture who was merged with the Greek divinity Kronos, ruled the universe with his sister-queen, Rhea.[56] Hoping to forestall his prophesied dethronement by one of his children, Saturn devoured each of them at birth. This continued until Rhea bore their sixth child, Jupiter (Zeus in Greek), whom she secretly dispatched to Crete to escape the fate of his siblings. Instead of Jupiter, Saturn swallowed a stone wrapped in swaddling clothes substituted by Rhea. Subsequently, with the help of his grandmother Earth, Jupiter forced his father to disgorge the first five children and to relinquish the throne. Saturn fled to Italy where he reigned over an era of perfect peace and contentment, the Golden Age.

Alchemists discerned in the cycle of Saturn consuming, retaining, and regurgitating his children a parallel to the stages of the alchemical process.[57] However, the exact number, nature, and succession of those stages were the subject of ongoing debate,

as were the colors associated with them.[58] From about the fifteenth century onward practitioners generally recognized three essential phases which were identified with three colors, in order: black, white, and red. Described in a skeletal manner, the first phase involved discovering the *prima materia*—often lead, the basest of metals—and subjecting it to several processes that approximated decomposition, putrefaction, and purification. This "death" of the base material aimed at achieving "a black more black than black itself" (*nigrium nigrius nigro*), a substance called *nigredo*. It was also known as *melencolia*, the state of sadness or madness that was associated with and provoked by black bile, one of the four humors.[59] By the ninth century, a correspondence had been established among the humors, the natures associated with them, certain colors, and specific planets. Consequently, the humor melancholy and the color of black bile were linked to Saturn, as were the metal lead and the *nigredo* phase of the alchemical process.[60]

The eighteenth-century scholar of alchemy Antoine-Joseph Pernety summarized the complex web of associations practitioners attached to Saturn in the following manner:

These Philosophers call the *reign of Saturn* the time the blackness (*nigredo*) lasts, because they name Saturn that same blackness, i.e., the time when hermetic matter, having been placed in the vessel, becomes like melted pitch. . . . The blackness is a result of dissolution. . . . During the blackness or the reign of Saturn, according to the Philosophers, the soul of gold unites with mercury. Consequently, they call this Saturn the *King's tomb* or the *Sun's tomb*. This is when the reign of the gods begins because Saturn is considered to be the father of the gods. This is in effect the Golden Age since the matter which became black contains within it the aurific principle and the gold of the Sages.[61]

This phase in the alchemical process—when the blackness of the reign of Saturn, which is also the Golden Age, envelops the gold that will result from the transmutation—is the subject of a stunning miniature (Figure 62) in the *Splendor Solis* by Solomon Trismosin.[62] Painted probably by Albrecht Glockendon within a border attributed to Simon Bening,[63] the stage of putrefaction is represented as the sun personified by the head of a black man emitting spiked and wavy rays at the moment it slips below the horizon to bury itself in the bowels of the earth.[64] The black sun enters its tomb from which it will rise purified and gold.

The second principal stage is associated with the color white. Called *albedo*, it produces the white elixir which would transmute metals into silver. Silver was the metal of Diana, goddess of the moon, who like Mary the mother of Christ with whom she was often conflated, had remained a virgin.[65]

Red is the color of the final stage, known as *rubedo*. This phase brings forth the red elixir which would transmute metals into gold. The Philosopher's Stone in the red state could be called by many names, as Pernety's list of 120 makes clear.[66] However,

62. After Albrecht Glockendon and Simon Bening. Illumination from Solomon Trismosin, *Splendor Solis*, fol. 49. Last third of sixteenth century. Watercolor on parchment. Staatsbibliothek, Berlin.

the image most frequently associated with the successful completion of the alchemist's work was the phoenix.⁶⁷ (In the context of Queen Elizabeth and her personal iconography, it is interesting to note that the pelican is also a symbol of the red stone.)⁶⁸ For practitioners the phoenix—a fabulous bird with fire red, purple, and gold feathers which lived in Ethiopia, the black land—had special resonance as a symbol of the Philosopher's Stone. In ancient Egypt, which was thought to be the home of alchemical operations, the cult of the fiery phoenix was linked to the cult of the sun. Further significance was found in the fact that the new phoenix rising from ashes would enclose its father's corpse in the trunk of a hollow myrrh tree. Thus, the Ethiopian origins of the phoenix as well as its burial practices were interpreted as parallels to the alchemist working in his furnace to create the black state or *nigredo*.⁶⁹

At this point it may be useful to recall that John Dee, the figure in Elizabeth's entourage who almost certainly was instrumental in shaping the symbols chosen to characterize her as a ruler, was an alchemist of international reputation. By Dee's own account, when his dense alchemical treatise, *Monas Hieroglyphica* was published in 1564, he and the queen read it together.⁷⁰ That the equation between the alchemist's work and the return of the Golden Age was not foreign to Queen Elizabeth is made clear by one of Sir John Davies of Hereford's *Hymnes to Astraea*. In this the first of the twenty-six fifteen-lined poems, Sir John uses an alchemical metaphor to hail ELISA-BETHA REGINA (as the initial letters of each line spell out) as the Virgin Astraea whose return reinstates the Golden Age:

E arly before the day doth spring
L et us awake my Muse, and sing;
I t is no time to slumber,
S o many ioyes this time doth bring,
A s Time will faile to number.

B ut whereto shall we bend our layes?
E uen vp to Heauen, againe to raise
T he Mayd, which thence descended;
H ath brought againe the golden dayes,
A nd all the world amended.

R udeness it selfe she doth refine,
E uen like an Alychymist diuine;
G rosse times of yron turning
I nto the purest forme of gold;
N ot to corrupt, till heauen waxe old,
A nd be refined with burning.⁷¹

KAREN
C. C.
DALTON

Returning to the Drake Jewel (see Figures 51, 52), we encounter once again its three images—the double cameo with profiles of a black emperor and a white woman; Nicholas Hilliard's miniature portrait of Queen Elizabeth I; and the phoenix with its multicolored wings. Viewed individually, each can be interpreted as a manifestation of the queen herself and of her imperial aspirations. The black emperor represents Saturn, imperial ruler of the Golden Age. The woman in profile behind him is the imperial Virgin Astraea who will restore Saturn's reign. As the sovereign who inaugurates the new Golden Age, Elizabeth embodies both Astraea and her predecessor Saturn. (In the frontispiece to John Case's *Sphæra Civitatis* published in 1588, Elizabeth incorporates the sphere of the planets and their corresponding virtues, beginning with "*Maiestas*, the all-embracing imperial virtue as Saturn."[72]) Hilliard's miniature depicts Elizabeth as the virgin moon goddess Cynthia or Diana wearing crescent- and arrow-shaped jewels in her hair. It is in the guise of Cynthia/Diana, as Roy Strong remarks, that Elizabeth "express[es] ideally Dee's concept of the Queen's sway over a maritime empire."[73] (Given his role in helping to implement Elizabeth's idea of empire, it is especially apt that Sir Francis Drake was awarded the jewel by his queen and that the jewel figures prominently in his portraits.) Finally, the phoenix is, as we have seen, one of Elizabeth's personal devices and, like Astraea, a recurrent symbol of "imperial *renovatio*, implying the return of that best rule under the One, when the world is most at peace, and justice, together with all other virtue, reigns."[74]

Viewed in relationship to each other, the images contained in the Drake Jewel symbolize the three stages in the alchemical process required to restore the Golden Age.[75] In this context the black emperor is Saturn the planet and the deity which reigns over the initial black (*nigredo*) stage of the transmutation. Elizabeth as the virgin moon goddess Diana represents the second step, the whitening (*albedo*) phase. The final red state (*rubedo*) is embodied in the classic symbol of the Philosopher's Stone, the phoenix rising from ashes, its brilliantly colored wings spread wide.[76] In the end, of course, each image in this triangle points to Elizabeth the imperial empress, or, as another of her favorite devices called her, the Una, the One and the All. According to the vision projected by this imagery, Queen Elizabeth I is the long-awaited sacred ruler who will restore the Age of Saturn and, from her own person, ever recreate the new Golden Age.[77]

It is interesting to note that Queen Elizabeth I is not the only late sixteenth-century monarch to tailor the imagery of Saturn's Reign Restored to express a combination of dynastic legitimacy, imperial mysticism, and magico-hermetic thought. King Henry IV of France likewise dramatized himself as the incarnation of the imperial *renovatio*. Further, his interest in and support of the alchemical arts were well known.[78] Both strains are evident in the *fêtes* and *entrées* staged in 1600 in honor of

Henry's bride and the new queen of France, Marie de' Medici. To welcome Marie to Avignon, the Jesuit André Valladier composed a program titled *Labyrinthe royale de l'Hercule Gaulois triomphant* ("Royal Labyrinth of the Gallic Hercules Triumphant"). This entry included, as Roy Strong describes it, "an arch dedicated to Henry as Apollo Economo, the god who 'governs the entire Universe by his rays and occult influences,' and in which the king appeared bearing up the celestial sphere, with, below, the inscription *Redeunt Saturnia regna*."[79] Visions of empire and alchemical imagery also combine in an octave written by the son of the astrologer Nostradamus to celebrate Marie's entry into the small town of Salon. Read against the backdrop of France's golden fleur-de-lis and the Medicis' red fleur-de-lis entwined with the sun, the moon, and an imperial crown above, the verse "expressed the hope that from the Union of this Mars and Pallas, this Sun and Moon would be born: 'So many Stars and so many Phoenixes . . . which from all the Universe one day will be able to have various Empires.'"[80]

It is in this context that one can understand the cameos in the candleholder given to Henry IV and Marie de' Medici (Figures 60, 63). As with the Drake Jewel, we encounter a large cameo with the profile of a black emperor joined to that of a white woman. Arrayed to the left and right of it in pairs are eight cameos. Proceeding from the bottom upward, Henry IV and Marie de' Medici are carved in right profile opposite their mythical counterparts, Hercules wearing his signature lion skin and Hebe, goddess of youth and daughter of Jupiter and Juno, to whom Hercules was wed after his ascent to Olympus. Hercules was the classical deity in whose guise Henry IV was most often represented. It is also pertinent to note that in the realm of alchemy Hercules and his labors were synonymous with the process of transmutation. And at times in alchemical treatises Hercules is the magister who conducts the search for the Philosopher's Stone.[81]

Above the pair of double cameos are heads identified by Henry Barbet de Jouy as the emperor Domitian facing Agrippina, next the head of an Omphale opposite a young Roman,[82] and finally the bust of a woman with long, wavy tresses looking toward a half-length figure of a woman wearing a garment that appears to be made of animal skin. It may be that the woman with long hair is Mary Magdalene while the other is Hagar, the two taken together representing the Catholic Church and the Protestant Church. This analogy is established in Henry IV's funeral oration when adherents to the Protestant faith are likened to Hagar and her "bastard" son Ishmael in the wilderness. Henry IV, who converted to Catholicism, is praised in this eulogy for his protection of the "true and unique religion" of the Catholic Church and for his godlike, paternal treatment of Protestants.[83] Directly above the central cameo is a reclining nymph with an Eros, an appropriate scene to decorate a gift intended for newlyweds, while below the black emperor cameo is situated the bust of a woman with her head turned slightly to the right.

63. Anonymous. Candleholder given to Henry IV of France and Marie de' Medici by the state of Venice on the occasion of their marriage (detail). 1600. Polished and carved sardonyx and agate. Musée national du Louvre, Paris.

Like the Drake Jewel, all the glyptics surrounding the central cameo relate to the rulers who are the celebrated subjects of the candleholder. And, once again, the black emperor and his white female companion represent Saturn, the Virgin Astraea, and the return of the Golden Age, in this case in the persons of Henry IV and Marie de' Medici.

This essay does not advance a single or definitive answer to the question, "Who is this black emperor?" Rather it offers an interpretation based on a close examination of two specific works and the contexts in which they existed. We know who offered these works as gifts to whom and when. In the fourth quarter of the sixteenth century an image of a black emperor does not have a fixed significance. It depends on the

context in which it is used, that is to say, at which court, by which sovereign, and, in many cases, on what occasion, and also in which matrix or matrices of ideas it is implanted, whether religious, political, alchemical, astrological, or other. The same can be said for the image of Hercules or Saturn, Diana or Astraea.[84] However, in this case perhaps it is worthwhile to state the obvious: an image of a black emperor does not represent a demon or a black pageboy or a slave for that matter. It represents an emperor whose blackness is not burdened with the medieval, Christian connotations of sin, evil, and death. Rather, associated with the classical imagery of Saturn and the imagery of the alchemical process, this blackness contains within itself not only death and burial but also the resurrection and the seeds of the new Golden Age.

Notes

Note to epigraph: Neil Cuddy, "Dynasty and Display: Politics and Painting in England, 1530–1630," in Karen Hearn, ed., *Dynasties: Painting in Tudor and Jacobean England, 1530–1630*, exhibition catalog, October 12, 1995–January 7, 1996 (London, 1995), p. 19.

1. For a thorough treatment of the efforts of the royal houses of Europe and England to construct genealogies that traced their lineages to Troy, to imperial Rome in the person of Augustus, and to biblical heroes, see Marie Tanner, *The Last Descendant of Aeneas: The Hapsburgs and the Mythic Image of the Emperor* (New Haven: Yale University Press, 1993). See also Roy C. Strong, *Art and Power: Renaissance Festivals, 1450–1650* (Woodbridge: Boydell Press, 1984), esp. pp. 65–97.

2. On the medieval retentions in the Elizabethan Renaissance and the multiplicity of meanings an image could convey, Roy C. Strong writes: "[O]ne begins to wonder whether perhaps Elizabethan portraiture is better regarded as a branch of emblematics in the English Renaissance than placed within the conventional textbook niche allocated to it within the history of art. . . . Inscriptions, emblems, symbolic objects and whole inset scenes are meant to be read separately as well as together; they are not governed by the single perspective viewpoint as re-created by the artists of Renaissance Italy. Ideas and emotions are not expressed through the mask of the face, but transmitted by means of motto and symbol. . . . Elizabeth had not need for such lines of false perspective to draw men's eyes to contemplate her. The basic assumptions of Elizabethan vision suited her court style well, above all because it was more comprehensive, diffuse and ambiguous. The strength of the Elizabethan image lay in its capacity to be read and re-read many ways and never to present a single outright statement which left no room for manoeuvre, as did its successors in the new style. All the riches of Renaissance philosophy and learning could be set into it, but, in a way typical of the Elizabethan age, the outward covering was neo-medieval. Each painting achieves its effect by using a multiplicity of images to construct for its subject a three-dimensional world in which the third dimension is that of time rather than of space; and this is a habit of mind essentially medieval, but perfectly adapted to the needs of a post-medieval age" (*The Cult of Elizabeth: Elizabethan Portraiture and Pageantry* [1977; reprint, Berkeley: University of California Press, 1986], pp. 111–12).

3. Roy C. Strong, *Gloriana: The Portraits of Queen Elizabeth I* (London: Thames and Hudson, 1987), p. 14; Strong, *The Cult of Elizabeth*, esp. pp. 14–16.

4. Strong, *Gloriana*, pp. 120–23. This author also notes (p. 30): "The Renaissance predi-

lection for the cameo was in imitation and emulation of the antique, and the wearing of the Queen's portrait in this manner would appear to have sprung from just such an intellectual framework. It is likely that the fashion was inspired by a passage in which Pliny describes how the Roman emperors wore cameo portraits as part of their personal insignia."

5. National Portrait Gallery, London, inv. no. 2162. Roy C. Strong, *National Portrait Gallery: Tudor and Jacobean Portraits*, 2 vols. (London: Her Majesty's Stationery Office, 1969), vol. I, *Text*, pp. 133–36, no. 2162; vol. II, pl. 265; Strong, *Gloriana*, p. 123, fig. 132. For another portrait of Hatton, this one full-length, holding the same jewel with a cameo of Queen Elizabeth, see *Princely Magnificence: Court Jewels of the Renaissance, 1500–1630*, exhibition catalog, Victoria and Albert Museum, London, October 15, 1980–February 1, 1981 (London: Debrett's Peerage in association with the Victoria and Albert Museum, 1980), p. 104, no. P13 (color reprod.).

6. National Portrait Gallery, London, inv. no. 1807. See Strong, *National Portrait Gallery*, vol. I, pp. 320–21; vol. II, pl. 636; Maurice Howard, *The Tudor Image* (London: Tate Publishing Ltd., 1995), pp. 37–38, fig. 37 (color reprod.). For additional examples, see Roy C. Strong, *Portraits of Queen Elizabeth I* (Oxford: Clarendon Press, 1963), pp. 27–30.

7. See, in addition to the Drake Jewel which will be discussed below, the Armada Jewel in *Princely Magnificence*, p. 60, no. 38 (color reprod.), as well as pp. 60–62, nos. 39 and 42 (color reprods.). For a discussion of the practice of giving and receiving jewels, see Peter Brooke, "Renaissance Jewels in Their Social Setting" in *Princely Magnificence*, pp. 8–11.

8. The Drake Jewel, in the collection of Lt. Col. Sir George Meyrick, Bart., and now on loan to the Victoria and Albert Museum, London, is discussed in *Princely Magnificence*, p. 61, no. 40 (color reprod.). Regarding the jewel's date, *Princely Magnificence* notes: "This exceptionally fine jewel, with its miniature by Nicholas Hilliard, and two-layer sardonyx cameo, dates from 1588, the twenty-ninth year of Elizabeth's reign: careful examination of the miniature has shown that the inscription once recorded this and this [is] compatible with the style of the portrait." See also Diana Scarsbrick, *Tudor and Jacobean Jewellery* (London: Tate Publishing, 1995), pp. 84, 85–86, fig. 67 (color reprod.).

9. On Nicholas Hilliard's miniatures of Elizabeth I, see Erna Auerbach, *Nicholas Hilliard* (London: Routledge and Kegan Paul, 1961), pp. 288–318, nos. 13, 19, 20, 52–56, 83, 84, 127–33, and p. 324, nos. 209, 210; Graham Reynolds, *Nicholas Hilliard and Isaac Oliver*, rev. ed. (1947; London: Her Majesty's Stationery Office, 1971), cat. nos. 4, 42, 47–49, 75–79, 102 (all illustrated); Strong, *Portraits*, pp. 89–93. On Hilliard's influence, see Roy C. Strong, *The English Icon: Elizabethan and Jacobean Portraiture*, Studies in British Art (London and New York: Paul Mellon Foundation for British Art in association with Routledge and K. Paul and Pantheon Books, 1969), pp. 13–15, 17–21.

10. In addition to the two portraits discussed herein, there is a portrait of Drake by Samuel Lane (1780–1859) after yet another picture which belongs to the Drake family. In the Lane portrait the model stands on a balcony beside a large globe on which his hand rests between Africa and South America. Just behind his right shoulder is a stone column, beyond which is visible a three-master at sea. The Lane painting belongs to the Crown Estate/Institute of Directors, London, and is reproduced on the dust jacket of John Cummins's biography of Drake. I have not been able to trace the current location of the original work that Lane copied.

11. The portrait dated 1591 is located in the National Maritime Museum, London (Greenwich), inv. no. BHC2662; see *Armada, 1588–1988*, exhibition catalog, National Maritime Museum, April 20–September 4, 1988; Ulster Museum, Belfast, October 12, 1988–January 8, 1989

(London: Penguin Books in association with the National Maritime Museum, 1988), pp. 226–27, no. 13.21 (color reprod.). For the 1594 portrait, in the possession of Lt. Col. Sir George Meyrick, Bart., see *Princely Magnificence*, p. 105, no. P15 (color reprod.).

12. Virgil *Eclogues* 4.4–10.

13. Frances Amelia Yates, *Astraea: The Imperial Theme in the Sixteenth Century* (London: Routledge and K. Paul, 1975), p. 38. Yates notes the antique use of the phoenix on coins as the symbol of *renovatio*. She remarks: "The return of the golden age and the rebirth of the phoenix are symbols with parallel meanings."

14. Walker Art Gallery, Liverpool, inv. no. 2994. See Strong, *Portraits*, pp. 60–61, no. 23 (illus.).

15. National Portrait Gallery, London, inv. no. 190; Strong, *Portraits*, pp. 60–61, no. 24 and pl. 7. For a color reproduction, see Roy C. Strong, *The Elizabethan Image: Painting in England 1540–1620*, exhibition catalog, Tate Gallery, London, November 28, 1969–February 8, 1970 (London, 1969), p. 44. On the iconography of both Hilliard portraits, see Strong, *Gloriana*, pp. 79–83.

16. British Museum, London, Department of Prints and Drawings, inv. no. O.7-207 M. I p. 285, no. 2; Strong, *Gloriana*, p. 104, fig. 90.

17. For the authoritative treatment of this imagery, see Yates, *Astraea*, pp. 29–87.

18. Strong, *Gloriana*, pp. 94–99 and fig. 79.

19. On John Dee, see Frances Amelia Yates, *Giordano Bruno and the Hermetic Tradition* (1964; reprint, Chicago: University of Chicago Press, 1991), pp. 148–50, 187–88, and Frances Amelia Yates, *Theatre of the World* (London: Routledge and K. Paul, 1969), pp. 1–41; Peter J. French, *John Dee: The World of an Elizabethan Magus* (London: Routledge and K. Paul, 1972); Frances A. Yates, *The Occult Philosophy in the Elizabethan Age* (London: Routledge and Kegan Paul, 1979), pp. 79–114; E. G. R. Taylor, *Tudor Geography, 1485–1583* (London: Methuen, 1930), pp. 75–139. For a recent publication aimed at correcting the view that Dee was "exclusively or even primarily—a Hermetic, Neoplatonic magus'" (p. xii), see William H. Sherman, *John Dee: The Politics of Reading and Writing in the English Renaissance*, Massachusetts Studies in Early Modern Culture (Amherst: University of Massachusetts Press, 1995). Concerning the readers of Dee's text, see Sherman, *John Dee*, pp. 155–56.

20. French, *John Dee*, pp. 182–83.

21. Bodleian Library, Oxford, MS Ashmole 1789, fol. 50. For explications of Dee's drawing, known as the "British Hieroglyphic," and the engraving after it, see Strong, *Gloriana*, pp. 90–93 and fig. 77; Yates, *Astraea*, pp. 48–50; Sherman, *John Dee*, p. 152.

22. John Dee, *General and Rare Memorials Pertayning to the Perfect Arte of Navigation: Annexed to the Paradoxal Cumpas, in Playne: now first published: 24 yeres, after the first Invention thereof*, The English Experience: Its Record in Early Printed Books Published in Facsimile, 62 (1577; reprint ed. Amsterdam and New York: Theatrum Orbis Terrarum and DaCapo Press, 1968), p. 53.

23. Sherman, *John Dee*, p. 149.

24. On the Trojan origins of Arthur's ancestor Brute and the latter's founding of the city of New Troy (London), see Geoffrey of Monmouth, *History of the Kings of Britain* (1138–39), trans. Sebastian Evans, rev. Charles W. Dunn (London: E. P. Dutton and J. M. Dent, 1963), pp. 5–28.

25. French, *John Dee*, pp. 191–99; Sherman, *John Dee*, pp. 148–90, esp. pp. 171–88. Lord Madoc was a Welsh prince who allegedly discovered America in 1170.

26. On Sir Francis Drake and his West Indian voyages during the 1570s, see John Cummins, *Francis Drake: The Lives of a Hero* (New York: St. Martin's Press, 1995); Taylor, *Tudor Geography*, pp. 107–19; *The Dictionary of National Biography from the Earliest Times to 1900*, ed. Leslie Stephen and Sidney Lee (London: Oxford University Press, 1917), vol. V, *Craik–Drake*, s.v. "Drake, Sir Francis," pp. 1331–47.

27. Regarding Drake's dealings with *cimarrones*, his employment of Negro sailors and pilots, and his liberation of several hundred African slaves on Santo Domingo and in Cartagena, see Edmund S. Morgan, *American Slavery, American Freedom: The Ordeal of Colonial Virginia* (New York: W. W. Norton, 1975), pp. 3–43. My thanks to Peter Wood for directing me to this reference.

28. Quoted in Cummins, *Francis Drake*, p. 56. For the mythification of Drake, see Cummins, *Francis Drake*, pp. 258–302.

29. For a careful examination of both the political and the personal considerations involved in this courtship, see Susan Doran, *Monarchy and Matrimony: The Courtships of Elizabeth I* (London: Routledge, 1996), pp. 130–94. See also Wallace T. MacCaffrey, *Elizabeth I* (London: Edward Arnold, 1993), pp. 178–217.

30. Doran, *Monarchy and Matrimony*, p. 130.

31. Ibid., p. 181.

32. Strong, *Gloriana*, pp. 94–99.

33. Pinacoteca Nazionale, Siena, inv. no. 454. Formerly this picture was attributed to Cornelius Ketel (Strong, *Gloriana*, p. 101). However, restoration of the canvas several years ago uncovered the painting's author and its date in an inscription on the base of the globe at right: "1583. Q. MASSYS/ANT." See Alessandro Bagnoli in *Restauri, 1983–1988*, exhibition catalog, Pinacoteca Nazionale, Siena, December 1988 (Siena: Soprintendenza per i Beni Artistici e Storici, 1988), pp. 41–43, no. 11 (illus.). See also Hearn, *Dynasties*, pp. 85–86, no. 40 (color reprod.).

34. Virgil *Aeneid* 1–4. For detailed explications of the iconography of the carved column in this portrait of Elizabeth, see Yates, *Astraea*, pp. 114–17; Strong, *Gloriana*, pp. 103–7.

35. Woburn Abbey, Woburn, inv. no. 1383; Strong, *Gloriana*, pp. 130–33, fig. 138. Two other versions of this picture exist, one of which may have been commissioned by Sir Francis Drake; see Hearn, *Dynasties*, p. 88, no. 43 (color reprod.), and *Armada, 1588–1988*, p. 270 (color reprod.), p. 274, no. 16.1. The Tabitha Barber quotation is from her catalog entry in *Dynasties* (p. 88, no. 43).

36. *Portraits and Propaganda: Faces of Rome*, exhibition catalog, List Art Center, Brown University, Providence, R.I., January 21–March 5, 1989 (Providence, R.I.: Brown University, 1989), esp. pp. 13–18.

37. British Museum, London, inv. no. S1; see *Princely Magnificence*, pp. 58–59, no. 35 (color reprod.). For additional examples of portraits of Elizabeth "à l'antique," see ibid., pp. 58–62, nos. 32, 33, 34, 38, 41–44, all reproduced in color. See also Strong, *Gloriana*, pp. 120–22.

38. Victoria and Albert Museum, London, inv. no.: M81-1935; *Princely Magnificence*, p. 60, no. 38.

39. For the cameos with black emperors, see Ernest Babelon, *Catalogue des camées antiques et modernes de la Bibliothèque nationale* (Paris: Ernest Leroux, 1897), pp. 286–89, nos. 594, 595, 596, 597, 599, 600, 602, 603, 607 and pls. LIX, LX; Fritz Eichler and Ernst Kris, *Die Kameen im Kunsthistorischen Museum: Beschreibender Katalog* (Vienna: Verlag von Anton Schroll, 1927), pp. 139–40, nos. 189, 190, 194 and pl. 40; O. M. Dalton, *Catalogue of the Engraved Gems of the Post-Classical Periods in the Department of British and Mediaeval Antiquities and Ethnography in the British Museum* (London: British Museum, 1915), pp. 32–33, nos. 215, 217, 218, 219, 220,

222, 223, 224, p. 60, nos. 434, 436, and pls. IX, X; Juliia Osvaldovna Kagan, *Western European Cameos in the Hermitage Collection* (Leningrad: Aurora Art Publishers, 1973), p. 63, no. 41a, b (illus.); Ernst Kris, "Notes on Renaissance Cameos and Intaglios," *Metropolitan Museum Studies* 3 (1930–31): 7, figs. 15, 16, and p. 11. Babelon also cites and reproduces a black king wearing a royal crown (p. 286, no. 593 and pl. 59).

40. Musée national du Louvre, Paris, Département des Objets d'art, inv. no. MR 251. For the cameos juxtaposing a black emperor and a white woman, see Babelon, *Catalogue*, pp. 288–89, nos. 602, 603. Specifically concerning the candleholder, see Henry Barbet de Jouy, *Notice des antiquités, objets du Moyen Age, de la Renaissance et des temps modernes composant le Musée des souverains*, 2nd ed. (Paris: Musées impériaux, 1868), pp. 162–63, no. 103; Ernest Babelon, *Histoire de la gravure sur gemmes en France depuis les origines jusqu'à l'époque contemporaine* (Paris: Société de propagation des livres d'art, 1902), pp. 142–44, fig. 48; Ernst Kris, *Meister und Meisterwerke der Steinschneidekunst in der italienischen Renaissance*, 2 vols. (Vienna: Verlag von Anton Schrol, 1929), vol. I, *Textband*, pp. 90, 177, nos. 417, 418, and vol. II, *Bilderband*, pl. 98. I wish to thank M. Daniel Alcouffe for providing me a copy of the Barbet de Jouy reference.

41. The cameos pairing a black emperor and a white emperor are located in the Metropolitan Museum of Art, New York, inv. no. 38.150.12, and the Hermitage Museum, St. Petersburg, inv. no. K4938. The Roman emperor in the Hermitage's cameo is Augustus; the one in the Metropolitan's cameo is unidentified.

42. See Kris, *Meister und Meisterwerke*, vol. 1, pp. 89, 176, no. 93; vol. 2, p. 93, figs. 399, 400; Kris, "Notes on Renaissance Cameos," p. 11.

43. For portraits of Philip the Arab, see Johann Jacob Bernoulli, *Römische Ikonographie*, 2 vols. in 4 pts., vol. 2, *Die Bildnisse der römischen Kaiser und ihrer Angehörigen*, pt. 3, *Von Pertinax bis Theodosius* (Stuttgart, Berlin, Leipzig: Union Deutsche Verlagsgesellschaft, 1894; reprint, Hildesheim: Georg Olms Verlagsbuchhandlung, 1969), pp. 140–44 and pls. 60–62, Münztaf. 4,8; Chris Scarre, *Chronicle of the Roman Emperors: The Reign-by-Reign Record of the Rulers of Imperial Rome* (London and New York: Thames and Hudson, 1995), pp. 166–68.

44. Babelon, *Catalogue*, p. lxxxv.

45. Ibid., pp. lxxxv, 287.

46. These observations are based on an examination of the 1,050 Adoration of the Magi executed between 1400 and 1699 that are inventoried in the Image of the Black in Western Art Research Project and Photo Archive at Harvard University. A calculation of the total number of Adoration scenes cataloged for a given geographical area compared with the number in which the black king is presented as a Roman emperor, yields the following data:

	1400–1499		1500–1599		1600–1699	
	Total	*Emperor*	*Total*	*Emperor*	*Total*	*Emperor*
Austria	18	0	2	0	1	0
Flanders	49	0	168	30	132	2
France	12	0	8	1	32	0
Germany	92	0	118	5	10	0
Italy	25	0	85	1	53	1
Netherlands	18	0	76	7	59	0
Spain	3	0	25	1	40	2
Switzerland	4	0	6	0	0	0
Other	4	0	9	0	1	0

47. Musée des Beaux-Arts, Valenciennes, inv. no.: 46-1-16; see Armin Zweite, *Marten de Vos als Maler: Ein Beitrag zur Geschichte der Antwerpener Malerei in der zweiten Hälfte des 16. Jahrhunderts* (Berlin: Gebr. Mann Verlag, 1980), pp. 216–17, 310, no. 90 and pl. 111. The only exceptions I have found to this statement appear in works by Italian artists: one by Andrea Meldolla, called lo Schiavone (ca. 1547; Pinacoteca Ambrosiana, Milan, inv. no.: 198); a second by Giorgio Vasari dated 1547 (Chiesa di San Fortunato, Rimini); and a third in a mid-seventeenth-century picture by Orazio Talami (Chiesa di San Filippo Neri, Reggio Emilia). In all these instances, the middle-aged white king is represented as a Roman emperor, and the black king is not.

48. Although not represented in an Adoration of the Magi scene, an important forerunner of this iconography is the black standard-bearer clad in cuirass and *paludamentum* in canvas 1 of Andrea Mantegna's *Triumphs of Caesar*. This series of nine paintings was created for the Gonzaga family in Mantua in the late 1480s and early 1490s. The canvases, now at Hampton Court Palace, went to England in 1629–30 when Charles I purchased part of the Gonzaga collection. However, Mantegna's *Triumphs* could have been known earlier in England from engravings, including three made by Hans Holbein the Younger in 1517–18. See Andrew Martindale, *The Triumphs of Caesar by Andrea Mantegna in the Collection of Her Majesty the Queen at Hampton Court* (London: Harvey Miller, 1979).

Two paintings by Spanish artists date from the seventeenth century. The first, by Pedro López, is dated 1608 and is located in Parroquia del Salvador, Toledo. The second was painted in the second half of the seventeenth century by an anonymous artist. It belongs to a private collection in Madrid.

49. See Christopher Brown, "British Painting and the Low Countries, 1530–1630," in Hearn, *Dynasties*, pp. 27–31.

50. Jacques van Lennep, *Alchimie: Contribution à l'histoire de l'art alchimique*, 2nd ed., rev. and enl. (Brussels, Crédit Communal de Belgique, 1985), p. 10.

51. For both Taylor and Roberts see Gareth Roberts, *The Mirror of Alchemy: Alchemical Ideas and Images in Manuscripts and Books from Antiquity to the Seventeenth Century* (London: British Library, 1994), p. 66.

52. Lennep, *Alchimie*, pp. 51–52, fig. 7.

53. Ibid., pp. 78–81, figs. 61–64.

54. For miniatures from a late fifteenth-century manuscript, *Donum Dei*, illustrating this process, see ibid., pp. 87–88, figs. 82–88. On this same subject, see Roberts, *The Mirror of Alchemy*, pp. 82–91.

55. See Roberts, *The Mirror of Alchemy*, pp. 74–78.

56. On the merging of Saturn and Kronos, see Raymond Klibansky, Erwin Panofsky, and Fritz Saxl, *Saturn and Melancholy: Studies in the History of Natural Philosophy, Religion, and Art* (London and New York: Thomas Nelson and Basic Books, 1964), pp. 133–35.

57. A manuscript titled *De Alchimia* dating from about 1526 includes a full-page miniature of Saturn and his children as exempla of the alchemist's work; see Lennep, *Alchimie*, pp. 98–99, fig. 109.

58. For clarifying summaries of the conflicting opinions on this matter, see Roberts, *The Mirror of Alchemy*, pp. 55–63; Lennep, *Alchimie*, pp. 28–30.

59. Lennep, *Alchimie*, pp. 30, 305.

60. Ibid., p. 30; Klibansky, Panofsky, and Saxl, *Saturn and Melancholy*, pp. 14, 127, 137.

61. Antoine-Joseph Pernety, *Les fables égyptiennes et grecques dévoilées et réduites au même*

principe, avec une explication des hiéroglyphes et de la guerre de Troye (Paris, 1786), vol. 1, p. 570, quoted in Lennep, *Alchimie*, p. 305 (my translation).

62. Staatsbibliothek Preussischer Kulturbesitz, Berlin, Handschriftenabteilung, Cod. germ. fol. 42, fol. 49. For an analysis with illustrations of the *Splendor Solis*, plus a list of its various manuscripts, the earliest of which dates from 1532 to 1535, see Lennep, *Alchimie*, pp. 110–29.

63. Regarding the attribution of these miniatures, see Lennep, *Alchimie*, pp. 111–14. Lennep notes several connections between the artists and the styles of the *Splendor Solis* and a *Missal* executed for Albert of Brandenburg in 1524. He also indicates that one scholar argues that the *Splendor Solis* was created for Albert of Brandenburg. This Renaissance prince and Maecenas, who was elected archbishop of Magdeburg in 1513 and made cardinal by Leo X in 1518, supported the development of the iconography of Maurice as a black saint. It was during his tenure that the veneration of the black Maurice reached its apex. One suspects that more than coincidence may be at work in the depiction of Saturn and Saint Maurice as black men in works realized for Albert of Brandenburg. On the spread of the cult of the black saint Maurice under Cardinal Albert's patronage, see Jean Devisse and Michel Mollat, *The Image of the Black in Western Art*, vol. II, *From the Early Christian Era to the "Age of Discovery"* (Cambridge, Mass., and London: Menil Foundation and Harvard University Press, 1979), part 2, *Africans in the Christian Ordinance of the World (Fourteenth to the Sixteenth Century)*, pp. 182–202.

64. In illustrations of alchemical writings, neither Saturn nor the *nigredo* stage is portrayed consistently as a black person. However, for an alchemical interpretation of a seventeenth-century painting by Gerbrandt van den Eeckhout in which a black youth signifies the *nigredo* stage, see Laurinda S. Dixon and Petra Ten-Doesschate Chu, "An Iconographical Riddle: Gerbrandt van den Eeckhout's *Royal Repast* in the Liechtenstein Princely Collections," *Art Bulletin* 71, no. 3 (December 1989): 610–27. (For depictions of Saturn in contexts other than alchemy, see Klibansky, Panofsky, and Saxl, *Saturn and Melancholy*, pp. 196–214.) The author currently is preparing an essay on the verbal and visual imagery of blackness and blacks in alchemy.

Regarding the sun's rays, they are represented in the same manner in John Dee's drawing for the title page of his *General and Rare Memorials Pertayning to the Perfect Arte of Navigation* (see Figure 57), in the initial illumination of Solomon Trismosin's *Splendor Solis* (see Lennep, *Alchimie*, p. 114, fig. 159), and on the summit of the obelisk erected for the entry of Henry IV in Rouen in 1596 (see Strong, *Art and Power*, fig. 11). The same is true of the sun behind the Virgin in a painting titled *La Vierge alchimique* in the Musée des Beaux-Arts of Reims (reproduced in Lennep, *Alchimie*, p. 307, fig. 15). Also, it is interesting to note that in Marten de Vos's *Adoration of the Magi* cited earlier (see Figure 61), the child attending the black king wears a crown of feathers and wavy arrows radiating outward. In alchemical imagery the arrow symbolizes the fire necessary to effect the merging of the volatile and fixed properties of the materials in the transmutation process. The dragon, such as the one perched on the chambered nautilus held by the black king, is equated with the *prima materia*, which is a prerequisite to beginning the alchemical process. Likewise, the ram's head on the hilt of the black king's sword brings to mind the alchemical symbol for red sulphur, which is, along with mercury, one of the principal components of the Philosopher's Stone. Further, Vos's representation of Melancholy, which includes vessels used by alchemists, indicates that at the very least he had some knowledge of alchemy. (On the significance in alchemy of the images pointed out above, see Lennep, *Alchimie*, pp. 60, 82, 25, 304, fig. 10.)

65. Lennep, *Alchimie*, pp. 30, 37.

66. Ibid., p. 31.

67. For images of the phoenix as the red Philosopher's Stone, see ibid., p. 66, fig. 37; pp. 98–99, fig. 110; p. 167, fig. 69; p. 206, fig. 187; pp. 220–21, fig. 207; Roberts, *The Mirror of Alchemy*, p. 30, fig. 15; Johannes Fabricius, *Alchemy: The Medieval Alchemists and Their Royal Art* (Copenhagen, 1976; rev. ed., London: Diamond Books, 1994), pp. 207, 209.

68. Just as the phoenix was self-renewing, so the pelican, with its ability to provide nourishment to others from its body, could "feed" base metals and increase the amount of gold produced in the alchemical process. (One of the tenets of alchemy is that all metals can be "grown" and perfected until they become either silver or gold.) See Lennep, *Alchimie*, pp. 42, 146, fig. 276; p. 147, fig. 279; pp. 220–21, fig. 207.

69. On the origins of alchemy in Egypt, see Roberts, *The Mirror of Alchemy*, pp. 18–19, and Lennep, *Alchimie*, pp. 10–13. Both authors note that some think the word *alchemy* comes from the ancient Coptic name for Egypt, *khemi* or *khoumi*. Lennep remarks (p. 11): "To this hypothesis which recognized in the land of Cham (*Chamia*), the biblical ancestor of the black race, the very origins of the [alchemical] art, was added the name of a Theban city, Chemmis, which was devoted to the god Pan. Alchemists did not fail to draw symbolical conclusions and relate the image of the black land to one of the phases of the process which consisted of 'blackening' the metal, of calcinating it (the *nigredo* stage)" (my translation).

70. See C. H. Josten, "A Translation of John Dee's *Monas Hieroglyphica* (Antwerp, 1564), with an Introduction and Annotations," *Ambix* 12, nos. 2 and 3 (June and October 1964): 88, 89.

71. Sir John Davies, *Hymnes to Astræa* (London, 1599), "Hymne I. Of Astræa," in *The Complete Poems of Sir John Davies*, ed. Alexander B. Grosart, 2 vols. (London: Chatto and Windus, 1982), vol. 1, p. 129.

72. Bodleian Library, Oxford, shelfmark Byw.L.4.6; Strong, *Gloriana*, p. 133, fig. 140. Regarding the image of Elizabeth at the beginning of John Case's *Sphæra Civitatis*, Strong notes: "The analogy of the parallel structure of heaven and earth is identical with that used by imperial theorists to justify the rule of the Holy Roman Emperor." Verses accompanying the woodcut praise Elizabeth as Astraea establishing the new Golden Age.

73. Strong, *Gloriana*, pp. 124–27. For a reproduction of another Hilliard miniature depicting Elizabeth as Cynthia or Diana, see p. 124, fig. 133.

74. Yates, *Astraea*, p. 66.

75. An alchemical treatise titled *Aureum seculum redivivum* ("The Golden Age Restored"), which presents the creation of the Philosopher's Stone as the restoration of the earlier and better era, was printed in a seventeenth-century compilation called *Musæum Hermeticum* (1625). For Arthur Edward Waite's English translation of this text, see *The Hermetic Museum, Restored and Enlarged: Most Faithfully Instructing All Disciples of the Sopho-Spagyric Art How that Greatest and Truest Medicine of the Philosopher's Stone May Be Found and Held*, 2 vols. (London: James Elliott, 1893), vol. 2, pp. 57–67.

76. I wish to thank Coureton C. Dalton for suggesting that I see the images in the Drake Jewel in the order presented herein, thereby enabling me to understand the three as representing the stages in the alchemical process.

77. For a different interpretation of the Drake Jewel, see Kim F. Hall, *Things of Darkness: Economies of Race and Gender in Early Modern England* (Ithaca, N.Y.: Cornell University Press, 1995), pp. 222–26.

78. Lennep, *Alchimie*, pp. 24, 198.

79. Strong, *Art and Power*, p. 71.

80. Ibid.

81. Ernest Babelon (*Histoire de la gravure sur gemmes en France*, p. 144) identifies the female in the cameo with Hercules as Omphale, the queen of Lydia to whom Hercules was enslaved as punishment by Zeus. While in her service, Hercules grew effeminate, wore women's clothes, and spun yard. This seems an improbable association to recall on a present to a recently married royal couple. It seems more likely that Hercules' companion in the cameo is Hebe, whom he married after he took his place as one of the twelve gods of Olympus. Babelon also sees in Hercules and Omphale/Hebe portraits of Alfonso d'Este II, duke of Ferrara, and his wife Lucretia di Cosimo de' Medici, duchess of Ferrara. However, given the identification between Henry IV and Hercules, that seems questionable. Further, it is difficult to understand what relevance Alfonso II and Lucretia would have on a candleholder created for two royal newlyweds. Lucretia died at the age of sixteen in 1569 after less than a year of marriage to Alfonso II (1533–97), certainly not the sort of bad fortune one would wish Henry IV and Marie de' Medici.

Regarding Henry IV as Hercules, see Françoise Bardon, *Le portrait mythologique à la cour de France sous Henri IV et Louis XIII: Mythologie et politique* (Paris: Editions A. and J. Picard, 1974), pp. 98, 116–21; Strong, *Art and Power*, pp. 24–25, 70. On the image of Hercules in alchemy, see Lennep, *Alchimie*, pp. 234, 287, 451.

82. Barbet de Jouy, *Musée des souverains*, pp. 162–63, no. 103.

83. See André Valladier, *Harangve fvnebre de Henry le Grand qvatriesme de ce nom, tres-inuincible & incomparable roy, de France & de Vauarre, d'eternelle memoire* (Paris: Sébastien Cramoisy, 1610), pp. 90–91: "C'est assez à vn bon Roy Catholique, sur tout qui porte le nom de tres-Chrestien pour le zele qu'il doit à la vraye et vnique religion, à la seureté de la côscience, & à la gloire du Dieu qu'il adore, & qui demande aussi bien compte aux Roys de leurs actions, comme aux autres premierement de faire en toutes choses distinction, de la vraye & ancienne Religion, avec l'errante, & la nouuelle: se souuenant que la Catholique est l'enfant legitime de la couche nuptiale de Sara, la ou la pretendue n'est que la bastarde de la seruante Agar: & partant que celle-la comme l'heritiere de la grace Euangelique doit estre precipuee, & priuilegee en toutes choses, & maintenue eu ses droicts immemoriaux de tous les siecles; la ou ceste-cy ne doit subsister que par soufrance, & tolérance; par pitié, & pour le desir de la sauuer avec douceur, & par voyes paternelles, & raisonnables, côme pere cômun, auec affection neantmoins de pere puisque Dieu, mesme se daigna de faire sortir miraculeusement vne fontaine pour subuenir à la soif du bastard Ismaël, & de la mere Agar."

84. Françoise Bardon (*Le portrait mythologique*, pp. 276–77) summarizes the molding of classical imagery by Renaissance rulers: "Les mêmes caractères de simplification et de polyvalence reparaissent au niveau des thèmes différenciés et proprement mythologiques. D'abord ces thèmes sont très peu nombreux: Hercule, Jupiter, Apollon, le Triomphateur romain debout, à cheval ou dans un char, pour le roi et le prince, les deux premiers employés avec la même fréquence pour Henri IV et pour Louis XIII, les derniers exploités surtout pour Louis XIII. Diane sert pour toutes les reines, les princesses du sang, telle Christine de Bourbon, les favorites, telle Gabrielle d'Estrées. . . . La rareté des thèmes implique leur polyvalence. L'obélisque des travaux d'Hercule, érigé à Rouen en 1597, en l'honneur d'Henri IV, renvoyait aux victoires du roi sur la Ligue, mais le sixième emblème peint à Aix en 1624 ou la gravure du frontispice de *l'Histoire des Gaules* en 1643 représentaient encore un Hercule terrassant l'hydre, or l'hydre désignait cette fois l'hérésie protestante! . . . Autre règne, autres ennemis—autres et identiques, car c'est toujours le monarque qui doit vaincre les ennemis, quels qu'ils soient, c'est-à-dire tous

KAREN
C. C.
DALTON

ceux qui s'opposent à l'unité monarchique. Ainsi, le modèle mythologique est à la fois con-
traignant et vacant. La vacuité et la mobilité des thèmes servent à fixer l'idéologie monarchique.
Ajustée au portrait du roi, la mythologie est analogue à une citation: on lui fait dire n'importe
quoi, pourvu qu'elle glorifie le souverain, *hic et nunc*, et pour l'éternité. . . . Le modèle des divers
travaux légendaires [d'Hercule] facilitait toutes ces variations, d'où la prospérité du thème, mais
il faut aller plus loin et voir que tout se passe comme si la valeur contraignante du thème était
corrigée par son ubiquité en même temps qu'elle est récupérée par l'idéologie royale. Le lieu de
l'imaginaire monarchique est précisément là, dans cette continuité stricte et assouplie, dans cette
violation du modèle mythologique qui, forcé, renaît sans être jamais mort. On fait de l'autre
avec du même. Monotones et polyvalents, les thèmes mythologiques sont également simplifiés,
parce qu'ils ont à exprimer quelque chose de précis et de fort: la puissance du Prince, la perma-
nence de la monarchie, et cela s'ajoute à ce qui n'est pas un thème: le portrait du prince vivant."

6. STAGING WOMEN'S RELATIONS TO TEXTILES IN SHAKESPEARE'S *OTHELLO* AND *CYMBELINE*

SUSAN FRYE

Women's Historic Relations to Textiles

In Shakespeare's *Othello* and *Cymbeline* handkerchiefs, sheets, tapestries, and purses become intertwined with violence when these plays stage but also disrupt women's historic relation to textiles. In early modern England, women were valued in part through the textiles that they both produced and consumed. Not only did women clothe themselves and their families, women made up the bulk of the laborers who carded and spun the wool that was England's primary export and internal resource. Poorer women and children as well as the servants of wealthier people carded wool, while working-class women and gentry alike spun wool and flax.[1] Women also wove wool and flax, together with some silk and cotton, despite the weavers' guilds' increasing prohibitions against women weaving for profit in towns and cities.[2] With the cloth resulting from this labor, women sewed their family garments and the household linen that they frequently owned, including the bed ticking, napkins, sheets, and, by the late sixteenth century, small distinctive items like handkerchiefs and purses that could easily be given as gifts.

Women's textile work situated them within networks of exchange because the textiles so often produced by women were central to the household, community barter, the marketplace, and a gift economy through which social alliances were confirmed.[3] Once the family's immediate needs were provided for, women in agricultural and other working households carded, spun, and wove cloth to sell or barter in order to supplement the household income, while still others labored for minimal wages as seamstresses. In this period before "leisure" was considered appropriate for women, women of the aristocracy, gentry, and merchant classes used the time not spent in immediate domestic tasks to perform needlework, creating the more finished objects that acted as indications of class and status. Working in response to a society whose principal marker of class was textiles, women embroidered shirts, vests, and coifs, lace, napkins and handkerchiefs, bed testers and covers, bench and (in the seventeenth century) chair cushions, needlework hangings, gloves, and book covers. Painstakingly embroidered objects worked in vivid silks as well as silver and gilt added substantially to the wealth of the household because they rivaled professionally produced textiles in their beauty and complexity. Even wealthy women sewed, although they were able to sup-

plement their domestic output by commissioning and consuming articles of clothing and tapestries.

The lives of early modern English women—which varied much according to locale and class—grew out of and were formulated through the complex associations among women who worked together, talked together, exchanged services and domestic items, competed with one another, on occasion took one another to court, and who interacted with one another through the complex distinctions of race, class, and wealth.[4] Geertruid Roghman's engraving of two women performing handiwork (Figure 64) provides a woman artist's view of the women's associations implicit in textile work. The domestic culture of the Netherlands at this time closely paralleled that of England in a number of ways, as is evident in the books of needlework patterns and other self-help books that passed easily across the channel in both English and Dutch.[5] Because the Dutch had the wealth and technical expertise to paint interior domestic scenes, and a fascination with both the morality and inherent sensuality of the domestic world, they left a visual legacy that is useful in understanding English domestic life as well. In Roghman's engraving, the woman on the right, who is sewing, pauses in the act of pulling her thread to look intently at her companion as if gravely considering her. This second woman, whose elevated feet indicate that she is making lace, is bowed over her work, yet from the corner of her eye casts a glance at the sewing woman that suggests she is aware of her gaze. Their subtle interaction implies a silent interval in the midst of an ongoing if mysterious conversation, Roghman's image of a complex relationship between women enacted over and through textiles.

Not only did women connect through textiles, the designs of their needlework—from patterns shared among women and duly recorded in "spot samplers" (samplers on which women worked the patterns that they learned from relatives and neighbors for future reference) to complex narrative pictures of Old Testament themes—bear witness to women's lives and affiliations. Women's textiles, especially those featuring designs, attest to the different ways in which women's activity was interpreted in the early modern period: from the perspective of the dominant masculinist culture, women's intimate connections to textiles might ensure their appropriate chastity, silence, and obedience. As the "water poet" John Taylor admonishes in his *Praise of the Needle*, a popular pattern book first published in 1631 (whose frontispiece duplicates that of a Dutch book on needlework), the needle "Will intreate [women's] peace, inlarge their store, / To use their tongues lesse, and their Needle more."[6] A woman's intricate and beautiful working of a transferred print of Esther and Ahasuerus, hanging in a house that was customarily owned by a man, might well be interpreted as the fruit of appropriate female labor. From the perspective of women's lives, however, such work embodied both the process of sewing within a network of household and community connections and a representation of each woman's self-perceived loca-

64. Geertruid Roghman. *Women Sewing*. 1600. Engraving. Rijksmuseum, Amsterdam.

tion within that community. As the artist Manuel Vega recently commented about Yoruba beadwork, "nothing is decorative—everything is a . . . coded language. Once you know the code, you can read the coded language like a paragraph in a book."[7] Women's domestic needlework, like Yoruba beadwork or the patterns woven within Oriental carpets, encoded ways of seeing the world.

To many of us at the turn of the twenty-first century, the texts that speak the loudest are those that are written or spoken. But in Western culture, as in many others, women have traditionally told stories in cloth. Texts and textiles are connected not only through the stories that both tell, but also through the ways that the basic material is produced: Linda Woodbridge points out that "'Text' and 'textile' come from Latin *textus*, that which is woven."[8] Traditionally, women wove or embroidered cloth to tell a story, as in the tradition of Philomel who made her story into "a tedious sampler" (*Titus Andronicus* 2.4.39). In England from about 1600 to 1700, thousands of women worked a limited range of designs and narratives. Stories from the Old Testament were particularly popular. In the seventeenth century, women could choose a variety of narrative designs from printers like Peter Stent, who controlled the line of prints available.[9] Typically, women chose a limited range of prints to have transferred onto linen or silk, and they paid a man at the print shop to do so, as Mall Berrie does in *The Fair Maid of the Exchange*.[10] The subjects that they regularly chose included the Judgment of Solomon, Judith and Holofernes, and Susannah and the Elders. The most popular subject for a needlework panel was that of Esther, who, silenced by the conditions of her marriage, nevertheless gains the attention of her emperor-husband and saves her people from genocide at the hands of the emperor's adviser, Haman. A needlework panel dated 1652 (Figure 65), chronicles both the meeting of Esther and Ahasuerus, in which Esther gains the attention of her husband, and that meeting's eventual outcome, with her success visible in that her enemy, Haman, is shown hanging from the gallows in the upper right. Not only such narrative pictures, but also popular patterns, like the peascod and the strawberry, could be had at a shop, although women themselves frequently transferred them from spot samplers, drew them, or pricked them out onto linen and silk from published pattern books like John Taylor's. Women's historical textiles featuring design simultaneously express women's outward conformity to a masculinist ideal of female behavior and illustrate the possibilities and limits of their lives.

Historians of visual culture have for the most part paid little attention to women's domestic textiles, much less to the female culture that produced them. Between Burckhardtian humanism and Berensonian connoisseurship, not only women artists but also female textile workers and consumers have been occluded from view. For Jakob Burckhardt the study of Renaissance culture permitted the "discerning and bringing to light the full, whole nature of man"—a perspective that included the mention of upper-class women as having "the mind and the courage of men." Although

65. Anonymous. *Esther and Ahasuerus*. 1652. Needlework panel. Glasgow Museums: The Burrell Collection.

Burckhardt was paying women the highest compliment of his time and certainly esteemed exceptional women as worthy of study in his account of the Italian Renaissance, subsuming all women into the intellectual category of men collapses women into a single class while preventing an exploration of women from within their own ways of seeing.[11] In contrast to Burckhardt, Bernard Berenson pursued the study of a specifically visual culture in the Renaissance through the conscious erasure of historical context. In developing and popularizing Giovanni Morelli's concept of "scientific connoisseurship," writes Mary Ann Calo, Berenson emphasized "the study and attribution of paintings based on careful scrutiny of morphological detail."[12] As he explained in "Decline and Recovery in the Figure Arts," "In every instance we shall begin with the decorative elements, and while doing so we shall ignore the other elements whether spiritual or material, social or political."[13] Burckhardt's humanism and Berenson's formalism have been critiqued by historical, economic, postmodern,

racial, ethnic, and feminist analyses, but such critiques still exist at the margins of art history. The move within the discipline to include and analyze women's textiles from the sampler to the quilt began in the mid-1970s when Miriam Schapiro and Judy Chicago first produced textile pieces together with art criticism that simultaneously challenged the absence of women from art history and sought to recognize the importance of women's textiles to visual culture, both in the past and in the present.[14] Recovering women's contributions to the visual culture of everyday life allows us to reassert the female context in which they were produced—the associations of women that they recall as well as the meanings they once held for women.

Despite the production and analysis of women's textiles that began thirty years ago, the continuing search in art history for what Dinah Prentice has called the "incorruptible truth of appearances" in wishful correspondence with "an apparently incorruptible truth" continues to hold the study of textiles as insignificant alongside, say, paintings in oils that have more successfully transformed canvas cloth into permanent images.[15] Cloth is, after all, foldable, malleable, and mobile: as clothing it folds away in a chest as easily as it takes on the shape of its wearer; a handkerchief slips into a pocket or up a sleeve; and tapestries were frequently transported from house to house by wealthy owners. Because cloth incurs hard use, it is not as durable as painting or sculpture. Yet the centrality of cloth in everyday life, the fact that it was produced, consumed, and actively used—that it touched, covered, and wrapped the human body [16]—makes it of primary importance in the attempt to recover the structures of everyday life in early modern England. Historical women were valued within these economic and social structures that women themselves helped to create and perpetuate, and which afforded them no small degree of identity and agency (where *identity* describes the consciously or unconsciously constructed "self" of the interpellated subject through the discursive systems at hand, and *agency* describes the actual choosing of forms of representation from within those discursive systems as the means to construct identity). Since cultural artifacts were prized in their day for contributing to a household's wealth and women's worth, textiles and the social practices surrounding them are evidence of the materiality of women's agency, however limited by constructions of the feminine from within masculinist cultures. As bell hooks points out in *Art on My Mind: Visual Politics*, "Representation is a crucial location of struggle for any exploited and oppressed people asserting subjectivity and decolonization of the mind."[17] In their textile work, English women represented themselves through narrative pictures and patterns that can be read as locations of their struggle for identity.

The "fictional" textiles of *Othello* and *Cymbeline*, which I term "staged" or "represented," are not the same textiles present in the "real" world outside the playhouse, which I term "historical" or "everyday." The difference between the staged and the historical textiles is the extent to which they are interpreted and possessed by men.

In the everyday world, men did interpret women's textile production—as work that contributed to their households, as well as evidence of the sort of virtuous activity thought to testify to women's chastity. These plays, however, to a large extent strip staged women of even the predictable masculinist values assigned to their work. As a result, the staged women of these plays find it difficult to use textiles to prove their worth and virtue. Instead, textiles mark and then signify the contested female body, which can be possessed entirely by men and, thus reduced, may be disposed of violently. The plays' separation of textiles from the everyday world of women redefines how female characters act and interact, with violent consequences for Desdemona and Emilia in the tragedy of *Othello* and with the threat of violence for Imogen in the romance *Cymbeline*.

The relation between historical women's lives and the plays is therefore complex. While any staged representation necessarily reconfigures a great many factors present in everyday life, from time and space to speech itself, these plays violently conflate women with cloth until they are perceived *as* cloth—cloth that is simultaneously metaphor and stage property, a representation and material embodiment of the female characters' suspected infidelity. The plays rewrite the forms of represented identity available to English women through textiles in order to make textiles metonymic of women's bodies. This symbolic reconfiguration of the agency and identity that historical women depicted in their textiles enables a radical concision and reduction of representation that in turn allows the plays to gain symbolic access to their staged bodies.

Women's historic relation to textiles contrasts so greatly with the staged relation that the gap between the two creates a double way of experiencing the plays. First, the staged textiles continue to materialize women's historic relations to cloth as its producers and consumers. As Marx writes with reference to art, "Production not only creates an object for the subject, but also a subject for the object."[18] When we consider objects as constituting "subjects who in turn own, use, and transform them," as Margreta de Grazia, Maureen Quilligan, and Peter Stallybrass urge us to do in their introduction to *Subject and Object in Renaissance Culture*,[19] then we can use these and other plays as part of the attempt to recover the early modern connection between women's textiles and the subjectivity that they enabled and inscribed. At the same time that *Othello* and *Cymbeline* register women's historic connection to textiles, however, the plays generate their violent narratives from the disruption of the material relation between female subject and textile object. Because the plays' readings work to circumscribe the relation between subject and object, staged woman and textile, in *Othello* and *Cymbeline* women tend to *become* the cloth rather than its producers and consumers.

Othello's use of the purse, the wedding sheets, and, most important, the strawberry-embroidered handkerchief draws on a powerful visual semiotic of the connections textiles expressed and enforced between men and men, women and women, and women and men—categories whose maintenance required the definition and exclusion of exoticized "other" races, other customs, and other systems of belief. But while domestic textiles formed powerful markers of these connections within English society, *Othello* sets up an implicit contrast between their everyday Englishness and the heterosexual, racialized, and homoerotic meanings with which Iago first invests them and that Othello so readily accepts.

If we consider the handkerchief in *Othello* as a *domestic textile*—that is, as an artifact produced, worn, or used by a woman within the context of women's social, familial, and economic relations with other men and women, and which may have been used in the play precisely because it was at hand—then we can see the extent to which *Othello* uses, extends, and alters the significance of the handkerchief. To a large extent, the sexual aspects of the handkerchief are implicit in its everyday use. As Peter Stallybrass has pointed out, the handkerchief's touch on body apertures like the nose and mouth in a period that frequently equated a woman's mouth with her genitals enables the handkerchief to become "in Othello's mind . . . metonymically associated with the operations of the body" because it is "metaphorically substituted for the body's apertures."[20] The handkerchief then comes to represent not only the female genitals, but also the sexual behavior of both Emilia (who refers to it as her "thing") and Desdemona.[21] Domestic textiles simultaneously evoke a chaste yet eroticized body, but the play extends their significance to represent the female body and behavior *as* a piece of cloth. The play differs from the everyday world, then, by making female identity as malleable as cloth, so that it derives its shape not from women's work and affiliations, but from Iago and Othello.

In the longest and most problematic explanation of the handkerchief's origin and power, the Egyptian sibyl speech of act 3, scene 4, Othello momentarily restores the handkerchief's association with historical women's lives. But he does so by placing it within an exoticized Africa and by providing it with a history that reveals the extent to which the categories of domestic and public space, of husband and wife, depend for stability on misogyny and racism. In this speech, interrupted only by Desdemona's exclamations of disbelief, Othello makes one last attempt to get Desdemona to show him the handkerchief and thus disprove Iago's allegations of adultery. In the process, Othello binds up his personal history with the handkerchief and its English embroidery pattern. The speech takes the production of the handkerchief out of the hands of the recognizably domestic women who spun, wove, and embroidered it to place it in the hands of the "Egyptian" who supposedly gave it to Othello's mother: this "hand-

kerchief / Did an Egyptian to my mother give" (3.4.53–54). Othello's narrative, while it restores female production and its place in the gift economy as an object exchanged between women, also recalls the fantastic tales of adventure, slavery, cannibals, and monsters of Othello and Desdemona's courtship. The point of this tale, however, is not to charm, but to situate the handkerchief in a narrative that parallels the suspicion and domestic violence through which Othello is now narrating his life. According to Othello, the handkerchief's power lies in its ability to make his mother "amiable, and subdue my father / Entirely to her love" (3.4.57–58). In contrast with his hasty explanation in the last act that the handkerchief was "an antique token / My father gave my mother" (5.2.223–24)—which places the handkerchief in his father's hand as *his* gift to give and pass on to his son[22]—in the sibyl speech Othello puts together a series of exotic details that position the handkerchief as an artifact that is distinctly female but also African, a piece of silk from "hallowed" worms, the product of a two-hundred-year-old Egyptian sibyl who reads minds. By this point in the speech, it's my contention, the contemporary audience member would have been seeing double: on the one hand, the handkerchief is a recognizable domestic article redolent of the household and appropriate womanly productivity; on the other, it is everything that Iago seeks to make it, and much more. The "it" in the sibyl's warning that Othello recounts for Desdemona's benefit makes the handkerchief interchangeable with Desdemona's sexuality and his honor in possessing a chaste wife. If his mother "lost it, / Or made a gift of it, my father's eye / Should hold her loathèd, and his spirits should hunt / After new fancies" (3.4.58–61). At the same time, the "it" has become magical, possessed of powers, curses, and clairvoyance. "Its" transformed nature is the source of "its" threat: "To lose't or give't away were such perdition / As nothing else could match" (3.4.65–66).

When Othello attempts to warn Desdemona with this tale, she—who until now has been as much Othello's willing audience as his lover—misses the warning but detects the threat in the narrative. She asks, "Is't possible?" Othello's reaction is to elaborate the handkerchief's North African origin. It is a sibyl—the type of prophetess who wrote her prophecies in verse rather than worked them in patterns of strawberries, one of the few mythic women said to have produced texts rather than textiles—who "In her prophetic fury sewed the work" "dyed in mummy which the skillfull / Conserv'd of maidens' hearts" (3.4.70–73).

As he thus elaborates the history of the handkerchief, Othello twists the dyeing and sewing of domestic textiles into the exoticized conflation of race, magic, and female sacrifice with which Brabantio first accused him when he discovered his daughter's elopement. "Damn'd as thou art, thou hast enchanted her" (1.2.64), Brabantio accuses Othello in act 1, charging that he must have charmed Desdemona for her to "Run from her guardage to the sooty bosom / Of such a thing as thou" (1.2.71–72). In this first situation, Othello rejects Brabantio's version of his courtship, to argue

that his storytelling "only is the witchcraft I have us'd" (1.3.168). But when he sus-
pects Desdemona of infidelity, Othello readily uses his storytelling to ascribe magical
powers and a highly exoticized and violent history to the handkerchief—"'Tis true;
there's magic in the web of it," he says (3.4.67). This shift in Othello's staged self-
conceptualization, from the first act's outsider who has crossed into Venetian society
to the third act's character who emphasizes his difference, is a result of Iago's work.
Iago labors to make Othello certain that Desdemona, "Of her own clime, complexion,
and degree," must consider marriage to a man of color "unnatural" (3.3.235; 238).[23] In
order to accept the fact that Desdemona has turned from her marriage bed to Cassio's,
Othello must be convinced by Iago that their marriage is itself unnatural because of
their racialized difference. Othello's acceptance of himself as other makes its first ap-
pearance in the Egyptian sibyl speech and culminates in the last tale that he tells:

> in Aleppo once,
> Where a malignant and turban'd Turk
> Beat a Venetian and traduc'd the state,
> I took by th' throat the circumcised dog,
> And smote him—thus.
> (5.2.361–65)

When Othello kills himself on the line, "smote him [the Turk] thus," in killing what
Patricia Parker calls "this narrativized other,"[24] he destroys the reconceptualized iden-
tity that makes possible his jealousy and murder. Othello, who in the first two acts of
the play exists to perform his ability to bridge the categories of Venetian and Other,
in act three concocts the handkerchief's Egyptian etiology while performing himself
as the other that Venetian society imagines him to be,[25] the other whom he slays.

If the handkerchief's double history as domestic and Egyptian artifact helps to
mark the fault lines of heterosexuality and the racialized other in the play, its pattern
of strawberries also marks divergent ways of reading the handkerchief. The strawberry
was popular as a pattern in part because it is a fertile vine and so lends itself to lines
of alternating leaves and fruit (the grapevine is another favorite for this reason, as is
the "peascod" that Mall Berrie seeks to have drawn on her handkerchief in *The Fair
Maid of the Exchange*). I have examined several dozen period samplers with strawberry
patterns of many different types in the collections of the Victoria and Albert Mu-
seum; nearly every sampler I saw in piles of samplers contained at least one strawberry
pattern. The Jane Bostocke spot sampler of 1598 (Figure 66), the earliest dated En-
glish sampler, for example, contains two different strawberry patterns—one worked
in red and green in the lower right-hand corner, and the other in blackwork above
the grapes. Such patterns, kept in a spot sampler to which a woman added stitches
and patterns throughout her life, could then be transferred onto such textiles as hand-

66. Jane Bostocke. Strawberry Sampler. 1598. Victoria and Albert Museum, London.

kerchiefs, collars, or coifs as desired. The strawberry's process of flowering, fruiting, and swelling in cultivated gardens and in wilder places makes it an inevitable representation of fertility within a narrow if decided range of design.[26] Thus the first reading of the handkerchief's pattern of strawberries is the potential for the fruition of Othello and Desdemona's marriage. Although many members of the audience might be able to see that the handkerchief is embroidered with strawberries (if the prop is), the second reading of the pattern as representing spots of adulterous lust begins to emerge when Iago first mentions this pattern after recounting how Cassio when asleep threw his leg over Iago's thigh while calling him "Sweet Desdemona." Iago shifts gears to torment Othello in tones that emphasize the patterned handkerchief's domestic significance while insinuating that all is not well at home: "She may be honest yet. Tell me but this: / Have you not sometimes seen a handkerchief / Spotted with strawberries in your wife's hand?" (3.3.438–40). The pattern's very inability to tell a coherent story—whether Desdemona's or Othello's or his mother's or the Egyptian sibyl's—points to the ways in which Iago and Othello control the reading of domestic textiles in this play, in violation of the fact that in everyday European life, textiles usually lay within the purview of women, if always subject to the interpretation of men. Iago's question eventually informs Othello's language as he justifies to himself Desdemona's murder, when her "bed, lust-stain'd, shall with lust's blood be spotted" (5.1.37). Although the murder as performed leaves no blood, the spots that Othello sees before him dictate his actions.

When Iago and Othello seize the meaning of the handkerchief, it speaks to them in the way that Desdemona once spoke to it: "It speaks against her with the other proofs" (3.3.446). By extension, they know what lies on the sheets as well: strawberry-like spots of illicit lust rather than the bloody spots resulting from Othello's rupture of Desdemona's hymen.[27] The taking of interpretive control of these domestic textiles from Desdemona and Emilia coincides with the minimizing and invalidating of women's speech (including Iago's silencing of Emilia as she begins to figure out his role in Desdemona's unhappiness at 4.2.148; Othello's smothering of Desdemona, 5.2.93; and Othello's attempting to silence Emilia's explanation of the handkerchief's loss, 5.2.169). As Eamon Grennan examines in more detail, in the later acts Emilia and Desdemona only speak freely to one another, especially in act 4, scene 3.[28] Silenced until the end, when a combination of their voices reveals the double murder plot, Emilia and Desdemona resort to the mute text of the wedding sheets at the moment when Othello's jealousy finally becomes apparent to his wife. Their appeal to the sheets—which should be stained with Desdemona's blood—is an attempt to reassert women's relation to the household linens throughout the early modern period, linens which they frequently owned, washed, and certainly managed.

An idealized expression of women's relation to the household linens is available to us in Pieter de Hooch's *Interior with Two Women at a Linen Chest* (1663) (Figure 67).

67. Pieter de Hooch. *Interior with Two Women at a Linen Chest*. 1663. Oil on canvas.
Rijksmuseum, Amsterdam.

The interior domesticity of the scene is established by a child playing in the background before a series of doors that open to a street, while placed forward and at the center of the composition, a shallow wooden tub resting against a wicker laundry basket suggests the cleanliness and order of laundry day. Within this wealthy merchant home with its painting of a Madonna and Child, its tessellated floors and needlework cushion on a chair, and its statue of Mercury with a bag of money over the doorway,[29] two women stand before an inlaid cabinet, one weighed down by a stack of folded linens, the other, whom we might expect would be helping her to transfer them to the cabinet, rests her right hand on the top sheet, as if caressing it. The two

women, associated through the linens, are yet portrayed without the implicit sense of communication of Geertruid Roghman's engraving because they gaze in two different directions, both suggesting the import of the linens: one looks into the interior of the cabinet, where the linens belong; the other looks down as she runs her hand along their surface. The relation among the clean linens, the orderliness of the household, and the chastity of the women is implicit, with a hint of sensuality in the touch of the top sheet. But the connections de Hooch makes between sheets and chastity may in *Othello* work against a woman as well as for her, because if clean sheets represent a woman's chastity, spotted sheets—even those spotted during the consummation of Othello and Desdemona's marriage—come to signify adultery when Iago can teach Othello to see all spots as stains of infidelity. Desdemona expresses her dawning awareness of her wedding sheets' inability to articulate her chastity when, immediately after Othello tells her to go to bed and Emilia tells her that the sheets are laid on it, Desdemona replies to her, "If I do die before thee, prithee shroud me / In one of these same sheets" (4.3.23–24).

Within the play Iago and Othello control the reading of both handkerchief and sheets, despite the audience's knowledge of their domestic uses and Desdemona's attempts to contain these textiles within a local, feminized reading. Similarly the purse, a frequently woven or embroidered gift from women wishing to mark alliance and connection, is controlled in the play by one man, Iago. The purse that "opens" *Othello* to the audience in the play's first scene is *about* a woman—Desdemona—but not *from* a woman. It is quite probably a textile (like the contemporary purse pictured in Figure 68), especially if it is able to "purse" closed. Although the purse lewdly comes to suggest that Desdemona's vagina opens and closes every time "money" is figuratively "put" in it, in the play it is a largely homoerotic textile in that it produces male-to-male exchange across Desdemona's continually deferred body. This is the case in act 3, scene 3, when Iago incites Othello to his first paroxysm of jealousy, in part by contrasting Othello's "good name" with the "purse" (by implication, again Desdemona's vagina) that any man may have: "Who steals my purse steals trash; 'tis something, nothing," he says, using the "nothing" of the purse as slang for the female genitals: "'Twas mine, 'tis his, and has been slave to thousands." Once stolen, Iago imagines that the contact that men make by "having" the "purse" is excusable. While relishing the thought of every man's Desdemona, he argues to an Othello now obsessed with recapturing the "purse" that the theft of a good name is the true violence of adultery: "he that filches from me my good name / Robs me of that which not enriches him, / And makes me poor indeed" (3.3.162–66).

However, Desdemona's "purse" has not actually been stolen, while the only actual theft is Iago's gulling Roderigo in order to fill *his* purse. The riches to gain Desdemona pass continually from Roderigo's purse "As if the strings" were Iago's (1.1.3), until eventually Roderigo's purse is emptied of "jewels" enough to "half have cor-

68. Anonymous. Purse with Tudor Rose. Ca. 1600. Silver and gold thread on silk. The Berger Collection at the Denver Museum of Art.

rupted a votarist" (4.2.191). Iago's purse must then be quite full. The interactions between Roderigo and Iago register the extent to which both are willing to fill Iago in order putatively to fill Desdemona as Iago convinces Roderigo that to feed his purse is the only means to fill Roderigo's, and thus Desdemona's: "It cannot be long that Desdemona should continue her love to the Moor—put money in thy purse—nor he his to her. It was a violent commencement in her, and thou shalt see an answerable sequestration—put but money in thy purse. These Moors are changeable in their wills—fill thy purse with money. . . . She must change for youth. When she is sated with his body, she will find the error of her choice. Therefore put money in thy purse" (1.3.335–44).

Iago "fills" Roderigo's "purse" with empty promises of filling Desdemona. As Patricia Parker points out, a purse "can be opened and closed at will, in the context

there too of something secret and concealed."[30] The purse not only conflates Desde-mona's female sexuality with its sale, it does so by invoking Iago's and Roderigo's body parts that "purse"—the forehead, lips, and anus. The sexuality of the purse, de-rived from mystery and morality plays whose vice figures perform antics routinely conflating money, purses, and the anus (as does Chaucer's "Summoner's Tale") could also be further amplified in performance by having it hang from Iago's belt like en-larged testicles as it did in a 1995 Acting Company Production of *Othello*. The hand-kerchief, the wedding sheets, and the purse appear along the fault lines of hetero- and homosocial relationships, mimicking and touching the physical body in ways that dis-cern and create the staged social body by appropriating women's control over the use and interpretation of their textiles and thus their bodies.

In a world in which textiles mark the disruption and disintegration of everyday domestic categories, the only inviolable "thing" is the thing that comes to mean so many things—the handkerchief itself. Unlike domestic textiles, whose patterns were copied from spot sampler onto christening robes and handkerchiefs within the context of shared domestic labor, this handkerchief's strawberry pattern cannot be copied or erased, although at first Emilia and then Cassio vow to have the work "taken out."[31] Aware that they will have the handkerchief for only a short time, both Emilia and Cassio are so drawn to this strawberry needlework that they must "take it out." What does it mean to "take out the work"? "To make a copy from an original; to copy (a writing, design, etc.) especially to extract a passage from a writing or book." The OED's explicitly textual definition, "especially to extract a passage from a writing or book," is contradicted by the contemporary examples that follow its definition, which include two lines from *Othello* and a quotation from *The Art of Limning* (1573), whose use of the phrase "to take out" joins the copying of texts or "letters" with the copy-ing of textiles or "knotts": "A pretie deuise *to take out* the true forme & proporcion of any letter, knott, flower, Image, or other worke" (my italics). "To take the work out" means then not only to copy, but to copy in some precise fashion, both text and textile, word and image, according to the "forme & proporcion" of the original. This meaning calls attention not only to the handkerchief as the text that Iago and Othello make it, but to the strawberry pattern itself. Like historical women who copied one another's stitches and patterns within a framework of community talk and trade, both Emilia and Cassio are seized with a desire to possess their own version of its fruitful domesticity, the small red drops like those on the wedding sheets. But unlike historical women, the characters in *Othello* handle the strawberry pattern as if they were discon-nected from its source. They cannot "take out" or "copy" the pattern because to do so implies connection and communication. Nor can they "take out" the work in the sense of "undo" or "erase" it—a meaning also evoked by these lines. The handker-chief, removed from the processes of production and exchange, has become part of a phallogocentric discourse, which Valerie Wayne has identified as "misogynistic."[32] So

situated, the strawberries on the handkerchief can be neither copied nor erased any more than the stains on a wedding sheet. Desdemona's body, marked indelibly as unfaithful, must be wrung to death, as Iago urges: "strangle her in her bed, even the bed she hath contaminated" (4.1.206–7).

Skirting Rape in Cymbeline

Like *Othello*, the story of *Cymbeline* may be told in terms of its textiles, but in the more elaborate terms of romance. For while the genres of Shakespeare's plays are constructed through complex interactions among playwrights, their audiences, the economics of theater, and the pleasures, anxieties, and traditions of early modern English culture, a pivotal difference between *Othello* as tragedy and *Cymbeline* as the comedic form we classify as romance is the variety—the thickness—of textiles in the two plays. The murders of Desdemona and Emilia and the suicide of Othello proceed by collapsing time and space in ways that accelerate the equation of Desdemona's body with handkerchief, sheets, and purse. The romance of *Cymbeline*, by contrast, proceeds by expanding the time and space in which the action occurs, consequently enlarging the number, kind, and meanings of the textiles whose movement and interpretation allow Imogen to skirt the play's violence.

The larger time and space of *Cymbeline* create a play that is more complicated and less familiar than *Othello*, with textiles so integral to its narratives that the set of the 1997 Royal Shakespeare Company's production at Stratford consisted of a stage overhung with a great piece of white cloth, like a giant handkerchief, sheet, or sail. *Cymbeline* opens with the interrupted marriage of Posthumus and Imogen, daughter of Cymbeline, the king of Britain. As Posthumus departs England for Italy—a departure marked by a description of his receding handkerchief—he leaves Imogen at a court in which her father the king is confused and ineffectual, her stepmother the wicked queen enjoys playing with poisons (although the physician who supplies her has in fact given her a sleeping potion rather than a poison), and her stepbrother, Cloten, relentlessly woos her. Once in Italy, Posthumus bets Iachimo that Imogen is chaste, so that Iachimo proceeds in haste to England to test that chastity. Having ascertained that she will not listen to his talk of Posthumus's carousing, he has himself smuggled inside a chest into Imogen's bedchamber for the night. This bedchamber, like those of many privileged women, is constructed through tapestry, visual imagery, and text. These Iachimo notes as "proof" that he has successfully tried her virtue, and, returning to Italy, provides Posthumus with a detailed description of the bedroom and gives him Imogen's bracelet, which he slipped from her arm while she lay sleeping. As a result, Posthumus in a fit of jealousy orders his servant Pisanio (who has stayed behind in England) to kill Imogen. Pisanio instead sends a bloody cloth to Posthumus

as proof of Imogen's death, and which Posthumus addresses as his wife. Meanwhile, in obedience to her husband's command that she come to Milford-Haven where he plans to have her murdered, Imogen makes her own use of textiles, dressing first as a franklin's wife, then, on learning of her husband's violent intentions, as a boy. So attired, she heads off into the wilds of Wales, where she spends time in a cave with two men who will turn out to be her brothers, lost since early childhood. Her step-brother Cloten, who has pursued her dressed in Posthumus's clothing with the intent to rape her, runs into one of these brothers and is beheaded in the ensuing fight over his clothing. When Imogen feels unwell and takes the potion that the queen has given her, she falls into a sleep like death, from which she awakens beside the headless body of Cloten dressed as Posthumus, whom she takes to be Posthumus. Reconciliation and reunion occur at the end of the play when, with the Romans invading Britain, the brothers and a disguised Posthumus fight to save the country and are reunited with Cymbeline, who acknowledges his sons and heir (thus dispossessing Imogen), and re-stores the British connection to Rome by paying the Romans their required tribute. Throughout these complex intersecting narratives, *Cymbeline* dodges rather than re-futes the violent narrative possibilities implicit in the logic of the male possession of the female body and figured in the appropriation and reinterpretation of cloth. At the same time, *Cymbeline* is thickly furnished with textiles, some of which recall the earlier *Othello* and some of which offer Imogen the possibility of resisting the efforts of Iachimo, Cloten, and Posthumus to turn her into cloth over which she has no control.

Among the many textiles present in *Cymbeline*, the handkerchief is the first to appear. In act 1, scene 4, the handkerchief represents the increasing gulf between Post-humus and Imogen as he sails away to Italy—a gulf that will result in the wager of her chastity, Posthumus's jealousy when he believes her to have been unfaithful to him, and ultimately his attempt to murder her. As Pisanio describes Posthumus's leaving to Imogen, his report both connects Imogen to the scene and emblematizes the grow-ing disconnection of the two newly married characters through the reported handker-chief. Imogen envies the handkerchief when Pisanio tells her that Posthumus kissed it on shore while sighing for her—"senseless linen, happier therein than I!" she cries; but gradually it fades from sight as Posthumus continues to wave "with glove, or hat, or handkerchief" (1.4.7, 11) until it and Posthumus disappear from sight. Posthumus's hold on the handkerchief both links and separates Posthumus and Imogen, signaling the play's return to the processes of interpretation whereby women's bodies may be reduced to cloth.

Like the handkerchief and bedsheets in *Othello*, the textiles in *Cymbeline* ask us to consider the extent to which the male appropriation and interpretation of women's textiles silence the women of the plays and allow men violent access to the female bodies that they seek to possess. At the same time, these textiles are sometimes located within Imogen's control and so function as emblems of her identity and agency. In

Imogen's bedroom the play stages the way in which privileged women surrounded themselves with texts and textiles as the means to articulate their identity both for themselves and for the limited audience of those who might enter these interior spaces. Imogen's bedroom encloses her within three gynocentric narratives frequently embraced by women in the early modern period: Cleopatra meeting Antony, Philomel's rape with its whisper of Progne's revenge, and Diana and Actaeon. The play nevertheless attempts to erase the more complex sense of Imogen's subjectivity evoked by these narratives by translating textiles into metaphors and stage props that serve to objectify her female body and thus make it vulnerable to such male possessive acts as rape and murder.

Imogen's room, like the Sala di Penelope designed for Eleonora of Toledo in the Palazzo Vecchio recently discussed by Georgianna Ziegler, encapsulates a way of thinking that grew out of the medieval practice of mingling allegorical self-representation with mythic and religious narratives in order to assert and validate one's identity. Although not yet completed at Eleonora's death in 1562, the Sala di Penelope presents a rich interaction of "the discursive modes of impresa, heraldry and allegory with that of history painting to create a unified programme which invites reading(s) and both defines and breaks its architectural space" in its friezes of "Ulysses' travels" and "four Cardinal Virtues," "personifications of four Italian rivers" alternating "with the Medici impresa and Medici/Toledo coats of arms." The whole is surmounted by a painting of Penelope, the figure that simultaneously defines a woman's body as her husband's and who "asserts power over her own body with her conscious decision to remain chaste by repulsing the advances to her by men."[33] Perhaps the Sala di Penelope was as much conceived by Giorgio Vasari as by Eleonora or Duke Cosimo de' Medici, but it nevertheless presents a model for the architectural interplay of the discursive systems through which many women constructed their subjective identity.

Textiles are never far from such multimedia emblems of representations of women's identities, for women since Penelope or the ideal wife of Proverbs who "seeks wool and flax, / and works them with willing hands" (31.13) had been defined through textiles. In the rooms of exceptional women, textiles were central to the construction of a feminine figure in three ways. First, the production of textiles—whether represented in Penelope's loom or made visible by displaying the handiwork of its occupant—as we have seen, signified female chastity. Second, in most such rooms, the architectural elements are so densely structured that they *look* like embroidery and so suggest the chastity of the room's inhabitant on a structural level. And third, the choice of subjects for tapestry and the narratives and patterns of domestic needlework encode the perceived identity of the rooms' female inhabitants.

Exceptional women frequently surrounded themselves with textiles that were chosen as the means to express identity. Elizabeth Tudor, whose inventory as "The Lady Elizabeth" included "6 pieces of Tapestry of the *Citie of Ladies*,"[34] may well have

69. Mary, Queen of Scots. *Pruning Hand*. Ca. 1585. Tent-stitch panel. Victoria and Albert Museum, London (on loan to Oxburgh Hall).

been surrounded by a visualization of the text by Christine de Pizan. Mary, Queen of Scots, spent her time in imprisonment under the watchful eye of the Talbots performing needlework that hung in her rooms as the expression of her identity as Scottish queen, wife of a deceased king of France, and claimant to the throne of England. On a large tent-stitch piece, the image of a dolphin recalls her marriage to the French "dolphin" or *dauphin* and her connection to the de Guise family. In one work, thought to be identical to a cushion cover that Mary sent to the duke of Norfolk and

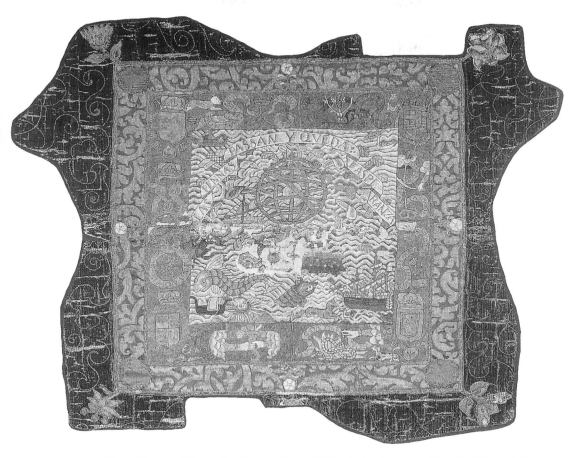

70. Mary, Queen of Scots. *Las Pennas Passan Y Queda La Speranza*. Ca. 1585. Tent-stitch panel. Victoria and Albert Museum, London (on loan to Oxburgh Hall).

which figured as evidence at his trial for treason, the pruning hand of God cuts off the barren branch (Elizabeth) so that the fruitful branch (Mary herself) might flourish (Figure 69). In another piece, a patient spider waits for an opportunity with its surrounding spiderlings; in another, an armillary sphere and motto in Spanish, "LAS PENNAS PASSAN Y QUEDA LA SPERANZA" (Sorrows pass but hope survives) is bordered by the arms of France, Spain, England, and Scotland (Figure 70). Although some of her surviving pieces are not so clearly political, certainly these and many others are. In exile, Mary, Queen of Scots, worked to invest her walls, bed, and cloth of state with compositions that articulate her willingness to wait for her opportunity to regain power, whether it should come through Elizabeth's natural death or the efforts of her Catholic supporters.

Elizabeth Talbot, countess of Shrewsbury (who continues to be known as "Bess

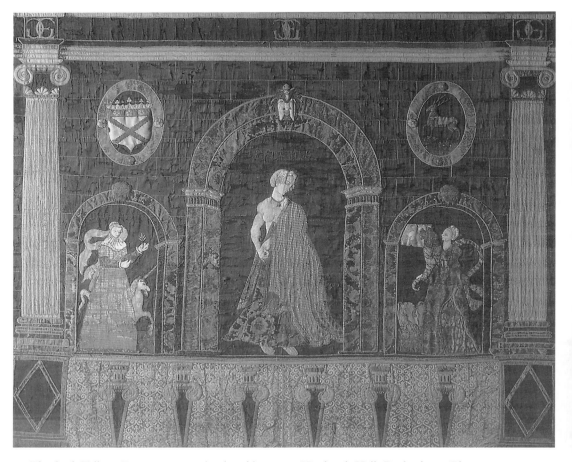

71. Elizabeth Talbot. *Lucretia*. 1580s. Appliqué hanging. Hardwick Hall, Derbyshire. (Photo: National Trust)

of Hardwick") participated in much of Mary, Queen of Scots's emblematic needle-work,[35] but also produced with the help of a professional embroiderer and the amateur labor at hand large appliquéd pieces of the Four Virtues, including Penelope, Temperance, and a muscular-armed Lucrece (Figure 71), cut from the copes of medieval priests, as well as a large needlework panel of Diana and Actaeon (Figure 72). She even named two of her daughters Temperance and Lucrezia, evidence of her internalization of these figures' value. In the 1590s, Talbot raised New Hardwick Hall, hung the earlier domestically produced Four Virtues in the Great Hall on the first floor, and bought a series of Ulysses tapestries that culminate in his reunion with Penelope. These tapestries were hung in the High Great Chamber on the third floor under a plasterwork frieze of Diana sitting in state as Elizabeth (or Elizabeth sitting in state as Diana) juxtaposed with a watching Actaeon figure around the corner on the next wall

(Figure 73). Talbot's architecture of subjectivity is to some extent inherently public, even theatrical: the Queen's Players may well have given a performance in this room when they were present at New Hardwick Hall in 1600.[36]

Women like Eleonora of Toledo, Elizabeth Tudor, Mary Stuart, and Elizabeth Talbot had the opportunity to have about them representations of their perceived identities, and so, apparently, does Imogen. As Janet Adelman points out, "Initially, Imogen is a wonderfully vivid presence, shrewd, impetuous, passionate, and very much the proprietress of her own will."[37] Imogen's choice of Posthumus against her father's wishes, her knowledge of the queen's sinister nature, and the fact that she is the heir apparent to her father's throne—which is why Posthumus calls her "queen" —give her considerable substance as a courageous yet vulnerable female character, with a represented identity reiterated in the symbolic architecture of her bedroom.[38] Imogen's chamber combines Cleopatra meeting Antony in one tapestry; a "chimney piece" features Diana and Actaeon, while her book is turned down at the point where Tereus rapes Philomel. Imogen sleeps her virgin sleep enshrined within this archi-tecture of female identity—if indeed she and Posthumus have not yet consummated

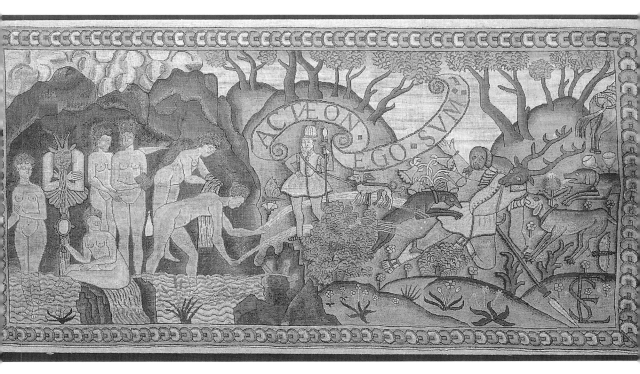

72. Elizabeth Talbot. *Diana and Actaeon*. 1580s. Needlework panel. Hardwick Hall, Derbyshire.
(Photo: National Trust)

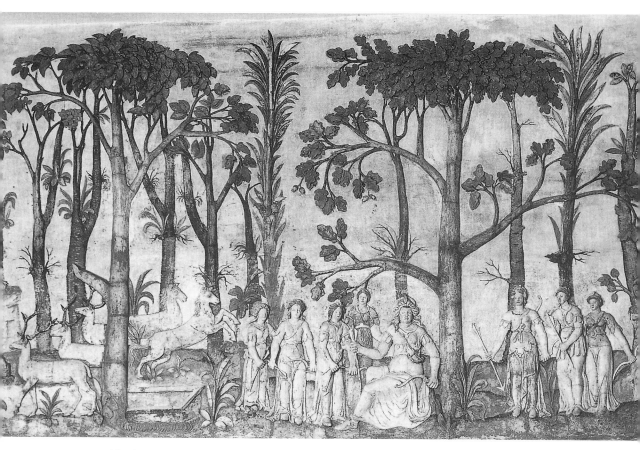

73. Abraham Smith. *Diana Enthroned*. Ca. 1590. Plasterwork frieze. Hardwick Hall, Derbyshire. (Photo: National Trust)

the marriage, as both the narrative and textile imagery suggest,[39] for Cleopatra is just meeting Antony; Diana is bathing and has not yet spied Actaeon; Tereus's rape of Philomel is suspended in the telling—Imogen has put the book down at this point. All three female figures surrounding Imogen are worthy associations for the young heir to the throne. Cleopatra, in inhabiting the edge of the Roman world, inhabits also a realm in which chastity is not so highly valued as sexuality and the exercise of power, so that although Cleopatra has an undeniable appeal for male authors in the period, she does for women as well. That in the end she is silenced by suicide is typical of the strong female figures available to Renaissance women. The translation by Mary Sidney Herbert, countess of Pembroke, of Robert Garnier's *Antonie* as the companion piece to her commissioned *Cleopatra* by Samuel Daniel makes strong claims for Cleopatra's intelligence, voice, and political activity.[40] When Eras asks Cleopatra, "Are

you therefore cause of his [Antonius's] overthrow?" Cleopatra answers in language that claims her agency: "I am sole cause: I did it, only I." Diomede, Cleopatra's secretary, describes her in terms that readily recall Elizabeth I, in that he admires her "training speach" and "forcing voice," her "hearing sceptred kings embassadors" to whom she can "Answere to each in his owne language make."[41] In providing Imogen with a tapestry of Cleopatra, then, Shakespeare evokes both the male tradition of viewing Cleopatra and the female perception of Cleopatra as a desirable and eloquent ruler.

The story of Diana and Actaeon in what was called the "chimney-piece," which may have been a tapestry, a painted panel, or, as at Hardwick Hall, a design in plaster, depicts a myth associated with Elizabeth and retold by Elizabeth Talbot in the large needlework hanging that isolates the moment when Diana turns Actaeon into the stag and marks it with her large initials, "ES" (Elizabeth of Shrewsbury) (see Figure 72). The textual reference to Philomel's rape is also a reference to a tapestry that again tells the story of a silenced but powerful female figure. While Philomel's story is much more disturbing than Cleopatra's, it is more than the rape taking place on the page turned down next to Imogen. Philomel's narrative includes her weaving a tapestry to communicate her rape to other women through what Jane Burns, writing about the medieval French romance *Philomena*, calls "an alternate economy of seeing and knowing cast in terms of women's work." The tapestry through which Philomel tells her story, Burns continues, "does more than make the silent woman speak. It also transfers the terms of embodiment and beauty from the lovely woman to the newly found woven 'speech,' a speech that is now embodied within an object, a speech given material form in fabric. This significant shift allows Philomena to write the body instead of being the body, to act upon a body of writing rather than having her body acted upon by others."[42] Like Elizabeth Talbot's appliquéd embroidery of a Lucrece with a muscular arm and determined expression (see Figure 71), Imogen's reading of Philomel's rape suggests early modern women's rereading of the narratives of violence toward women available to them, including Dido and Mariam as well as Philomel, Cleopatra, and Lucrece. Elizabeth Talbot's Lucrece, like Artemisia Gentileschi's, explores the moment before her suicide, with Lucrece's strength of arm or, as in Gentileschi, the arms and exposed leg, suggesting the physical strength and determination necessary for a victim of rape to commit suicide.[43] Diana's transformation of Actaeon asserts the possibility of revenge when she, like Imogen, is violated by the male gaze. The chamber's architecture of Imogen's identity is borne out within the play when like a chaste Cleopatra she is reunited with Posthumus amid the spectacle appropriate to the joining of bodies and empires.

Although we need to acknowledge the extent to which Imogen's self-perceived identity is located in the visual and textual tapestries of her room, the representations of gynocentric narratives that I have just discussed are contaminated in the telling because it is Iachimo who provides both descriptions of the bedroom he has violated.

The first description comes when he is in the room talking to himself about the necessity to note its details in order to prove that Imogen has lain with him, a project that consumes him as much as observing Imogen, because by noticing each detail he is also taking in the visual forms of her identity: "But my design. / To note the chamber: I will write all down: / Such and such pictures . . . the arras . . . and *the contents o' th' story*" (2.2.23–27, my italics). If Iachimo were only interested in later redescribing the room, he would not make such a point of noting the story of Tereus's rape of Philomel, which in fact he never tells Posthumus about. Iachimo notes the rape narrative in order to place himself within it, although he chooses to call himself Tarquin instead of Tereus, which makes his victim Lucrece instead of Philomel. For Iachimo is committing a metaphoric but unmistakable rape of Imogen's person and her chamber: "For Iachimo," writes Georgianna Ziegler, "a woman's body is part and parcel of her room and can be similarly violated. Though he does not physically rape Imogen, we nevertheless feel that a rape has been committed in his voyeuristic intrusion on her privacy."[44] In recounting the room as Imogen's emblematic identity, Iachimo further assaults Imogen because he must appropriate her bedroom's expression of her identity in order to prove that she is unchaste. The Philomel rape narrative for example forms part of the architecture of Imogen's subjectivity that Iachimo takes in with such attention that he can later boast to Posthumus that he has "brought / The knowledge of your mistress home" (2.4.50–51)—a phrase that connects what a man may see, know, and possess.

The second time that Iachimo describes the room is when he must prove to Posthumus that he has had sex with Imogen. It is this description that provides our "knowledge" of the room on which I base my analysis, including the "tapestry of silk and silver, the story / Proud Cleopatra, when she met her Roman" (2.4.69–70); "the chimney-piece, / Chaste Dian, bathing" (81–82); the ornate "fretted" ceiling, and the Cupid andirons. From these two descriptions associated with and told through a male who threatens at the least a metaphoric rape and prepares to recount a willing surrender, a double way of reading emerges. The first way of reading this scene, which I have teased out above with the help of historical information about women's architectural expression of identity, is to see how the play at least opens the possibility that women express their sense of identity through the textual/textile resources available to them. The second way of reading this scene is that even the most chaste female is vulnerable to male violation, a vulnerability expressed by the female figures with whom Imogen is surrounded. Tereus, who rapes Philomel, and Actaeon, who violates Diana with his gaze, may be punished in their different bizarre ways—Tereus, when Progne cooks up their son for his dinner; Actaeon, by being turned into a stag that is then torn to pieces by his own dogs. Despite their punishments, these violators of the female body cannot be contained. Both Tereus and Actaeon violate a female body, just as Iachimo has succeeded in violating Imogen's, down to noting the unusually shaped "cinque

foil" mole on her breast. The opportunity that exists to imagine Imogen's perception of her own subjectivity through her bedroom's texts and textiles, or for the audience to imagine one for her, is largely overwritten by the violation through which it comes to us. This violation is in turn overwritten by the fact that the rape remains metaphoric and thus easily erased or denied. Paying attention to the violence that occurs in Imogen's bedroom even as it is skirted reminds us of how much the play revolves around threats to Imogen.[45] Violence that is threatened but avoided by Imogen constitutes the metanarrative of the play, and the interpretation of her relation to textiles is repeatedly the vehicle of that violence.

If the tapestries momentarily open up the possibility of Imogen's identity, many of *Cymbeline*'s other textiles—the handkerchief, sheets, and especially the bloody cloth —serve to objectify her body in ways that make the issue of its possession visual and immediate. Yet Imogen continues to assert her identity, even when it is reduced to cloth, and, by occupying two different disguises, survives the attempts by Iachimo, Cloten, and Posthumus to possess and annihilate her. *Cymbeline*, which was probably written for the then recently acquired Blackfriars and so is likely first to have been performed indoors,[46] presents a number of textiles whose richness and variety help to create—and are created by—the romance in which they appear. Although the possibility that Imogen wants to rule England is written out of the play when the disguises that she dons to preserve her virginity and life also lead to her missing brothers, she, unlike Desdemona, survives the play's insistence that cloth is metonymic of her body by asserting a decided if limited control over the play's textiles. In particular, as the textiles increasingly signify her violent end, moving from handkerchief to sheet to bloody cloth, Imogen demonstrates with the help of Pisanio that her ability to use cloth for her own purposes is not limited to her bedroom's tapestries, but includes using costumes to disguise her identity.

Shakespeare's audience might well have felt comfortable with the extent to which *Cymbeline*'s different textiles connect with one another because its members were familiar with the everyday practice whereby cloth moved from one form to another. In the sixteenth century, valuable textiles were reused, cut down, and reshaped in a process called "translating," writes Jean MacIntyre. As we have seen, Elizabeth Talbot cut down medieval priests' copes to appliqué her series of hangings called the "Virtues." Likewise, crimson satin "that first dressed cardinals, bishops, and then clowns was cut down repeatedly to be used as new costumes, then parts of costumes, and at last ever more exiguous trimmings." Thus one warrant orders that "the gardinge of vj compassed garmentes for women" become "Ierkins and half Sleves of Thextronomers [the astronomers' costumes]. 20 of which were againe *translated* into barbariens and thereof. Into gardinge of the neither lace & false sleves of vj Moores garmentes" (my italics).[47] Costumes for Elizabeth I were likewise "*translated* and new made" to entertain marital ambassadors from France in 1564.[48]

The historical process of "translating" textiles from bishop's robe to clown's motley to trimmings proves a useful contemporary term for what happens in the world of staged representation to the textiles in *Cymbeline*, which have a strong tendency to mutate or "translate" during the play from one form or meaning to another. To a lesser extent we are familiar with the process of a staged textile translation from *Othello*, which has us follow the strawberry-spotted handkerchief as it moves from hand to hand and which metaphorically turns into the wedding sheets on the bed where Othello strangles Desdemona.[49] In *Cymbeline*, the handkerchief evokes the interconnection of female chastity and male honor in the first act; in the second act, the handkerchief's associations move to the sheets, whose whiteness Iachimo notes as he approaches the sleeping Imogen, muttering "Our Tarquin thus / Did softly press the rushes, ere he waken'd / The chastity he wounded" (2.2.12–14) and "fresh lily! / and whiter than the sheets! That I might touch! / But kiss, one kiss!" (2.2.15–17). As Iachimo casts himself in the role of Tarquin and Imogen becomes Lucrece, the Italian moves silently toward Imogen to reenact the moment before Tarquin wakened "The chastity he wounded." In that moment, Iachimo/Tarquin sees Imogen/Lucrece as chastity itself, the "fresh lily . . . whiter than the sheets"—a series of associations in which woman, chastity, lily, and sheets become the means by which Iachimo equates her identity with chastity, and that chastity with white sheets.

Imogen's own language picks up the extent to which the sheets have become metonymic of her body when Pisanio shows her the letter in which Posthumus orders her murdered for her infidelity. But she envisions herself as a complexly worked garment rather than the blank sheet of chastity on which a man might write. Before she begs Pisanio to carry out her husband's order that she be killed for infidelity, she castigates herself for having lost his faith in her, calling herself "a garment out of fashion" which, too rich (in the OED's sense of "elaborately ornamented or wrought") to be translated to a wall hanging, must be reduced to rags: "And, for I am richer than to hang by th' walls, / I must be ripp'd:—to pieces with me!" (3.4.52–54). As a garment too elaborately made—too complete in its own identity to be cut up and made part of a narrative on a wall in the way that Elizabeth Talbot translated the priests' copes—she must be ritually destroyed, ripped to pieces.[50] To Iachimo, she may be the blank white of the sheet, but to herself she is complex and colorful even when discarded and contemplating her own destruction.

As Imogen's personal narrative momentarily vies with the interpretation of textiles that would enable her possession and murder, she has a powerful helper in the form of Pisanio, who, like Iago, understands the importance of reading cloth, but who uses his awareness to help Imogen regain her ability to make cloth work for her. Pisanio knows that the best way to convince Posthumus of Imogen's death at his hands is not to send such an elaborate piece of cloth as she imagines herself to be, but a

simple piece stained with blood. As a chilling reminder of *Othello*'s strawberry-spotted handkerchief and blood-spotted sheets, as well as the fatal version of Posthumus and Imogen's own wedding sheets, the bloody cloth provides Posthumus with the ocular proof that Imogen is dead. Act 5 opens with Posthumus sorrowfully addressing this bloody cloth as if it were Imogen as he acknowledges her supposed death at his command: "Yea, bloody cloth, I'll keep thee: for I wish'd / Thou shouldst be colour'd thus" (5.1.1–2). The "Thou" he addresses is both Imogen and the bloody cloth, which have become indistinguishable to him.[51] Pisanio, who knows so much about cloth (as we shall see, he also supplies key costume changes as well), successfully uses the logic of Iago, Othello, and Iachimo to make Posthumus confront the consequences of equating his wife with her chastity and her chastity with cloth. In mourning the bloody cloth as Imogen, Posthumus comes to realize the price of his jealousy and even questions whether her fidelity is more important than her life as he asks, "how many / Must murder wives much better than themselves / For wrying but a little?" (5.1.3–5).

A second group of textiles undergoes translation within the play—the costume disguises, which take on a life beyond costuming the actors in order to costume the characters. These alterations or "translations," like Bottom's "translation" in the woods of *A Midsummer Night's Dream*, reveal how much this theater relies on metaphoric translations made literal through costume change. Imogen crosses class as a franklin's wife to flee the court where Cloten presses her in order (she thinks) to rejoin Posthumus, and then crosses gender as Fidele on hearing of Posthumus's order to have her murdered. Like Jessica in *The Merchant of Venice*, Imogen is a reluctant appropriator of the male role. As a boy she is without the architectural subjectivity within which she usually sleeps. Her comment when she first enters in boy's clothing bewails this translation: "I see a man's life is a tedious one, / I have tir'd myself: and for two nights together / Have made the ground my bed" (3.6.1–3). "Tiring" oneself as a boy means being "tired" by rough living and incommodious sleeping.

Yet however reluctant Imogen is to wear the cloth that thinly veils her gender, the disguise that she has obtained from that wardrober Pisanio preserves her virginity and her life. Pisanio also (rather surprisingly) happens to have the clothes that Posthumus wore when bidding his farewell to Imogen, which he gives to Cloten, who is obsessed with transforming into revenge Imogen's statement that she prefers Posthumus's "mean'st garment, / That ever hath but clipp'd his body" to her stepbrother (2.3.132–33). But because she has fled the court in disguise, the closest he gets to her is when she awakens next to his dead body. Cloten's need to translate Imogen's love for Posthumus's "mean'st garment" into her rape derives from the fury with which he absorbs the news of her preference in act 2, scene 3. This scene combines Cloten's expressions of rage—"'His garment!' Now the devil . . . 'His garment!'" (136, 138) and "'His meanest garment!'" (148)—with Imogen's attempt to find the bracelet stolen

from her arm by Iachimo during his intrusion, in a scene that recalls Desdemona's search for the missing handkerchief: "I do think / I saw't this morning: confident I am . . . go and search" (2.3.143–44, 148), Imogen directs her lady, Helen. Cloten's increasing obsession with Posthumus's clothes and Imogen's search for her bracelet juxtapose the issue of Imogen's chastity and the possession of that chastity within rape. After Imogen exits, Cloten finishes the scene by vowing, "I'll be reveng'd: / 'His mean'st garment!' Well" (154–55). Cloten, who has earlier tried to "penetrate" Imogen's chamber with the song "Hark, hark the lark" in the hope that if the musicians can "penetrate her with your fingering, so: we'll try with tongue too . . . I'll never give o'er" (2.3.12–15), takes Imogen's statement as the insult that will justify her rape: "With [Posthumus's] suit upon my back will I ravish her; first kill him, and in her eyes . . . and when my lust hath dined (which, as I say to vex her I will execute in the clothes that she so prais'd) to the court I'll knock her back" (3.5.138–39, 143–45). But because Imogen is safely disguised and because Cloten has become so obsessed with wearing Posthumus's clothing, he actually dies in an argument with Imogen's older brother, Guiderius, about his tailor (4.2).[52] Instead of robbing Imogen of her maidenhead, Cloten is himself literally beheaded. This violent death both preserves Imogen's "head" and reverses the common image of the "headless" woman whose beheading figures her lost virginity. But because Cloten remains dressed in Posthumus's clothing, Imogen must still experience the nasty shock of awakening beside the headless body she believes to be her husband.

Even Posthumus's disguise, which he adopts the moment he is through addressing the bloody cloth as Imogen, becomes a means to preserve Imogen. Posthumus determines to change his clothes because " 'tis enough / That, Britain, I have kill'd thy mistress" (5.1.19–20), "I'll disrobe me / Of these Italian weeds, and suit myself / As does a Briton peasant: so I'll fight" (5.1.22–24). By dressing across class as a Briton peasant, Posthumus finally wins his place at Imogen's side after defending the narrow passageway of Milford-Haven. As Linda Woodbridge points out, the attack on this "lane" signifies a corporeal image of invasion: "When the Romans invade . . . [they] try to penetrate through a lane whose narrowness is repeatedly emphasized. A stand being made at the cervix of this lane, British society, direly endangered, is saved."[53] Posthumus's appearance at the crucial moment at the port of Milford-Haven made possible by his disguise prevents still another kind of rape, the invasion of Britain as figured in its queen-to-be, Imogen. Thus the disguises in the play, like the other textiles, circulate around issues of sexual possession and violence, including Posthumus's intent to have Imogen murdered, Cloten's intent to rape Imogen, and Posthumus's defense of Britain whose "body" is, like England under threat of the Armada, feminized and thus conflated with the body of Imogen who remains the heir until her brothers' identity is disclosed in the final scene.

 * * *

As part of the structures of everyday life, textiles enter both tragedy and romance as the means to recover and to violate the subjectivity of their female characters. In contrast with the structures of everyday life, however, textiles as staged and interpreted in *Othello* and *Cymbeline* enable the plays' violence against their female characters even when, as in *Cymbeline*, no lasting physical harm is done. In *Othello*, the reading of textiles is so determined by Iago and Othello that the promise of Desdemona's and Emilia's agency is violently repressed. In *Cymbeline*, the textiles are so various and translatable that they themselves represent the multivalent interpretations residing in cloth as well as the multivalent possibilities for controlling cloth. The emblematic architecture of Imogen's chamber, the contingencies presented by disguise, and Pisanio's repeated interventions allow Imogen the time and material necessary to survive intact, as well as to open alternative if limited readings of a privileged woman's mind and body, so that at the play's conclusion Imogen and Posthumus live to unite handkerchief with bloody cloth, disguise with disguise. If the path toward marital murder in *Othello* is paved with a purse, handkerchief, and bedsheets, in *Cymbeline* the path toward marital bliss is paved with a handkerchief, Imogen's bedroom texts and textiles, her sheets, the bloody cloth, and the misapprehensions and recognitions occasioned by disguise. As in *Othello*, the textiles in *Cymbeline* allow the objectification of the central female character, demonstrating that her body is the possession of men, but at the same time, construct at least the possibility of her self-possession. If at the play's conclusion she finds herself both dispossessed of the throne and at last firmly affianced to Posthumus by her father's consent, Posthumus has momentarily acknowledged that her body is her own.

When *Othello* and *Cymbeline* stage women's relations to textiles, they proceed by simultaneously recalling and reinterpreting the historic relation of women to these objects and to the connections and social processes that they embody. On stage, the textiles' "visual politics," in the phrase of bell hooks's title, underwrites violence because the plays evoke but disrupt the historical, always evolving relation between women and their handiwork, which is also to say the relation between women and their domestic lives. This disruption in turn provides access to staged women's lives— to their forms of constructing identity, to their sexuality, and thus to their bodies. As disturbing as this process is, *Othello* and *Cymbeline* im-personate the importance of women's historical relations to textiles, the situation of these textiles within networks of kinship and domestic alliance, their visual impact when worn on the body or used to enrich domestic space. In reinterpreting women's historical relations to textiles, these plays point to the centrality of textiles in early modern life as objects whose production and exchange offered to make the lives of women meaningful and safe.

I am grateful to Clark Hulse, his assistant Elli Shellist, and to Valerie Wayne, Karen Robertson, and Peter Parolin for their valuable comments.

Othello and *Titus Andronicus* quotations are from *The Norton Shakespeare*, ed. Stephen Greenblatt, Walter Cohen, Jean E. Howard, and Katherine Eisaman Maus (New York: W. W. Norton, 1997); *Cymbeline* quotations are from the Arden edition, ed. James Nosworthy (London: Methuen, 1955; reprint, 1966).

1. Alice Clark's chapter "Textiles," in *Working Life of Women in the Seventeenth Century* (1919; reprint, New York: Routledge, 1992), pp. 93–149, remains the most comprehensive discussion of English women and textile labor. As Clark points out, "there can be no doubt that the Woollen Trade depended chiefly upon women and children for its labour supply" (p. 98). The Vicar of Leeds estimated in 1588 that sixty cloth workers would "be as follows: sorting and dressing, 6, spinning and carding, 40, weaving, 8, shearing 6." *H.M.C. Kenyon MSS*, 572–7, cited in John T. Swain, *Industry Before the Industrial Revolution: North-East Lancashire, c. 1500–1640* (Manchester: Manchester University Press, 1986), p. 109. The proportion of women to men in the production of wool, assuming that men constitute most of the weavers and shearers, would have been nearly two to one according to these figures. John T. Swain himself estimates that "the ratio of women and children working in these activities compared with males in weaving would be 5:1" (p. 112).

2. On the attempted prohibition of "any maiden, damsel, or other women" from weaving, see Steve Rappaport, *Worlds Within Worlds: Structures of Life in Sixteenth-Century London* (Cambridge: Cambridge University Press, 1989), pp. 37–40; see also Clark, "Textiles," pp. 103–4. On women continuing to weave during the early modern period, see Clark, pp. 104–5; Alfred P. Wadsworth and Julia De Lacy Mann, *The Cotton Trade and Industrial Lancashire, 1600–1780* (New York: Augustus M. Kelley, 1968), pp. 333–37; and J. de L. Mann, *The Cloth Industry in the West of England from 1640 to 1880* (Oxford: Clarendon Press, 1971), p. 228.

3. On women's complex relationships of exchange, see Sara Mendelson and Patricia Crawford, *Women in Early Modern England, 1550–1720* (Oxford: Clarendon Press, 1998), p. 221.

4. On women's connections as forming a distinct female culture, see ibid., p. 13, and chap. 4, "Female Culture," pp. 202–255. See also the many forms of women's association or alliance in Susan Frye and Karen Robertson, eds., *Maids and Mistresses, Cousins and Queens: Women's Alliances in Early Modern England* (New York: Oxford University Press, 1999).

5. The similarities between English and Dutch domestic culture are also visible in places like Great Yarmouth, where the Dutch influence was particularly strong. Extant Yarmouth merchant houses are modeled on the Dutch pattern and were even built of brick imported from Holland. Many more Dutch homes featured paintings than needlework pictures on the walls, yet paintings frequently feature women's textile production as emblematic of the producers' combined overt sexuality and demure femininity. See Wayne E. Franits, *Paragons of Virtue: Women and Domesticity in Seventeenth-Century Dutch Art* (New York: Cambridge University Press, 1993), and Whitney Chadwick, *Women, Art, and Society* (1990; reprint, London: Thames and Hudson, 1994), pp. 104–19. See also Peter Thornton, *Seventeenth-Century Interior Decoration in England, France and Holland* (New Haven: Yale University Press, 1978).

For brief discussions of Geertruid Roghman, see Simon Schama, *The Embarrassment of Riches: An Interpretation of Dutch Culture in the Golden Age* (New York: Alfred A. Knopf, 1987), p. 416, and Chadwick, *Women, Art, and Society*, p. 115.

6. John Taylor, *The Praise of the Needle* (1631), Sig. A(v).

7. Manuel Vega, an American artist who converted to the Yoruba religion, on National Public Radio, April 7, 1999. The entire segment about a traveling exhibit of Yoruba artwork is currently available in the National Public Radio sound archive at www.npr.org.programs/ morning/archives/1999/990407.me.html.

8. Linda Woodbridge, "Patchwork: Piecing the Early Modern Mind In England's First Century of Print Culture," in *English Literary Renaissance* 23 (1993): 36.

9. For more on the process by which women chose particular pictures at the print shops, see Rozsika Parker, *The Subversive Stitch: Embroidery and the Making of the Feminine* (New York: Routledge, 1989), the germinal discussion of women's needlework, pp. 96–97. On Peter Stent and earlier printsellers, see Alexander Globe, *Peter Stent, London Printseller* (Vancouver: University of British Columbia Press, 1985).

10. Thomas Heywood, *The Fair Maid of the Exchange* (Oxford: Malone Society Reprints, 1962), lines 861–83. Mall Berrie enters talking aloud of the possibilities for handkerchief decoration: "Now for my true-loues hand-kercher; these flowers / Are pretie toyes, are very pretie toyes: / O but me thinkes the Peascod would doe better, / The Peascod and the Blossome, wonderfull!" (lines 151–54).

11. Jakob Burckhardt, *The Civilisation of the Renaissance in Italy*, trans. S. G. C. Middlemore (London: Swan Sonnenschein, 1898), pp. 308, 398. In fairness to Burckhardt, he was aware that "To each eye, perhaps, the outlines of a given civilisation present a different picture; and in treating of a civilisation which is the mother of our own, and whose influence is still at work among us, it is unavoidable that individual judgment and feeling should tell every moment both on the writer and on the reader. . . . Such indeed is the importance of the subject, that it still calls for fresh investigation, and may be studied with advantage from the most varied points of view" ("Introduction," p. 3).

12. Mary Ann Calo, *Bernard Berenson and the Twentieth Century* (Philadelphia: Temple University Press, 1994), p. 32.

13. Bernard Berenson, "Decline and Recovery in the Figure Arts," in *Studies in Art and Literature for Belle da Costa Greene*, ed. Dorothy Miner (Princeton: Princeton University Press, 1954), p. 25.

14. See for example Miriam Schapiro, *Wonderland*, a sampler tacked onto canvas and *Barcelona Fan*, both reproduced in *The Power of Feminist Art: The American Movement of the 1970s, History and Impact*, ed. Norma Broude and Mary D. Garrard (New York: H. N. Abrams, 1994), figures 217 and 84. See also Norma Broude and Mary D. Garrard, "Conversations with Judy Chicago and Miriam Schapiro," in *The Power of Feminist Art*, pp. 66–87. Judy Chicago's 1979 *Dinner Party* remains an eloquent statement about women's place in history and the relation of needlework to that place. The two books about *The Dinner Party*, one of which is specifically about embroidery in the work, explore this relationship in detail and in the process offer a history of women's relation to textiles. See Judy Chicago, *The Dinner Party* (1986; reprint, New York: Penguin, 1996) and Judy Chicago, *Embroidering Our Heritage: The Dinner Party Needlework* (Garden City, N.Y.: Anchor Press/Doubleday, 1980). For a reassessment of *The Dinner Party* from a 1990s perspective, see Josephine Wither, "Judy Chicago's Dinner Party," in *The Expanding Discourse: Feminism and Art History*, ed. Norma Broude and Mary D. Garrard (New York: HarperCollins, 1992), pp. 451–65. For African-American artist Emma Amos, cloth borders around her paintings point to historic connections to Africa and the Civil War. See *The Overseer*, *Mrs. Gauguin's Shirt*, and *Malcolm X, Morley, Matisse & Me*, reproduced in un-

numbered color inserts in bell hooks, *Art on My Mind: Visual Politics* (New York: New Press, 1995).

15. Dinah Prentice, "Sewn Constructions," in *New Feminist Art Criticism: Critical Strategies*, ed. Katy Deepwell (Manchester: Manchester University Press, 1995), p. 182.

16. On the extent to which clothes "receive the human imprint," see Peter Stallybrass, "Worn Worlds: Clothes, Mourning, and the Life of Things," *Yale Review* 81, no. 2 (April 1993), pp. 35–50 (quotation is from p. 37). See also the later version of his essay, "Worn Worlds," in Margreta de Grazia, Maureen Quilligan, and Peter Stallybrass, eds., *Subject and Object in Renaissance Culture* (Cambridge: Cambridge University Press, 1996), pp. 289–320.

17. hooks, *Art on My Mind*, p. 3.

18. Karl Marx, *Grundrisse*, trans. Martin Nocolaus (Harmondsworth: Penguin Books, 1973), p. 92. For a lengthier discussion of this passage with reference to feminist art history, see Griselda Pollock, *Vision and Difference: Femininity, Feminism, and Histories of Art* (New York: Routledge, 1988), pp. 2–5.

19. De Grazia, Quilligan, and Stallybrass, eds., *Subject and Object in Renaissance Culture*, p. 5.

20. Peter Stallybrass, "Patriarchal Territories: The Body Enclosed," in Margaret W. Ferguson, Maureen Quilligan, and Nancy J. Vickers, eds., *Rewriting the Renaissance: The Discourses of Sexual Difference in Early Modern Europe* (Chicago: University of Chicago Press, 1986), p. 139.

21. On the relation between paper and cloth that enhances the idea of Othello "reading" his wedding sheets, see Stallybrass, "Worn Worlds," in de Grazia, Quilligan, and Stallybrass, eds., *Subject and Object*, pp. 306–7.

22. My thanks to Peter Parolin for making this point to me. Edward Snow has also discussed the difference between the sibyl speech and the explanation for the handkerchief's existence that is more male-centered. See Edward Snow, "Sexual Anxiety and the Male Order of Things in *Othello*," *English Literary Renaissance* 10 (1980): 404–5. See also Valerie Wayne's discussion of Snow and this point in "Historical Differences: Misogyny and *Othello*," in Valerie Wayne, ed., *The Matter of Difference: Materialist Feminist Criticism of Shakespeare* (Ithaca: Cornell University Press, 1991), pp. 170–71.

23. On Iago's ability to twist both Othello's and Desdemona's origins to explain why she would prefer Cassio, see Michael Neill, "Unproper Beds: Race, Adultery, and the Hideous in *Othello*," *Shakespeare Quarterly* 40:4 (Winter 1989): 410.

24. Patricia Parker, *Literary Fat Ladies: Rhetoric, Gender, Property* (New York: Methuen, 1987), p. 71.

25. Stephen Greenblatt writes that Othello's "identity depends upon a constant performance . . . of his story, a loss of his own origins, an embrace and perpetual reiteration of the norms of another culture." Stephen Greenblatt, *Renaissance Self-Fashioning from More to Shakespeare* (Chicago: University of Chicago Press, 1980), p. 245.

26. On the strawberry as also signifying the Virgin Mary and hence virginity as well, see Lynda Boose's discussion of the iconography of the strawberry in "Othello's Handkerchief: 'The Recognizance and Pledge of Love,'" in *Critical Essays on Shakespeare's Othello*, ed. Anthony Barthelemy (New York: G. K. Hall, 1994), p. 56.

27. On the custom of displaying the wedding sheet as ocular proof of a bride's virginity, see Boose, "Othello's Handkerchief," p. 57. As Boose points out, the handkerchief is "a visually recognizable reduction of Othello and Desdemona's wedding-bed sheets, the visual proof

of their consummated marriage, the emblem of the symbolical act of generation so important to our understanding of the measure of this tragedy" (p. 56).

28. See Eamon Grennan, "The Women's Voices in *Othello*: Speech, Song, Silence," *Shakespeare Quarterly* 38:3 (Autumn 1987): 275–92.

29. See Schama, *Embarrassment of Riches*, p. 393.

30. Patricia Parker, *Literary Fat Ladies*, p. 95.

31. Emilia says when she picks up the handkerchief that Desdemona has carelessly let drop, "I'll have the work ta'en out, / And give't Iago" (3.3.300–301). When he receives the handkerchief, Cassio gives it to Bianca, saying, "Sweet Bianca [*Giving her Desdemona's handkerchief.*] / Take me this work out" (3.4.179–80); when Bianca questions him about the source of the handkerchief, Cassio replies, "I found it in my chamber. / I like the work well. Ere it be demanded— / As like enough it will—I would have it copied" (3.4.183–85). In the next scene, however, Bianca rejects Cassio along with the handkerchief: "I must take out the work? . . . This is some minx's token, and I must take out the work. . . . Wheresoever you had it, I'll take out no work on't" (4.1.145–50).

32. See Wayne, "Historical Differences," pp. 153–75. Wayne discusses the problem of "taking the work out" on page 172, concluding that "Because the handkerchief serves as proof of married chastity, it cannot be copied by Emilia and Bianca."

33. Georgianna Ziegler, "Penelope and the Politics of Woman's Place in the Renaissance," in *Gloriana's Face: Women, Public and Private in the English Renaissance*, ed. S. P. Cerasano and Marion Wynne-Davies (New York: Harvester Wheatsheaf, 1992), p. 26.

34. W. G. Thomson, *Tapestry Weaving in England from the Earliest Times to the End of the Eighteenth Century* (London: B. T. Batsford, 1914), p. 41. Susan Groag Bell, who first found a reference to them, has been working on the significance of these tapestries.

35. For a discussion of the political and needlework relations of Elizabeth Talbot and Mary, Queen of Scots, see Margaret Swain, *The Needlework of Mary Queen of Scots* (London: Van Nostrand Reinhold Company, 1973), and Susan Frye, "Sewing Connections: Elizabeth Tudor, Mary Stuart, Elizabeth Talbot, and Seventeenth Century Anonymous Needleworkers," in *Maids and Mistresses, Cousins and Queens: Women's Alliances in Early Modern England* (New York: Oxford University Press, 1999), pp. 165–82. On Talbot's needlework, see also Santina M. Levey, *Elizabethan Treasures: The Hardwick Hall Textiles* (London: Harry N. Abrams, National Trust, 1998).

36. Mark Girouard, *Hardwick Hall* (London: National Trust, 1989; reprint, 1992), p. 33.

37. Janet Adelman, *Suffocating Mothers: Fantasies of Maternal Origin in Shakespeare's Plays, Hamlet to The Tempest* (New York: Routledge, 1992), p. 209.

38. On Imogen's bedchamber, see also Peggy Muñoz Simonds, *Myth, Emblem, and Music in Shakespeare's* Cymbeline: *An Iconographic Reconstruction* (Newark: University of Delaware Press, 1992), pp. 95–134.

39. David Bevington, "Sexuality in *Cymbeline*," *Essays in Literature* 10 (2) (Fall 1983): 160.

40. Margaret Hannay, *Philip's Phoenix: Mary Sidney, Countess of Pembroke* (New York: Oxford University Press, 1990), p. 223.

41. Mary Sidney Herbert, *The Tragedie of Antonie Doone into English by the Countesse of Pembroke* (London: William Ponsonby, 1595; typescript, Brown Women Writers Project, 1990), pp. 13, 21.

42. E. Jane Burns, "Beauty in the Blindspot: Philomena's Talking Hands," in *Bodytalk:*

When Women Speak in Old French Literature (Philadelphia: University of Pennsylvania Press, 1993), p. 131.

43. On Artemisia Gentileschi's treatment of Lucrece, see Mary D. Garrard, *Artemisia Gentileschi: The Image of the Female Hero in Italian Baroque Art* (Princeton: Princeton University Press, 1989), pp. 210–44 and passim; of Cleopatra, see pp. 210–16, 241–77, and passim. Garrard includes the transcript of the trial following Gentileschi's rape in 1612, pp. 403–87.

44. Georgianna Ziegler, "My Lady's Chamber: Female Space, Female Chastity in Shakespeare," *Textual Practice* 4 (1990): 82.

45. See Linda Woodbridge, "Palisading the Elizabethan Body Politic," *Texas Studies in Literature and Language*, 33 (3) (Fall 1991): 334–35.

46. J. M. Nosworthy, Arden edition of *Cymbeline*, pp. xvi–xvii.

47. R. O. Elizabeth 25, quoted in Jean MacIntyre, *Costumes and Scripts in the Elizabethan Theatres* (Edmonton: University of Alberta Press, 1992), pp. 55–56.

48. MacIntyre, *Costumes and Scripts*, p. 65.

49. Boose, "Othello's Handkerchief," p. 65.

50. J. M. Nosworthy, editor of the Arden *Cymbeline*, glosses Imogen's lines, "Poor I am stale, a garment out of fashion, / And, for I am richer than to hang by th' walls, / I must be ripped: to pieces with me!" (3.4.52–54), by noting that "Malone curiously accepts the theory of one Roberts that Imogen here alludes to the hangings on walls, i.e. tapestries. But the characteristic Shakespearean image is of discarded clothing or armour, cf. *Troil.*, III. iii. 151–3: 'to have done is to hang / Quite out of fashion, like a rusty mail.'" Given Imogen's intimate connections with tapestries, however, it seems most likely that she is talking about woven hangings, especially since she is discussing her translation from a rich garment to something that might hang on the walls but that should instead be ripped to pieces.

51. Compare Janet Adelman's reading of the cloth, in *Suffocating Mothers*, p. 214. Peter Stallybrass stresses the separation of the bloody cloth from Imogen's body in "Worn Worlds," p. 310. Valerie Wayne argues in a forthcoming article on the manacle in *Cymbeline* that during Posthumus's speech opening act 5, he puts on the bloody cloth, as has sometimes been done in performance. This action signifies his reconnecting himself to, and acceptance of, Imogen's body.

52. On the costumes in *Cymbeline*, see Stallybrass, "Worn Worlds," in de Grazia, Quilligan, and Stallybrass, eds., *Subject and Object*, pp. 308–10. As Stallybrass points out, because "in the Renaissance clothes could be imagined as retaining the identity and the form of the wearer," for Imogen, Posthumus's clothing "bears quite literally the trace and the memory of its owner" (p. 310), with the result that "For Cloten, as much as for Imogen, Posthumus's clothes come to embody memory": "It is as if the clothes will keep Posthumus, imagined as dead, alive so that he, in the remaining form of his suit, can witness Imogen's rape, while, simultaneously, the suit, and thus Posthumus, will be both defiled and appropriated by Cloten" (p. 309).

53. Woodbridge, "Palisading the Elizabethan Body Politic," p. 334.

7. IDOLS OF THE GALLERY

Becoming a Connoisseur in Renaissance England

STEPHEN ORGEL

Near the end of *The Winter's Tale* we are told of a surpassingly lifelike statue of the late queen Hermione, the work of "that rare Italian master Giulio Romano," commissioned and owned by the noble Paulina, connoisseur and architect of the play's reconciliations. In the final scene, the statue is revealed, and brought to life. The invocation of Giulio Romano is striking for a number of reasons: this is the only allusion in Shakespeare to a modern artist and, indeed, one of the earliest references to Giulio in England—Shakespeare here, as nowhere else, appears to be in touch with the avant-garde of the visual arts. But Giulio was not a sculptor, and in fact the name is all the play gives us—as it turns out, there is no statue; the figure Paulina unveils is the living queen.

The relation between art and life is particularly direct here, and the ability of the great artist to restore the losses of the past and reconcile the present to them is represented as axiomatic. But the name of the artist is essential, the name of an artist renowned for his skill at producing the illusion of life; and a modern artist, moreover, not a historical figure like Phidias or Zeuxis, who might be expected to be supplying art treasures in ancient Sicily, where *The Winter's Tale* is set. Paulina is presented in the play as a connoisseur, the owner of a collection of artistic rarities; she knows what she's doing, and her expertise reminds us that the collecting instinct was starting to burgeon in the England of 1610—Figure 74 is a portrait of the obvious, formidable contemporary model for Paulina, the Countess of Arundel, before her gallery. She and the earl formed the greatest collection of art works in Jacobean England. They owned, indeed, a number of Giulio's drawings, including preparatory sketches for the luxuriantly lifelike frescos at the Palazzo Tè, though these had not been acquired by 1610. Still, the Arundel circle would have been a good source of information about what artists were both in vogue and especially adept at the lifelike.

There was, in fact, a good deal of information circulating in Shakespeare's England about who were the right artists to invest in. Richard Haydocke, translator of an artistic handbook by Paolo Lomazzo, published in English in 1598, noted "many noblemen then furnishing their houses with the excellent monuments of sundry famous and ancient masters, both Italian and German,"[1] and English collectors in the first decade of the seventeenth century began for the first time to be serious connoisseurs, dispatching experts to the continent to buy for them, and concerned with acquiring expertise of their own. In 1609, the Earl of Exeter was advising the Earl of Shrewsbury to purchase paintings by Palma Giovane and sculpture by Giambologna,[2]

74. Daniel Mytens. *Alathea, Countess of Arundel and Surrey*. 1618. Oil on canvas.
By courtesy of the National Portrait Gallery, London.

suggestions both shrewd and in the best modern taste. Prince Henry became a passionate collector of paintings and bronzes. By 1610 Inigo Jones's expertise was being employed: he had certainly traveled in Italy by this time and was advising first the Earl of Rutland on artistic matters and later the Prince of Wales and the Arundels.

On the continent conspicuous collections of great art had for more than a century been an attribute of princely magnificence, and Henry VIII had to some extent undertaken to emulate his contemporaries Francis I and Charles V in this respect: there were no Titians in the Tudor royal gallery, but the Holbeins and Torrigianos suggest a very high standard of artistic taste. The taste, however, was obviously not genetic: Queen Mary's court painter was Antonio Mor, not a bad choice, but hardly in the league of Holbein; and neither Elizabeth nor James had much interest in the arts as such, nor had they any interest whatever in increasing the royal collection. But King James nevertheless provides a directly topical source for Paulina's statue: in 1605 he commissioned sculptures of Queen Elizabeth and of his mother, Mary, Queen of Scots, who had been executed for treason against Elizabeth in 1587. These were tomb effigies for their monuments in Westminster Abbey—James's treasonous mother was to be rehabilitated by being reburied among the kings and queens of England. Elizabeth's statue was completed in 1607, Mary's before 1612; both statues were lifelike, in the sense that they were painted, as Hermione's is said to be, and as effigies always were in the period. The royal patron of Shakespeare's company was not a connoisseur or a collector, but he nevertheless relied on the power of art to memorialize, reconcile, and restore.

Let us begin with Prince Henry's collection. He seems to have been introduced to connoisseurship around 1610, when he was sixteen, by Robert Cecil, Earl of Salisbury, and Arundel. Cecil already had a notable collection (he was furnishing Hatfield House), including mythological and biblical subjects by both Italian and Netherlands artists. At Henry's request he sent a group of paintings for the prince's attention; it went without saying that one of them would remain with the prince as a gift to form the nucleus of a royal collection that would stamp this prince as a true Renaissance monarch. Cecil was to accompany the pictures and expound their merits (and presumably to ensure that Henry chose the right one to keep with the earl's compliments); he was advised, however, that if he was unable to come himself, "you may send my lord of Arundel as deputy to set forth the praise of your pictures"[3]—Arundel was the real expert. The painting Cecil gave the prince was Palma Giovane's *Prometheus Chained to the Rock* (Figure 75). It had been acquired for him in 1608 by Sir Henry Wotton, the English ambassador in Venice. This is a painting that is not much regarded now, and it *is* rather grim. Nevertheless, it really can be considered one of the foundational works of English artistic taste, a touchstone that almost by itself established the market for Venetian painting in England. Wotton, indeed, had sent it to Cecil in the first place in order to establish his own credentials as an artistic agent

75. Palma Giovane. *Prometheus Chained to the Rock*. 1600–1607. The Royal Collection
©2000 Her Majesty Queen Elizabeth II.

and broker. There were, to be sure, some Venetian paintings in English collections already—the Earl of Leicester is said to have owned some, though we don't know what they were, and Leicester's nephew Sir Philip Sidney, always in the avant-garde of taste, knew enough to sit for his portrait by Veronese when he was in Venice (this was not a success; Sidney was disappointed in it, complaining that it made him look too young, and it has since disappeared). But Palma's *Prometheus* was the work that made everyone want big dramatic Venetian paintings, not just Palmas, but the bigger

(and more expensive) names: Titians, Tintorettos, Veroneses. Thereafter it was made clear that gentlemen desiring Prince Henry's favor could do no better than give him paintings.

The prince's own taste, insofar as one can judge it, was eclectic, voracious, and, it has to be admitted, relatively uninformed. The largest purchases were Dutch and Flemish, but that was only because the market was closer and the agents more familiar: he was in fact the first large purchaser of Venetian paintings in England. When he asked for gifts from continental princes eager to curry favor with the next king of England, the requests were little short of megalomaniac: not merely miniature bronzes by Giambologna—in response he received a number of miniature *copies* of Giambologna statues (Figure 76)—but the famous bigger-than-life *Rape of the Sabines* in the Piazza Signoria in Florence and a Michelangelo ceiling from the Palazzo Medici in Siena. (This last—both the ceiling and the palace—was fortunately nonexistent, so a refusal was easy.) But the collection was to consist not only of works by famous artists; the subject matter was as important as the artist, and in some cases more important. He asked for and was sent portraits of illustrious men, such as had graced the royal gallery of Cosimo de' Medici—being a Renaissance prince meant imitating the lifestyles of the rich and famous; scenes of famous battles both on land and sea, night pieces, exercises in perspective and *trompe l'oeil* combining art with the new science of optics; even scientific instruments, including a model of a perpetual motion machine constructed by the prince's resident magus Cornelius Drebbel, which worked by changes in barometric pressure and was somehow supposed to demonstrate the validity of the Ptolemaic system against the claims of Copernicus and Galileo (Figure 77). Indeed, the request for the miniatures and the Michelangelo ceiling was accompanied by further requests for a new type of magnet and the latest book by Galileo (was the prince unpersuaded by Drebbel's machine?), as well as for the plans of Michelangelo's staircase in the Laurentian library, and the formula for a new cement capable of sealing pipes so they could carry water uphill without leaking. The art gallery was also to be a historical and scientific museum, a cabinet of wonders, perhaps most of all an architectural masterpiece including elaborate fountains and waterworks.

Figure 78 is the companion piece to Mytens' portrait of the Countess of Arundel. The earl's collection was less eclectic than Prince Henry's, but here again, it was not simply a reflection of the new connoisseurship, and despite the obvious pride expressed by the two portraits of the earl and countess posing before their treasures (see Chapter 8), it was really not what we would call an art gallery. The Arundel marbles seem to us the forerunners of the Elgin marbles; but they looked quite different to contemporary observers. Arundel's protégé Henry Peacham, the author of *The Compleat Gentleman*, praises the statues in terms that are indicative: there is nothing about ideal Greek bodies or perfect proportion or *contrapposto*; they bring the past to

76. Copy after Giovanni da Bologna. *Astronomia*. 1611. Gilded bronze. Kunsthistorisches Museum, Vienna.

77. Cornelius Drebbel, "Perpetual Motion Machine," from Thomas Tymme,
A Dialogue philosophicall. Wherein natures secret closet is opened (London, 1612).
By permission of the Folger Shakespeare Library, Washington, D.C.

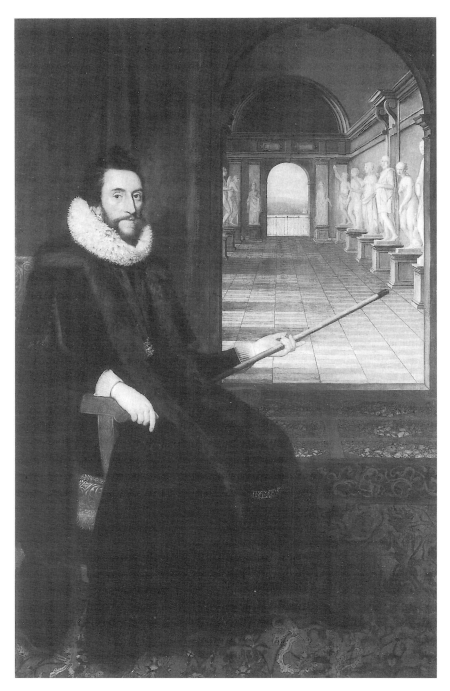

78. Daniel Mytens. *Thomas Howard, Second Earl of Arundel and Surrey*. 1618. Oil on canvas. By courtesy of the National Portrait Gallery, London.

life—what they give the observer, he says, is "the pleasure of seeing and conversing with these old heroes"; moreover, "the profit of knowing them redounds to all poets, painters, architects, . . . and by consequent, to all gentlemen." As for Arundel House, Peacham calls it "the chief English scene of ancient inscriptions." It is rather startling to us to take up John Selden's book entitled *Marmora Arundelliana* and to find in it not depictions of the sculptures but pages like the one reproduced in Figure 79. Peacham continues, "You shall find all the walls of the house inlaid with them and speaking Greek and Latin to you. The garden especially will afford you the pleasure of a world of learned lectures in this kind."[4] A world of learned lectures: the collecting passion was not simply aesthetic; it also involved a profound interest in recovering and preserving the past, an education in history; and, significantly, connoisseurship has become the essential mark of a gentleman, who is here identified with the artist, marked as much by his taste as by his lineage.

Such a claim involves quite a new notion of both gentleman and artist. In 1628, the year in which Selden published the *Marmora Arundelliana*, Rubens wrote from London to a friend in Paris of "the incredible quantity of excellent pictures, statues, and ancient inscriptions which are to be found in this Court"—notice how the inscriptions are mentioned in the same breath as the works of art. His highest praise was reserved for one of Arundel's sculptures: "I confess that I have never seen anything in the world more rare, from the point of view of antiquity."[5] As the last bit suggests, to collectors like Arundel and artists like Rubens, a primary value of the visual and plastic arts was their memorializing quality, their link to the past and the vision of permanence they implied. This is why Peacham emphasizes the importance and rarity not only of the statues but of the inscriptions: they were an essential element of the artistic power of the past. The word established the significance, the authority, of classical imagery, and modern masterpieces, the work of Giambologna, Michelangelo, Rubens, existed in a direct continuum with the arts of Greece and Rome.

Here is a very clear example of the relation of the verbal and visual arts in the period. Arundel conceived his collection not simply as a private matter, treasures for his personal enjoyment, but as an education in taste for the nation—as such, it would also serve, of course, as a monument to his own taste and magnificence. To this end he commissioned Wenceslaus Hollar to produce etchings of the principal masterpieces, with a view to publishing a volume of them. One of the first that Hollar completed was a rather grisly scene from ancient history, *King Seleucus Ordering His Son's Eye to Be Put Out*, after a sketch by Giulio Romano for a fresco in the Palazzo Tè (Figure 80). The subject was a moral story about the perquisites and obligations of power—the son had committed adultery, the stipulated punishment for which was that the perpetrator's eyes were to be put out. The father, as king, could have repealed the sentence, but instead he chose merely to mitigate it by ordering that only one of his son's eyes be blinded. The etching could certainly have stood on its own, a record of an exem-

XXIX.

ΠΡΕΙΜΑΤΗΙΔΙΑ ΓΥΝΑΙ
ΚΙ.ΛΕΟΝΤΑC ΤΙΒΕΡΙΟΥ
ΙΟΛΙΟΥ ΚΕΛCΟΥ ΠΟΛΕ
ΜΑΙΑΝΟΥ ΔΟΥΛΟC
ΚΟCΜΙωC ΚΑΙΑΜΕΝ
ΠΤωC CΥΝΖΗCΑCΗ
ΑΥΤωΕΤΗ ΔΕΚΑ ΤΟ
ΜΝΗΜΕΙΟΝ ΤΟΥΤΟ ΕΚΤωΝ
ΙΔΙωΝ ΕΠΟΙΗCΕ
ΤΟΥΤΟ ΤΟΜΝΗΕΕΙΟΧΙΕΧΕΙ
ΕΙCΟΔΟΝ ΚΑΙ ΕΞΟΔΟΝ

Hactenus Græca. Sequuntur ex Latinis, etiam
Arundellianis , selecta aliquot.

I.

BONAE DEAE VENERI CNIDIAE

D IVNIVS ANNIANVS HVMENAEVS ET IN VICIA SPIRAEPII AEDIMIANA.

Habetur in Fronte siue porticus siue ostij , vt videtur, Fani.

II.

M. ANNI AVCTI , ET
SEMPPONIAE SCVRRAE
IN FR.CVM VSTRINO P. LIII.
IN AGRO P. XXIII.
M. ANNIVS M. ANNI FELICIS. F.
SATVRNINVS VIX. ANNXIIX PIVSET
SANCTVS IS EREPTVS MATPINEC
ILLAE POTVIT GRATIAM REFERRE.

III.

79. John Selden, *Marmora Arundelliana* (London, 1629), p. 50. Getty Research
Institute, Research Library.

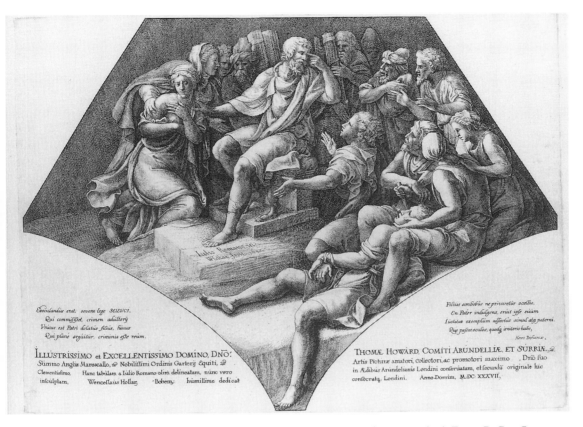

80. Wenceslaus Hollar, after Giulio Romano. *King Seleucus Ordering His Son's Eye to Be Put Out.* 1637. Etching. Fitzwilliam Museum, Cambridge.

plary work by one of the greatest Renaissance history painters, but it comes accompanied with a set of inscriptions. First Henry Peacham moralizes the scene in a Latin epigram which effectively suppresses the fact that the story is as much an instance of judicial nepotism as of justice tempered with mercy: one always had to be told how to take historical examples, which have an uncomfortable tendency to imply the wrong morals along with the right ones. Below this Hollar places a dedication to Arundel establishing all his credentials—his hereditary titles, his position as earl marshal, his Garter knighthood, the fact that he is the greatest amateur, collector, and promoter of the visual arts in the world—and then establishing his own claims to artistic eminence: "This picture, first drawn by Giulio Romano"—notice how long it takes to get to the artist—"now preserved in Arundel House, and here engraved after the original, Wenceslaus Hollar humbly dedicates and consecrates . . . ," and so on. The drawing comes accompanied with both a pedigree and an ethical commentary, a "learned lecture"; these are both essential to the picture.

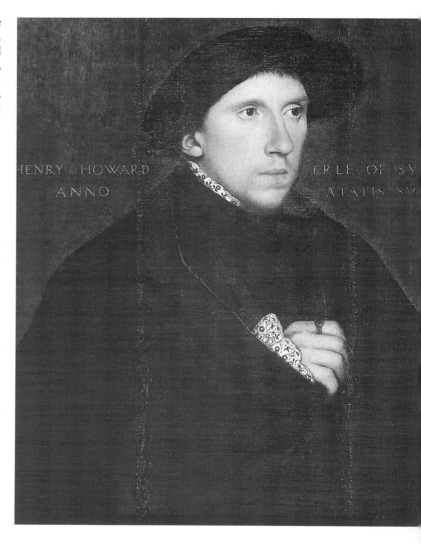

81. Hans Holbein the Younger. *Henry Howard, Earl of Surrey*. 1532. Oil on panel. Museu de Arts, São Paulo. (Photo: Giraudon/Art Resource, NY)

Arundel's pictures served him as a species of validation, establishing not only his taste but his authority within his own history as well. Early in his career he began collecting Holbein portraits, of which a number had come to him by inheritance. Holbeins were very expensive in England at this time, as much for nationalistic reasons, the artist's record of Henry VIII and his court, as for his artistic excellence. But he had a particular connection with the Arundels, having painted many of the earl's ancestors, including the unfortunate Henry Howard, earl of Surrey (Figure 81), who had been executed for treason; so the expense was also undertaken to assemble a visible family history. It undeniably helped to establish the earl's fame as a connoisseur—Arundel House contained over thirty Holbein oil portraits—but here again, the his-

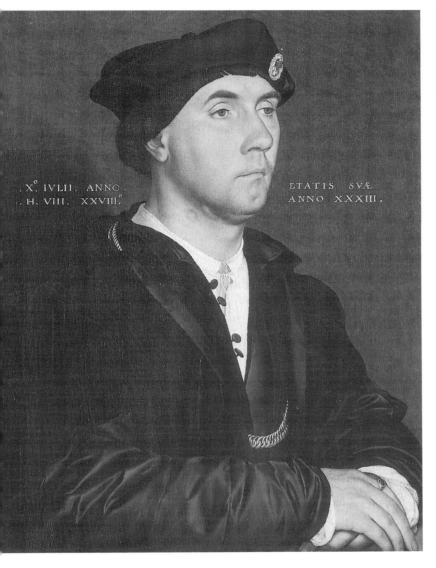

.X°. IVLII. ANNO.
.H. VIII. XXVIII.°

ETATIS SVÆ.
ANNO XXXIII.

82. Hans Holbein the Younger. *Sir Richard Southwell*. 1536. Oil on panel. Uffizi, Florence. (Photo: Scala/Art Resource, NY)

tory was as important as the aesthetics, as the following story shows. In 1620 Cosimo de' Medici II, the duke of Florence, wrote requesting one of the earl's Holbeins as a gift; he offered to send any of his own paintings in exchange. He was, he wrote, "passionately set upon having a work by this artist."[6] Arundel dispatched a splendid portrait of Sir Richard Southwell (Figure 82), duly furnished with appropriate inscriptions praising the artist, memorializing the sitter, and identifying the donor and recipient connoisseurs by their coats of arms—once again, the inscriptions are essential.

Now for Arundel, the Southwell portrait was a piece of family history in the worst way: Southwell had been instrumental in the arrest and execution of the Earl of Surrey. If the decision to purge the art collection of an old enemy seems logical, however, this in fact was not Arundel's motive. He at once commissioned a copy of the painting, and it continued to hang among the ancestors Southwell had betrayed. However demonic the sitter, whatever else the painting was, it was history. For Cosimo, on the other hand, it was both art and an index to his own power as a collector, and he hung it among the greatest treasures of the Uffizi, in the Tribuna, where it still hung when Zoffany visited Florence in 1777 and recorded its presence there.

After Prince Henry's death in 1612, Prince Charles inherited most of his brother's treasures, and, with the advice and encouragement of two of his father's favorites, Somerset and Buckingham (Charles and Arundel were on the whole not on good terms), added constantly to them, both by purchasing other collections and by commissioning paintings from the major artists of the day, most significantly Rubens and Van Dyck. By the mid-1630s the Caroline royal pictures constituted one of the greatest art collections in the world. There was more in this acquisitive passion than aesthetics and conspicuous consumption. Just as, in the sixteenth century, artists came increasingly to be considered not mere craftsmen but philosophers and sages (thus the greatest artist of the age is referred to, in the account of his funeral, as "the divine Michelangelo"), so increasingly in the period great art was felt, in a way that was at once pragmatic and quasi-mystical, to be a manifestation of the power and authority of its possessor. Great artists became essential to the developing concept of monarchy and to the idealization of the increasingly watered-down aristocracy, to realize and deploy the imagery of legitimacy and greatness, providing, for example, in Van Dyck's 1638 equestrian portrait (Figure 83), an imperial persona for the beleaguered king on the eve of the Civil War.

The extent to which the power of art became a practical reality in England at this time may be gauged by a brief comparison of two large royal expenditures. In 1627, in the midst of the long and disastrous war England waged with Spain and subsequently with France, the Duke of Buckingham led an expedition to relieve a trapped Huguenot garrison at La Rochelle. But his troops proved insufficient, and in urgent need of reinforcements and pay for the soldiers, he appealed to the king. Charles believed wholeheartedly in the cause, but money was difficult to find; after three weeks, £14,000 and two thousand additional troops were committed to the enterprise. These proved utterly inadequate, and Buckingham was forced to retreat ignominiously. Throughout this period, however, Charles was eagerly negotiating for the magnificent art collection of the Gonzaga dukes of Mantua, which had recently come on the market, including Mantegna's vast *Triumph of Caesar*, still one of the

83. Anthony Van Dyck. *Charles I on Horseback*. Ca. 1638. Oil on canvas. National Gallery, London.

glories of the British royal collection. For this Charles paid, in 1627 and 1628, a total of £25,500.[7] To this monarch, a royal gallery was worth far more than a successful army.

I turn now to the uses of art to power in this period. I have suggested its function as a way of memorializing and restoring, and the way it serves as a link with the past, something that brings to the present the authority and significance of history. But as Van Dyck's heroic image of the shy and intellectual Charles I suggests, it functions increasingly also as a way of remaking the present. Daniel Mytens's portraits of Arundel and his countess before their gallery express the authority of this aristocratic couple specifically through both their taste and their ability to afford the vast expen-

ditures necessary to acquire such treasures. In these images the sitters epitomize the concept of magnificence, which Aristotle defined as the virtue of princes, and though there is obviously a good deal of idealization at work here, the collection and the taste were real. In contrast, consider Rubens's version of the earl in a military persona (see Figure 115); the connoisseur is replaced by the active hero. The only property visible here is his armor, and he poses before a triumphal arch. This, unlike the portraits with the art collection, is pure fantasy: by 1629, when the picture was painted, Arundel had had no military experience whatever. He held his first military office only ten years later, when the king appointed him general of the army against the Scots, a position in which he served for all of three months, at which time the unsuccessful army was disbanded. Clarendon said of him that he had "nothing martial about him but his presence and his looks," and that he was made a general for "his negative qualities: he did not love the Scots, he did not love the Puritans."[8] The artist is supplying what life had denied him; but this was also a way that Arundel wanted to be seen—or perhaps more precisely, a way he needed to see himself, not simply as a connoisseur, bureaucrat, aristocrat, but as a man of action in the line of descent from his heroic ancestors.

Any collection is the expression of the collector's taste and personality, in the fullest sense a manifestation of his—and in the case of the Arundels, her—mind. And as my examples have already indicated, the most enlightening part of any collection in the period is not what is bought but what is commissioned: the crucial pictures in Renaissance collections are the portraits of the patrons, those specific manifestations of their view of themselves (it's to the point that Veronese didn't see Sidney as Sidney wanted to be seen; it's probably also to the point that the painting doesn't survive). Let us return to Prince Henry and look at an aristocratic image in the process of creation. Prince Henry is an ideal case, because the iconographic documentation is so thorough and the time span so brief. Henry was born in 1594. He became Prince of Wales (that is, he was formally declared the heir to the throne) in 1610, at the age of sixteen, and died two years later, of typhoid fever, in 1612. He embodied, for that brief two years, all the militant idealism of Protestant England chafing under a pacifist king who was increasingly pro-Catholic. All the portraits we shall consider were done during that two-year period.

In the standard official portrait by Robert Peake (Figure 84), Henry is aged about sixteen. The picture can be dated by the ostrich feathers on his hat: these are the emblem of the Prince of Wales, hence the date must be after his investiture in 1610. He is presented as a slim, boyish, serious, splendidly appointed young man; the idealization is all in the clothing, the properties, the decor—the white satin doublet lavishly embroidered with gold and jewels, the jeweled pompoms on the shoes, the Order of the Garter on his left leg, the Saint George medal around his neck, the gold-handled sword, the jeweled hat, the rich oriental rug on which he stands, his parklands beyond the window. Figure 85, painted during the next year, is an Isaac Oliver portrait

84. Robert Peake. *Henry Prince of Wales*. Ca. 1610. Oil on canvas. By courtesy of the
National Portrait Gallery, London.

85. Isaac Oliver. *Prince Henry as Roman Emperor*. Ca. 1610–1611. Miniature. Fitzwilliam Museum, Cambridge.

86. Isaac Oliver. *Prince Henry in Armor*. Ca. 1612. Miniature. The Royal Collection © 2000 Her Majesty Queen Elizabeth II.

87. William Hole. "Prince Henry at the Lance," from Michael Drayton, *Poly-Olbion* (London, 1613), p. 4r. Newberry Library, Chicago.

miniature, the boyishness is gone, and this is basically the cameo portrait of a Roman emperor. Figure 86 is another Isaac Oliver portrait of ca. 1612. The face is forceful and manly, and much more romantically handsome than any we've looked at yet, and the iconography is explicitly martial—he poses in armor, and in the right background are soldiers and tents, a military encampment. Figure 87 shows Prince Henry practicing at the lance, a very popular engraving that appeared as the frontispiece to Michael Drayton's long poem about England's history and topography, *Poly-Olbion*, published in 1613 and dedicated posthumously to the prince. This expresses more of the military idealization, and we note the imperial Roman profile again. And finally, Inigo Jones's version of the prince in Ben Jonson's court masque *Oberon* on New Year's Day, 1611, when he was not yet seventeen (Figure 88), was done less than a year after the investiture portrait, of the slim youth in the fancy clothes. It hardly needs to be emphasized that the physical idealization here—the classic musculature, the commanding stance—is the work of the artist: this young man has not been pumping iron for the past six months.

This image is fully consistent with the role the prince imagined for himself. Had he lived, his plan was to follow his sister Elizabeth to Germany after her marriage to the elector palatine, and to lead the Protestant armies in support of his brother-in-law's claim to the Bohemian throne—something that his pacifist father, dedicated to accommodations with the Roman Catholic powers on the continent, would certainly not have permitted the Prince of Wales to do.

Let us now consider Inigo Jones's own development. We have seen how Peacham considers Arundel's collection especially valuable for the way it functions as an education specifically for painters and architects, and for their potential patrons. But in a sense this gets things backward, because Jones was as much the architect of all three of the collections we have considered as their beneficiary; he was the expert to whom first Prince Henry and Arundel and then Charles turned for the legitimation of their taste. And this gives us our first inkling of how unexpected Peacham's use of aesthetic sophistication as the mark of a gentleman is: the arts were still very much crafts in Jacobean England; there is nothing comparable to the Italian notion that artistic ability rendered the artist godlike, producing "the divine Michelangelo." Hilliard and Oliver are admired because they so admirably fulfill the requirements of their employers. Even in Charles I's time, the artists' union was still the Guild of Painters and Stainers, who had banded together in 1502 and were primarily active in attempting to prevent lucrative commissions from going to foreign workmen. The Florentine artists by this time were calling themselves an academy and insisting that painting was not a craft but one of the liberal arts, literally "arts worthy of a free citizen"—a gentleman. Inigo Jones was emphatically not a gentleman; he came into the artistic world precisely as a craftsman, the son of a London clothworker, trained as a joiner. He is first referred to not as an artist or even as a painter, but as a "picture maker," a producer of

88. Inigo Jones. *Costume for Prince Henry* in *Oberon*. 1611. Pen, ink, and wash on paper. Devonshire Collection, Chatsworth. Reproduced by permission of the Duke of Devonshire and the Chatsworth Settlement Trustees.

commodities. There is more than irony in the fact that the detractors of his collabora-
tor and adversary Ben Jonson were fond of reminding him that he had once been ap-
prenticed to a bricklayer: the arts in England were still very much crafts. The changes
in status came eventually, but only through the mediation of foreign artists: Rubens
was Charles I's ambassador extraordinary, negotiating peace with Spain, not because
he was a great painter, but because on the continent his artistic talent had given him
an easy familiarity with the world of kings and courts; he was duly knighted, as, after
him, was Van Dyck. No English artist was treated in this way until Lely.

So Jones really is a pivotal figure, not least in his deep and long-standing associa-
tion with the snobbish and superaristocratic Arundel, whose taste he was instrumen-
tal in forming; a crucial figure in the transformation of the artist, and the arts, and
of artistic taste itself, in England. I shall conclude with what we may call Jones's own
collection, the imagery that he appropriated and adapted to his own uses.

I begin with the earliest of Jones's surviving stage designs, the House of Fame,
for Ben Jonson's *Masque of Queens*, performed at Whitehall Palace in 1609 (Figure 89).
This is, stylistically, a remarkably miscellaneous building to have come from the pen of
the architect who was to introduce neoclassicism into England. A Roman arch below
supports a Gothic trefoil above. Within the trefoil is a piece of stage machinery, a turn-
ing machine bearing the queen and eleven other ladies on one side and on the other
the winged figure of Fame (she is visible in the minimalist sketch at the lower left).
The façade is adorned with classical statues: on the lower tier are Homer, Virgil, and
Lucan, on the upper, Achilles, Aeneas, and Julius Caesar—these are not based on the
Arundel marbles, which hadn't been acquired yet, but they spring from the same sen-
sibility that found in classical sculpture the essential link between heroism and history
on the one hand, history and taste on the other.

Jones designed a palace for Prince Henry in *Oberon* two years later, in 1611 (Figure
90). Again, the miscellaneous quality of the invention is striking: this is a veritable an-
thology of architectural styles. A rusticated basement seems to grow out of the rocks.
The parterre has a Palladian balustrade. A splendid pedimented arch surmounted by a
Michelangelesque figure fills the central façade, supported by grotesque Italian terms,
and accented by Doric pilasters and Serlian windows. The crenellated turrets of an
English castle are topped with tiny baroque minarets; two pure Elizabethan chim-
neys frame an elegant dome based on Bramante's *tempietto*. And here there seems to
be a point, even a program, being enunciated; the inspiration is not merely eclec-
tic. This design begins to make a claim about the national culture and the sources
of its heroism: that England becomes great, a suitable context for the heroic young
prince, through the imposition of classical order upon British nature; the rough native
strength of the castle is remade according to the best models, civilized by the arts of
design, by learning and taste. In the same way Prince Henry as Oberon emerges in
classical armor from the woods, tames the rough satyrs who open the masque, and

89. Inigo Jones. *House of Fame* from *The Masque of Queens*. 1609. Pen, ink, and wash on paper. Devonshire Collection, Chatsworth. Reproduced by permission of the Duke of Devonshire and the Chatsworth Settlement Trustees.

90. Inigo Jones. *Oberon's Palace* from *Oberon*. 1611. Pen, ink, and wash on paper. Devonshire Collection, Chatsworth. Reproduced by permission of the Duke of Devonshire and the Chatsworth Settlement Trustees.

descends from the stage to salute his father, the real King James, at the center of the Palladian architecture of the Whitehall Banqueting House.

There are clear analogues to this in Jones's architectural thinking: for example, in the façade he designed for old Saint Paul's (Figure 91), combining ancient and modern Roman elements to refine and complete the venerable Gothic cathedral; or perhaps most notoriously, in his reconstruction of Stonehenge (Figure 92), surely the most uncompromisingly British of ancient monuments, as a Roman temple in what he calls the Tuscan style. But the refining could also work in the other direction, with British strength restoring ancient virtue. The decay of chivalry is exemplified in the opening scene of another entertainment starring the prince, *Prince Henry's Barriers*, presented in 1610 (Figure 93). This scene is of ancient ruins, several recognizable as real Roman

91. Inigo Jones. *Design for the West Façade of Old Saint Paul's Cathedral, London*. Ca. 1608. Pen, ink, and wash. Royal Institute of British Architects, London.

monuments—the pyramid of Caius Cestius, Trajan's column, a bit of the Colosseum (and for more local color, in the lower left, a nicely classical tomb Jones designed in 1607 for a lady in Shropshire). When the prince appears, the scene changes (Figure 94); the ruins now include a triumphal arch based on the Arch of Titus on the left, not at all in ruins, though rather perilously placed at the edge of a cliff; and both Trajan's column and the building in front of it have been considerably refurbished. There are also, however, modern fortifications and, at the center, Saint George's Portico, through which the prince is to enter. Despite some classical sculpture and a dome, it is basically a Gothic pavilion—Jonson's text describes it as an ancient monument "yet undemolished," but the ancient monument now is British, not Roman.

92. John Webb after Inigo Jones. *Stonehenge Restored*, from *A Vindication of Stone-Heng Restored* (London, 1665), p. 145. Newberry Library, Chicago.

93. Inigo Jones. *Prince Henry's Barriers, scene 1*. 1610. Pen, ink, and wash on paper. Devonshire Collection, Chatsworth. Reproduced by permission of the Duke of Devonshire and the Chatsworth Settlement Trustees.

Sometimes, of course, the connoisseur's instinct leads not to synthesis but to direct appropriation. At the opening of Ben Jonson's masque *Pleasure Reconciled to Virtue*, performed at Whitehall in 1618, the entry of Hercules' drunken cupbearer with two satyrs derives, scarcely altered, from a Bacchic scene engraved by Marcantonio Raimondi after a Roman sarcophagus. It's a little disappointing to find a splendid Whining Lover from *Love's Triumph Through Callipolis*, performed in 1631, deriving so literally from Callot; or to find that the only thing original about the deliciously original Dwarf Postman from Hell in *Chloridia* a month later is the chicken-footed

94. Inigo Jones. *Prince Henry's Barriers, scene 2*. 1610. Pen, ink, and wash on paper. Devonshire Collection, Chatsworth. Reproduced by permission of the Duke of Devonshire and the Chatsworth Settlement Trustees.

horse (Figures 95, 96). In a sense all this is hardly worth remarking. Art historians will properly object that all artists do this sort of thing; this is simply the nature of artistic invention—imitation is what art is all about. Especially in this era: this is the age, after all, when Julius Caesar Scaliger told aspiring poets that although the function of art was certainly to imitate nature, the best way to imitate nature was to imitate Virgil. The only interesting point in Jones's copies, really, is what gets imitated, and that is what is new: English artists never practiced this kind of imitation before—what Jones's genius is all about is deciding what the right models are. That is what he did for Arundel, Prince Henry, and King Charles too.

95. Inigo Jones. *Dwarf Postman from Hell* for *Chloridia*. 1631. Pen, ink, and wash on paper. Devonshire Collection, Chatsworth. Reproduced by permission of the Duke of Devonshire and the Chatsworth Settlement Trustees.

96. Jacques Callot. *Dwarf* from *Varie Figure Gobbi.* 1616–1622. Etching.

Here, finally, is a scene that we may read as Jones's tribute to his first and most faithful patron: the Forum of Albipolis, for the 1632 masque *Albion's Triumph* (Figure 97) in which the increasingly imperial King Charles once again presents himself as a Roman emperor. The whole is thoroughly, splendidly classical. The architecture comes not from Vitruvius, or some other properly classical scholarly source, however, but from recent stage history: it is adapted from the Temple of Peace, a Giulio Parigi design for *The Judgment of Paris*, performed in Florence in 1608 and subsequently engraved (Figure 98). But the setting is also localized: David Howarth has recognized

97. Inigo Jones. *Forum of Albipolis* from *Albion's Triumph*. 1632. Ink on paper. Devonshire Collection, Chatsworth. Reproduced by permission of the Duke of Devonshire and the Chatsworth Settlement Trustees.

the first two statues at the head of the colonnades as two of the Arundel marbles, Caius Marius on the left, and on the right a draped Roman lady.[9] History was soon enough to reveal the imperial vision as hollow, something that could be maintained only in the world of court masques, but there is more than irony in the placing of Arundel's artistic vision at the forefront of an England idealized and restored. What politics could not effect, aesthetics did.

98. "Temple of Peace" from Giulio Parigi, *Il giudizio de Paride* (Florence, 1608). Newberry Library, Chicago.

Notes

1. From the preface to Richard Haydocke's translation of Paolo Lomazzo's *Trattato, A Tracte containinge the Artes of curious Painting, Caruinge & Buildinge* (Oxford, 1598), p. 6.

2. David Howarth, *Lord Arundel and His Circle* (New Haven: Yale University Press, 1985), p. 21. My discussion of Arundel's collection is greatly indebted to Howarth's account.

3. Roy Strong, *Henry Prince of Wales* (London: Thames & Hudson, 1986), p. 188.

4. Howarth, *Arundel*, p. 120.

5. R. S. Magurn, ed., *Letters of Peter Paul Rubens* (Cambridge, Mass.: Harvard University Press, 1955), pp. 320–21.

6. Howarth, *Arundel*, p. 69.

7. See Oliver Millar, *The Queen's Pictures* (New York: Macmillan, 1977), pp. 40–42.

8. *Dictionary of National Biography*, s.v. "Howard, Thomas" 1:1018/75.

9. Howarth, *Arundel*, pp. 108–9.

8. MADAGASCAR ON MY MIND

The Earl of Arundel and the Arts of Colonization

ERNEST B. GILMAN

> On a round ball
> A workeman that hath copies by, can lay
> An Europe, Afrique, and an Asia,
> And quickly make that, which was nothing, *All*
> John Donne, "A Valediction: Of Weeping"

In the autumn of 1639, Thomas Howard, earl of Arundel and Surrey, was in ill health, virtually bankrupt, and embittered by the recent course of political events. Having led the king's armies into Scotland, he returned from the First Bishops' War after a punishing campaign and the conclusion of what many of Charles's supporters could only regard as an ignominious peace. Reduced nearly to nothing, he turned all his thoughts to Madagascar. Perhaps his hope lay in the east. Arundel's debts were mounting toward one hundred thousand pounds, much of it expended on the collection of antiquities. With a ship provided by the king and an ample fund to be raised by the sale of stock to fellow "Adventurers," might he not repair his fortunes by planting a colony on that favored isle off the Afrique coast? My discussion will focus on these two apparently unrelated ventures: Arundel's brief, abortive scheme—long forgotten—to establish an English colony on Madagascar, and his long, spectacularly fruitful if ultimately ruinous career as a collector of antiquities, for which he is justly renowned. My principal object of study will be Anthony Van Dyck's "Madagascar" portrait of Arundel, completed in the autumn of that same year of 1639 (Figure 99), in which these two projects are combined. The context of my discussion includes several other paintings and documents produced by the members of the Arundel circle that shed light on this particular convergence, but I am ultimately concerned with the broader question of the relation between "old" and "new" knowledge of the world at this exemplary moment in the early modern history of English exploration and colonial ambition.

* * *

In Arundel's lifetime, the expansion of geographical frontiers in every direction of the compass was matched by a like expansion in the scope of knowledge, which "by the early seventeenth century had burst the bounds of the library" and challenged ancient truths on every front.[1] The fruits of mariners' reports and other travelers' accounts, as well as of telescopic observations of the heavens and anatomical explora-

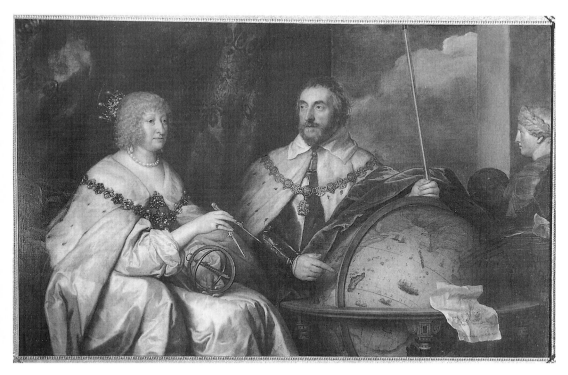

99. Anthony Van Dyck. *Thomas Howard, Earl of Arundel, and His Countess* ("Madagascar" Portrait). Ca. 1639. Oil on canvas. Arundel Castle, Sussex, Collection of the Duke of Norfolk. (Photo: Courtauld Institute)

tions of the little world of man, promised new stocks of knowledge and reassured the Baconians—if not a more skeptical Donne—that the mind's dominion over nature would expand apace. At the same time, as recent work in various fields has shown, "old" patterns of thought, classical and biblical, retained much of their power and durability. What we might now characterize as the beginning of a paradigm shift in the conception of knowledge itself, provoked both by an expansion of the "known" world and by the parallel invention of new technologies of intellectual exploration, was as much propelled as impeded by an undercurrent of conventional wisdom. Whether in the expectation that the "new" world might likely harbor Homeric Amazons or lost tribes of Israel, or the allegory of "America" as a buxom maiden reawakened from the slumber of the ages by the European explorer,[2] or the impression formed by Sandys on his African travels that certain village women were the image of Medean witches out of Ovid,[3] the "old" was always, perhaps inevitably, available as a template for (re)conceiving new experience. The persistence of ingrained habits of thought in this (or any) period of abrupt cultural change hardly surprises us, especially, since Kuhn, in the realm of natural philosophy—where we have come to understand even the con-

temporary claims of unprecedented invention (in the modern sense) as a thematic within the discourse of science.

However, the convergence of Arundel's antiquarian and colonial interests in the program of the Madagascar portrait reveals a subtle network of connections between the "old" and the "new" in a particularly brilliant instance of Van Dyck's work that reflects the collaboration of artist and patron in the creation of a colonial ideal; it thus makes possible a more nuanced description of what I will call the imagination of the protocolonial moment in Caroline England. For as Donne's "Valediction," quoted above, suggests in its conjunction of mimesis with making, the reproduction of familiar "copies" or patterns with acts of autonomous—even magical—creation *ex nihilo*, the idea of Madagascar at that moment will depend upon the recovery of an image of the past even as it contemplates the foundation of a new colony. This essay is about the "making" of such an idea within the Arundel circle and, by implication, beyond its circumference.

The prospective voyage would be undertaken, in the ringing tones of the earl's public "Declaracon concerning Madagascar" of September 6, 1639, for the "propagacion of Christian Religion and prosecucion of the Eastern Trafficque." He had no doubt that investors would be attracted in great numbers by "powerfull inducements of honor and profitt," and he directed them to appear, money in hand to guarantee their share, between eight and eleven in the morning, Tuesdays and Fridays, at Arundel House in the Strand.[4] Surely riches beckoned from an island not only bounteous in itself but strategically located athwart the trade routes linking India, Africa, and the Levant. The idea of Madagascar represented more than a canny investment in an area whose seemingly limitless commercial potential had already been suggested by the successes of the East India Company. Leaving behind his creditors and an England torn by civil strife, Arundel and his company might look forward to the retirement of a tropical paradise. Despite these alluring prospects, however, the scheme quickly collapsed—perhaps because of fears for the parlous state of the earl's health, or perhaps because too few were willing to venture a stake in what Sir Thomas Roe had called the "dreame of Madagascar"[5]—but not before it was commemorated in Van Dyck's double portrait of the earl and the countess, the sitters indicating the location of the future colony on a large round ball of the earth.

The Madagascar Portrait

The Van Dyck painting opens the idea of Madagascar, not simply by recording the event (or nonevent) of the earl's anticipated voyage but by giving it an imaginative shape. It advertises the venture, forms part of its brief history, and epitomizes the cultural matrix within which the Madagascar project figures. My interest lies in pursu-

100. After Anthony Van Dyck. *Thomas Howard, Earl of Arundel, and His Countess* ("Madagascar" Portrait, version 2). Ca. 1639. Oil on canvas. Private collection. (Photo: Courtauld Institute)

ing the several apparently disparate, yet finally converging, themes suggested by this image. If Arundel's colonial ambition is at the center of the image, then radiating from it, holding it in place, are the interests of portraiture itself, of heraldry, of connoisseurship and the collection of antiquities, and even, as we shall see, of the origins of the discourse of art history. For in one version of the portrait, at Knole (Figure 100), a figure appears in the background who has been identified as either the Reverend William Petty, Arundel's chief agent in the antiquities trade, or as the scholar Franciscus Junius the Younger, Arundel's librarian and resident philologist, who at Arundel's had published his *De pictura veterum* in 1637, followed the next year by an English translation of this groundbreaking history of art in antiquity, *The Painting of the Ancients* (London, 1638).

In the first place, *as* a Van Dyck, the Madagascar portrait would have been received at the time as more than a disinterested representation. The painter's fame in England, the very fact that such a subject is worthy of his art, indeed that the meticulously rendered globe contemplated by Arundel with proprietary interest has already been conceived and realized by Van Dyck—all this stands as an implicit en-

dorsement of the project, although the somber cast of the painting also reveals Van Dyck's perception, if not Arundel's, that Madagascar will be a melancholy retreat rather than a bright prospect. Van Dyck's enormous prestige enhances that of his subjects of course, just as their patronage enhances his. But the exchange works in subtler ways as well. Arundel had been influential in attracting Van Dyck to England, his sponsorship of the painter going back perhaps as far as 1620–21 when the twenty-year-old Flemish genius first visited London. After establishing himself permanently in England in 1632, Van Dyck eclipsed all others, including not only Daniel Mytens but even Rubens, as the craftsman of Arundel's image. In 1635 he produced a magnificent portrait of the earl with his young grandson Thomas, later fifth duke of Norfolk (Figure 101), to which we shall return. In the Madagascar portrait the artist's authority and that of the would-be colonial administrator converge as the very fact of the painting's commission testifies as much to the earl's power to command such a celebrated "workeman" as Van Dyck as to his ability to share in the imaginative power of the artist. In ca. 1633 Van Dyck had already produced a literal vision of the exotic such as might now allure Arundel's imagination: a lush full-length portrait of William Feilding, earl of Denbigh, on the sitter's return from a voyage to India and Persia (Figure 102). Denbigh is depicted in Indian dress, fowling-piece in hand. He has just emerged from an unmistakably English landscape to his right, but has now stopped before the improbable scene of a palm tree, parrot, and native boy which seems suddenly to have opened on his left—as if he had just stepped into and been transformed by an Indian fantasy. Although parrots and coconuts betoken the riches to be had in the Indies,[6] Denbigh's gaze, like Arundel's in the Madagascar portrait, is directed as much inward as outward, slightly elevated and intensely absorbed: he is not looking at the parrot toward which the boy is trying to direct his attention. As Richard Wendorf observes in his discussion of this work, Denbigh's expression, if marked by a certain disquiet or apprehension like Arundel's, is nonetheless suffused with curiosity, wonder, and a kind of awe evoked from the realm of sacred painting,[7] and reminiscent of the marvelous spectacle revealed at the end of an Inigo Jones masque. In this Indian reverie we see what in the Madagascar portrait is unseen but strongly suggested in Arundel's expression: the vision before the mind's eye of a new world unsullied by debts and wars—a sceptered isle under the earl's own dominion.

In the September 6 declaration of his plans—in effect, a prospectus for the Madagascar expedition—potential investors are invited to join with Arundel in "soe worthy a designe."[8] Arundel's "design" for Madagascar, like the Platonized *disegno interno* of Mannerist art theory, is the Idea or preconception of the colony, perfect in the inventor's mind and there judged to be "worthy" even before it is embodied in material reality.[9] To adapt the earlier but apposite language of Sidney's *Defence of Poesy*, it is the "*idea* or fore-conceit for the work" in which the skill of the artificer may be seen, its enticing narrative of the impending expedition no mere fiction, but an "imaginative

101. Anthony Van Dyck. *Thomas Howard, Earl of Arundel, and His Grandson, Lord Maltravers.* 1635. Oil on canvas. Arundel Castle, Sussex, Collection of the Duke of Norfolk. (Photo: Courtauld Institute)

ground-plot"—the mind's blueprint or ground plan—"of a profitable invention." [10] The architectural metaphor implicit in Sidney's "ground-plot" (which may also suggest the prepared background of a painting) reinforces the ancient connections between the artistic imagination and the building of civilization. As Sidney reminds us elsewhere in the *Defence*, "Amphion was said to move stones with his poetry to build Thebes," and among the other great foundational poets—Musaeus, Homer, Hesiod, Orpheus—the lawgiver Solon was credited by Plato in the *Timaeus* with having composed a (lost) epic on the (lost) island of Atlantis. [11] The added note, in Sidney's memorable phrase, that such an invention is "profitable," in our context takes on a financial as well as a moral inflection.

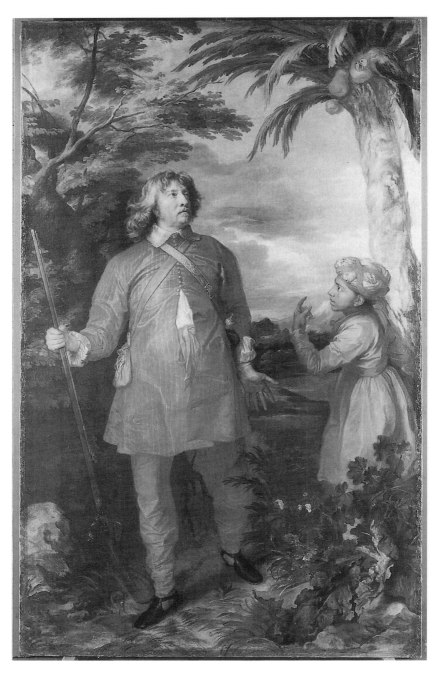

102. Anthony Van Dyck. *William Feilding, First Lord Denbigh*. 1633. Oil on canvas. National Gallery, London.

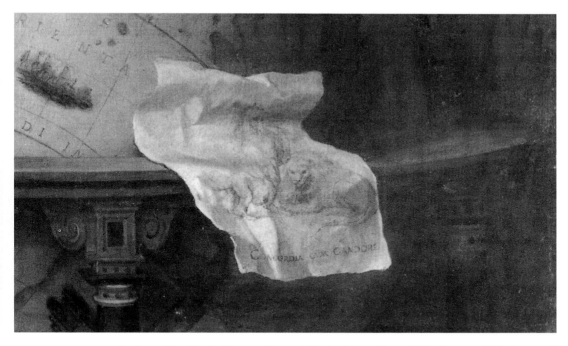

103. Anthony Van Dyck. *Thomas Howard, Earl of Arundel, and His Countess* ("Madagascar" Portrait) (detail). Ca. 1639. Oil on canvas. Arundel Castle, Sussex, Collection of the Duke of Norfolk. (Photo: Courtauld Institute)

In the Madagascar portrait, a half-crumpled drawing, draped with apparent casualness over the frame of the globe (we will return to the heraldic content of this drawing below), catches the eye of the viewer (Figure 103). Might it suggest the role of the painting itself, analogous to that of the declaration, as the preliminary sketch for a project (like the "copies" or templates available to the world-making workman in Donne's "Valediction") that now exists as a glimmer in the earl's imagination, just partly revealed in the rapt expression on Arundel's face as he contemplates the idea, but soon to be given a local habitation and a name on the island of Madagascar? Among the other art objects represented in the portrait, the presence in the background of a bronze head known then as the "Arundel Homer" also reinforces the earl's connection to the poetry of epic voyages and durable heroic achievement. The fragility of the drawing, however—how easily could a small movement of the globe, a slight gust of air, blow this one out of the picture—may also suggest the fragility of the idea. As we are reminded by the title of Jeffrey Knapp's recent book, *An Empire Nowhere*, until fairly late in the history of European colonization, and certainly compared with the successes of Spain and Portugal, England's "empire" outside the British Isles was largely "nowhere," imaginary and utopian [12]—a noplace like the featureless

island toward which Arundel gestures in the portrait, and which still awaits the stamp of the Idea for its realization. We shall return at the end to the anachronism of applying to this period of sporadic venturing, piratic expeditions, and failed plantations any notion of "empire," and hence of "imperialism," with any of the later connotations of those words. Indeed, Arundel's September declaration seems to anticipate the skepticism of the potential investor who may regard the project as something like an illusion of Prospero's, for in that document, the money, the ships, the earl's own "Creditt with the world," and the fact that he plans to go to Madagascar in person, are all offered as evidence to "disabuse such as shall thinke this a vayne & ayrye undertaking." [13]

The subsequent history of Madagascar would, inevitably, devalue the golden world of Arundel's conception to a far harsher, brazen reality, although several enthusiasts kept the vision alive, however vain and airy it may have seemed, into the 1640s. Since the early years of the sixteenth century, first the Portuguese and later the Dutch, the Spanish, and the French had all made forays into the area. On Christmas Day, 1601, an English expedition of three ships headed for the spice islands—the first such venture to be launched by the newly chartered East India Company—stopped for provisions in Madagascar. There, in Antongil Bay on the northeast coast of the island, they learned from an inscription scratched into a rock that five Dutch ships had preceded them in October, and that as many as two hundred Dutch seaman had succumbed to a tropical fever during their brief and tragic visit. In 1636 King Charles considered sending an expedition to the island, over which he somewhat prematurely appointed his nephew Prince Rupert of the Palatinate, then only seventeen, as viceroy. Rupert's own mother, Elizabeth, concerned that her son was getting swept up by the "Romance" of the idea that he might "Don Quixotte-like conquer that famous island," wrote to Sir Thomas Roe imploring him to "put such windmills out of [the prince's] head." [14] But Rupert himself seems to have lost interest before long. By mid-1637 Roe was able to reassure Elizabeth, "The dream of Madagascar, I think, is vanished." [15] The dream reappeared in 1643 with the publication of Walter Hamond's *Madagascar: The Richest and Most Fruitful Island in the World*, followed a year later by Richard Boothby's *A Briefe Discovery or Description of the Most Famous Island of Madagascar*. Boothby touted the island as "a very Earthly Paradise" and "the chiefest place in the World to enrich men by trade." [16] In 1644, 120 English colonists sailed into the Bay of Saint Augustin and built a fort. However, they quickly ran afoul of the local inhabitants, unwisely declining to join them in battle against their tribal enemies. Murder and starvation took all but twelve of the colonists within a year, and the survivors returned to England— leaving "behind them only a ruined fort and a large cemetery." [17]

A feeling of melancholy and unease in the painting, the slight apprehension in the faces of the earl and the countess, may already convey a prescient awareness that this overreaching venture was destined to fail. A laudatory "Short View" of Arundel's life, written by Sir Edward Walker in 1705, concedes that if the earl were "defective

in anything, it was that he could not bring his Mind to his Fortune; which though great, was far too little for the Vastness of his noble Designs"[18]—a judgment that applies equally to the huge sums lavished by Arundel on his purchase of antiquities, and to the colonial design too vast either for his own fortunes or for those of his chimerical shareholders. For this gap between design and realization, as for a painter like Leonardo who could not finish pictures already perfected in his mind, there is at least the consolation offered by Sidney that "any understanding knoweth the skill of the artificer standeth in that *idea* or fore-conceit of the work, and not in the work itself"[19]— and in the completion of Van Dyck's work embodying the nascent idea and, as it happened, the graveyard of Arundel's hopes.

In the Madagascar portrait, the stiff twin compasses held by the countess in her right hand, pointing, like the earl's index finger and on a line with it, toward the location of the future colony on the globe, also serve to unite the expedition to Madagascar with its representation by Van Dyck, for these are the instruments of navigation and artistic composition alike. Worlds, as the Renaissance knew from Pythagorean and scriptural sources alike, are created in number, weight, and measure. As Junius's editors observe of this detail, again in terms that apply equally to the underlying *ratio* of artistic and political design, the compasses "confirm as much the Arundels' commitment to measured order in their resolve to establish the colony as they ensure the safe course of navigation on which the enterprise depends."[20] The motif may also be taken to emblematize the guarantee of the prospectus that in due measure every adventurer will be given "his full and ratable proporcion in the proffitts of the voyage," according to the amount of his initial investment.[21]

Such a liaison between Arundel and Van Dyck, their imaginative partnership in the Madagascar project, is strengthened by the tendency of Europeans—as Stephen Greenblatt has noted, citing a passage in Peter Martyr—to see colonized regions and their peoples as "rased or vnpainted tables," blank canvases "apte to receave what formes soo ever [of religion or civilized custom] are fyrst drawen theron by the hande of the paynter."[22] Painters would frequently accompany colonial expeditions to record whatever marvels might be found. From the time of Elyot's *Booke of the Governor* courtiers had been urged to learn at least the rudiments of painting as an adjunct to the military virtues, allowing them to make sketches for the purpose of reconnaissance, for example. In the witty allegory of civil war in "Upon Appleton House," Andrew Marvell would survey the meadow of his patron's estate cleared by the mowers with military precision and see in this "leveled space" a "new and empty face of things"— a portrait *in potentia*, a blank canvas prepared for the designers of a new social order like "cloths for [the painter Sir Peter] *Lely* stretched to stain" (lines 442–44). The winners in the civil war would have their opportunity, however brief, to sketch in their design for a commonwealth, while Marvell's Fairfax, like Arundel a disillusioned military commander, would retire to cultivate his private gardens. For Arundel, the sat-

isfactions of Amphion could only be found in art. As a collector he could reassemble the stones of an old world; the prospectus for Madagascar allowed him to imagine a new one—in the event, no less remote and inaccessible as the ancient world whose fragments he preserved. In the compensatory fantasy of the Van Dyck portrait, the painter anticipates rather than accompanies the expedition, heralding it by recording its inception in the idea from which it will (never) be realized, and investing the depicted colonizer with his own artistic mastery of invention and design.

Heraldry

There is, however, a much more specific sense in which Arundel *heralds* the upcoming project, for in the Van Dyck portrait he appears most prominently in his role as earl marshal, the chief herald of the realm. While the earl's right hand points toward the globe along a near-horizontal line, his left seems to steady it from above. In this hand he holds the earl marshal's baton, establishing a near-vertical line that seems to pierce the top of the globe like a polar axis. In contrast to the open pointing gesture of the right hand, the left hand is closed, almost clenched around the staff of office so as to suggest the potential power that Arundel has (literally) in his grasp. The golden baton placed into his hand by that of King James might now be used as a lever to turn the very world. The surviving portraits of Arundel show him to be inseparable from this emblem of the high office he had held since 1621. It is prominently displayed in the 1635 Van Dyck portrait of the earl and his grandson already mentioned (see Figure 101), where the child's gaze draws our attention to it with something of his own mixed feelings of apprehension and respect. We know, even if the child is too young to understand it, that his own future rests on the security of his grandfather's titles, both symbolized in, and guaranteed by, the baton of the chief heraldic officer of the kingdom. That the earl himself begins the Madagascar prospectus of 1639 by giving this title the same prominence—"I, Thomas Earle of Arundell and Surrey, Earle Marshall of England"—leads us to consider this aspect of his authority more closely. How is the power of this (to us) arcane and curious office enmeshed with that of the artist and the colonialist?

Of the project's "powerful inducements of honor and profitt," it is "honor" that is the special province of the earl marshal. He is an honorable man himself, of course, in the moral as well as in the technical sense that he is a gentleman entitled to the honor of bearing arms. To this, in the Madagascar portrait, the drawing visible on the casually draped paper mentioned above (see Figure 103) offers a kind of visible certification by exhibiting the earl's heraldic animals and his motto. By virtue of his office he is not only a trustworthy administrator but the guardian of the kingdom's honor as well. As symbolized by the full armor worn by Arundel under his ermine cloak, the

earl marshal had originally—in the late Middle Ages—been supreme military com-
mander.[23] One of his ceremonial duties, joining the worlds of arms and arts, was still
to arrange the order of combats in the lists. By Arundel's day, the office having been
newly strengthened for him, the earl marshal presided over the Court of Chivalry,
which had in its purview all matters relating to the honor of a gentleman. Its main
function was to legalize and enforce decisions made by the College of Arms—adju-
dicating contested claims to title and prosecuting alleged infringements of armorial
bearings.

Heraldry is thus a judicial and an administrative institution concerned with
granting, recording, and securing the legitimacy of coats of arms. In the context of
the Madagascar portrait, it is important to recall that heraldry is also a form of art,
involved in the emblematic design of coat armor as well as the orchestration of cere-
monial occasions. Despite Ben Jonson's jibe at the pretenses of title in the *Epigrams*—
"I a *Poet* here, no *Herald* am"[24]—heraldry incorporates a kind of poetics with its own
style and the technical language of the *blazon*, whose "azure waves" and "sable nights"
migrate from the precise stipulation of armorial bearings into the broader stream of
poetry.[25] In the legal and the poetic sense alike, the herald can be said to "create" both
gentlemen and the symbolism in which their titles are registered. A similar power of
denomination is exercised by Arundel and his fellow Renaissance collectors when they
simply declare—as was their typical practice—an unidentified statue to be a Cicero
or a Marius.[26] The bronze head in the Madagascar portrait is the "Arundel Homer"
by virtue of the earl's authority to confer that name upon it. Like the royal scepter
and the artist's pencil, the earl marshal's baton has the power to call into being—in
the instance of the Madagascar portrait, an island colony, as Donne had said, quickly
making "that, which was nothing, all." The historical underpinnings of such quasi-
magical power to create is provided by the polymath John Selden, a member of Arun-
del's circle, who in his *Titles of Honour* (London, 1614) had argued that systems of rank
and title existed from the beginning as the organizing principle of civil society. The
herald's duty also includes vigilant police work to shore up that foundation. In the
face of such widespread abuses as the sale of honors to those with weak or disputed
claims, even outright fraud in the confection of bogus genealogies,[27] heraldic officers
dispatched on official visitations throughout the realm were charged with making the
most scrupulous investigations of questionable cases. As J. F. R. Day observes, citing
the case of an offender who suffered a whipping and the loss of his ears for dispensing
counterfeit coats of arms and pedigrees, "Heraldic abuses were considered attacks on
the foundation of the state, and were punished accordingly."[28]

To discriminate between the authentic and the fake, to establish true identities
and weed out forgeries and impostors by historical research—these are the requisite
skills of the art collector as well as the herald. Selden's antiquarian work under the pa-
tronage of Arundel reflects both pursuits. The author of *Titles of Honor* went on to

publish his *Marmora Arundelliana* in 1628, a digest of the ancient inscriptions found on the marbles in Arundel's collections, and one inspiration for Junius's *The Painting of the Ancients* ten years later. Reinforcing this same connection between heraldic and artistic enterprise, the earl marshal's baton also appears in an earlier portrait of Arundel with his collection of statuary painted by Daniel Mytens (see Figure 78), who also served the earl as a purchasing agent of art in the Low Countries, and who, after the Restoration, would portray a much older Prince Rupert in the role of a colonial adventurer in the African trade, the object of the adoring gaze of a black child.[29] The Mytens portrait of Arundel shows the earl seated at the threshold of his sculpture gallery, while a companion portrait also by Mytens shows the countess seated outside another long gallery in which paintings are displayed (see Figure 74). The countess sits composed, her own likeness echoing those of the other sitters whose portraits are depicted in the gallery. Juxtaposed with this image of contemporary art presided over by the countess, Arundel takes a more active role as he draws our attention with the baton to the classical statues arrayed along the wall of the deep space opening behind him.

Within Mytens's painting of the earl, the gallery space is framed off in such a way by the portals to either side of the door and by the high step at the bottom to be read, ambiguously, as the painting of a sculpture gallery—the gallery, that is, as a work of art in itself—as well as an actual room set deep in perspective space. And this fictive space is at once present as an architectural feature of Arundel House, and distant in time, an Albertian window opening into the classical past in which these statues first had their being. This *trompe l'oeil* effect is punctuated by the ambiguity of the baton. Its tip seems at once to indicate a point on the surface of the painting-of-a-gallery, and yet to reach by some magical extension into the room itself to touch that same point in fact. At that point "in" the space of the gallery it touches the base of a statue resembling a Venus *pudica*, and by doing so it seems to animate the marble goddess, for she alone among the otherwise erect and impassive figures in her row seems to bestir herself in response to the earl's gesture, seems to be just in the process of rousing herself to her full height through his influence. The collector's seeming power to restore the ancient world to life—like Amerigo Vespucci awakening "America" from her long torpor—is reflected as well in an anecdote told of Sir Francis Bacon. The great philosopher who had devoted his career to reinvigorating the diseased and vermiculate body of learning, "coming into the Earl of Arundel's Garden" in 1626, the last year of his life, and finding there "a great number of Ancient Statues of naked Men and Women, made a stand, and as astonish'd cryed out: *The Resurrection.*"[30]

This formal play of elements in the Mytens painting reflects an equally intriguing *trompe l'oeil* in the circumstances of the painting's composition. In fact, as David Howarth argues on the basis of other contemporary views and descriptions of the "decidedly old fashioned" gallery wing of Arundel House, the fine Italianate details of

the room as depicted by Mytens are illusory despite their meticulous rendering: "the barrel vault and the classical door cases and their consoles beneath, were no more real than that arched opening overlooking the Thames."[31] What is more, as Howarth goes on to show, the statues displayed in this imaginary room were not actually among those in Arundel's possession in 1616. Rather, in all likelihood, they represented a collection of sculpture he hoped to acquire in that year from Sir Dudley Carleton, the English ambassador in Venice. The Mytens portrait would then have been intended to serve as "part of [Arundel's] campaign to get Carleton to sell his statues," as Carleton might be more inclined to do if he were persuaded that in such elegant quarters as awaited them, they would "enjoy a setting worthy of their quality."[32] Like the Madagascar portrait in relation to Arundel's prospective expedition to the island, this Mytens portrait does not so much represent its subject as implicate itself in its history. This sculpture gallery reveals the image of a collection in Arundel's mind, the vision of a potential reality no less alluring and no less fragile than the idea of a Madagascar colony in 1639. In Tara Hoag's phrase, both portraits engage us in a "visual paradox, a history of the future,"[33] a future in which, however imaginary, both participate in a direct and material way. As sales prospectuses their intention is to bring about in fact what they can only depict as fantasy. It is worth noting that the earl marshal's baton is itself a key part of the illusion conjured here: although the office had been a traditional honor in Arundel's family, in 1616 he would not come into sole possession of it for another five years. Possibly the image of his (would-be) success as a collector was intended to further that ambition as well.

From the point of view of the later portrait of Arundel by Van Dyck, the Mytens sculpture gallery, like the island of Madagascar under the sway of Arundel's baton, may itself appear as a kind of colonial possession. A small subject population of marble figures is shipped in from afar like the Native Americans put on display in the Jacobean court. Such figures, whether Native Americans or Roman statues (and we should perhaps recall that in the iconography of representations of the Native American the two categories are often mixed) are objects of curiosity, fascination for the exotic, and potential profit, figures here authenticated, arrayed, and disciplined—put in good order—by the earl marshal's judicial authority as much as by his connoisseur's eye for the proper alignment of a sculpture gallery. Even more clearly, the Madagascar portrait insists upon bolstering the colonial enterprise at hand with reminders of Arundel's prestige as a collector of art. In all versions of the painting, on a table to Arundel's left—partially concealed by the globe but emphasized for the viewer by the strategic proximity of the hand holding the baton—are "books and scroll of paper to represent, *pars pro toto*, Arundel's library." Behind them appear the bronze head of the Arundel Homer, mentioned above as lending an epic cast to the impending voyage, "and a marble head, probably restored as Apollo" (Figure 104). The purpose of the display, as this commentator goes on to conclude, is to "make evident the magnanimity of

104. Anthony Van Dyck. *Thomas Howard, Earl of Arundel, and His Countess* ("Madagascar" Portrait) (detail). Ca. 1639. Oil on canvas. Arundel Castle, Sussex, Collection of the Duke of Norfolk. (Photo: Courtauld Institute)

the Madagascar scheme. Learning and the arts will assist in the pursuit of the project
but their advancement also will reflect the nobility in the name of which the Arun-
dels propose to exercise the rule of Madagascar."[34] In fact, these heads rest here at the
halfway point of their own cultural trade route. Under Arundel's heraldic aegis, ob-
jects of art imported from abroad will be accorded their proper place in the domestic
order of things. In turn the civilizing benefits incorporated and commemorated in the
heraldic art will be exported to Madagascar.

Collecting and Classical Scholarship

The link between colonial and artistic acquisition is strengthened in the copy of the
Madagascar portrait at Knole (see Figure 100) by the presence of a figure in the back-
ground—his hand resting on Homer's head, in a visual echo of Arundel's hand resting
on the globe of the world—a figure who, as I noted at the beginning, may be either
the Reverend William Petty or Franciscus Junius the Younger. It seems to be beside
the point to try to resolve this disputed identification. It is telling that a plausible case
may be made for either man, for in Arundel's enterprises the purchasing agent and the
classical scholar figured as the two sides of the same coin.

In appearance, this mysterious figure bears little resemblance to Junius as he was
painted by Van Dyck himself only a year later, in a portrait of 1640 now in the Bod-
leian (Figure 105). Strengthening the claim for Petty is the fact that this confidante of
Arundel had just died in September 1639. There is some evidence that in 1637 Arundel
planned to set aside a room for "Designes" at Arundel House that would be furnished
with both a portrait and a marble bust of his trusted agent, and that it was Petty who
encouraged Junius to undertake his scholarly researches into the history of art.[35] It is
not certain how the bronze head long known as the Arundel Homer and represented
in the Madagascar portrait came into the earl's possession, but Petty may have had
a hand in this important acquisition as in so many others on Arundel's behalf.[36] As
Howarth argues, Petty's inclusion in at least one version of the Madagascar portrait
would be an appropriate commemoration. Petty's energy and shrewdness had more
than anything else made possible the Arundel collections as, for a period of fifteen
years before his death, he had scoured Italy, Greece, and Asia Minor on the commis-
sion of his patron, acquiring marbles, old manuscripts, and a host of other antiquities,
often in competition with agents dispatched by Buckingham to the same territories.
Howarth notices "an abundance of paper" in the portrait. This, he suggests, is entirely
appropriate for Petty in that "the whole collection had been built on a mountain of
paper—upon those hundreds of letters which passed between Arundel and Petty, all
but a handful of which have vanished."[37]

105. Anthony Van Dyck. *Franciscus Junius*. 1640. Oil on panel. Bodleian Library, University of Oxford (Poole Portrait 151).

Insofar as the head of the Arundel Homer gives the art of collecting itself a kind of epic flair, Petty would seem to fit the role of a latter-day Odysseus better than the retiring and scholarly Junius. Correspondence from the 1620s from Sir Thomas Roe, then ambassador to Constantinople, to Buckingham and Arundel

gives a vivid picture of Petty's energy and determination; it recounts also the hardship and great risk which Petty had to undergo in his activities, his fearlessness and his utter disregard of severe personal danger. For the purpose of collecting classical antiquities he also visited the mainland of Greece and the Greek islands, and in 1625, while returning from a successful visit to Samos, he suffered shipwreck near the coast of Asia Minor, lost all the objects he had collected at the expense of great labour and personal privation and was furthermore in grave danger of losing his life. As he lost the ambassador's letters of introduction and other identity papers on that occasion, he was promptly arrested by the Turkish authorities as a spy and only freed after Roe's intervention.[38]

Undaunted, Petty bought up another shipload which, delivered to England, became the basis for Selden's *Marmora Arundelliana* (1628). Selden's praise for Petty's "ardent and incomparable devotion to the glory of old Greek art" would surely justify his place in any painting commissioned by the earl in which that art was so prominently displayed.[39]

Yet other scholars, including Sir Oliver Millar, still think the figure in the upper right corner of the Knole version is Junius,[40] and this traditional identification has its own compelling logic. Junius had been the earl's librarian since 1621, the year Arundel had been created earl marshal, and also the year in which, perhaps not coincidentally, Arundel had "embarked on a great scheme to enlarge his already considerable and for English circumstances, altogether astonishing collection of antiquities"[41] with the help of men like Junius and Petty. Enjoying the earl's patronage for over twenty years, Junius joined an illustrious circle around Arundel that included, beside Van Dyck and Selden, such celebrated men as Inigo Jones, Henry Peacham, William Harvey, and the mathematician William Oughtred. Van Dyck had consulted Junius once before the Madagascar portrait, in 1636, about an appropriate inscription for the portrait of Sir Kenelm Digby. The artist was then preparing to publish a series of engraved portraits of famous contemporaries known as the *Iconography*, a collection of modern worthies to match his patron's collection of antiquities. Digby was to have a place of honor in this pantheon, and no one was better qualified than Junius to supply an apt classical tag. One Van Dyck scholar is convinced that the scheme of the Madagascar portrait was drawn up by Arundel with Junius's help.[42] His inclusion in the Knole version of the portrait would then be an appropriate acknowledgment of all these services, both to the patron and the painter.

Junius had also provided important logistical support for Arundel's collecting campaign. Among his other philological and historical projects—and as part of the

same research that would lead to *The Painting of the Ancients*—he had worked for years to compile an encyclopedic *Catalogus* of antiquities. This is an alphabetical listing of ancient painters, sculptors, and other artisans from Aaron (who made the Golden Calf) to Zosimus, noted in a Roman inscription as surpassing all others "in the art of engraving Clodian silverware."[43] For each name, the catalog entry lists and, where possible, describes the works attributed to that artist in the classical sources. It also contains entries for works by anonymous artists and such generic entries as "Alexandrian tapestries" and "Cumaean dishes," the latter a particularly luxurious kind of red earthenware mentioned in Pliny and Martial. The *Catalogus* was not published until 1694, long after Junius's death. Completed by 1628, however, it was arguably intended to serve a very practical purpose, allowing Arundel—or his agents, if they were to carry manuscript copies of it into the field—to tell whether a piece offered for sale matched the classical accounts, and so was more or less likely to be what it was represented to be by the seller. The fact that the catalog was *not* published may in itself suggest an interest in keeping so valuable a reference guide to the antiquities market out of the hands of the competition.

In this respect, Junius's authority as an arbiter of the authentic in the realm of art doubles that of the earl marshal in the realm of heraldry. But their imaginative correspondence, the Madagascar portrait implies, runs deeper still. Junius's scholarship, in *The Painting of the Ancients* as well as in the *Catalogus*, has the power to recover—for the mind's eye at least—a wealth of visual riches unseen for millennia but now excavated from their literary repositories. Like the idea of Madagascar in Arundel's mind, the far-removed realm of ancient art appears, in Junius's phrase, as a "conceived presence" in the author's book.[44] Junius's epic voyages in the seas of classical learning—if less thrilling than Petty's actual shipwrecks—yielded a near-exhaustive survey of all references to the visual arts in the literature of the Greeks and Romans, and so opened up the world of antiquity. Arundel's agents follow the Homeric routes to return from the shores of Ilium with treasures that will now accrue to the glory of Britain. It is to Arundel, writes Henry Peacham in 1634, in the second edition of *The Compleat Gentleman*, that "this angle of the world oweth the first sight of Greeke and Romane Statues, with whose admired presence he began to honour the Gardens and Galleries of Arundel-House about twentie yeeres agoe, and hath ever since continued to transplant old Greece into England." Peacham records the fact that the king personally examined these treasures on a visit to Arundel House in 1629 and was inspired to build a collection of his own: indeed, so great became the "Royall liking of ancient statues," that Charles caused "a whole army of old forraine Emperors, Capitaines, and Senators all at once to land on his coasts, to come and doe him homage, and attend him in his palaces of St James and Sommerset House."[45] In their parallel contributions to this cultural work, Junius offers the model of the *vita contemplativa* to set against Petty's *vita activa*, the scholar and the hero whose joint efforts assist in the re-

turn of emperors, captains, and senators to Britain, now not as conquerors but as the conquered.

The transplantation of the past from "old" Greece and Rome into England offers, in turn, a precedent and a model for the future cultivation of Madagascar—the site of a new colony transplanted from England. In this cultural commerce, what Arundel takes from the peripheral world in art and antiquities, he will refund to Madagascar in the civilizing influence of which these very objects are the sign. The coincidence of the word "transplant" in Peacham's account of the importation of classical culture and in the common currency of colonial discourse is revealing. "Transplantation" has its literal senses in the movement of people to new places where they become "planters," and in the transplantaton of food grains from the old world to the new and back again. It also emphasizes a deeper continuity between the two modes of *translatio imperii*, the movement of empire from its "antique springs" (Jonson's phrase for the sources of his teacher Camden's learning) in the remains of Greece and Rome to England, where it will spring anew in the hands of such expert cultivators as Arundel, and from which it will be transplanted again to fresh seedbeds in far-off island possessions.

Such colonial tranplantation, it is important to note, figures doubly as the cultivation of a new world and the recultivation of the old, the renovation of the broadly eastern world of antiquity long since fallen into ruin. In *The Anatomy of Melancholy* (1621), Robert Burton had asked rhetorically, "[W]hy is that fruitful Palestine, noble Greece, Egypt, Asia Minor, so much decayed, and (mere carcasses now) fallen from that they were?"[46] The answer was not hard to find. It was not that the land was any less fertile, but that the inhabitants have long neglected their responsibility for its tillage:

The ground is the same, but the government is altered, the people are grown slothful, idle, their good husbandry, policy, and industry is decayed. The soil is not tired nor exhausted, as Columella well informed Sylvinus, but barren through our own laziness, &c. . . . If any man from Mount Taygetus should view the country round about, and see so many delicate and brave cities built with such cost and exquisite cunning, so neatly set out in Peloponnesus, he should perceive them now ruinous and overthrown, burnt, waste, desolate, and laid level with the ground. . . . To shut up all in brief, where good government is, prudent and wise Princes, there all things thrive and prosper, peace and happiness is in that land: where it is otherwise, all things are ugly to behold, incult, barbarous, uncivil, a Paradise is turned to a wilderness.[47]

The solution is to understand that civility and good government are the fruits of a long historical march of colonization: "This Island"—that is, Britain—"in a short time, by that prudent policy of the Romans, was brought from barbarism; see but what Caesar reports of us, and Tacitus of those old Germans; they were once as uncivil as they in Virginia, yet by planting of colonies and good laws, they became, from barbarous outlaws, to be full of rich and populous cities, as now they are, and most

flourishing kingdoms." The lesson for the future is clear: "Even so might Virginia, and those wild Irish, have been civilized long since, if that order had been heretofore taken, which now begins of planting colonies."[48] The seeds carried into Britain by the Romans will be replanted in the barren but receptive soil of Britain's colonies, restoring wildernesses to paradises. In Van Dyck's portrait the emblems of Arundel's success as a collector—the scrolls, the head of Homer, the bust of Apollo, the figure of Junius (or Petty) clustered around the globe—all augur the success of the earl marshal's impending colonial expedition to the Indian Ocean and support his implied warrant to undertake such a voyage. The Arundel marbles, having literally been dug out of the ground like dormant seeds and figuratively resuscitated by Arundel's art, will now be disseminated in their civilizing virtue to other climes.

Such enterprises will, in Burton's legal phrase, bring the "barbarous outlaw" under the sway of the law. Old foreign emperors will come to do homage in the palaces of the new ruler, to confer upon him the legitimacy that will now reestablish and extend the *imperium* they have forsaken. But—as befits a medical treatise on the causes and remedies of melancholy—the colonial mission also takes on a wonderful therapeutic power, restoring life to the "mere carcasses" of the ancient world. Travel itself, Burton advises, "must needs refresh and give content to a melancholy dull spirit."[49] The immediate effect of an expedition to Madagascar may be to offer a cure for Arundel's melancholy. Yet in its power to act at a distance on the decayed and barren lands it will restore to cultural health, colonization works much like those controversial therapies that filled the pages of medical polemics in the 1630s, the "Powder of Sympathy" and the "Weapons-Salve."

Reviving Cold Marble

In the light of such cultural transplantation we can look again at the Van Dyck portrait of the earl and his grandson (see Figure 101) by way of an earlier portrait by Van Dyck, done at Rome and dating from 1622 to 1623, of George Gage (Figure 106). Gage is an obscure figure, apparently involved at once in the politics of religious and artistic intrigue. Sir Dudley Carleton, James's ambassador to Venice, reports during the winter of 1613–14 that Arundel and the countess have turned up in Rome despite official prohibitions on travel by English tourists to that sinkhole of papist corruption. He would not have believed it if he had not "spoken wth some who had seen them there," but Carleton's qualms are partly allayed in that he has heard "of no English who did much resort unto them but Toby Mathew and George Gage, neither of any course they took for other purposes than the satisfying of curiosity."[50] Carleton's report implies that, however uneventful the contact may have been, resorting to the likes of Gage is not to the Arundels' credit. Gage and Mathew both took holy orders

106. Anthony Van Dyck. *George Gage Examining a Statuette*. 1622–23. Oil on canvas. National Gallery, London.

from Cardinal Bellarmine at Rome later that year, in May 1614 (*DNB*). In the 1620s Gage acted as an intermediary in Rome on behalf of James during the protracted and fruitless negotiation to secure a papal dispensation for Prince Charles to marry the Spanish infanta—the ill-fated "Spanish match." Gage's name appears, finally, among those priests and recusants arrested for their subversive activities in England between 1640 and 1651. Quite possibly he died in prison.

Gage played the same ambidextrous mediating role as a facilitator in the art and antiquities trade, becoming, in the 1630s, a successful rival of Thomas Roe and Arundel's invaluable William Petty as "one of Charles I's most effective agents in the building up of his great collection."[51] Van Dyck portrays him in this very role, leaning casually, even with a certain insouciance, on a ledge on which his family arms are carved as a means of identifying the sitter as Gage. In contrast with his relaxed pose, his face is bright with a watchful alertness as he attends to the man to his left proffering a statuette identified by Howarth as "a reduced version of the *Aphrodite*, now one of the Arundel marbles in the Ashmolean Museum."[52] This man is furtive, insistent, suspicious—in Howarth's words, "combative and tense as a greyhound as he leans forward to press a sale."[53] Negotiations have begun but the game is young, and there is a whiff of danger. The scene has the air of a chance encounter, but perhaps that is just the impression intended to be conveyed by Gage's pose. Christopher Brown observes that Gage "registers interest, but, like a skillful poker player, is careful not to appear too enthusiastic."[54]

These descriptions catch the mood of the art market depicted here, but not Van Dyck's complex portrayal of Gage's pivotal role in a larger cultural drama. Gage's head and that of the dealer are the most prominent in the painting—both are in the foreground, strongly lit, and each is the object of the other's assessing gaze. These two are, however, part of a suite of four heads clustered in the upper right of the painting, including the two partly shadowed in the background: that of the statuette, and that of a black servant (as he appears to be) mirroring the dealer's gesture of pointing to the marble with one hand while (perhaps) supporting its weight with the other (hidden behind the sculpture). The picture is, in fact, a carefully composed roundelay of hands as well as heads: one of its starkest visual contrasts is that between the strong, purposeful gesture of the black man's finger indicating the object for sale, and the very pale, very thin and fragile-looking hands of George Gage, the left one hanging limply off the shelf on which he supports his arm. A line running through these two carefully opposed hands, the servant's dark right hand and Gage's strangely bloodless left hand, defines one major diagonal controlling the design of the painting, just as a line connecting Gage's eyes with the broker's defines another. The former diagonal continues up to the right corner of the painting, to the head of the marble statue whose stony hue more closely resembles the pallor of Gage's hand than does the warm flesh tone of Gage's own face, even as the hand's flaccid droop forms a contrast with the rigidity of the marble.

Formal similarities and contrasts of this kind could be multiplied. For example, while the rough and open heartiness of the servant's expression acts as a foil to the polished sophistication of Gage's, and the dealer and his servant are professionally allied against Gage in the transaction under way, nevertheless Gage and the servant—their heads tilted toward one another in opposition to the dealer's—also share a sense of

mutual bonhomie completely lacking in the dealer's nearly ferocious glare. If we focus on the interrelationship of the three human heads, the rather swarthy dealer mediates between the servant and Gage in the color of their complexion, while Gage mediates between the servant and the dealer not only positionally in space (he is "between" them in the painting's recession in depth, just as the servant is between the other two on the surface of the canvas) but in a look that combines something of the servant's good humor with something of the dealer's intense concentration. The marble statuette, the inanimate if crucial focus of the implied narrative (the picture is "about" her, about the desire to possess her, to purchase her just as the black servant was presumably purchased in his turn by the man who now offers the sculpture for sale) nonetheless takes on something of a human aspect and animation in this company. She seems to twist her body away from the probing finger of the servant, seems to want to force herself not to look at this scene of her own merchandising.

These many small notations point beyond the sophistication of Van Dyck's style. They create an image not only of this particular transaction but an implied history of antiquities dealing in which the black servant, relegated to the background of the painting, nonetheless figures prominently. What the painting shows in this (dimly allegorical) light is the handing over of the goddess from the dark man whose origins lie on the geographical periphery whence she herself comes, to the middleman who will place her in the hands of Gage—who will, in turn, give her to those for whom he acts as agent. It is an image of a transmission as well as a transaction, of the removal of the old gods to their new habitation. The goddess is the object that visually connects the exotic background of the painting denizened by the black servant with the European foreground: she has covered the distance and traversed the time separating her world from this present place and moment.

In this interchange, the other sculptural motif in the painting, Gage's coat of arms at the bottom right (balancing the statuette on the top right) assumes a significance greater than as a clue to the identity of the sitter. In a market where the goddess offered for sale may or may not be genuine, the arms certify Gage's authenticity and— as he supports himself on the ledge on which they are carved—they provide him with a firm genealogical as well as visual basis. As himself a visual echo of the statuette in the painting (their heads and torsos are turned in the same direction), resting on his own foundation, Gage almost seems to pose himself as a work of art (in the same measure as the goddess almost seems to come to life). Furthermore, insofar as the ram's head, the crest of the Gage family arms, refigures the blunt animal strength of the black servant—we recall Iago's taunting characterization of Othello as the "black ram"—it declares that Gage is the legitimate heir of the ancient realm he represents, and thus the legitimate owner of its artifacts. In its fullest resonance the painting is not only about buying a statue but insuring and continuing a historical order in which the buyer is honored in and by that very act.

The 1635 Van Dyck portrait of Arundel and his grandson, for all its obvious differences from that of Gage, depicts the earl in a similar mediating role once the provenance of the painting is taken into account. Howarth suggests with some plausibility that the two figures represented are based on a fragment of funerary sculpture known to have been in the earl's collection of marbles, a bas-relief showing an adult and a child in the same general pose as that in the Van Dyck double portrait.[55] If he is right about the sculptural context of this image, we may think of it as coming to be by a kind of metamorphosis from its stony origin. In effect it comes to life, just as the statue of Venus in the Mytens painting of the earl's gallery seems to be waking from its frozen sleep at the touch of Arundel's staff—the same staff as he holds in this portrait and, we recall, in the Madagascar portrait, signifying his genealogical authority as a herald, the earl marshal's power to "create." What had appeared on an ancient sarcophagus as the image of death is rejuvenated, as much in the rich colors of Van Dyck's art as in its focus on the grandchild and the promise for the future that he represents under Arundel's protection and discipline. Furthermore, as Howarth also notes, Arundel writes to William Petty in 1636 that he is sending him this same painting, "a Picture of my owne and my little Tom bye me," with the "desire it may be done at Florence in marble *Basso relievo*, to try a yonge Sculptor there who is said to be *valente Huomo*."[56] The identity of the young sculptor can only be guessed at, and this would not be the only painting sent abroad to serve as a sculptor's model—one thinks of the more famous "triple head" of Charles I painted by Van Dyck in 1635 for the studio of Bernini. Nonetheless Arundel's intention in this case is uniquely fascinating, for to commit his image to the hand of the young Florentine sculptor who would (re)create it as a marble "*Basso relievo*" would be to complete the circle by returning it to stone—from ancient bas-relief, to the portrait taken from the life, and then, through the artistry of the young Florentine sculptor, back to the form reminiscent of its funerary origin.

Arundel and his little Tom, as painted by Van Dyck, thus stand at the center of a complex mediation between the old world and the new. Playing a role in its way like that of Van Dyck's image of the goddess in the Gage portrait, they connect an ancient work of art with its modern replication, and the site from which that fragment of sculpture was broken off with the English collection in which it has found its place. They connect a long-dead sculptor with a "yonge" one now in Florence who, thanks to Arundel, will take instruction from that same ancient master—just as, within the painting, young Tom, holding a paper, looks up (and back) to his grandfather Thomas with a pupil's mixture of respect and fear toward a stern teacher. The painting's image of the transmission of learning and authority from one generation to the next is writ large in the more sweeping act of cultural transmission in which it is implicated by Arundel's gesture of returning it to the Mediterranean world. What came as a funerary image is now renovated by an art that will make the picture speak across the ages

to the new sculptor who will reclaim it. The translation of the image from stone to pigment to stone is the formal product of a cultural *translatio* in time and space, from the imperium of antiquity to modern England and back again to the same place by the authority of Arundel.

One question, otherwise trivial perhaps, suggests itself in this context. If the theme so powerfully articulated in this painting is the passage of authority from one generation to the next—the bond of paternal and filial obligation by which the dead past is re-collected and handed down to the "yonge"—then we may ask: where is the father who should stand between the Thomas and Tom, the grandfather and the grandson? How are we to account for the gap concealed, as it were, by the very proximity of the two figures? It may be, of course, that Arundel simply wanted himself painted with the grandchild who would carry on his Christian name, and for whom he had a special fondness. The child's father, Arundel's second son and heir Henry Frederick, Lord Maltravers, sat separately for Van Dyck, who painted him in armor much like Arundel's in this portrait.[57] There was a son named Thomas, Arundel's third-born, who died as a child, as did the fourth of his four sons, Gilbert. Indeed, with the death of his firstborn son, James, in 1623, at the age of sixteen, Henry Frederick became the sole survivor among Arundel's progeny. By his absence Henry Frederick stands (out) for the missing generation of his brothers, a kind of commemoration for which the funerary provenance of the image is entirely appropriate, and deeply evocative of Arundel's loss. The absent father brings to mind—and may have brought to mind for the earl—Arundel's own father, Philip, imprisoned for most of Arundel's childhood and dead in the Tower when Arundel was ten, about the same age as little Tom in this painting. In Van Dyck's portrait, Arundel literally "stands" in the place of the (lost) father. Having, as it were, revived this child from his cold marble image on an antique sarcophagus, the painting enacts the double purpose of restoring the generation of the dead son Thomas in his namesake, while securing at least the lively image of this child (as Arundel protectively places a hand on the boy's shoulder) from their sad fate. In the lineage of his own family as in the longer cultural lineage running through the painting, Arundel (the "father of virtu in England") connects dead sons with living ones: ultimately, the dead child on the sarcophagus with the young sculptor in Florence, in whom Arundel takes a necessarily distant but warmly paternal interest.

The Art of Colonization

What are the implications of the convergences we have been tracing by means of the Van Dyck portraits and their ancillary texts? One is a reminder that a book like Junius's *Painting of the Ancients*—long canonical in the history of art scholarship as the

first comprehensive survey of the field of classical objects, practices, and commentaries as reflected in the literary archive—should be understood first of all as the product of its own historical moment. The most influential scholarly work to come out of the Arundel circle, it would remain the standard source on classical art until the time of Winckelmann, and it was still sufficiently prestigious in the later eighteenth century for Lessing to challenge its authority in the *Laocoön* as enmeshed in an untheoretical confusion of poetry and painting. In this tradition we tend to think of Junius—not mistakenly, but detached from any particular circumstances—as having made a founding contribution to the history of aesthetic theory. However, as we have seen, in the context of Arundel's overlapping projects of the 1630s, Junius's scholarship has its more complex rationale as well as its more immediate practical uses. Disciplinary histories tend to absorb and canonize their founding works by claiming for them, explicitly or in effect, a timeless pertinence that conceals the conditions of their origin. A closer look at the Caroline art market in which Junius plays a key role reveals, unsurprisingly, that the liaison of dealers, collectors, and art historians long predates the age of Berenson and Warburg. The discipline of art history, creating itself in the late Renaissance by the appropriation of a field of study within the larger domain of classical scholarship, is inseparable from the appropriation of the artworks it authenticates, classifies, and—in both senses of the word—evaluates. These connections may prompt us to speak of a colonization of art, a venture in which Junius's scholarship, Van Dyck's portraiture, and the far-flung enterprises of Arundel and his transnational antiquities brokers are joined. Conversely, we may also speak of an art of colonization, of colonization as an *ars*—a phrase that describes the Van Dyck painting in a literal sense, as well as the earl's larger visionary and commercial designs on Madagascar. On the evidence of the Madagascar portrait, the discourse of colonialism, as it interweaves such diverse strands as heraldry, antiquities, classical scholarship, and painting itself, is both subtler and more diverse in Arundel's world than we may be led to suppose if we look at its history from too narrowly a political or economic point of view.

Those of us accustomed to working primarily with the evidence of visual and literary culture, especially when our view of the English Renaissance has tended to be refracted through the prism of our latter-day "postcolonial" assumptions, need to take into account the nominalist position argued forcefully and with near unanimity by historians of English expansionism in the sixteenth and earlier seventeenth centuries. For the English, as late as Arundel's chimerical colony in Madagascar, and indeed well past midcentury, there was in fact—as I suggested above in alluding to the title of Jeffrey Knapp's book—an "empire nowhere," except in the imagination of the visionary. According to John Appleby, when John Dee used (perhaps coined) the phrase "British Impire" in the 1570s to "justify England's claim to the North Atlantic," his case was based on the "mythical conquests of King Arthur and Prince Madoc, the latter allegedly the first discoverer of North American in the twelfth century."[58] Dur-

ing the Protectorate Cromwell conceived of the "Western Design" of 1654–55, a plan to export the Revolution of the Saints to the New World, which fizzled in a "disastrous attempt to seize Hispaniola as a base for a subsequent invasion of the Spanish-American mainland."[59] Even these instances in which the word, if not the reality, of an "imperial" impulse referred to the larger world were exceptional. Normally, phrases like "great Brittaines imperial crowne" or "the Empire of Great Britaine" referred, after 1603, to the united kingdoms of England, Scotland, and Ireland, and the principality of Wales. Carrying "no necessary expansionist associations," Britain's imperial status implied just the opposite: her independence from foreign control, her isolation and self-sufficiency, rather than any ambition on her part toward foreign dominion.[60] David Armitage argues that not until after the Restoration

did the British Empire come to include the territorial settlements of North America and the Caribbean or the factories of Africa and Asia; even then it was couched in the form of "the British Empire *in* America" or "the British Empire *of* America," implying the territory over which the authority of the monarchy was exercised rather than a unitary political body. . . . That sense of the British Empire seems only to have appeared in the second quarter of the eighteenth century.[61]

Until the 1630s and 1640s, the history of British expansionist amibitions was still very largely a history of failure, punctuated by such "violent and humiliating failures" as those in "North and South America, embodied in the lost colony of Roanoke and the repeated debacles of plantation efforts in the region of the Amazon."[62] Even then, at the moment of its emergence, this "empire" consisted mostly in privateering expeditions, trading posts, more or less speculative ventures promoted by the proliferating number of companies (East India, Virginia, Bermuda, Levant, Muscovy, Massachusetts Bay, New England), the crown, and individual entrepreneurs like Arundel. Indeed, as an emblem of these early years, the collapse of the earl's Madagascar scheme makes it entirely typical of the haphazard and precarious chararacter of English colonialism—not so much an "empire" in any later sense of the word, as a "motley assortment of competing interests," as yet lacking any "coherence in direction or ideology."[63]

My intention in the case of Arundel's Madagascar portrait has been to explore the sources of such coherence in a work of art. The Van Dyck portrait does not reflect reasons of state or economic policies from which the more overt features of that coherence would ultimately take shape. Instead it creates a matrix for the protocolonial imagination, engendering the stuff that Arundel's dreams were made on. In this, of course, it is not unique. Images of sea monsters, Homeric Amazons, Ovidian witches, Antipodeans, and men whose heads do grow beneath their shoulders populated the margins of the known world, hovering somewhere between fiction and reality, and fleshing out a geography of the unknown by which not even Raphael Hythloday's

Utopians were completely implausible. Earlier explorations had always been guided to a large extent by the light of the imagination. In the 1570s John Davis and Martin Frobisher searched the frozen bays and inlets of the Canadian north for what they were sure must be there: a northwest passage as a counterpart to the Strait of Magellan. Similarly, the belief in the existence of a northeast passage to match the Cape of Good Hope in the south led Willoughby and Chancellor on a fruitless quest around the North Cape of Norway—which providentially sat along the same line of latitude in the north as the Horn of Africa in the south—into the Barents Sea.[64] Such expectations were based on a sense of creative design too durable to be erased even by the mounting, and painful, evidence of its fictiveness: symmetry required that the northern and southern hemispheres reflect one another. That there is a "north" America and "south" America only confirms the rationale by which it had been held since Pliny that there was a similarly correspondent relation between the land and the sea ("horses" in both), and by which it must now be assumed that the two northern passages must exist as the reflection of their southern counterpart. Just as these aesthetic assumptions set the actual course of English navigation, Van Dyck's portrait, as well as other works such as William Davenant's long poem of 1638 entitled "Madagascar," create the kind of colonial fiction that would then be available for the representation, and misrepresentation, of colonial realities once the ships set sail in earnest. Even in our own time, Aimé Césaire's rewriting of *The Tempest* as a means of understanding the postcolonial experience of the Caribbean testifies to the persistent force of such shaping fantasies.[65] Arundel's arts combine those of the herald, the collector of antiquities, and the patron of painters and scholars. Those arts are not peripheral to Arundel's role as the would-be creator of a colonial plantation, or to the creation of an early modern colonial ideology. Rather, they define it.

Notes

Note to epigraph: John Donne, *Poetical Works*, vol. 1, ed. H. J. C. Grierson (Oxford: Oxford University Press, 1912), p. 38.

1. Anthony Grafton, April Shelford, and Nancy G. Siraisi, *New Worlds, Ancient Texts: The Power of Tradition and the Shock of Discovery* (Cambridge: Harvard University Press, 1992), p. 3.

2. Louis A. Montrose, "The Work of Gender in the Discourse of Discovery," *Representations* 33 (1991): 1–41.

3. Jonathan Haynes. *Humanist as Traveler: George Sandys's Relation of a Journey begun An. Dom. 1610* (London: Associated University Presses, 1986).

4. Mary F. S. Hervey, *The Life, Correspondence and Collections of Thomas Howard, Earl of Arundel* (Cambridge: Cambridge University Press, 1921), p. 506; David Howarth, ed., *Art and Patronage in the Caroline Courts, Essays in Honour of Sir Oliver Millar* (Cambridge: Cambridge University Press, 1993), pp. 167–68.

5. Quoted in Hervey, *Earl of Arundel*, p. 417.

6. Kim F. Hall, *Things of Darkness: Economics of Race and Gender in Early Modern England* (Ithaca: Cornell University Press, 1995), p. 232.

7. Richard Wendorf, *The Elements of Life: Biography and Portrait Painting in Stuart and Georgian England* (Oxford: Clarendon Press, 1990), p. 103.

8. Hervey, *Earl of Arundel*, p. 506.

9. James V. Mirollo, *Mannerism and Renaissance Poetry: Concept, Mode, Inner Design* (New Haven: Yale University Press, 1984).

10. Sir Philip Sidney, "Defence of Poesy," in *Sir Philip Sidney: A Critical Edition of the Major Works*, ed. Katherine Duncan-Jones (Oxford: Oxford University Press, 1989), pp. 216, 235.

11. Ibid., p. 213.

12. Jeffrey Knapp, *An Empire Nowhere: England, America, and Literature from Utopia to the Tempest* (Berkeley: University of California Press, 1992), pp. 1–4.

13. Hervey, *Earl of Arundel*, p. 506.

14. Quoted in Sir William Davenant, *The Shorter Poems, and Songs from the Plays and Masques* ed. A. M. Gibbs (Oxford: Clarendon Press, 1972), p. 343.

15. Ibid.

16. Richard Boothby, *A Brief Discovery or Description of the Most Famous Island of Madagascar* (London, 1644), n.p.

17. Nigel Heseltine, *Madagascar* (New York: Praeger, 1971), pp. 68–70.

18. Howarth, *Art and Patronage*, pp. 222.

19. Sidney, "Defence of Poesy," p. 216.

20. Franciscus Junius, *The Literature of Classical Art*, ed. Keith Aldrich, Philipp Fehl, and Raina Fehl (Berkeley: University of California Press, 1991), vol. 1, caption to fig. 11.

21. Hervey, *Earl of Arundel*, p. 506.

22. Stephen J. Greenblatt, *Learning to Curse: Essays in Early Modern Culture* (New York: Routledge, 1990), p. 16.

23. J. F. R. Day, "Primers of Honor: Heraldly, Heraldry Books, and English Renaissance Literature," *Sixteenth-Century Journal* 21 (1990): 98–99.

24. Ben Jonson, *Works*, ed. C. H. Herford, Percy Simpson, and Evelyn Simpson (Oxford: Clarendon Press, 1947), vol. 8, p. 29.

25. Day, "Primers of Honor," pp. 98–99.

26. Adolf Michaelis, *Ancient Marbles in Great Britain*, trans. C. A. M. Fennell (Cambridge: Cambridge University Press, 1882), p. 8.

27. Raphael Falco, *Conceived Presences: Literary Genealogy in Renaissance England* (Amherst: University of Massachusetts Press, 1994).

28. Day, "Primers of Honor," p. 98.

29. Hall, *Things of Darkness*, pp. 228–29.

30. Thomas Tenison, *Baconiana* (London, 1679), p. 57.

31. Howarth, *Art and Patronage*, pp. 58–59.

32. Ibid., p. 59.

33. Tara Hoag, "Culture and Imperialism: The Fashioning of a Patron, in Two Portraits" (unpublished essay, 1993), p. 11.

34. Franciscus Junius, *The Literature of Classical Art*, vol. 1, fig. 13.

35. Francis C. Springell, *Connoisseur and Diplomat: The Earl of Arundel's Embassy to Germany in 1636* (London, 1963), pp. 194–95.

36. Ashmolean Museum, *The Earl of Arundel: Patronage and Collecting in the Seventeenth Century*, exhibition catalog November 1985–January 1986 (Oxford, 1985), p. 62.

37. David Howarth, *Lord Arundel and His Circle* (New Haven: Yale University Press, 1985), p. 169.

38. Springell, *Connoisseur and Diplomat*, pp. 196–97.

39. Quoted in Hervey, *Earl of Arundel*, p. 280.

40. Oliver Millar, *Van Dyck in England* (London: National Portrait Gallery, 1982).

41. Franciscus Junius, *The Literature of Classical Art*, vol. 1, p. xxxvii.

42. Christopher Brown, *Van Dyck* (Ithaca: Cornell University Press, 1983), p. 209.

43. Franciscus Junius, *The Literature of Classical Art*, vol. 2, p. 424.

44. See Falco, *Conceived Presences*.

45. Henry Peacham, *The Compleat Gentleman*, 2nd ed. (London: 1634), pp. 107–8.

46. Robert Burton, *The Anatomy of Melancholy*, ed. Floyd Dell and Paul Jordan-Smith (New York: Tudor, 1927), p. 74.

47. Ibid., pp. 74–75.

48. Ibid., p. 71.

49. Ibid., p. 444.

50. Quoted in Hervey, *Earl of Arundel*, pp. 83–84.

51. Brown, *Van Dyck*, p. 74.

52. Howarth, *Art and Patronage*, p. 158.

53. Ibid.

54. Brown, *Van Dyck*, p. 76.

55. Howarth, *Art and Patronage*, p. 161.

56. Hervey, *Earl of Arundel*, pp. 391.

57. Ibid., pl. 15, facing p. 334.

58. John C. Appleby, "War, Politics, and Colonization, 1558–1625," in Nicholas Canny, ed., *The Origins of Empire: British Overseas Enterprise to the Close of the Seventeenth Century*, Oxford History of the British Empire, vol. 1. (Oxford and New York: Oxford University Press, 1998), p. 62.

59. Anthony Pagden, "The Struggle for Legitimacy and the Image of Empire in the Atlantic to c. 1700," in Canny, *Origins of Empire*, p. 35.

60. Canny, *Origins of Empire*, p. 1.

61. David Armitage, "Literature and Empire," in Canny, *Origins of Empire*, p. 113.

62. Alison Games, "Sir Thomas Roe and the Integration of the First British Empire," paper presented to the Columbia University Seminar on Early American History, February 1999, p. 2.

63. Ibid., p. 3.

64. John Keay, *The Honourable Company: A History of the East India Company* (New York: Macmillan, 1991), pp. 6–9.

65. Aimé Césaire, *Une tempête* (Paris: Éditions du Seuil, 1969).

9. "GOD FOR HARRY, ENGLAND, AND SAINT GEORGE"

British National Identity and the Emergence of White Self-Fashioning

PETER ERICKSON

Building on Ernest Gilman's superb account of Van Dyck's Madagascar portrait of 1639, I shall focus on two specific elements: the image of Saint George and the dragon in the Garter badge that Arundel displays on his chest, and the image of race implied by the island of Madagascar and the adjacent African subcontinent to which the large globe in the foreground is turned. My goal is to redirect traditional study of the Order of the Garter by bringing it into the mainstream of current discussions of race as a specifically early modern category.[1] I propose that the two elements of the Garter and of race are linked: during the early modern period, the Garter emblem of Saint George gradually becomes racialized as it is applied to new commercial ventures in a widening international frame of reference. Under the pressure of this global outreach, Saint George as the symbol of British nationhood comes to be associated with racial whiteness. This new conjunction is what we see enacted in Van Dyck's Madagascar portrait when the Garter badge is deployed to support a vision of white presumption to colonial possession.

Although the word *race* in our modern sense was not available in the Renaissance, a narrow appeal to the history of early modern linguistic usage does not suffice to bar race as an interpretive term.[2] The whole question of color-based racial awareness in the early modern period cannot be channeled into this one word and thereby dismissed. The concept of color as an ethnic marker is present even if the word *race* is not used to denote it. To insist on one definition of race derived from the institution of slavery in the United States creates an all-or-nothing circular reasoning that will, by definition, see race in the Renaissance as unhistorical. But it is not historical to restrict race to one phenomenon associated with one time period and then apply it as the single standard by which all earlier periods must be assessed. We need to adopt a more supple understanding of periodization that permits definitions of race to vary according to different historical situations.

What is involved is not simply the reassessment of individual periods but also an overall revision of the entire structure of periodization. In Stuart Hall's analysis of a postcolonial critical approach, this more comprehensive revision results in "an alternative narrative" that reaches back into the early modern period:

In terms of periodisation, however, the "post-colonial" retains some ambiguity because, in addition to identifying the post-decolonisation moment as critical for a shift in global relations, the term also offers—as all periodisations do—an alternative narrative, highlighting different key conjunctures to those embedded in the classical narrative of Modernity. . . . By "colonisation," the "post-colonial" references something more than direct rule over certain areas of the world by the imperial powers. I think it is signifying the whole process of expansion, exploration, conquest, colonisation and imperial hegemonisation which constituted the "outer face," the constitutive outside, of European and then Western capitalist modernity after 1492.[3]

This recalibrated historical framework, with its emphasis on the Renaissance as an originating moment for international cross-cultural encounters, allows us to ask the question of race, including the question of white identity formation. In what follows, the first section sketches the possibilities for visual representations of race in the early modern period, and subsequent sections focus more specifically on emerging images of racial whiteness.

The Black Figure in Velázquez, Bailly, and Homer

This opening section presents a contrast between seventeenth-century and nineteenth-century images of blacks. Rather than using the nineteenth century as a base from which to deny the existence of race in the seventeenth century, I want to argue that it is more persuasive and more productive to develop an account of the differences between the two periods. I begin with a nineteenth-century example in order to establish a historical reference point that allows us to see both the possibilities and the limits of seventeenth-century representations of race.

Posing the question of the black man's status, Winslow Homer's *Gulf Stream* (1899) (Figure 107) probes the dialectic of inclusion versus exclusion far more sharply than is possible within a Renaissance time frame.[4] The black sailor in *Gulf Stream* has broken the mold of the servant role to become an individual actor on the historical stage. It is a misreading to see the painting's outcome as a foregone tragic conclusion in which the black man is irrevocably doomed. Rather, *Gulf Stream* raises a more open-ended question, with the emphasis on the black man's ability to struggle even in the face of seemingly insurmountable odds.

The Caribbean setting indicates not only a geographical but also a political location, as several cues signal. First, the sign on the boat's stern—"Anne—Key West"— identifies the home port and hence the U.S. citizenship of this black man in the post–Civil War era. Second, the man's food supply—the stalks of sugar cane protruding from the hold onto the open deck—alludes to sugar production, one of the crops in the triangle trade that brought Africans to the New World as plantation slaves. Third,

107. Winslow Homer. *The Gulf Stream*. 1899. Oil on canvas. Metropolitan Museum of Art, New York (Wolfe Fund, 1906. Catharine Lorillard Wolfe Collection. 06.1234).

the painting's title *Gulf Stream* reinforces the idea of cross-oceanic currents connecting continents in international transactions.

The primary qualities *Gulf Stream* accents are heroic: fortitude, resilience, survival. This is not a picture of certain defeat. The negative factors are all too visible: the distant ship, sealed off by a screen of gray-white mist, offers no hope of rescue; the small, isolated boat has been battered into a fragile raft by the loss of bowsprit, mast, rudder, and a portion of gunnel; the waterspout approaching behind the man from the upper right brings further hazard; the sharks circle in anticipation. Yet the center of attention remains the positive power exuded by the black man's readiness. His weariness is far outweighed by his wariness. The limbs and musculature suggest not only tenseness but also conservation of energy. The propped elbow, the facial grimace, the set lips, the squinted eyes scanning the horizon—all convey alertness, steadiness, and determination. Having outlasted previous storms, he may yet survive the next.

Homer's *Gulf Stream* has behind it the pictorial tradition of Turner's *Slave Ship* (1840) and the abolitionist strand in literary transcendentalism.[5] Having its source in the overall development of an artist whose career stretches back to the Civil War, *Gulf Stream* puts us within reach of W. E. B. Du Bois's assertion in *The Souls of Black Folk* (1903) that "The problem of the twentieth century is the problem of the color-line,—the relation of the darker to the lighter races of men in Asia and Africa, in America and the islands of the sea. It was a phase of this problem that caused the Civil War."[6] In the symbolic arena of *Gulf Stream*, Homer acknowledges that the black man's newly won status as an emancipated subject is precarious and always in danger of reverting to the category of mere object. But, despite his perilously problematic situation, the painting equally insists on the black man's heroic stance.

In turning to the Renaissance, I want to stress the heightened intensity with which Homer portrays the uncertainty of the black man's condition. My two early modern examples—Diego Velázquez's *Kitchen Maid with Christ at Emmaus* (ca. 1620) and David Bailly's *Vanitas with Negro Boy* (ca. 1650)—both display surprising ability to question the status of object to which blacks as servants were consigned.[7] Yet the heroism to which the black sailor in *Gulf Stream* has access is not an option for the black figures in either case. The greater depth of Homer's questioning stands as a historical limit to the degree of early modern political perception.

Velázquez's *Kitchen Maid* (Figure 108) dramatizes the question of whether the black woman's role as maid restricts her status to object or whether she might be seen as human subject—one who possibly overhears Christ and is thus capable of crossing the gap between the two separate planes of activity indicated by her position in the foreground and the framed scene in the background of the risen Christ's moment of revelation.[8] The drama is concentrated in a single gesture, the tilt of the maid's head. The bowed head expresses the submissiveness assigned to the humble station of servant as well as the fatigue of menial labor. But the slight turn of the head also suggests both a cocked ear straining to listen and the probable failure of the effort—the distance may be too great, despite the momentary silencing of the kitchen clatter. The uncertainty is what makes the painting so unsettling. Velázquez does not resolve the problem; the point is rather his vivid rendering of the tension between potential inclusion and ongoing exclusion.

David Bailly's *Vanitas* (Figure 109) presents a more complex relationship than is usual in the conventional portrait of a white patron attended by a black servant, who is often smaller in size to indicate lesser stature.[9] Temporarily transcending his position as object, the black youth gains a measure of control when he literally bears the message of his owner's mortality by holding up the portrait miniature of his master. The white man is reduced to the size of an oval that fits between the boy's thumb and forefinger, a diminutive shape echoed and surpassed by the boy's eyes and head.

108. Diego Velázquez. *The Kitchen Maid with Christ at Emmaus*. Ca. 1620. Oil on canvas. Courtesy of the National Gallery of Ireland.

The radical shift in relative dimensions conveys an extraordinary reversal of normal power relations. The limit of the boy's leverage becomes evident, however, when we ask where this action takes place. The boy's privileged role is located not in the everyday real world but rather in the realm of allegory. The dual spheres imply a doubleness in the boy's identity. As the symbolic vehicle of the *Vanitas* message, the boy gains authority. But he also remains an ordinary servant, who recedes, visually absorbed by the surroundings, back into the collection of objects.

The distinction between Velázquez's *Kitchen Maid* and Bailly's *Vanitas*, on one hand, and Homer's *Gulf Stream*, on the other, is that the formers' representations of black figures demonstrate an awareness without arriving at the latter's critical consciousness. This early modern awareness is capable of creating complex effects which convey uneasiness yet stop short of a fully committed political challenge, with the result that the social status of the black figure, in the end, does not change. In such works as the Madagascar portrait, Van Dyck elaborates his version of this uneasiness, though only after becoming conversant with, and working through, the orthodox hauteur of *Marchesa Elena Grimaldi*.

109. David Bailly. *Vanitas with Negro Boy*. Ca. 1650. Oil on canvas. Herbert F. Johnson Museum of Art, Cornell University (Gift of Louis V. Keeler, Class of 1911, and Mrs. Keeler, by exchange).

The Construction of White Identity

Two groundbreaking essays by Dympna Callaghan and Kim Hall chart the historical relevance of whiteness as a racial category in early modern England by identifying, in Hall's words, "new social pressures that force fairness/whiteness into visibility."[10] My goal is to extend this analysis to visual art by first considering the examples of Van Dyck's *Marchesa Elena Grimaldi* (1623) and *Henrietta of Lorraine* (1632).[11]

 Van Dyck's portrait of Elena Grimaldi (Figure 110) is manifestly about skin color as an index of racial difference. The motif of whiteness is visually defined by the three points of light formed by the triangle of the woman's hands and—most centrally and prominently—her face. The express purpose of the attendant's solicitous action with the parasol is to protect his mistress's complexion from discoloration by the sun as

110. Anthony Van Dyck. *Marchesa Elena Grimaldi*. 1623. Oil on canvas.
National Gallery of Art, Washington, D.C. (Widener Collection).

she steps outside; the threat of exposure looms because the sunlit patches of blue sky suggest that the cloud cover may be about to disperse.[12] In this connection, the racial identity of the servant contributes crucially to the overall picture. By providing a stark counterpoint, his blackness makes the motif of the lady's whiteness more emphatic.

White self-fashioning is conveyed not only by the parasol held by a black servant but also by the sprig of white orange buds in the woman's outstretched right hand. The implication is that, unlike the freshness of the white blossoms, her own white skin can be prevented from wilting and thus be permanently preserved. While this potential triumph of art over nature proves the power of whiteness, it also shows that white superiority is not a given but must be cultivated, maintained, and vigilantly guarded. There is even the suggestion of a discreet cosmetic touch if the delicate red coloring of the lady's cheeks has been enhanced by rouging. The redness of her cheeks complements the red of her sleeve cuffs and parasol, and the combined effect is to highlight the fundamental whiteness of her face.

In Van Dyck's *Henrietta of Lorraine* (Figure 111), the flower motif plays a similar role. Presumably fetched from the bush on the right, the roses are presented on a platter as a tribute to the lady, whose face mirrors their red-and-white composition with her far more impressive display of these colors. The woman's primary whiteness is further dramatized by contrast with the blackness of the servant who brings the flowers. Almost as big as his head, her large white hand placed on the servant's shoulder makes this link particularly clear.

Moreover, the proximity of the black boy racializes the pattern of the lady's massive dress. The contrast of lady and servant maps onto the sharply delineated sectors of white and black, imbuing the dress with racial symbolism. The visual effect also works in the other direction as the black-and-white segments of the dress map back onto the boy to reinforce his racial difference from the white lady. The painting shows whiteness to be visually dominant over all versions of blackness, whether the black portions of the dress or the black face of the servant.

Since both artists and works of art circulated widely in the early modern period, a specific focus on British culture is not incompatible with a more general survey of European art. Van Dyck is an important case because his career illustrates that the image of the black servant is not confined to a Mediterranean-based southern Renaissance but rather becomes part of a northward dissemination. As Ernest Gilman suggests in this volume, Van Dyck's *George Gage* (ca. 1622) (see Figure 106) places the black servant in the primal scene of collecting—the moment of negotiation when a roving agent purchases an art object to be shipped across national boundaries to build a patron's private collection back home.

Although *Marchesa Elena Grimaldi* originates in Van Dyck's stay in Italy and in the context of the Italian tradition of Titian's *Laura Dianti*,[13] the related painting *Henrietta of Lorraine* evidences a different geographical trajectory. Not only does Van

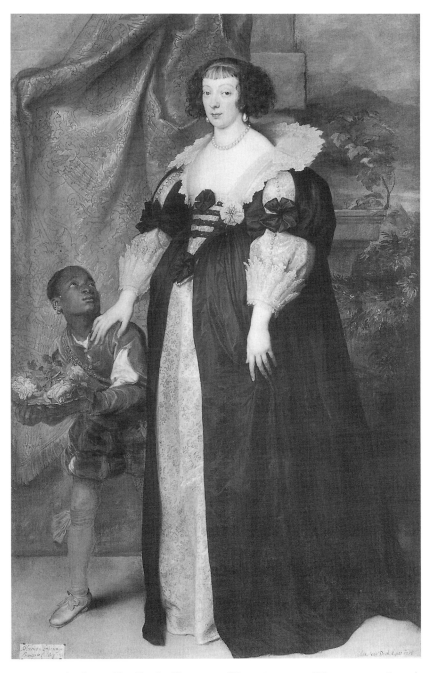

111. Anthony Van Dyck. *Henrietta of Lorraine*. 1634. Oil on canvas. Iveagh Bequest, Kenwood House, London.

Dyck himself come to England under the earl of Arundel's sponsorship, so too does this painting when purchased for Charles I and put on display in Whitehall.[14] Nor is this migration limited to high art but extends to everyday life in England, as exemplified by Lady Arundel's acquisition of an actual black page during her travel to Italy.[15]

The word *race* is often accompanied by a tacit mental operation that translates the term to mean *black*. However, my concern here is with a definition of race that encompasses whiteness and is hence based on a comprehensive system of racial contrasts in which perceptions of blackness necessarily imply a corresponding concept of white identity. Pursuit of this inquiry in the early modern period raises two special challenges.

The first is the question of origins, the problem of locating an exact moment when the recognition of whiteness can be said to have emerged.[16] I address this issue by delineating two stages that I call precursor and emergent phases, which are the focus, respectively, of the next two sections. Thus I draw a broad distinction between a prior phase that anticipates, but does not realize, the thematics of white identity formation and a subsequent phase in which we can see a fully developed white self-fashioning begin to appear.

The second challenge concerns the question of racial whiteness in instances where there are no accompanying black figures. My argument is that once the specific motif of the black servant is recognizable as an established visual convention, it becomes part of the larger cultural repertoire and so attunes viewers to a black-white racial dynamic in ways that are generalizable and transferable. Because of this power of extrapolation, a black figure need not be present in a painting for racial whiteness to be evoked.

Saint George, the Dragon, and the Queen

This section identifies a precursor phase in the development of a racially charged image of whiteness; the initial phase is a preliminary moment in which the imagery of whiteness is deployed with its racial meanings remaining latent or tentative. My specific test case involves the juxtaposition of Raphael's *Saint George and the Dragon* in the National Gallery of Art in Washington (Figure 112)[17] and the anonymous Garter portrait of Queen Elizabeth I in the Royal Collection at Windsor (Figure 113).[18] Raymond B. Waddington's important recent essay brings the two paintings together because both allude to the Order of the Garter.[19] However, Waddington makes the connection too literal by presenting as fact the supposition that Castiglione, Guidobaldo da Montefeltro's proxy, brought Raphael's painting from Urbino to England as a gift for Henry VII on the occasion of Guidobaldo's investiture in the Order of the Garter.

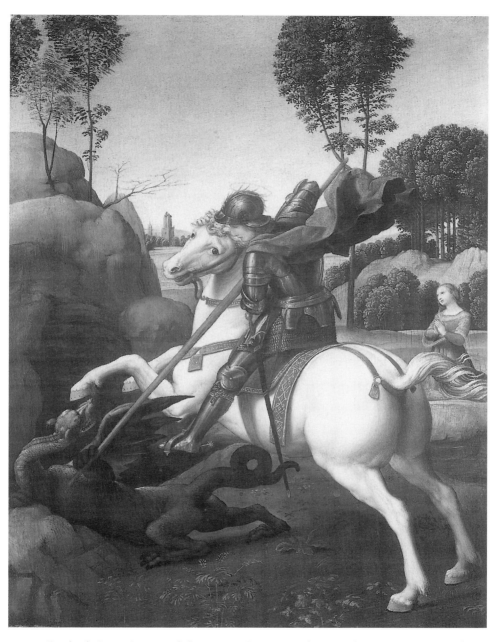

112. Raphael. *Saint George and the Dragon*. Ca. 1506. Oil on panel. National Gallery of Art, Washington, D.C. (Andrew W. Mellon Collection).

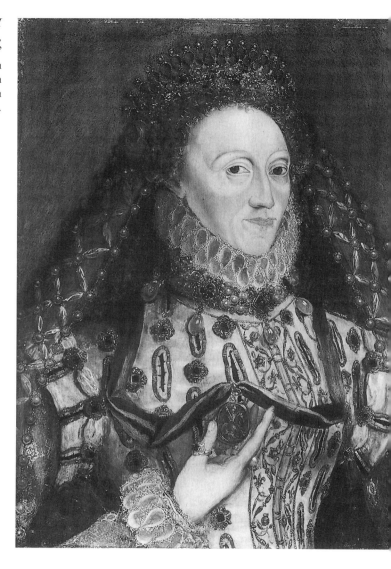

113. Anonymous. *Elizabeth I Holding the Badge of the Garter, the "Lesser George"* ("Garter" portrait). Ca. 1575–80. Oil on panel. The Royal Collection ©2000 Her Majesty Queen Elizabeth II.

But this specific point is very much in dispute: the theory of Castiglione's gift-bearing is now considered not only unproven but unfounded.[20] The English context for the painting cannot be definitively established until 1627 when Lucas Vorsterman made an engraving of the painting, which was then owned by the earl of Pembroke and which subsequently became part of Charles I's collection.[21]

What brings the painting within a British cultural orbit is the presence within the painting itself of the blue garter on Saint George's left leg, a clearly visible symbol of the British Order of the Garter. Whatever the exact route by which Raphael's

Saint George reached the collections of Pembroke and Charles I, it was part of an
established pattern of the general prominence accorded to the image of Saint George,
as Steven Gunn notes: "The royal collection included at least seven pictures of St.
George by 1547." In addition, Gunn points to the proliferation of Garter-related ob-
jects: "Knights commissioned the designs for garters and georges from artists as dis-
tinguished as Holbein, and bequeathed them to one another as signs of special friend-
ship."[22]

The two paintings before us are composed of three obvious common elements—
Saint George, the dragon, and the lady. The motif of Saint George's defeat of the
dragon can seem so familiar and repetitive that it may be considered thoroughly con-
ventional and therefore fixed. What I hope to show is that the three principal figures
form a set of triangular relationships that is not limited to only one invariable mean-
ing: considerable latitude is possible in how the interrelationships are arranged and
in how they are perceived. Each of the three locations in the triad represents a point
of view both in terms of visual orientation and of cultural perspective. As we move
from one point on the triangle to another within a single work of art, abrupt shifts
of perspective may occur. No matter how organically unified the overall composition,
such discrete internal steps can introduce a note of discontinuity and tension. More-
over, comparative study further demonstrates how this interplay of perspectival shifts
might be organized quite differently as we move from one work to another. When
seen against the background of Raphael's image of Saint George, the Garter portrait
of Queen Elizabeth I presents a graphic reconfiguration of the three main elements.
The most striking contrast is the drastic compression of Saint George's conquest of
the dragon in the portrait of Elizabeth. The effect of this sharp reduction is to cut male
heroism down to size; thus putting male triumph in perspective conveys a different
view of male and female roles.[23]

Elizabeth's portrait reverses the traditional power relations between men and
women. The queen's commanding presence easily surrounds, dwarfs, and contains
male power. The portrait freezes male action into a medallion that exists only to adorn
the queen's authority and that is all but swallowed up in the overwhelming profusion
of the ornamentation of her dress and head gear. In the midst of this lavish display,
the Garter badge becomes only one more decoration among many. The portrait thus
visibly enacts the concept of male service to female rule.

The queen's dominant position is achieved not only by the ornate magnificence
of her accoutrements but also by the fashioning of her body. Here we confront a theo-
retical problem concerning the range of representational options open to Elizabeth.
Applying the traditional concept of the king's two bodies to Elizabeth's special situa-
tion as a female ruler, Constance Jordan emphasizes that the culturally perceived weak-
ness of Elizabeth's literal female body had to be offset by construing the authority
vested in her abstract body politic as male: "Elizabeth had reason to promote . . .

works of art that provided imagistic possibilities of the legal fiction of the second male body."[24] One difficulty with this formulation is that it does not clearly address the question of how far the queen could plausibly go in the direction of creating a male political identity.

The most sensitive area in which she appeared to encounter a limit to her symbolic capacity is the male realm of military action. For example, Elizabeth's access to the iconography of weapons as an imagistic resource is largely blocked. A rare print in which the queen is shown directly in the role of Saint George was created more than two decades after her death. As Margaret Aston remarks, "its tone is unlike that of the imagery of the queen's reign."[25] Furthermore, the major apparent exception of Elizabeth's self-presentation in military attire at Tilbury in 1588 is, according to Susan Frye, part of a myth retrospectively constructed in the seventeenth century.[26]

At a more metaphorical level, another example of Elizabeth's directly seizing control of a male phallic medium is the Rainbow portrait of about 1600. The intervention envisioned here is certainly a provocative challenge: the placement of the rainbow against her body makes it appear at first sight that Elizabeth has taken on her own phallic power. Yet closer inspection shows that Elizabeth does not so much appropriate as contravene phallic imagery in order to enhance female authority in the form, as Joel Fineman notes, of an "ear over Queen Elizabeth's genitals." Fineman's contrast between the "oddly colorless" "dildo-like rainbow" and the "florid" eroticism of the "vulva-like" ear is telling.[27] The portrait functions to empty out male phallic prowess: a rainbow is not only evanescent but also permanently bowed and incapable of erection. The result in Fineman's words is "a kind of dead rainbow." The portrait thus enacts a transfer of energy from male to female biological symbolism. This shift permits the queen's physical and political bodies to coincide and thereby enables her to represent both to her best advantage. In this way, Elizabeth might avoid competing with her male courtiers on their own military terms and instead employ a strategy based on the assimilative powers of her distinctively female rule.

This version of her authority is very much on display in the Garter portrait. The image of male military triumph is present in the Garter badge, yet the queen does not mimic but rather environs and absorbs it. Her means of doing so are expressly female. Her face, hands, and breasts combine to suggest a sheer physical power of incorporation: the oval of her face oversees the much smaller round shape of the Garter George, which is clasped by her hand and held between her breasts. The last detail indicates that the force of her body politic is conceived as deriving from a specifically female body. This impression is reinforced by a second element, the uterine shape of the narrow, ringed ovals sewn into the queen's dress. One in particular is positioned immediately above the Garter badge, as though a convenient repository into which, if she desired, the queen by a slight move of her hand might make the badge disappear.

The Garter portrait is of course ideological in that it depicts Elizabeth's preferred

329

"GOD FOR
HARRY,
ENGLAND,
AND SAINT
GEORGE"

point of view. But the move in the direction of the queen's portrait cannot be imagined as permanent and final. The visual contrast continues to work the other way: as we turn to the rendering of Saint George in a work such as Raphael's painting, the representation of female strength accomplished by the queen's portrait is unraveled, undone, reopened. In the version given in Raphael's painting, it is the male who is magnified, the woman who is minimized. Here the female posture is presented as vulnerable, dependent, ancillary, literally marginal, with the woman's figure shunted off to the side of the centrally positioned Saint George. These spatial relations convey an altogether different image of the power relations between men and women. Each of the two paintings has a certain neatness, a clear-cut sense of resolution. Yet when seen in combination they imply a constant possibility of oscillation. Going back and forth, we see that the seemingly solid, stable arrangement is capable of being decomposed and reassembled to construct very different lines of power. Taken together, the two visual images communicate a comprehensive force field in which the tensions between men and women are variously negotiated.

The greatness of Raphael's *Saint George* can be seen in the vividness of the encounter between the knight and the dragon. By comparison, the effect of Raphael's *Saint George* in the Louvre is scattered and lacks the concentrated intensity of the painting in Washington. A telling detail is the positioning of the horse's head. In the version in the Louvre, the horse pulls away from the action; the head looks up and out. In the Washington version, the horse's head turns back in toward the action, creating a sense of involvement that is strengthened by the horse's almost human facial expression reflected especially in the eyes. The two faces of the horse and of Saint George are placed so closely together that they appear to mirror each other and to function as a single unit, thus enhancing the overall effect of compactness and inwardness.

In the Washington painting, the tensile energy of the struggle with the dragon is erotically charged. However, since the dragon's genitals are not visible and the dragon's gender remains indeterminate, the nature of the erotic exchange remains ambiguous. If the dragon is read as female, the scene composes into the standard pattern of compartmentalized male perception that divides women into two types, degraded sexual objects to be conquered and idealized icons to be revered. If the dragon is read as male, the scenario dramatizes the primacy of male-male interaction while the woman is, emotionally speaking, left out of the picture. The slender halos which link Saint George and the lady are visually too weak to offset the central focus on the knight-horse-dragon ensemble.

The woman's peripheral status is accentuated by other details: the dynamic tail of the horse partly cuts off our view of her, while the reflection of her red dress in the small pool of water below her is too faint and fragmentary to have any magnifying effect. Moreover, the lady has to compete for visual attention not only with the

dragon but also with the city towers just to the left of the two heads of Saint George and the horse. The towers create a strong vertical pull that works against the horizontal vision needed to take in the lady; the visual consequence is to create a split in Saint George's mission that makes his action seem directed more toward saving the city than toward rescuing the woman.

The ensemble of Saint George, the horse, and the dragon is drawn together by the general sense of muscular exertion and angularity and more specifically by the emphatic diagonal lines—the lance with upthrust elbow, billowed cape, outstretched leg, and scabbard of Saint George; the upraised front legs of the horse; the turned head and twisted neck, raised serrated wing, and lifted tail of the dragon. Despite this vigorous unifying effect, Saint George is paradoxically removed from any taint of contact with the dragon. The calmness and serenity of Saint George's facial expression mute and perhaps even cancel the sense of his physical participation.[28] His huge horse acts as a buffer that prevents the vectors of linear force from traveling back up to the knight. Only the rearing horse, and not the rider, is potentially aligned for sexual attack on the exposed (though unspecified) area below the dragon's upturned tail. The horse further deflects attention from his master by serving as the dragon's double in echoing the posture of its buttocks and tail. The eye-catching curlicue of the dragon's tail is matched by the waving twist of the horse's tail. In both cases, the buttocks face outward toward the viewer and the raised tail draws attention to this feature. The harness looped underneath the horse's tail makes the point more noticeable.

Saint George is protected as well by the overall color scheme of contrasting white and dark. The dark hue of Saint George's armor is external and intended for its apotropaic value, as the massive, dominant whiteness of the horse confirms. By contrast, the dragon, the conquered and despised other, is coded negatively with regard to color. Whiteness, with its incipient racial connotations, is celebrated as victorious and virtuous. Despite their conflicting representations of gender relations, Elizabeth's Garter portrait coincides with Raphael's painting in its deployment of whiteness, for the queen's portrait proclaims her identity as white.[29] The whiteness of her face and dress makes white the predominant color in the portrait, and this color helps to establish the symbolic basis of her moral appeal. The queen's body politic is thus not only gendered but raced.

Racial associations are part of the medieval history of Saint George.[30] In the instance of Hans Baldung Grien's work for the church at Halle in 1507, Saint George appears in an altarpiece wing opposite the black Saint Maurice. Though the painting is harmonious, it nevertheless provides a context for seeing Saint George's identity as white. A more problematic example is Bernt Heynemann's statuette of Saint George from 1503 in the treasure of the House of the Black Heads in Riga, which is linked to Saint Maurice. Here the black head on George's shield is placed in an anomalous position between George and the dragon; the possibility is left open that the black

331

"GOD FOR
HARRY,
ENGLAND,
AND SAINT
GEORGE"

head, like the Medusa on Perseus's shield, is to be associated with the dragon rather than with Saint George.

In the gradual transition from the medieval to the early modern period, the growing emphasis on international exploration and commercial venture offered a stimulus to expand the field of racial connotations attaching to the dragon, which now begins to emerge as an image of the nonwhite, non-European populations potentially available for domination. Michael Neill provides an example of how the image of Saint George could gain new meanings when transferred to the new geographical location of a remote outpost in Java, where the small British mercantile community conducts a traditional celebration of Queen Elizabeth's Accession Day: "Our day beeing come, wee set vp our Banner of *Sainct George* vpon the top of our House, and with our Drumme and shott we marched vp and downe within our owne grounde"; even if this banner is only "a Flagge with the red Crosse," it nevertheless brings the spirit of the whole image of Saint George and the dragon into play. The nationalist significance of England's patron saint is not only more pronounced but altered and adapted to fit the new situation. Under the pressure of these circumstances, the definition of British national identity facilitated by Saint George includes drawing lines "ultimately of racial difference." As Neill's analysis indicates, British strategic festivity was not simply an intra-European affair aimed at the rival Dutch. It was designed as well to demonstrate British "moral superiority" to the audience of East Indians.[31]

In *The Discoverie of Guiana* (1596), Walter Ralegh had located the queen's double: "I have seen a Lady in England so like to her, as but for the difference of color I would have sworn might have been the same."[32] The difference color makes is not specified, though one implication might be that in Ralegh's eyes Elizabeth's white color is her cultural justification. Elizabeth's 1601 proclamation "Licensing Caspar von Senden to Deport Negroes" marks a turning point where we can see the status of whiteness begin to shift from latent to manifest.[33] Broadly speaking, the transition from the Tudor to the Stuart period correlates with a transition from a precursor to an emergent phase in the presentation of whiteness; in the latter phase, whiteness is increasingly portrayed with the specificity of a self-conscious attitude.

Representations of Arundel by Rubens and Van Dyck

This section pursues the second step in the development of racial whiteness, the point at which active construction of white identity emerges. There are more obvious examples in the early modern period than the instance on which I concentrate here—Van Dyck's Madagascar portrait. The reason for this choice is my desire to consider a more difficult case in which no black figures are present. It also needs to be stressed that the two precursor and emergent phases described in this essay are not the final

steps; beyond the historical scope of the early modern period are more drastic subsequent developments connected with the later growth of the slave trade and plantation slavery in the new world.

My consideration of whiteness in the Madagascar portrait proceeds by way of a comparison of Rubens's and Van Dyck's treatments of their common patron, the earl of Arundel, because I think this comparative context better enables us to establish the distinctive features of Van Dyck's art. Rubens's images of Arundel consist of three paintings and two drawings from the concentrated period, 1629 to 1630, while Van Dyck's three paintings are dispersed over a wider range of dates: 1620–21, 1635–36, and 1639.[34] This cluster of works is large enough to allow us to discern patterns of stylistic difference, yet also small enough to enable us to maintain the specificity of detailed close interpretation and thus to avoid vague characterological speculation. The challenge is how to identify and articulate the differences Rubens and Van Dyck exhibit with regard to representing Arundel.

A chief obstacle is that the comparison of Rubens and Van Dyck is a timeworn topic whose conventional formulation produces a one-sided account that favors Rubens. The relation between Rubens as master and Van Dyck as apprentice has been translated into a psychological formula that makes Rubens the norm to which Van Dyck fails to measure up. Frances Huemer's comment draws as if by reflex on this venerable tradition of Van Dyck's deficiency in relation to Rubens: thus Van Dyck's "poses have nothing of the dynamic power of Rubens, and are all strangely static."[35] The built-in bias of the formula blocks any attempt to consider Van Dyck's strangeness on its own terms.

In the gendered version of the standard contrast, Rubens is portrayed as robustly masculine, while Van Dyck is perceived as unable to invest himself fully in an image of heroic masculinity—an inability which is then construed as a feminine stance.[36] Given these terms of comparative analysis, Van Dyck is bound to lose and the critic is left with no way to account for, or even to recognize, Van Dyck's achievement in the portraits of Arundel. One alternative is to revalue the feminine as a mode of insight and to treat Van Dyck's presumed feminine sensibility as a strength rather than a weakness. However, such a reversal is not completely satisfactory because it continues to frame the argument in terms of questionable gender stereotypes.

The problem demands a more fundamental reopening of the critical terminology with which the comparison of Rubens and Van Dyck is conducted. A more balanced mode of analysis might make it possible to speak of negative aspects of Rubens and positive aspects of Van Dyck. Thus, where Rubens tends to enhance and idealize Arundel's heroic bearing, something in Van Dyck appears to resist this purely transcendent image. Van Dyck's portraits of Arundel are certainly sumptuous, but in each case there is also a countermovement that disturbs and undercuts the elegant atmosphere. The result is that Van Dyck cuts deeper; where Rubens begs, Van Dyck poses the ques-

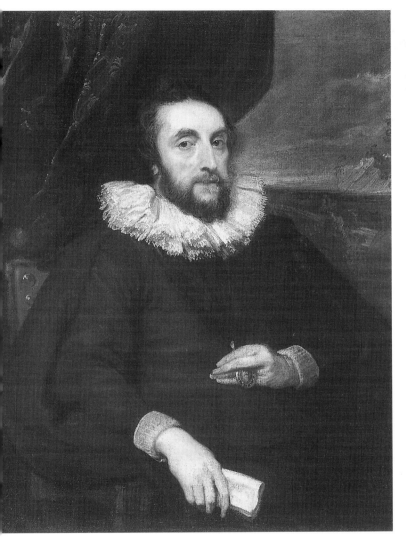

114. Anthony Van Dyck. *Thomas Howard, Second Earl of Arundel*. 1620–21. Oil on canvas. Collection of the J. Paul Getty Museum, Malibu, California.

tion. If we reject Van Dyck's possession of feminine insight as the explanation for the disruptive element in his portraits of Arundel, then the special power of these portraits can be turned to better interpretive account if his unusual aesthetic effects are seen as registers of cultural pressures and doubts. Van Dyck's different attitude toward heroism is expressed in two specific structural devices in Van Dyck's portraits of Arundel, as I shall demonstrate through a comparison of Van Dyck's first portrait of 1620–21 (Figure 114) with Rubens's painting of almost a decade later (Figure 115).[37]

The first device is Van Dyck's counterpoint between interior, represented by the curtain on the left, and exterior, figured by the landscape opening out on the right.

115. Peter Paul Rubens. *Thomas Howard, Earl of Arundel*. Ca. 1630. Oil on canvas.
Isabella Stewart Gardner Museum, Boston.

This counterpoint, strategically situated directly behind Arundel's centrally featured face, is not a harmoniously supportive background but rather a source of slight distraction. An area of instability is implied by the teasing effect of the curtain's possible movement in opposite directions: might the curtain be pulled across to close off the view of the outside, or might the curtain be pushed back to open up the landscape even more? The result is to introduce a low-key tension that suggests an underlying note of ambiguity about the identity so firmly and impassively presented by Arundel's face.

By contrast, the window in Rubens's painting, whose very narrow vertical opening on the right edge is easily contained by the massive stone arch, has no capacity to disrupt the dominance of Arundel's dramatic pose. Whereas Van Dyck's image of Arundel is concentrated in the somber dignity of the face, Rubens creates an expansive jauntiness by coordinating the facial expression with the demonstrative posture of the body. The strong physical lines and angles of the tilted back, the foregrounded hip, the thrust of the arms and ostentatiously bent elbows, and the turned head are echoed and reinforced by the intricate body armor. Body and armor form a single unit that exerts a centrifugal force that turns the rest of the painting into two side panels, swept up by the highlighted vertical section in the middle so imposingly filled by Arundel.

The second structural device used by Van Dyck involves a counterpoint between face and action that is not present in Rubens's overwhelmingly unified visual effect. As our eyes move back and forth between Arundel's face and his hands below in Van Dyck's portrait, we become conscious of a duality because we cannot closely examine both at the same time. The bottom half of the painting seems to take on a separate life of its own, as though the face does not know what the hands are doing. In particular, the peculiar placement of the fingers of the left hand around the Garter badge attracts attention. Since this is not the most convenient or unobtrusive way to hold an object, the question arises whether the action of the hand is in concert or at variance with the image projected by the face.[38] Rubens's Arundel also boasts a Garter badge suspended from the chain on his chest. The difference is that here the badge in no way obtrudes but rather participates in the impression of a unified whole. In the case of Van Dyck's Arundel, the face is doing what it is supposed to do, but it is surrounded by discrete elements that function as split-off fragments that subtly erode and counteract the face's pose of restrained heroism.

The significance of the Garter in Van Dyck's first portrait of Arundel is part of a much larger cultural context to which I now turn. As yet there is no comprehensive study of the Order of the Garter for the Stuart period that is comparable in scope and substance to Roy Strong's account of the Garter ritual as an aspect of the cult by which Elizabeth I organized her political base. Strong himself, however, has pointed the way.[39] In *Britannia Triumphans*, Strong provides two images of James I associated with Garter symbolism—Rubens's *Judgment of Solomon: James I Recreates the Empire*

116. Peter Paul Rubens. *Landscape with Saint George and the Dragon* (detail). 1630. Oil on canvas. The Royal Collection ©2000 Her Majesty Queen Elizabeth II.

of Great Britain (p. 17, fig. 10), in which the king wears a collar of the order (p. 18), and Paul van Somer's portrait of James holding up the Garter badge (p. 39, fig. 36). In *Van Dyck: Charles I on Horseback*, Strong devotes a short chapter to Saint George (pp. 58–63). Under Charles I the Order of the Garter received new emphasis. In this regard Van Dyck's sketches of the Garter procession serve as an updated equivalent to Marcus Gheeraerts's engraving of 1576.[40] Images of Charles in Garter regalia are frequent; it is not too much to say that Garter imagery is a major motif in the portraits of Charles I.[41]

Rubens's contribution to the iconography of the Order of the Garter includes *Landscape with Saint George and the Dragon* (Figure 116), in which Charles I performs the part of the victorious dragon-slayer, with Queen Henrietta Maria in the role of the grateful, rescued lady.[42] The couple enacts a reciprocal submission as the king hands

337

"GOD FOR
HARRY,
ENGLAND,
AND SAINT
GEORGE"

his wife the rope by which the slain dragon was tethered, while she welcomes him with open breasts, signifying the restoration of nurturant eroticism. The premise of this exchange—the deflated dragon at Charles's feet—looks slightly silly, excessively melodramatic as well as trivial and toylike. The idealizing tendency visible in Rubens's heroic embellishment of Arundel here goes over the top into sheer sentimentality. Though they stop well short of this extreme, the spirit of Rubens's portraits of Arundel is of a piece with the *Landscape with Saint George and the Dragon* in that they display a similar one-dimensional heroicizing.

Rubens's and Van Dyck's representations of Arundel all contain visual icons of the Garter motif. Following Patricia Fumerton's remark that the Garter ornament is "at once peripheral and strangely central,"[43] I argue that the Garter symbol plays a significant role in the overall meaning of individual portraits. The detail of Arundel's handheld Garter badge in Van Dyck's portrait of 1620–21 is a specific site at which the artist places pressure on orthodox expectations and assumptions about conventional heroism. Against the atmospherics of Rubens, Van Dyck's renderings of Arundel display a precision and an astringency that encourage clarification rather than mystification.

Two forms of duality—the counterpointing of interior and exterior and the juxtaposition of face and action—continue in Van Dyck's two subsequent portraits of Arundel. Neither is a simple portrait of a single individual; both increase the possibilities for complex dramatic action by portraying the relationship between two people. The portrait of the earl with his grandson (see Figure 101) begins conventionally enough when we focus on Arundel. The precipitous cliffs, whose rocky abutment obligingly echoes the bend in his armored right elbow, conform to Van Dyck's use of "a craggy setting for men in armor to symbolize heroic strength."[44] This environmental symbolism correlates with the political symbols of Arundel's status, the Garter badge suspended in the center of his chest and the upheld earl marshal's baton. However, the addition of the grandson changes the dynamic.

The contrasting backgrounds should flow in logical generational sequence: the protective domestic curtain with its lavish artificial vegetation is an appropriate backdrop for the youth, whose eventual maturation will fit him for the austerity of the rugged promontory with sparse vegetation, which is at present the domain of his grandfather. What interrupts this orthodox progression is the grandson's gaze—the rapt expression riveted on the baton's tip. Though the actual distance between the boy's eye and the end of the baton is extremely short, the emotional distance seems immense. Where continuity might be expected, the generational exchange produces a gap at the most acute point of contact. Instead of reassurance, the principal visual effect is one of self-consciousness intensified to the level of embarrassment. As viewers, we are caught up in an unsettling triangle of gazes: our eyes follow the boy's, even as we are uneasily aware that Arundel's gaze is fixed on us.

Part of what the painting exposes is the phallic pretension of the baton's place-ment, with its erect linearity seconded by the alignment of the earl's extended right thumb. Van Dyck's visual repertoire of phallic gestures can be seen at its most face-tiously egregious in the two portraits of Algernon Percy. In each case, the admiral is not only outfitted with the Garter badge but also equipped with three different phallic implements strategically positioned and caressed.[45] But the sense of exposure in the portrait of Arundel and his grandson is not limited to a visual joke; rather, Van Dyck's insistence on a discordant note, a disruptive site, introduces a doubleness that sets off an undercurrent of question about the entire cultural apparatus by which authoritative male identity is produced and transmitted.

In the Madagascar portrait (see Figure 99), the awkward assertion of power is greatly expanded in scope both because of geographical specificity and because of female participation. First, the background contrast between the curtained domestic space and the open window giving access to the outside world takes on new meaning. The amorphous clouds are given definition by the huge globe in the foreground in front of the window. The exterior realm has become the international arena charted by the map.[46] Second, the image of marital collaboration implies the woman's equal involvement in the symbolic vectors of power. The countess's deployment of the com-passes parallels the earl's index finger as it targets the island of Madagascar; both com-passes and finger serve as surrogates for Saint George's weapon in the Garter emblem on the earl's breast. In establishing the connection between Saint George and colo-nial conquest, the painting provides a setting in which the couple might give voice to the cry, "God for the Arundels, England, and Saint George." But as soon as we imag-ine such an utterance, it immediately falls flat. Unlike the complacent fantasy Rubens creates for the royal couple in *Landscape with Saint George and the Dragon*, the Mada-gascar portrait puts on display the partners' unhappiness with their role of colonial entrepreneurs.[47]

Palpable discomfort is the most prominent emotion communicated by Van Dyck's image of the Arundels. Neither the earl nor the countess appears happy in the role their joint venture calls for, with the result that what we see and feel is the effort of their trying to be heroic. Though they both point to Madagascar, the goal of their am-bitious project, neither can look at it. Nor can they look at each other: the earl turns in his wife's direction as though seeking reassurance, but eye contact is conspicuously lacking.

The Arundels surround themselves with ritual objects that serve less as symbols of an expansive international vision than as a burden that pulls them back into a crowded interior still-life scene with hints of *vanitas*. The Garter badge, for example, traverses and ideally reconciles the two realms of heroic adventure far afield and of domestic festivity. Here the synthesis breaks down. As the Garter emblem of Saint George is broadened to represent British national identity in new global enterprises,

339

"GOD FOR

HARRY,

ENGLAND,

AND SAINT

GEORGE"

the plausibility of the emblem is subject to increasing strain. The badge attempts to project the heroic action of Saint George as an image of British national greatness, but threatens to collapse into mere appurtenance emptied of symbolic efficacy. It is as though Van Dyck's clear-eyed portraits cannot help revealing the strain, but they do so from within rather than outside the arena of belief. This equivocal halfway point between total belief and complete detachment is what allows the portrait to express delicate tremors of cultural doubt.

The Madagascar portrait dramatizes not only the presumption of incipient white privilege but also the hesitation and uncertainty accompanying this assertion of power. The fumbling, staged quality of the couple's pose betrays a deeper anxiety. Because white dominance is not yet fully achieved and assured, this emergent moment reveals the insecurity and ambivalence that attend white superiority in the making. Coming before the point when automatic routines of absolute confidence close off vulnerability, the Arundels remain open both to numbing fear that the attempt to impose white dominance might fail and to furtive guilt that it might succeed.

Notes

1. A survey of key issues in recent work on race in the Renaissance, with full bibliography, is provided by my essays—"Representations of Blacks and Blackness in the Renaissance," *Criticism* 35 (1993): 499–527; "The Moment of Race in Renaissance Studies," *Shakespeare Studies* 26 (1998): 27–36; and "Representations of Race in Renaissance Art," *The Upstart Crow: A Shakespeare Journal* 18 (1998): 2–9—and by my reviews in *The Art Bulletin* 78 (1996): 736–38 and *Shakespeare Quarterly* 48 (1997): 363–66.

2. Raymond Williams provides a concise history of the term *racial* in his *Keywords: A Vocabulary of Culture and Society* (London: Fontana, 1983), pp. 248–50. However, in view of the sustained critique of Williams on the issue of race conducted by Paul Gilroy and Stuart Hall, it becomes necessary to reassess the interrelations between Williams's linguistic account and his general interpretive stance. Gilroy's discussion of Williams appears in *"There Ain't No Black in the Union Jack": The Cultural Politics of Race and Nation* (London: Unwin Hyman, 1987), pp. 49–51, and *The Black Atlantic: Modernity and Double Consciousness* (Cambridge: Harvard University Press, 1993), pp. 10–14. Hall's appears in "Culture, Community, Nation," *Cultural Studies* 7, no. 3 (October 1993): 349–63, esp. 358–61.

3. Stuart Hall, "When Was 'The Post-Colonial'? Thinking at the Limit," in *The Post-Colonial Question: Common Skies, Divided Horizons*, ed. Iain Chambers and Lidia Curti (London: Routledge, 1996), pp. 242–60; quotation from p. 249.

4. Discussions of *The Gulf Stream* include: "The Gulf Stream," in *American Paintings in the Metropolitan Museum of Art*, vol. 2 (New York: Metropolitan Museum of Art, 1985), pp. 482–90; Hugh Honour, *The Image of the Black in Western Art*, vol. 4: *From the American Revolution to World War I* (Houston: Menil Foundation, and Cambridge: Harvard University Press, 1989), part 2, *Black Models and White Myths*, pp. 199–202; Albert Boime, *The Art of Exclusion: Representing Blacks in the Nineteenth Century* (Washington, D.C.: Smithsonian Institution Press, 1990), pp. 36–46; Nicolai Cikovsky, Jr., "Homer Around 1900," in *Winslow Homer: A Sympo-*

sium, ed. Nicolai Cikovsky, Jr. (Washington, D.C.: National Gallery of Art, 1990), pp. 133–54; and *Winslow Homer*, ed. Nicolai Cikovsky, Jr. and Franklin Kelly (Washington: National Gallery of Art, 1995), pp. 368–71 and catalog entry no. 231, pp. 382–83. A specifically American benchmark for Homer's *Gulf Stream* is Edward Savage's *Washington Family* (ca. 1790–96) in the National Gallery of Art, where the black male servant is stationed on the perimeter, literally outside the central compositional unit of the four family members.

5. The history of Turner's *Slave Ship* in America from its arrival in New York in 1872 to its acquisition by Boston's Museum of Fine Arts in 1899 is described in Andrew Walker's "From Private Sermon to Public Masterpiece: J. M. W. Turner's *The Slave Ship* in Boston, 1876–1899," *Journal of the Museum of Fine Arts, Boston* 6 (1994): 4–13. Paul Gilroy comments on the incompatibility between Ruskin's ownership of this painting and his aesthetic values in *The Black Atlantic*, pp. 13–14. For a more general overview, see Gilroy's introduction to *Picturing Blackness in British Art, 1700s–1990s* (London: Tate Gallery, 1995). The connection between transcendentalism and abolition is exemplified by *Emerson's Antislavery Writings*, ed. Len Gougeon and Joel Myerson (New Haven: Yale University Press, 1995).

6. Homer's early career is discussed in Marc Simpson, *Winslow Homer: Paintings of the Civil War* (San Francisco: Fine Arts Museums of San Francisco, 1988), and in Peter H. Wood and Karen C. C. Dalton, *Winslow Homer's Images of Blacks: The Civil War and Reconstruction Years* (Houston: Menil Collection, 1988). Two paintings in the latter have especially powerful resonance as precursors to *Gulf Stream: Sunday Morning in Virginia* (1877), pp. 87–89, and *A Visit from the Old Mistress* (1876), pp. 92–95. For Du Bois's *The Souls of Black Folk*, I cite Henry Louis Gates, Jr., and Terri Hume Oliver's Norton Critical edition (New York, 1999, p. 17).

7. Norman Bryson discusses both paintings—Velázquez's *Kitchen Maid* in *Looking at the Overlooked: Four Essays on Still Life Painting* (Cambridge: Harvard University Press, 1990), pp. 60–61, and Bailly's *Vanitas* in his introduction to *In Medusa's Gaze: Still Life Paintings from Upstate New York Museums* (Rochester: Memorial Art Gallery of the University of Rochester, 1991), pp. 6–7.

8. Velázquez's *The Kitchen Maid with Christ at Emmaus* is cited in Rosemarie Mulcahy's catalog, *Spanish Paintings in the National Gallery of Ireland* (Dublin: National Gallery of Ireland, 1988), pp. 79–82. As in Bryson's *Looking at the Overlooked* (pp. 152–54), the separation of foreground and background is discussed with reference to a similar motif in Velázquez's *Kitchen Scene with Christ in the House of Martha and Mary* in two recent exhibitions: William B. Jordan and Peter Cherry, *Spanish Still Life from Velázquez to Goya* (London: National Gallery, 1995), p. 40, and *Velázquez in Seville* (Edinburgh: National Galleries of Scotland, 1996), pp. 132–35.

9. Acquired by the Herbert F. Johnson Museum of Art in 1986, Bailly's painting is listed in the 1998 edition of the *Handbook of the Collections* under the title *Vanitas Still Life with Portrait*. In the 1991 exhibition *In Medusa's Gaze* (n. 7), the title is given as *Vanitas with Negro Boy* (introduction, pp. 9–11, and catalog entry no. 4, pp. 50–53).

10. Dympna Callaghan, "'Othello Was a White Man': Properties of Race on Shakespeare's Stage," in *Alternative Shakespeares*, vol. 2, ed. Terence Hawkes (London: Routledge, 1996), pp. 192–215, and Kim F. Hall, "'These Bastard Signs of Fair': Literary Whiteness in Shakespeare's Sonnets," in *Post-Colonial Shakespeares*, ed. Ania Loomba and Martin Orkin (London: Routledge, 1998), pp. 64–83; quotation from p. 79. I discuss recent approaches to the study of whiteness in "Profiles in Whiteness," *Stanford Humanities Review* 3, no. 1 (Winter 1993): 98–111, and "Seeing White," *Transition* 67 (Fall 1995): 166–85.

341

"GOD FOR
HARRY,
ENGLAND,
AND SAINT
GEORGE"

11. *Marchesa Elena Grimaldi* and *Henrietta of Lorraine* are catalog nos. 36 and 72 in *Anthony van Dyck*, ed. Arthur K. Wheelock, Jr., and Susan J. Barnes (Washington, D.C.: National Gallery of Art, 1990), pp. 174–77 and 278–80. Additional commentary on *Marchesa Elena Grimaldi* includes Susan J. Barnes's dissertation "Van Dyck in Italy: 1621–1628" (New York University, 1986), pp. 112–15 and 223–27; Marjorie E. Wieseman's entry in Peter C. Sutton, *The Age of Rubens* (Boston: Museum of Fine Arts, 1993), pp. 332–34; and Elise Goodman's essay "Women's Supremacy over Nature: Van Dyck's *Portrait of Elena Grimaldi*," *Artibus et Historiae* 30 (1994): 129–43. In this context, I am grateful to Zirka Filipczak for bringing to my attention Bellori's description of a nonextant painting by Van Dyck: "He also portrayed a lady as Venus with an Ethiopian; she admires herself in a mirror and makes fun of her black companion, as she draws a comparison with her whiteness" (Christopher Brown, *The Drawings of Anthony van Dyck* [New York: Pierpont Morgan Library, 1991], p. 21).

12. Kim F. Hall discusses sunburn as an explicitly racial theme in *Things of Darkness: Economies of Race and Gender in Early Modern England* (Ithaca: Cornell University Press, 1995), pp. 92–107.

13. Paul H. D. Kaplan makes the connection between *Laura Dianti* (ca. 1523) and *Marchesa Elena Grimaldi* in "Titian's *Laura Dianti* and the Origins of the Motif of the Black Page in Portraiture," *Antichità Viva* 21, no. 1 (1982): 11–18, and 21, no. 4 (1982): 10–18. An image that predates the black-page motif is the emblem of the African head on the wall in the first panel of Uccello's Urbino predella (1467–68); although situated in a three-part constellation with a scorpion and a star, the African head stands out because of the larger size and elaborate shape of its frame and because of its prominent placement at the apex of the triangular composition.

14. In his entry on *Henrietta of Lorraine* for the 1990 Van Dyck exhibition catalog (n. 11), Arthur Wheelock reports: "When Endymion Porter returned to England after having been in Brussels in the winter of 1634–35, he brought with him this portrait, which he presented to King Charles I and which subsequently hung prominently at Whitehall" (*Anthony van Dyck*, p. 280).

15. In *A Descriptive Catalogue of the Etched Work of Wenceslaus Hollar, 1607–1677* (Cambridge: Cambridge University Press, 1982) under the heading for numbers 2003–23, "Negroes, American Indians, Chinese, and a Turk," Richard Pennington gives 1632 as the date for the countess's acquisition of the black servant (p. 316). However, both Mary F. S. Hervey and David Howarth place the acquisition a decade earlier during Lady Arundel's trip to Italy in 1620–1622—Hervey, *The Life, Correspondence and Collections of Thomas Howard, Earl of Arundel* (Cambridge: Cambridge University Press, 1921), p. 227, and Howarth, *Lord Arundel and His Circle* (New Haven: Yale University Press, 1985), p. 152. Howarth goes on to speculate that the black figure in Van Dyck's painting of George Gage "may be Lady Arundel's black servant" (p. 158).

16. Stuart Hall's remarks on the issue of origins in "The West and the Rest: Discourse and Power," in *Formations of Modernity*, ed. Stuart Hall and Bram Gieben (Cambridge: Polity Press, 1992), pp. 275–320, are apt here. Although Hall takes the Portuguese exploration of the West African coast beginning in 1430 as his historical starting point, he also emphasizes that "long historical processes have no exact beginning or end, and are difficult to date precisely" and that "historical sociology" both requires and validates the level of analytic abstraction that "historical generalizations" make possible (pp. 280–81).

17. Raphael's *Saint George and the Dragon* is listed as item 26 in Fern Rusk Shapley, *Catalogue of the Italian Paintings* (Washington, D.C.: National Gallery of Art, 1979), vol. 1, pp.

391–94. Shapley gives the painting's date as between 1504 and 1506. Discussions of the painting and of the history of the Saint George and the dragon motif include: David Alan Brown, *Raphael and America* (Washington, D.C.: National Gallery of Art, 1983), pp. 135–57; David Alan Brown, "Saint George in Raphael's Washington Painting," in *Raphael Before Rome*, ed. James Beck (Washington, D.C.: National Gallery of Art, 1986), pp. 37–44; and Brigit Blass-Simmen, *Sankt George, Drachenkampf in der Renaissance: Carpaccio—Raffael—Leonardo* (Berlin: Gebr. Mann, 1991). The proliferation of artistic renderings of Saint George and the dragon is documented in *San Giorgio tra Ferrara e Praga* (Rome: Gabriele Corbo, 1991); *St. Georg: Ritterheiliger, Nothelfer, Bamberger Dompatron* (Bamberg: Historisches Museum, 1992); and Georges Didi-Huberman, Riccardo Garbetta, and Manuela Morgaine, *Sainte Georges et le dragon: Versions d'une legende* (Paris: Adam Biro, 1994).

18. The portrait of Elizabeth holding the Garter badge is listed as item 48 in Oliver Millar, *The Tudor, Stuart and Early Georgian Pictures in the Collection of Her Majesty the Queen* (London: Phaidon, 1963), vol. 1, p. 66. It is also noted in Roy C. Strong's *Portraits of Queen Elizabeth I* (Oxford: Clarendon Press, 1963), p. 62, item 28. In his essay "Saint George for England: The Order of the Garter," in *The Cult of Elizabeth: Elizabethan Portraiture and Pageantry* (London: Thames and Hudson, 1977), pp. 164–85, Strong places this portrait at the head of the chapter and dates it at about 1573.

19. Raymond B. Waddington, "Elizabeth I and the Order of the Garter," *Sixteenth Century Journal* 24 (1993): 97–113. On the origins of the order, see Jonathan Bengtson, "Saint George and the Formation of English Nationalism," *Journal of Medieval and Early Modern Studies* 27 (1997): 317–40. For my previous study of Shakespeare's response to the Order of the Garter as a cultural medium through which Elizabeth I consolidated her position as a female monarch, see "The Order of the Garter, the Cult of Elizabeth, and Class-Gender Tension in *The Merry Wives of Windsor*," in *Shakespeare Reproduced: The Text in History and Ideology*, ed. Jean E. Howard and Marion F. O'Connor (London: Methuen, 1987), pp. 116–40. I would now want to expand this analysis by considering the racial undercurrent that comes into view when the invocation of Elizabeth as "our radiant queen" is placed in the wider global context signaled by Falstaff's allusion to Ralegh's *Discoverie of Guiana*.

20. This account of the early provenance of Raphael's painting is questioned by Shapley and vigorously refuted by Helen S. Ettlinger in "The Question of Saint George's Garter," *Burlington Magazine* 125 (January 1983): 25–29. Waddington ("Elizabeth I and the Order of the Garter," pp. 104–5, n. 21) gives as his source Cecil H. Clough's 1967 essay "The Relations Between the English and Urbino Courts, 1474–1508," reprinted in Clough's *The Duchy of Urbino in the Renaissance* (London: Variorum Reprints, 1981), pp. 202–18. Yet in the "Additions and Corrections" to the 1981 edition, Clough changes his position: "I no longer consider the evidence supports the claim that this painting is destined for Henry VII" (p. 10). Clough's new view is elaborated in "Sir Gilbert Talbot, K. G., and Raphael's Washington 'St. George,'" *Report of the Society of the Friends of St. George's and the Descendants of the Knights of the Garter* 6, no. 6 (1984–85): 242–54, and "Il 'San Giorgio' di Washington: Fonti e Fortuna," in *Studi su Raffaello*, ed. Micaela Sambucco Hamoud and Maria Letizia Strocchi (Urbino: Quattro Venti, 1987), vol. 1, pp. 275–90.

21. In addition to Shapley and Ettlinger above, see Francis Haskell's paragraph on Charles's acquisition of the Raphael *Saint George* in "Charles I's Collection of Pictures," in *The Late King's Goods: Collections, Possessions and Patronage of Charles in the Light of the Commonwealth Sale Inventories*, ed. Arthur MacGregor (London: Alistair McAlpine in association with Oxford

University Press, 1989), p. 216. The same volume contains a copy of Raphael's painting by Peter Oliver (fig. 59, p. 118).

22. Steven Gunn, "Chivalry and the Politics of Early Tudor Court," in *Chivalry in the Renaissance*, ed. Sydney Anglo (Woodbridge, Suffolk: Boydell Press, 1990), pp. 107–28; quotations from p. 110.

23. In chapter 1, "Female Rule, Patriarchal Ideology," in *Rewriting Shakespeare, Rewriting Ourselves* (Berkeley: University of California Press, 1991), I sketch a framework for approaching Elizabeth I's position as one focal point for gender conflicts in the period. Subsequently published work to which I am indebted includes: Susan Frye, *Elizabeth I: The Competition for Representation* (New York: Oxford University Press, 1993) and "Of Chastity and Violence: Elizabeth I and Edmund Spenser in the House of Busirane," *Signs* 20, no. 1 (Autumn 1994): 49–78; Nanette Salomon, "Positioning Women in Visual Convention: The Case of Elizabeth I," in *Attending to Women in Early Modern England*, ed. Betty S. Travitsky and Adelle F. Seeff (Newark: University of Delaware Press, 1994), pp. 64–95; Carole Levin, *The Heart and Stomach of a King: Elizabeth I and the Politics of Sex and Power* (Philadelphia: University of Pennsylvania Press, 1994); Steven Mullaney, "Mourning and Misogyny: *Hamlet, The Revenger's Tragedy*, and the Final Progress of Elizabeth I, 1600–1607," *Shakespeare Quarterly* 45 (1994): 139–63; and Louis A. Montrose, "Idols of the Queen: Policy, Gender, and the Picturing of Elizabeth I," *Representations* 68 (Fall 1999): 108–61.

24. Constance Jordan, "Representing Political Androgyny: More on the Siena Portrait of Queen Elizabeth I," in *The Renaissance Englishwoman in Print: Counterbalancing the Canon*, ed. Anne M. Haselkorn and Betty S. Travitsky (Amherst: University of Massachusetts Press, 1990), pp. 157–76; quotation from p. 161. By contrast, Susan Frye argues that Elizabeth "gives herself two political bodies"—she not only "retains her male body politic" but also "replaces her weaker, natural body with the innovative conception of female body politic" (*Elizabeth I*, p. 13).

25. Margaret Aston, *The King's Bedpost: Reformation and Iconography in a Tudor Group Portrait* (Cambridge: Cambridge University Press, 1993), p. 147 and fig. 99. This image is listed as number 15 in the section on posthumous portraits in Roy Strong's *Portraits of Queen Elizabeth I*.

26. Susan Frye, "The Myth of Elizabeth at Tilbury," *Sixteenth Century Journal* 23 (1992): 95–114.

27. Joel Fineman, *The Subjectivity Effect in Western Literary Tradition: Essays Toward the Release of Shakespeare's Will* (Cambridge: MIT Press, 1991), p. 228. In "Political Allegory, Absolutist Ideology, and the 'Rainbow Portrait' of Queen Elizabeth I," *Renaissance Quarterly* 50 (1997): 175–206, Daniel Fischlin notes that the queen's right hand holding the cylindrical rainbow is counterbalanced by the action of her left hand "with its index finger inserted in one of the mantle's folds" and hence that "phallic representation is undercut by the more subtle visual and figurative resonances of the fold" (pp. 186–87).

28. David Alan Brown's "Saint George in Raphael's Washington Painting" has a useful discussion of Saint George's facial features.

29. On the cult of Elizabeth as a cult of whiteness, see my essay "Representations of Blacks and Blackness in the Renaissance," p. 517.

30. References are to *The Image of the Black in Western Art*, vol. 2, *From the Early Christian Era to the "Age of Discovery"* (Cambridge: Harvard University Press, 1979), which consists of two books: part 1, *From the Demonic Threat to the Incarnation of Sainthood* by Jean Devisse, and part 2, *Africans in the Christian Ordinance of the World (Fourteenth to the Sixteenth Century)* coauthored by Devisse and Michel Mollat. For Hans Baldung Grien, see part 1, p. 187 and

fig. 147; part 2, p. 171. For the House of the Black Heads, see part 1, p. 176 and part 2, p. 212 and fig. 222.

31. Michael Neill, "Putting History to the Question: An Episode of Torture at Bantam in Java, 1604," *English Literary Renaissance* 25 (1995): 45–75; quotations from pp. 67, 70, and 69.

32. On this passage, see Jeffrey Knapp, *An Empire Nowhere: England, America, and Literature from Utopia to the Tempest* (Berkeley: University of California Press, 1992), pp. 203–4.

33. The text of Elizabeth's proclamation of expulsion is given in *Tudor Royal Proclamations*, vol. 3, *The Later Tudors (1588–1603)*, ed. Paul L. Hughes and James F. Larkin (New Haven: Yale University Press, 1969), pp. 221–22.

34. The five works by Rubens are numbers 4, 4a, 5, 5a, and 5b in the catalogue raisonné section of Frances Huemer, *Portraits I* in the *Corpus Rubenianum Ludwig Burchard*, vol. 19, part 1 (Brussels: Arcade, 1977). The two drawings are further described in Egbert Haverkamp-Begeman, Standish D. Lawder, and Charles W. Talbot, Jr., *Drawings from the Clark Art Institute* (New Haven: Yale University Press, 1964), vol. 1, pp. 28–29; and Christopher White, "Rubens's Portrait Drawing of Thomas Howard, Second Earl of Arundel," *Burlington Magazine* 137 (May 1995): 316–19. Oliver Millar's *Van Dyck in England* (London: National Portrait Gallery, 1982) contains the three Van Dyck paintings as items 2, 21, and 59.

35. Huemer, *Portraits I*, p. 91. See also the implied negative evaluation of Van Dyck in comparison to Rubens in the portrayal of the former as a defective transmitter of Titian's artistic legacy in the two concluding paragraphs of Julius Held's "Rubens and Titian," in *Titian: His World and His Legacy*, ed. David Rosand (New York: Columbia University Press, 1982), p. 334. Significantly, one of the touchstones for Held's celebration of Rubens here is his painting of Arundel in the Gardner Museum (pp. 330–31).

36. Julius Held, "Van Dyck's Relationship to Rubens," in *Van Dyck 350*, ed. Susan J. Barnes and Arthur K. Wheelock, Jr. (Washington: National Gallery of Art, 1994), p. 64, traces the construction of Van Dyck as feminine to Eugene Fromentin. Zirka Zaremba Filipczak, *Picturing Art in Antwerp, 1550–1700* (Princeton: Princeton University Press, 1987), p. 90, cites Lionel Cust's characterization of Van Dyck's behavior as "'feminine obstinacy and indecision.'"

37. The acquisition of Van Dyck's first portrait of Arundel is reported in the *J. Paul Getty Museum Journal* 15 (1987): 180–81. The Getty subsequently published Christopher White's full-length study, *Anthony van Dyck: Thomas Howard, the Earl of Arundel* (Malibu: J. Paul Getty Museum, 1995). *Dynasties: Painting in Tudor and Jacobean England, 1530–1630*, ed. Karen Hearn (London: Tate Gallery, 1995), includes Van Dyck's painting as item 146 (pp. 217–18). Rubens's portrait of Arundel in the Gardner collection is discussed in Philip Hendy, *European and American Paintings in the Isabella Stewart Gardner Museum* (Boston: Isabella Stewart Gardner Museum, 1974), pp. 211–15; Philipp P. Fehl, "The Ghost of Homer: Observations on Rubens's *Portrait of the Earl of Arundel*," *Fenway Court* (1987): 7–23; Peter C. Sutton, *The Age of Rubens* (Boston: Museum of Fine Arts, 1993), pp. 294–97; and *Titian and Rubens: Power, Politics and Style* (Boston: Isabella Stewart Gardner Museum, 1998), pp. 52–54.

38. Christopher White's general comments on Van Dyck's rendering of hands are extremely useful (*Anthony van Dyck*, pp. 52, 54, 57), but his characterization of the hand holding the Garter as "gentle, refined clasping" is off the mark. In my view, David Jaffé's description of "casually fondling" is nearer to the tonal oddity of the hand's action—"The Earl and Countess of Arundel: Renaissance Collectors," *Apollo* 144 (August 1996): 3–35; quotation on p. 9. "Fondling" rightly suggests that the hand does not match the level of dignity the face wants to convey.

39. Strong's briefer contributions to the study of the Order of the Garter are contained in *Van Dyck: Charles I on Horseback* (London: Allen Lane, Penguin Press, 1972) and *Britannia Triumphans: Inigo Jones, Rubens and Whitehall Palace* (New York: Thames and Hudson, 1980). My disagreement with, and extension of, Strong's work concerns his statement that "Post-Reformation Protestant glosses transform the saint into a sacred emblem designed to incite valiant Garter Knights to vanquish the Roman Antichrist" (*Britannia Triumphans*, p. 42). This view is too restrictive in limiting the meanings of Saint George to European religious conflict and in thus neglecting issues pertaining specifically to the global context beyond.

40. Kevin Sharpe surveys Charles I's dedication to the Order of the Garter in *The Personal Rule of Charles I* (New Haven: Yale University Press, 1992), pp. 219–22. Detailed notations on the insignia and clothing connected with the order are given by Ronald Lightbown and Valerie Cumming, respectively, in *The Late King's Goods*, pp. 270–74 and 342–45. Van Dyck's *Charles I and the Knights of the Garter in Procession* is item 102 in *Anthony van Dyck* (Washington: National Gallery of Art, 1990). Roy Strong discusses Gheeraerts's engraving in *The Cult of Elizabeth*, pp. 168–72.

41. Examples from Erik Larsen's catalogue raisonné, *The Paintings of Anthony van Dyck* (Freren: Luca, 1988), are nos. 786–95 and 797–98 in vol. 2.

42. References to Rubens's *Landscape with Saint George and the Dragon* include Oliver Millar, *The Age of Charles I: Painting in England, 1620–1649* (London: Tate Gallery, 1972), pp. 56–57, and Christopher Lloyd, *The Queen's Pictures: Royal Collectors through the Centuries* (London: National Gallery, 1991), pp. 104–5.

43. Patricia Fumerton, *Cultural Aesthetics: Renaissance Literature and the Practice of Social Ornament* (Chicago: University of Chicago Press, 1991), pp. 18–22; quotation from p. 21.

44. Zirka Zaremba Filipczak, "Reflections on Motifs in van Dyck's Portraits," in *Anthony van Dyck* (Washington, D.C.: National Gallery of Art, 1990), pp. 59–68; quotation from p. 59.

45. Oliver Millar, *Van Dyck in England*, pp. 69–70. Sometimes an anchor is just an anchor, but not here.

46. On Madagascar, see Mervyn Brown, *Madagascar Rediscovered: A History from Early Times to Independence* (Hamden, Conn.: Archon, 1974). This explicit international reach is not unprecedented in Van Dyck's art, as his portrait of William Feilding, earl of Denbigh (ca. 1633), indicates. See the discussions of this painting by Richard Wendorf, *The Elements of Life: Biography and Portrait-Painting in Stuart and Georgian England* (Oxford: Clarendon Press, 1990), pp. 101–3, and Kim F. Hall, *Things of Darkness*, pp. 230–32.

47. The term "optimistic painting" in Graham Parry's "Van Dyck and the Caroline Court Poets," in *Van Dyck 350* (p. 255), is unconvincing because it wrongly imposes the simplicities of William Davenant's poem "Madagascar" on the complexity of Van Dyck's double portrait. In *Kings and Connoisseurs: Collecting Art in Seventeen-Century Europe* (Washington, D.C.: National Gallery of Art, 1995), Christopher Brown points to the grandiosity of the Madagascar portrait, commenting that it "unintentionally reveals how desperate the Arundels were to restore their financial position" (p. 60). The operative word "unintentionally" usefully suggests a distinction between the intention of the artist and the far wider complexity of the work of art.

10. OBJECT INTO OBJECT?

Some Thoughts on the Presence of Black Women in Early Modern Culture

KIM F. HALL

My title refers to Michelle Cliff's landmark essay "Object into Subject: Some Thoughts on the Work of Black Women Artists." I'd like to begin, as she does, by contemplating a sixteenth-century sculpture, the *Black Venus* by Danese Cattaneo (Figure 117). Here is Cliff's description:

The full-length nude figure is bronze. In one hand she holds a hand-mirror in which she is looking at herself. On her head is a turban, around the edges of which her curls are visible. In her other hand she carries a cloth—or at least what appears to be a cloth. Who was she? A slave? Perhaps from the artist's own household, or maybe that of his patron—one of the many Black women dragged from Africa to enter the service of white Europeans. I have no idea who she actually was: she was an object, then as now.[1]

I teach this essay quite a bit in my women's studies courses—with increasing discomfort with the binary that Cliff sets up in which we dismiss earlier images in order to embrace the later, more resistant images of modern black women artists like Bettye Saar, Elizabeth Catlet, and others. I worry that in teaching Cliff's essay I am somehow undermining my own intellectual work in other arenas. That is, I may be enabling students only to see objectification, subtly encouraging them to reject the past as wholly denigrating and to look only to the present for empowering images and models of resistance.

Of course, there is no doubt that the sculpture does objectify; like Cliff, I find that these images have little to do with actual black women. They are the visual equivalent of the "Africanist presence."[2] Most images of black women in the period, even beautiful, eroticized ones, in some way fit Cliff's definition of objectification: "Through objectification—the process by which people are dehumanized, made ghostlike, given the status of Other—an image created by the oppressor replaces the actual being. The actual being is then denied speech: denied self-definition, self-realization: and overarching all this, denied selfhood—which is after all the point of objectification.[3] In the many images I have looked at of black women, there is no doubt of this—the "actual being" behind the image is lost, in part through "indifferent archives and hostile historiography."[4] It is equally true that black men, other ethnic groups, laborers, and the poor are often similarly objectified. However, blackness is so symbolically crucial to early modern culture that black women inhabit a different con-

117. Danese Cattaneo. *Black Venus*. Ca. 1550. Bronze. Metropolitan Museum of Art, New York, Gift of Ogden Mills, 1926 (26.14.15).

ceptual space than these other figures. Black women become, as they are in modern culture, both highly visible as symbols and invisible as subjects.

Edward Scobie suggests a different reading of (and historical context for) the Venus when he claims her as evidence for the assertion that "Black women were the most talked about, sought after and courted women in Europe from the time Europe made contact with Africa. European men of all ranks could not resist their charm: a charm that was mysterious, spiritual, yet with that spark or flicker of sensuality that ignited the passions of European men and made them pay homage to both a physical and a spiritual quality."[5] Scobie's answer to centuries of scholarly and social invisibility is to present us with a past replete with desirable African women, women highly visible as sex symbols, albeit with a mystical/spiritual quality.

In both cases I am left with a rather static objectification, either through the "depersonalization of racism"[6] identified by Cliff, or through the granting of mostly erotic power and sexual agency suggested by Scobie. I find myself caught between Cliff's dismissal and Scobie's glorification, between a hardheaded and skeptical look at the cultural work of the representation and a desire to see a past in which black women are not demonized welfare queens or castrating sapphires. This bind, I believe, mimics a larger (if somewhat muted) tension between the current wave of studies of "race" in the early modern period and the longer history of race/ethnic studies that focuses on the black presence. The former mode of scholarship is deeply influenced by contemporary schools of critical inquiry, most notably postcolonial studies, cultural materialism, and feminism.[7] This project is not simply to locate representations of racial difference, but to question the uses and meanings of the category "race" itself. Significantly, it challenges essentialist views of race, the "common sense" notion that "the evidence of racial difference appears to be figured so *obviously* on the surface of the body."[8]

The latter school, represented most notably by James Walvin, Eldred Jones, Edward Scobie, and David Dabydeen, is less worried about the anachronistic "problem" of race as a category and finds its resistance in analyzing the racism within representation as well as in a focus on uncovering images and records (preferably empowering) of African diasporic peoples in Europe. Both models are (or should be) antiracist, but one attacks the foundations of the category and its effects in the name of historical accuracy, while the other more overtly sees history as a battleground to be reclaimed in the name of accuracy. As Ann DuCille notes of the relationship between postcolonialism and Afrocentrism, although both are resistance narratives that propose "therapeutic antidotes to the imposed alterity of imperialism," they inhabit different positions within the academy.[9] For this reason, current work in race, even while drawing from this earlier work, in some ways posits "black presence" studies as the "other" that we must distance ourselves from, witnessed by Ania Loomba's assertion that: "The notion of 'race' must transcend the black presence in the plays and inform

understandings of gender, the state, political life, and private existences, otherwise the 'others' within Shakespeare as well as in the Shakespeare academy or classroom will be granted only a token legitimacy which will disguise, among other things, the dynamic and intricate intersections of these categories in the creation of Renaissance culture as well as our own contemporary cultures."[10] Even though Loomba's essay primarily critiques a certain school of liberal feminism within Renaissance studies, this particular call to "transcend" black presence studies interestingly is based both on the need for more dynamic conceptions of race and on a desire for full academic acceptance/legitimacy. Loomba foregrounds an issue that is at most watermarked on the pages of other scholarship: the insistence that race is fluid is not only a call for historical accuracy and a refusal simplistically to hunt for racism in Renaissance texts, but also a need to make this work legitimate by distancing it from other resistance discourses like Afrocentrism. This very truncated genealogy admittedly collapses, within the rubric "black presence studies," largely ignored work by scholars in academically valued disciplines with authors more associated with the academically degraded discourses of Afrocentrism. I do this in part because I want to hold onto the notion that both types of earlier work (and related political struggles—black nationalism, the black-is-beautiful movement, the Black Arts movement) helped create the current historical moment in which "race" is a valid (even if greeted skeptically) arena of inquiry within Renaissance studies.[11]

Moreover, as what used to be called a "race" woman and feminist, I find I cannot easily abandon or transcend black presence studies. I, too, would like to find some "real" black women who are not given to me through the scrim of white ethnocentrism/racism. In this sense, I have a lot of sympathy with black presence studies, although my training and sympathies lie within another mode. Interrogating the category "race" is not a worthwhile endeavor if it makes no connection to the realities of people's lives and does not take into account that desire to know "who she actually was"—to know more about the real people who lurked behind the representation. As John Berger notes, artworks are particularly answerable in this regard since "No other kind of relic or text from the past can offer such a direct testimony about the world which surrounded other people at other times."[12]

More to the point, a focus on visual culture—which is for me also linked to the issue of black presence—means that the very attempt to seek out images of black people makes one rely on visual schemas and thus risk losing the more contradictory, nuanced sense of race which is the goal of current critical practice. What part do I play in racial construction when I base my data on visible signs of race? Gathering material privileges the gaze, which in turn gives the illusion that race is an actual fact, something that can been seen and identified. I somewhat precariously move from the discursive and social to the biological and genetic. For example, when I "read" Michelangelo's black chalk drawing of Cleopatra as "black" (Figure 118), identifying

118. Michelangelo Buonarroti. *Head of Cleopatra*. Ca. 1533. Black charcoal on paper. Gabinetto dei Disegni e delle Stampe, Florence. (Photo: Scala/Art Resource, NY)

"the so-called bodily insignia—black skin, thick lips . . . and the rest—which appear to function as foundational," does that reinscribe a racism based on taxonomy and visual cues? I am, after all, recategorizing her—not as a representation of Cleopatra, but as a black woman—because she "looks" black. On the other hand, if I assume her whiteness, I renormalize that quality and make blackness once again invisible.

Stuart Hall eloquently captures the dilemma of blackness in visual culture in his work on Fanon and "the constitutive role of the look":

However, the body in Fanon's text is both a privileged and ambivalent site of strategic intervention. . . . In the "epidermalization" of the racial look, Fanon tells us, exclusion and abjection are

imprinted on the body through the functioning of these signifiers as an objective taxonomy—a "taxidermy"—of radicalised difference; a specular matrix of intelligibility. . . . It is therefore sometimes tempting to believe that these are indeed the "evidence" rather than the *markers* of difference. We mis-take their function as signifiers for their biological fact and thus read "race" as the product of a genetic or biological schema rather than as a *discursive regime*.

Many visual practices influenced by poststructuralist and psychoanalytic ideas seem to have managed to evade a foundational materialism, only to allow "the body" to make a surreptitious return as a sort of "token" of the material, a terminal signifier, which brings the discursive slide, the infinite semiosis of meaning around "race" to an abrupt halt.[13]

Hall, as usual, precisely hits on the methodological and political problems posed by the visual. However, I would argue that he speaks from the vantage point of modern visual culture and thus renders the idea of the "discursive regime" as a concept that can save readers from a corrupt materialism in a way that may be too easy for an early modern terrain that we have only just begun to excavate. When confronted with the mere image (and a corresponding lack of art/historical work) the "infinite semiosis of meaning" of race is at once too infinite and too sparse. We are still looking for evidence that suggests historical agents, not just markers that make for a more complex and "multicultural" early modern world.

Cliff mentions that the *Black Venus* is one of many black images in her collection, indicating that she considers such images part of black women's history even as she recognizes them as images designed to serve the psychological and social needs of increasingly colonizing countries.[14] Art objects have the capacity to bring the past to the present in an immediate way,[15] and this figure offers to her viewers a tantalizing hint of a black woman behind a mask—a person, a subject. To do recuperative work in this period, we need to think in more nuanced ways about such images or risk "*white-washing*" European history and culture and losing our place within it.

In this vein, I'd like to think for a moment about the assumptions Cliff reads into this sculpture. While Cliff is perhaps justified in asking whether the woman was a slave, Edward Scobie, Paul Edwards, and others give convincing evidence of a free black population in Europe.[16] Black men came as translators, students, ambassadors, sailors, and soldiers. Unfortunately, these authors give us precious little indication of the lives free black women might have led, although their work at least suggests the possibility of a population of free black women.[17] Cliff also assumes that objectification works in a monolithic fashion. Do all representations objectify in the same way and for the same reasons? The silent and pregnant "Moor" in *The Merchant of Venice* and the pregnant Queen Anne of Denmark who appears in blackface in Jonson's *Masque of Blackness* both "represent" black women in some fashion, but they perform different functions and seem to be "Africanist" presences. One cannot imagine an original model the way one might—albeit with difficulty—for the *Black Venus*.[18]

Cliff's confident assertion that she is an object "then as now" assumes that there is

no space between the original moment—the black model with the artist/spectator—and the material remains of that initial encounter that are left to us as an artwork, which does not leave much room for resistant readings. I suspect that she/we read such representations differently because we have experienced a history of rather rigid stereotypes about black women. Certainly the point has been made by feminist art historians that visual art, particularly portraits, objectify white women: "the portrait of a beautiful woman belongs to a distinct discourse from which the woman herself is necessarily absent."[19] Are black women then any different? The answer is obviously yes. Even though white women have been objectified in Western art and have been largely effaced from history, there is still much more evidence of their presence than of black women. Moreover, "the African woman is even less likely than the Englishwoman to represent herself,"[20] while the growing scholarship on early modern white women writers demonstrates the increased likelihood that at least some white women's voices can be heard behind male representation. As I will discuss later, the absence of a deeper black woman's history and self-representation increases the depersonalizing effects of these images.

Highly aestheticized images such as the *Black Venus* capture Cliff's imagination (and Scobie's and mine) because their beauty provides a counterweight to such mockery and suggests some moment of fluidity when black women existed outside of the reigning racial stereotypes that are so common today. As Allison Blakely comments in his study of racial representation in Dutch culture, "these works exude a vitality that demands recognition of their originality and sensitive regard for the subjects treated."[21] Beauty does suggest approval and attribute value,[22] but I find my own attraction suspect since a focus on "abstract conceptions of corporeal form, beauty and aesthetic value" also mystifies power relations, particularly issues of dominance and submission.[23]

Visual culture offers both a more powerful and a more perplexing sense of the possibilities for black women in early modern representation. This essay will review several types of representations, less to give readings of the images than to reveal the problems and possibilities with this type of work. In many images, black women become a "paradoxical combination of the socially peripheral and the symbolically central."[24] What we find is a range of textual and stage representations that depict black women as ugly and oversexed that can be juxtaposed with highly aestheticized images of black women as chaste, knowledgeable, noble and yet alluring. As Peter Erickson notes, images of black women are quite variable: "in non-religious situations that include a black woman, spatial relations are harder to read because they appear less hierarchically fixed, more capable of multiple scenarios."[25]

Hendrik Goltzius's *Dawn*, part of his *Creation* series (Figure 119), depends on the opposition between a masculine, transcendently white male light and a feminized,

119. Hendrik Goltzius. *Dawn*, detail from *The Creation*. Ca. 1590. Engraving. Print Room,
University of Leiden.

almost conquered darkness. Her body is not so much black as it is embedded in dark-
ness. As is somewhat common in visual representations, she is isolated, pushed aside
by the two angelic, yet warlike, males who wield the phallus. So too, the servant
woman in a sixteenth-century *Birth of the Virgin* (Figure 120) is surrounded by white-
ness, from the headdress and inner collar to the linens draped over the basket and
the white, directing hand by her face and chest. Unlike the other servant women in

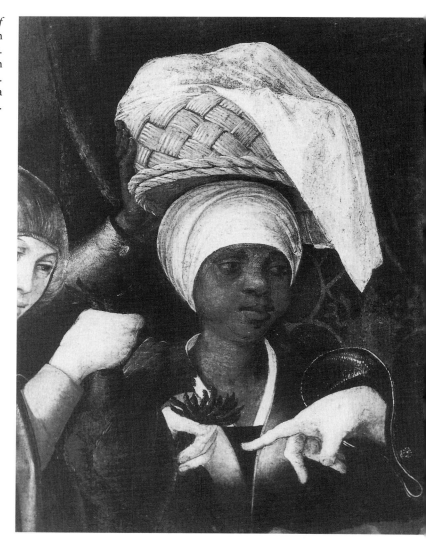

120. Anonymous. *Birth of the Virgin* from polyptych *Life of the Virgin* (detail). First half of sixteenth century. Oil on panel. Duchess of Palmela Collection, Sesimbra.

the painting, her eyes are neither on a task nor on the birth mother. It is almost as if blackness, already highly visible, must be reframed and made "noticeable" in some new way.

In many representations, the allure of blackness is linked to more material interests in black women's fertility and productivity. Black women's fertility becomes increasingly significant, particularly in the sixteenth and seventeenth century when Europe becomes more dependent on the slave trade. Jennifer L. Morgan notes of travel writing, "Writers who articulated religious and moral justifications for the slave trade simultaneously grappled with the character of the female African body—a body both

desirable and repulsive, available and untouchable, productive and reproductive, beautiful and black."[26] Several of the elements Morgan finds in travel writing are rendered visually in a rather ethnographic Eeckhout painting, *Mother and Child* (Figure 121). Instead of the transcendent, spiritual whiteness typical of the religious allegory of Madonna and Child, this mother and child are linked through their blackness to more earthly and exotic concerns. The mother is located firmly within economically based discourses of fertility; she is, in Morgan's words, both productive and reproductive. The basket of fruit on the right hand symbolizes her capacity as worker and cultivator—her productivity, while the child under her left hand potently figures her reproductive capacity. The phallic and suggestively placed ear of corn simultaneously marks both figures' reproductive promise. The image seems compelled to remind the viewer of popular stereotypes of black male sexuality by prosthetically enhancing the child's penis and pointing toward her covered genitals.

The bird the child holds in the other hand and the pearls the woman wears again locate them within a traditional iconography of blackness.[27] Both closed and exposed, between nature—the foliage on the left, and culture/trade—the harbor and some sight of production on the right, this woman figures the erotic and exotic possibilities of European travel. Her child's lighter skin hints at a range of overlapping possibilities: a more nuanced sense of the variety in "black" skin, an absent white father or an old stereotype that African children were born white and became darker as they grew older.

More commonly, secular paintings include black women as indicative of sensuality in more subtle ways that support Scobie's assertions about the interest in the sexuality of black women. In the Mignard portrait of Louise-Renée de Kéroualle, the duchess of Portsmouth, the obvious adoration of the relatively asexual black girl is charged by her position in the portrait as she holds over the countess's lap a conch shell full of pearls that represent eroticism. Rubens's *Venus Before the Mirror* (1616) seems to fracture the associations of Venus with blackness in the Cattaneo sculpture and here simply accentuates the sensuality of the Venus whose white body—flowing outward—seems to dominate the portrait (Figure 122). In contrast, the black woman is "cropped and compressed." The effect is "simultaneously to separate the two women and to draw them together."[28] Venus becomes associated with the gold, red, and white of European poetic beauty. Her attendant's dark arm is entwined in the gold hair and they are further linked through the red in the coral necklace (associated with Africa) and the ruby arm band. As Erickson further points out, the attendant's gaze makes us focus our attention on Venus's face.

In Van Dyck's *Amaryllis and Mirtillo* (1631–32), the black woman is more visually dominant (Figure 123). Aesthetically, she serves to complement a certain balance of light and shadow. The exposed body of the nymph in the lower right corner glows whitely in the dark shade of the trees and the red drape diagonally opposite to the sun-

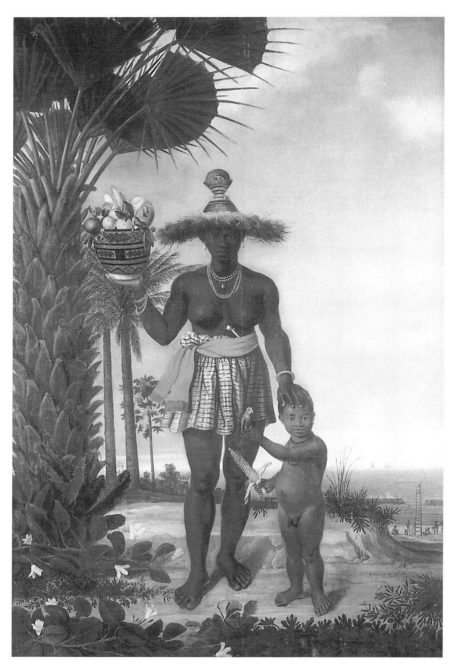

121. Albert Eeckhout. *Mother and Child*. Ca. 1640–1645. Oil on canvas. National Museum of Denmark, Department of Ethnography. Photo: Lennart Larsen.

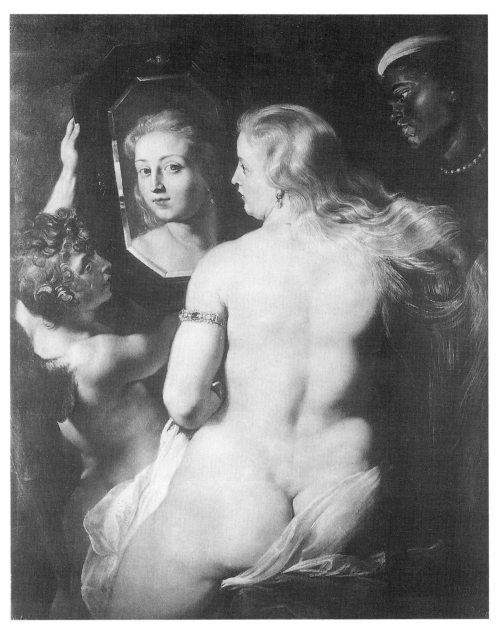

122. Peter Paul Rubens. *Venus Before the Mirror*. 1616. Oil on canvas. Liechtenstein Palace, Vienna. (Photo: Giraudon/Art Resource, NY)

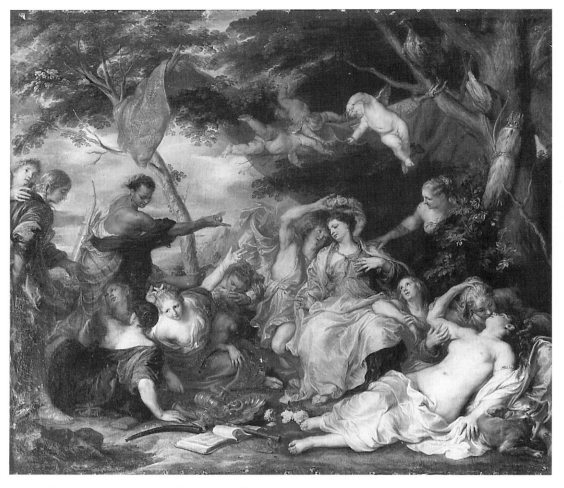

123. Anthony Van Dyck. *Amaryllis and Mirtillo*. 1631–32. Oil on canvas. Kunstsammlungen Graf von Schönborn, Pommersfelden, Germany.

shine. In contrast, the black woman stands out from the open air and directly across from the enclosed right side. As with other black figures, the symmetry here is broken and unstable. She focuses the spectatorial relations of the portrait. Even though she looks downward at the nymphs kissing, her strong forearm directs the viewer's attention to the couple and the red drape recirculates the attention back to her.

The scene is drawn from the pastoral tragicomedy *Il Pastor Fido*, in which Amaryllis orders a "kissing warre" amongst the nymphs in which she is judge. Mirtillo disguises himself as a woman and wins the contest. At the moment of the portrait he is chivalrously removing the winner's wreath and giving it back to Amaryllis; their kiss fulfills an oracle's promise which breaks the curse on Arcadia. This extremely sensu-

ous painting is characterized by transgression: both in Mirtillo's disguising himself to encroach on the all-female space and in the rather enthusiastic kissing of the nymphs, some of whom (the couple on the right and the one right under her hand) are too busy kissing to notice that the contest is over. The black woman presides over this scene of transgressive sexuality and her blackness may in fact work to estrange the scene, to place it as similarly exotic and "other."

Narrative and Image: The Queen of Sheba and Colonization

Narrative and visual representations of the Queen of Sheba suggest the complexity and resonance of images of black women. Sheba seems to have been a significant presence in the European imagination; her image offers a chance to trace the response of an early modern image to evolving racial ideologies. Although sexuality plays a part in her story, she does hint at a more liberating history. To put it bluntly, she is a black woman with a brain. Her wisdom is a key part of her story and her relations with Solomon. In her many incarnations, she is associated through a history of biblical exegesis and typology with other queens or ruling women who are themselves associated with Africa or blackness. These women—Sheba and Candace, queens of Ethiopia; Zippora, Moses' first wife; the Bride of the Song of Songs—all begin their early history as merely "blackened" symbolically, but in a sporadic fashion their blackness becomes increasingly racialized as their narratives are adapted to colonial interests.

Louise Olga Fradenburg's commentary on the mythic functions of queens usefully illustrates their representational force:

queens—always outsiders, so often foreigners—were easily distrusted, their mysteriousness easily imagined as secret intrigue, witchcraft, hidden poison working its way through the natural or the body politic. But, being liminal figures—such as the wild people also were—queens could be identified with "land," "people," "nation," their liminality serving the very principle of identity—of the invulnerability rather than the vulnerability of the body of the realm. Queens themselves, then, are talismanic; they are a potential threat—a foreign body let in through open and even decorated gates, capable of causing internal torment—turned into an aegis of protection, a banner under which to ride against the enemy (hence, the *divina virago*).[29]

The biblical African queens mentioned above alternatively represent land, people, and nation and embody a liminality that makes them potent symbols for the difficulties of incorporation of peoples, whether though conversion, colonization, or military conquest. All of these women engage in marriages which come to represent their conversion and salvation; some are "turned white" and thus inhabit the ground of possibility between such structuring oppositions in Western culture as East/West, white/black, Christian/pagan. Sheba in particular embodies both inspirational force

and potential threat when she comes to be identified with Ethiopia in highly specific ways.

Sheba becomes a talismanic figure with the advent of Atlantic colonial trade—her story promises great wealth brought without contest to a powerful, wise, rational, white male. Her wisdom validates and makes authoritative this recognition of Solomon's (colonial) power; however, her sexual allure suggests that she is also a potential threat to male rule. Hearing of his wisdom, she visits his kingdom laden with wealth in order to "prove him with hard questions" (Geneva Bible, 1 Kings 10:1). After meeting Solomon and seeing his house, "she said unto the King, It was a true word that I heard in mine own land of thy sayings, and of thy wisdom. Howbeit I believed not this report, till I came, and had seen it with mine eyes: but lo, the one half was not told me: for thou hast more wisdom and prosperity, than I have heard by report. Happy are thy men, happy are these thy servants, which stand ever before thee and hear thy wisdom" (10:6–9). The original biblical verse does not give her a nation of origin, but she quickly becomes associated with Ethiopia. For example, in the Geneva Bible, the marginal gloss notes, "Josephus saith that she was queen of Ethiopia and that Sheba was the name of the chief city of Meroe, which is an island of Nilus" (1 Kings 10:2a). In other versions, she is said to be from Arabia. Her connection with Ethiopia is theologically important because Ethiopia is seen as the "dark region" which has not yet been touched by the Gospel.[30] Their meeting symbolizes ministry to those outside the faith and prefigures the marriage heralded in the Song of Songs which itself is said to represent the "union of spiritual Law with the Gentile nations, which in turn foreshadowed the universal Church."[31]

In this association, Sheba is, like the Bride, "black and comely." The blackness is associated with the belief that Ethiopes were a "sun-burned" people, but Sheba's (and the Bride's) blackness is said to come from their being too far from the "spiritual" sun and thus in darkness. Hence we see the dark/light dichotomy playing out across geographic and spiritual lines. Those allegedly closest to the actual sun are those farthest from the light of grace and are therefore doubly "black." In the fifteenth-century Soudenbalch Bible, she embraces the bridegroom while being looked upon by the "white" daughters of Jerusalem.[32] Her blackness in these images seems predicated on the potential whiteness brought by conversion: "the wanton bride Israel might be 'in the end beautiful' when fidelity to the right man, a willingness to be ruled by him, are revealed."[33]

This fidelity and willingness to be ruled are equally important to the Sheba narrative's colonial and religious valences. Sheba seems to become an increasingly important figure for biblical exegesis during the twelfth century. Visual representations at this time demonstrate that she is not yet attached to a fixed racial ideology; that is, her blackness is neither wholly negative nor associated with a specific culture. In an enameled plaque by Nicolas of Verdun, she appears in front of the enthroned and sceptered

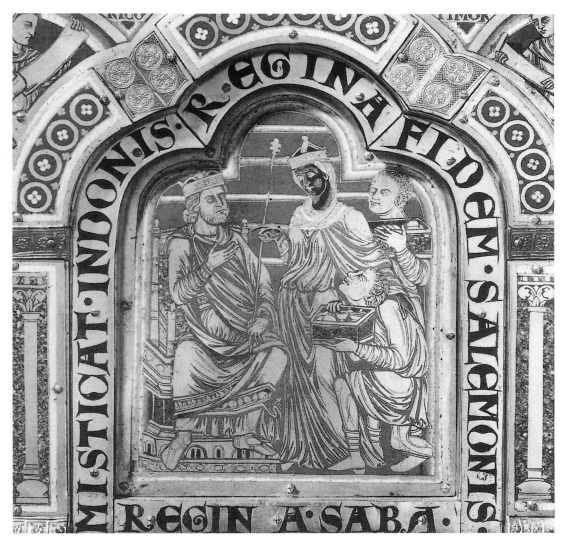

124. Nicolas of Verdun. *Solomon and the Queen of Sheba*. 1181. Enameled plaque of an ambo. Museum des Chorherrenstiftes Klosterneuburg, Klosterneuburg, Austria.

Solomon as black but with blond hair (Figure 124). The accompanying legend, "In the mystery of her gifts the queen reveals the faith to Solomon," gives her an unprecedented stature in the Solomon story as a bringer of faith. Hans-Joachim Kunst points out that Sheba and her attendants are almost mirror doubles: she is painted black with European features, while they are fair skinned with African features. "By giving the Queen a swarthy complexion he wanted to indicate that she represented a distant foreign country; while the classical European features made it clear to the observer she

was the wise king's equal, which in turn made Solomon himself appear even grander by the application of the tacit principle that he to whom great queens pay homage must indeed be mighty himself. Similarly the fair skins of the queen's followers serve to stress her dignity and might."[34] Kunst's analysis suggests a significant racial issue in the Sheba story: blackness at this point does not yet automatically imply servitude. The obeisance of a black woman becomes devalued when it does.

In some fourteenth-century images of Sheba, she and her servants' skins are painted dark blue, evidently to distinguish them from the devil and his minions, who were typically painted black (Figure 125). In these, as in the Klosterneuburg plaque, Sheba is a mediating figure, compositionally always on par with, but between Solomon and her own servants, who represent the people who will be converted. For example, the legend over the scene reads "this image represents typologically . . . the people coming to Christ."[35] The hand gestures suggest that the servants are offered, along with gifts: Sheba is fixed between Solomon and the servants. Her head and hand offsetting their fair skins, she seemingly brings "Africa" to Solomon.

A most elegant Sheba appears, again with blond hair and European features, in a 1405 military treatise, *Bellifortis*. Blackness does not appear to be connected to a racial identity—"her genealogy is uncertain and her place of residence variable";[36] however, the image does operate on a Manichean grid in which white is originary and good. As Jean-Marie Courtès points out, "the salvation of the black people, real or symbolic, supposes a mutation, a return to whiteness."[37] By the time this Sheba makes her appearance, another more misogynist tradition of Sheba, seeming to originate in France, takes over and lessens her prominence. The virtuous Solomon is said to fall into sin because of the wiles of his foreign wives, who seem to be represented by the Queen of Sheba:

But King Salomon loved many outlandish women: both the daughter of Pharaoh & the women of Moab, Ammon, Edom, Zidom, and Heth, Of the nations whereof the Lord had said unto the children of Israel, go not ye in to them nor let them come in to you: for surely they will turn your hearts after their Gods. To them I say did Salomon join in love. And he had seven hundred wives, that were princesses, and three hundred concubines, and his wives turned away his heart. For when Salomon was old, his wives turned his heart after other gods: so that his heart was not perfect with the Lord his God, as was the heart of David his father. (1 Kings 11:1–4)

This story of Solomon's dotage almost reverses the dynamic outlined by Fradenburg. The queen who proved Solomon's invulnerability comes to represent those queens who make him vulnerable. Within this narrative, rather than being on an equal footing with Solomon, Sheba is depicted as "above" or "leading him." She becomes the dominating temptress who puts Solomon to the test, this time in a losing contest. In the 1430 image from *Speculum humanae salvationis* (Figure 126), her dominance can

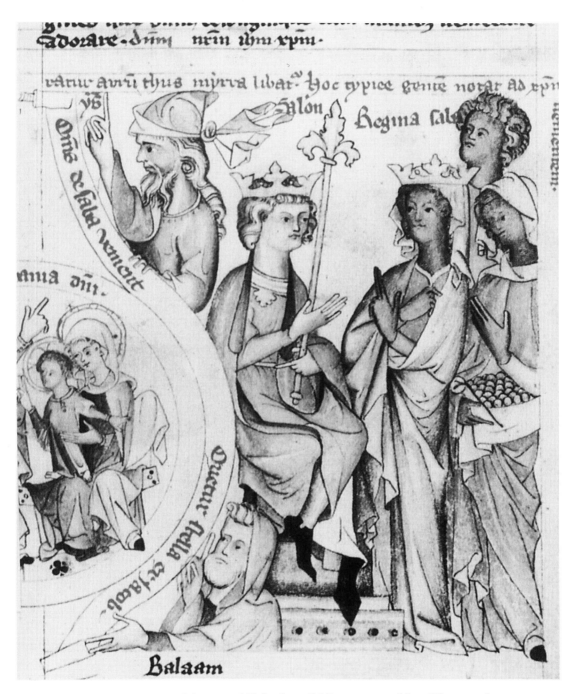

125. *Solomon and Sheba*, from *Biblia pauperum*, fol 2r. Klosterneuburg, 1330–31. Osterreichesche Nationalbibliothek, Vienna.

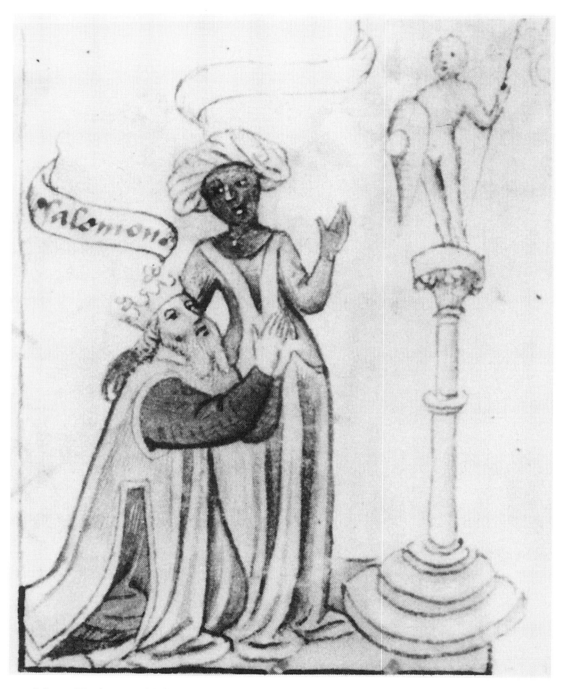

126. *Solomon Worshipping Idols* from *Speculum humanae salvationis*, fol. 16r. Lübeck, 1430.
Royal Library, Copenhagen.

be seen more clearly in the stance of the two figures: he appears to be kneeling both to her and the idol, as she is shown slightly leaning over to instruct him. This posture seems iconic/typical, as it appears in a seventeenth-century Jordaens painting of Solomon as well as in Rembrandt's drawing of Solomon tempted into idolatry. Her foreignness seems key to the liminality of Sheba. She is both learned convert and evil temptress, the "gate" through which Christians can change others or through which they can be changed themselves.

Like the Black Magus or the myth of Prester John, the story of the Queen of Sheba comes to articulate a desired profitable relationship between Christianity and colonialism as well as to suggest hope against fears of Islam. Instead of robbing or plundering a land by force, a wise ruler is given tribute by an awed and obedient black woman. In the final book of the *Geographical Description of Africa*, John Pory gives a version of Sheba's story which is in fact highly literalized and very specific to Africa. The inclusion of the biblical narrative concretely links religious modes of blackness to specific geographical and imperial/colonial concerns:

In times past Ethiopia was governed by Queens only. Whereupon we read in the history of the old testament, that the Queen of the south came to King *Saloman* from Saba, to hear his admirable wisdom, about the year of the world 2954. The name of this Queen (as the Ethiopians report) was *Maqueda*, who from the head-city of Ethiopia called Saba (which like an Isle, is environed on all sides by the river Nilus) travelled by Egypt and the Red sea to Jerusalem. And she brought unto *Solomon* an hundred & twenty talents of gold, which amount to 720000. golden ducats of Hungarie, that is, seven tunnes of gold and 20000 Hungarian ducats besides. This mighty sum of gold, with other things of great value, she presented unto Salomon, who likewise requited her with most princely gifts. She contended with him also in propounding of sage questions & obscure riddles.[38]

Pory's version of an Ethiopian matriarchy is notably unthreatening, partly because it is clearly a narrative of the past.[39] Another curious feature of this description is the specificity of the route and the materiality of the wealth, since the biblical 120 talents are turned into more specific and contemporary sums.

Pory maintains the reciprocity of the exchange of gifts in the Sheba/Solomon story. In the biblical verse, this is clearly a sign of mutual obligation and respect. However, other narratives make the gift seem less like mutual exchange and more like tribute. A narrative from Samuel Purchas's *Purchas His Pilgrimes* gives this truncated version of Sheba's visit in a discussion of Ethiopia and Prester John: "They doe honour themselves very much of the Queene of Saba, and they say, she tooke shipping in the port of Macua; and others affirme, that it was in Suaquen, and carrying great riches with her and Jewels of great value, she came to Jerusalem to see King Salomon, giving him great gifts, and returned from thence with child by the King, to her Kingdome."[40] Instead of receiving wisdom and exchanging material gifts, Sheba receives a child,

which suggests the enduring nature of the conversion. In these later colonial texts, Sheba seems to be used specifically to arouse a desire for riches. Colonial narratives indicate that Sheba and other African queens, rather than being threatening Amazons, are necessarily valorized because their power is used in the service of Christianity. Along with their discussions of Sheba, both Purchas and Pory evoke Queen Candace, who is said to be "the first Christian that this Land had."[41] Pory also mentions a later queen, Helena, who specifically is allied with Christians against an Islamic threat: "Howbeit Queene Helena, and after her king David, seeme only to have sought and desired some conjunction with the Romish church, and the Christians of Europe: to the end that with their powers and forces united, they might assaile and vanquish the Mahumetans, being most deadly enimies to the Christian name."[42] This brief history reveals how traditional Christian iconography and color symbolism become a fertile ground for the negotiation of colonial interests. All of these figures become associated with each other through their spiritual blackness and work to create expectations that women are only valuable and visible as domesticated in the service of the state.

Changing Contexts: "Mass" Production and Stereotyping

Collecting images of black women has been for me haunted by the search for a more immediate context than the generalized language of blackness. As we have seen, a painting often offers an allusion to a biblical, mythical, historical, or biographical narrative. The ostensible subject of the painting allows one to read a black figure into a narrative and to understand how it might resonate within that narrative. When I look at "mass produced" or multiply imitated objects, however, that method not only breaks down, it brings to the fore the quintessential problem of how blackness and black people are endowed with meaning if not subjectivity.

The popular cameos of black women circulated in the late sixteenth century share similar features with the *Black Venus*: they are alluring, devoid of personality and vaguely exotic. Another popular genre of cameo, the "Moor and Emperor" pairings are reminiscent of critic Judith Williamson's argument that women of color in contemporary advertising are rendered essential women in contrast to the specific connections to the social world offered to men;[43] as the customary name "Moor and Emperor" suggests, the man is given a familiarity of status, while the woman remains unlocatable, merely vaguely beautiful and exotic. The mass production of art objects becomes another source of difficulty: such items are somewhat more static and difficult to read.

What initially appears to be a rather intimate, more personal engraving—Wenceslaus Hollar's 1645 etching of a black woman (Figure 127)—acquires a similar lack of concreteness through the wide circulation of print images and demonstrates the dif-

127. Wenceslaus Hollar. *Black Woman*. 1645. Etching. By permission of the Folger Shakespeare Library, Washington, D.C.

ficulties of assessing subjectivity and uncovering a discursive context. Isolated images that neither appear within a visual narrative nor are accompanied by a text frustrate the desire to find a proper historical context, yet offer much more room for "reading." One art historian argues that Hollar is "nearer in spirit to a modern professional photographer than to a print-maker,"[44] and this almost documentary quality contributes to the sense of a subject behind the artwork. The etching, an isolated figure, yet reproduced in a number of contexts, paradoxically accrues meaning. However, any sense of agency I might attribute to the subject falls apart at the moment it seems within my grasp. Although nameless, when I first saw this image, she appeared to me to be a real woman, someone whose background I could begin to imagine as a valued servant or as part of a black Dutch community. Like the servant woman in *Birth of the Virgin*, this woman is surrounded by the whiteness of her linens, a detail that may in some ways mimic her social position. Of course, that feeling began to dissipate when I saw a painting obviously based on the engraving in a house in Kent. Even detached from the original, it still seemed to have a more specific meaning as a reminder of a former black woman servant. However, any sense of actual resemblance may have meant nothing to the owners; it is then a painting of *a* black servant, not a specific servant.

The early American miniature portrait *Negro Girl*, by Charles Zechel (Figure 128), has such a similarity to the Hollar engraving that it must be a copy (an alternative understanding might suggest that there is an iconography for blacks of a certain status); however, Guy McElroy, who reproduces it in his *Facing History: The Black Image in American Art, 1710–1940*, reads it as a portrait and suggests that such miniatures "hint at the existence of a small but self-sufficient middle-class in colonial America, most probably composed of free blacks, mulattoes, and servants who were adequately compensated for their work as laborers and domestics."[45] By now, I suspect that McElroy engaged in an act of imagination similar to mine when I saw Hollar's etching. He clearly wants to make this part of a resistance narrative and, although it is possible that this image represents a member of that "small but self-sufficient middle-class" that was not only free, but not even exploited ("adequately compensated"), the similarity to the earlier engraving certainly makes that doubtful and, at the very least, makes me wonder whether such blacks had a full range of choice in self-representation.

The feeling of intimacy I connected to the engraving disappeared entirely when I opened a copy of Thomas Duffett's *Empress of Morocco* at the Folger Shakespeare Library and saw what at first glance seemed to be the same engraving next to the frontispiece.[46] This 1673 farce, performed by the King's Company, parodies Elkanah Settle's *Empress of Morocco* and an earlier performance of *Macbeth*. It might go without saying that this is a clear example of the need for interdisciplinary methodologies. Evidently none of the textual work done on this play and the literary controversy it

128. Charles Zechel. *Negro Girl*. Ca. 1807. Oil on glass. The Art Museum, Princeton University, gift of Mrs. Gerald Wilkinson.

was enmeshed in was familiar with this iconography. A modern edition tentatively identifies it as "William Harris (?), the actor, represented as Morena"[47]—a major role. The card on this text at the Folger Shakespeare Library says that this is a "portrait of Griffin the actor" in the role of Laula and John Harold Wilson's work on the actor Cardell Goodman reproduces the Folger image as "possibly Goodman as 'Mariamne a Scinder Wench,'" both more minor roles.[48] This possible first print of a cross-dressed, blackface actor in England seems shrouded in uncertainty, and not simply because of the Hollar original. Not only do we not know who it is (which is due as much to the invisibility of the actors as to any racial notions), the image is our only indication that any actors appeared in blackface. Indeed Ronald Eugene DiLorenzo notes, "the 'Aunt Jemima' aspect of Duffett's frontispiece has caused one commentator to suggest that all of the performers in Duffett's burlesque wore blackface."[49] This critic relied on an admittedly contentious contemporary frame of reference—the American history of blackface minstrelsy—and anachronistically superimposed the caricatured head scarf and wide grin of the Aunt Jemima/mammy stereotype onto the linen headdress and somber features of the earlier image.

While I see no relation to the "mammy" figure, the striking similarity of these images suggests a movement from a type to a stereotype of a sort. It also raises several questions about the relationship between Hollar's engraving, the theatrical event, and the printing of the play text: Was the actor's costume in fact modeled on the Hollar engraving? Did an engraver create this image for publication without any reference to its original moment of production? Was the production actually in blackface or does the engraving simply give us the illusion that it was? What happened to the Hollar original in the twenty-odd years between his etching the black woman in Antwerp and the performance of *The Empress of Morocco*?

The clothing is clearly different enough to suggest that it is not a reworking of an engraving, but it also bears none of the assumed signs of farce or satire such as exaggeration, false proportion, or the grotesque. It actually seems intent on preserving the naturalized look that is a potent aspect of Hollar's work. The cost alone leads one to assume that the illustration is not simply an afterthought, but a significant part of the text. Unlike woodcut illustrations, engravings and etchings have to be printed separately from the letterpress and are much more expensive.[50] This frontispiece parodies Settle's earlier printed text,[51] which, if not the first printed play with illustrations, marketed the illustrations/etchings as part of the book commodity: *The Empress of Morocco, A Tragedy. With Sculptures. As it is Acted at the Duke's Theatre.* Indeed, whatever long-dead reference librarian identified this image as a "portrait" for the Folger in some ways marked a strange formality (strange for this context) of the reputedly parodic image. Nonetheless, the very formality and de-exoticization may be part of the larger parody. Elkanah Settle's early play was criticized for a lack of verisimilitude in part because he included a masque in the play which never could have been per-

formed in Morocco. Duffett's parody de-exoticized its original by moving the setting
from Morocco to Hot-cockles and by making the heroic ruling characters common
laborers (Morena, the eponymous empress, is an apple woman; the emperor a corn
cutter).[52] A reader of both texts would be struck by the contrast of the almost home-
spun single portrait with the energy and tropical excess of Settle's earlier engraving
showing "moors" dancing to African drums—an excess contained by the European
monumentality of the frame. One can imagine a similar contrast in the juxtaposition
of the frontispiece with the prologue's gibes at black women and European Petrarchan
convention:

> As when some dogrel-monger raises
> Up Muse, to Flatter Doxies praises,
> He talks of Gems and Paradises,
> Perfumes and Arabian Spices:
> Making up Phantastick Posies
> Of Eye-lids, Fore-heads, Cheeks and Noses,
> Teeth Orient Pearl, and Coral Lips are,
> Neck's Alabaster and Marble Hips are;
> Prating of Diamonds, Saphyrs, Rubies,
> What a Pudder's with these Boobies?
> Dim Eyes are Stars, and Red hairs Guinnies
> And thus described by these Ninnies,
> As they sit scribling on Ale-Benches
> Are homely-dowdy Country Wenches. (Duffett, 1-15)

The rather dignified contours of the Hollar original are reworked visually and discur-
sively by Duffett's play. Any idea that her blackness may be beautiful is here made
inconceivable and ludicrous by its distance from traditional European beauty.[53] The
class contrast of "homely-dowdy Country Wenches" being praised in the same man-
ner as aristocrats marks the contrast between the blackface servant and the eponymous
"empress."

Blackness here seems to signify beyond (or even against) context. Clearly an
image of a black person is "usable" across different registers. In this case, one might
even speculate that the interest in the black image might be linked to the media and
technology—the black and white—of print. Just as black cameos seem to have been
inspired in part by the new media—an influx of black onyx in the sixteenth-century
etchings seems to allow for a nuance of shade and light that escapes the broad strokes
of the woodcut. Hollar, with his evident interest in visual effect, and his successors
may have been intrigued by the technical challenge of "printing" black skin and con-
veying its contours along with the texture of the woman's dress and headlinens.[54]

While most scholars of race/racism (including myself) are comfortable with eco-
nomic explanations—that the more solidified notions and negative depictions of Afri-
can peoples are generated within a circuit of economic exploitation (and sexual fear)—
we have not yet given as much attention to the early role of multiply produced or
copied images that serve to stereotype, to fix in the mind a certain image that accumu-
lates cultural fears or fantasies. As Sander Gilman reminds us, the very word *stereotype*
refers to a method of casting multiple copies from a papier-mâché mold and thus to
a technological process of making multiple and immutable images.[55] In this case, the
printed reproduction seems to fix the meanings of "blackness" and remove the fluidity
that is characteristic of early modern texts.

Benedict Anderson argues that the "interaction between capitalism, technology
and human linguistic diversity" and the resulting developing dissemination of stan-
dardized printed vernacular texts formed the embryo of the "nationally imagined
community";[56] however, his claim does not take into account the circulation of "ver-
nacular" printed images. The same texts that helped foster that feeling of "imagined
community" through the common experience of a vernacular language may also have
produced enduring images of outsiders who are marked as outside of that commu-
nity. One might then view this portrait in the context of Hollar's etchings of national
clothes or "types" found in his *Ornatus muliebris Anglicanus* (1640) and *Theatrum
Mulierum* (1644). While that collection of types serves to identify national bodies, his
later etchings such as this young black woman and the bust of a Turkish man in a
flowered waistcoat (produced at approximately the same time) might identify them
as located outside of European borders.[57]

This startling range of interpretations produced in relation to the black woman's
portrait—from middle-class black girl to white actor in blackface to Aunt Jemima—
vividly demonstrates Stuart Hall's point that such "bodily insignia" and their mean-
ings are "not only constituted through and through in fantasy, but are really signifying
elements in the discourse of racism"[58] and also reminds one that "fantasy" is as alive
in the archives as on the street. More important, it gives a sense of objectification as a
process, with infinite variations. The person seeking the meaning of an image or of the
person behind the image will find layers of objectification, the loss of the subject to
time, to disinterest, and to a racist mapping of present stereotypes onto past images.

Individual sketches (rather than mass-produced objects like engravings) seem to
suggest more personality and give an impression of escape from this layering. Would it
have made a difference, I wonder, if Cliff had a postcard of Dürer's *Katherina* (Figure
129) in her collection? Dürer's drawing, while certainly part of his early ethnographic
impulses, does suggest a real woman behind the sketch, an individual with eyes down-
cast in modesty. It is this sense of the subject behind the art object that gives portraits
their representational force; however, in the case of European black women, the full-

1521

Katherina alt 20 Jar

129. Albrecht Dürer. *Katherina*. 1521. Silverpoint drawing. Uffizi, Florence.
(Photo: Foto Marburg/Art Resource, NY)

ness of the subjectivity one can imagine seems limited. For white figures, the subjectivity of the original is a key part of the power of a portrait. Richard Brilliant argues:

the oscillation between art object and human subject, represented so personally, is what gives portraits their extraordinary grasp on our imagination. Fundamental to portraits as a distinct genre in the vast repertoire of artistic representation is the necessity of expressing this intended relationship between the portrait image and the human original. Hans-Georg Gadamer called this intended relation "occasionality," precisely because the portrait, as an artwork, contains in its own pictorial or sculptural content a deliberate allusion to the original that is not a product of the viewer's interpretation but of the portraitist's intention.[59]

But what happens to the occasionality of portraits/images of black women where the sense of human originals is so distant? In reproduced engravings such as Hollar's, the occasionality seems lost in the multiplicity of images across continents and time. The focus on white male agents in European history allows us to fill in an imaged life of the original (or even to know details about that life); nonetheless, the same cannot be said for black women. While Rembrandt's sketch of a black woman who seems to be carrying water (Figure 130) suggests a particular historical moment and one can picture her walking through a street or house, the not-unusual isolation of the figure acquires a poignancy when one ponders the place of the woman in the household. Brilliant argues that "this vital relationship between the portrait and its object of representation directly reflects the social dimension of human life as a field of action among persons, with its own repertoire of signals and messages."[60] Unfortunately, that field of action requires a greater act of imagination when looking at black women in Europe. Did this water carrier have a cohort of servant-friends with whom she gossiped while carrying on household tasks? The compositional isolation, along with the scarcity of examples, makes it difficult to make any statements about individual renderings of black women, but they do all have a sense of "occasionality" and allow more scope for imagining actual women. This is even true of Rembrandt's *White Negress*; even though she probably represents a paradox within racial ideology—she is "white" with the features of "blackness"—one can imagine an original, perhaps unhappy, sitter.

Tellingly, Scobie's discussion of the *Black Venus* occurs in an essay that is putatively about the presence of black women in early modern Europe. Within his essay, the hope/project of "discovering" historical black women subtly mutates into the exercise of imagining their presence through the evidence of images. While one might fault him at times for lack of historical rigor, the attempt to invent a different narrative must also be applauded. And while I do not want to argue for an intellectual project that makes of the past whatever we want, this element of fantasy, this disruption of the imperialist glance is an important weapon in any arsenal of resistance. I may be able to imagine and possibly locate a different trajectory that produces a care-

130. Rembrandt van Rijn. *A Negro Servant*. Ca. 1650–51. Black chalk on paper. Private collection.

ful, yet rather more liberatory history. The images I have discussed in this essay suggest that there may be a great deal of latitude in how we "read" black women in this period. Rather than assume their objectification, I can begin to imagine women with an agency that is more than simply sexual. In this vein, I would like to close with the images of Katherina and Sheba—to see them, not as anonymous bodies on display for the pleasure of European men or as passive recipients of male wisdom, but as women who resist, talk back, and test the patriarch with "hard questions."

Notes

I thank the audiences who heard this essay at Fordham University, the University of Alabama—Tuscaloosa, the University of New Hampshire, and the Johns Hopkins University. I also deeply appreciate the energizing dialogue and true intellectual camaraderie generated by the members of the "Theorizing Race in Pre- and Early Modern Studies" seminar organized by Margo Hendricks at the University of California—Santa Cruz. Bonita Billman and Dave Hagan at Georgetown University provided invaluable help at critical moments.

1. Michelle Cliff, "Object into Subject: Some Thoughts on the Work of Black Women Artists," in *Making Face, Making Soul/Haciendo Caras: Creative and Critical Perspectives by Women of Color*, ed. Gloria Anzaldua (San Francisco: Aunt Lute Foundation Books, 1990), p. 271.

2. Toni Morrison, *Playing in the Dark: Whiteness and the Literary Imagination* (Cambridge: Harvard University Press, 1992), pp. 6–7.

3. Cliff, "Object into Subject," p. 272.

4. Ania Loomba, "The Color of Patriarchy," in *Women, "Race," and Writing in the Early Modern Period*, ed. Margo Hendricks and Patricia Parker (London: Routledge, 1994), p. 24.

5. Edward Scobie, *Black Britannia: A History of Blacks in Britain* (Chicago: Johnson Publishing, 1972), p. 216.

6. Audre Lorde, "The Transformation of Silence into Language and Action," in *Sister Outsider: Essays and Speeches by Audre Lorde* (Trumansburg, N.Y.: Crossing Press, 1984).

7. This scholarship was inaugurated by the volume, *Women, "Race," and Writing*, along with Ania Loomba's *Gender, Race, Renaissance Drama* and essays by Peter Erickson, Karen Newman, and Joyce MacDonald.

8. Stuart Hall, "The After-life of Frantz Fanon: Why Fanon? Why Now? Why *Black Skin, White Masks*?" in *The Fact of Blackness: Frantz Fanon and Visual Representation*, ed. Alan Read (Seattle: Bay Press, 1996), p. 21.

9. Ann DuCille, "Postcolonialism and Afrocentricity: Discourse and Dat Course," in *The Black Columbiad: Defining Moments in African American Literature and Culture*, ed. Werner Sollors and Maria Diedrich (Cambridge: Harvard University Press, 1994), p. 30.

10. Loomba, "The Color of Patriarchy," p. 26.

11. While there is not time to delve into this, there is a sense in which Afrocentric work, precisely because of its glorification of the black presence, actually does admit the fluidity (at least of notions of blackness) in early modern racial discourses.

12. John Berger, *Ways of Seeing* (New York: Penguin, 1977), p. 10.

13. Hall, "The After-life of Frantz Fanon," pp. 20–21.

14. Cliff's juxtaposition is telling. With the Venus, she has photographs of black women heroes and works by black women artists, who offer a presumably more "real," revitalizing history than the image of the Venus.

15. Berger, *Ways of Seeing*, p. 10.

16. Scobie, *Black Britannia*; Paul Edwards, "The Early African Presence in the British Isles," in *Essays on the History of Blacks in Britain: From Roman Times to the Mid-Twentieth Century*, ed. Jagdish S. Gundara and Ian Duffield (Brookfield, Vt.: Avebury, 1992).

17. In the eagerness to find "positive" representations (and given that a visible black woman is the exception in this period), some of this work does run the risk of only reading black women as special or extraordinary in some way. The "exceptional black woman" approach to black women's history and lives has been critiqued by the editors of *But Some of Us Are Brave* as well as by Elizabeth Higginbotham: "The 'exceptions' approach fails to depict a larger social system in which the struggles of women of color, whether successful or not, take place" (Elizabeth Higginbotham, "Designing an Inclusive Curriculum: Bringing All Women into the Core," in *Words of Fire: An Anthology of African American Feminist Thought*, ed. Beverly Guy-Sheftall [New York: The New Press, 1995], p. 483).

18. For more on the significance of the black/white binary in early modern racial ideologies, see my *Things of Darkness: Economies of Race and Gender in Early Modern England* (Ithaca: Cornell University Press, 1995).

19. Elizabeth Cropper, "The Beauty of Woman: Problems in the Rhetoric of Renaissance Portraiture," in *Rewriting the Renaissance: The Discourses of Sexual Difference in Early Modern Europe*, ed. Margaret W. Ferguson, Maureen Quilligan, and Nancy J. Vickers (Chicago: University of Chicago Press, 1986), p. 190.

20. Felicity Nussbaum, "The Other Woman: Polygamy, *Pamela*, and the Prerogative of Empire," in *Women, "Race," and Writing*, p. 141.

21. Allison Blakely, *Blacks in the Dutch World: The Evolution of Racial Imagery in a Modern Society* (Bloomington: Indiana University Press, 1993), pp. 86–87.

22. Wendy Chapkis, *Beauty Secrets: Women and the Politics of Appearance* (Boston: South End Press, 1986).

23. Rosemary Betterton, "How Do Women Look? The Female Nude in the Work of Suzanne Valadon," in *Looking On: Images of Femininity in the Visual Arts and Media*, ed. Rosemary Betterton (London: Pandora, 1987), p. 252.

24. Peter Erickson, "Representations of Blacks and Blackness in the Renaissance," *Criticism* 35 (1993): 506.

25. Ibid., p. 506.

26. Jennifer L. Morgan, "'Some Could Suckle over Their Shoulder': Male Travelers, Female Bodies, and the Gendering of Radical Ideology, 1500–1700," *William and Mary Quarterly*, 54, no. 1 (January 1997): 170.

27. Hall, *Things of Darkness*, pp. 240–53.

28. Erickson, "Representations of Blacks," p. 514.

29. Louise Olga Fradenburg, *City, Marriage, Tournament: Arts of Rule in Late Medieval Scotland* (Madison: University of Wisconsin Press, 1991), pp. 252.

30. Sheba is discussed in both books comprising volume 2 of *Image of the Black in Western Art* (Houston: Menil Foundation, and Cambridge: Harvard University Press, 1979). Part 1 is by Jean Devisse and contains an introductory essay by Jean-Marie Courtès; part 2 is by Jean Devisse and Michel Mollat. For Ethiopia as a "dark region," see vol. 2, part 1, p. 22.

31. Blakely, *Blacks in the Dutch World*, p. 98; quotation from *Image of the Black*, 2.1.15.

32. *Image of the Black*, 2.2.134–35 and fig. 136.

33. Fradenburg, *City, Marriage, Tournament*, p. 254.

34. Hans-Joachim Kunst, *The African in European Art* (Bad Godesberg: Inter Nationes, 1967), p. 11.

35. *Image of the Black*, 2.2.18.

36. Ibid., 2.1.129.

37. Ibid., 2.1.25–31 on the conversion of blacks to whiteness; quotation from p. 25.

38. Johannes Leo Africanus, *A Geographical History of Africa*, trans. and ed. John Pory (London, 1600), p. 396.

39. This is not to say that there is no lurking sense of a gendered threat. The question Pory chooses to "reveal" to the reader is Sheba's test of whether Solomon can see through cross-dressed disguise; she asks him "how he could discerne one sexe from another" (ibid.).

40. Samuel Purchas, *Hakluytus Posthumus or Purchas His Pilgrimes: Contayning a History of the World in Sea Voyages and Land Travells by Englishmen and others*, 20 vols. (Glasgow: J. MacLehose and Sons, 1905–7), 7:256.

41. Ibid., 7:16.

42. Africanus, *Geographical History*, p. 398.

43. Judith Williamson, "Woman Is an Island: Femininity and Colonization," in *Studies in Entertainment: Critical Approaches to Mass Culture*, ed. Tania Modleski (Bloomington: University of Indiana Press, 1986), pp. 104–5.

44. Edward Hodnett, *Francis Barlow: First Master of English Book Illustration* (London: Scholar Press, 1978), p. 136.

45. Guy McElroy, *Facing History: The Black Image in American Art, 1710–1940* (San Francisco: Bedford Arts Publishers, 1990), p. xi.

46. This seems to have been bound with the book by the book's owner. I have looked at copies in other libraries and on microfilm and have not seen the engraving in any of them.

47. Ronald Eugene DiLorenzo, *Three Burlesque Plays of Thomas Duffett* (Iowa City: University of Iowa Press, 1972), p. 6.

48. John Harold Wilson, *Mr. Goodman the Player* (Pittsburgh: University of Pittsburgh Press, 1964), frontispiece.

49. DiLorenzo, *Three Burlesque Plays*, p. xviii. The quotes around "Aunt Jemima" suggest the author's need to distance himself from the term. However, it has the effect of suggesting that he picked it up from the original source, which is not the case.

50. Hodnett, *Francis Barlow*, p. 8.

51. DiLorenzo, *Three Burlesque Plays*, p. xviii.

52. If Settle's work was performed in blackface, it may be that the literary struggle over verisimilitude is also a struggle over the appropriate use of blackface.

53. I say this even though the reference to "red hairs" suggests that it still refers to white women; the equation with "guinea coins" makes it part of the commodification of the slave trade. For more on the use of blackness in conventional descriptions of beauty, see my *Things of Darkness*, especially chapter 2.

54. Hollar's interest in texture and line can be seen in his prints of women with muffs as well as of muffs along with other ornamental wear. One particularly striking image contains five muffs with distinct patterns. See George Vertue, *A Description of the Works* . . . (London: W. Bathoe, 1759), 8:12–19, 23–24.

55. Sander L. Gilman, *Difference and Pathology: Stereotypes of Sexuality, Race, and Madness* (Ithaca: Cornell University Press, 1985), p. 15. For Gilman's early work on stereotypes, see also *On Blackness Without Blacks: Essays on the Image of the Black in Germany* (Boston: G. K. Hall, 1982).

56. Benedict Anderson, *Imagined Communities: Reflections on the Origin and Spread of Nationalism* (London: Verso, 1983, 1991), pp. 44–45.

57. Vertue's collection reproduces this paradigm by naming the section of portraits as "Portraits English and Foreign."

58. Hall, "The After-life of Frantz Fanon," p. 21.

59. Richard Brilliant, *Portraiture* (Cambridge: Harvard University Press, 1991), p. 7.

60. Ibid., p. 8.

EPILOGUE

PETER ERICKSON

The foregoing essays have opened up different avenues and it is not my purpose to channel these multiple initiatives in one direction so that they all fulfill the same agenda. Rather, by calling this concluding section an epilogue, I mean to signal that these remarks are not a summary but an addition and that this addition itself is highly selective. I shall be singling out one strand in order to provide a specific example from among the many possibilities for future development.

An important subtheme of this volume has been the issue of race, an issue which has emerged with full force in early modern studies only in the 1990s, at approximately the same time that the issue of homoeroticism has likewise come to the fore.[1] And each discussion has emerged in distinctly visual terms.

For same-sex erotic relations, the breakthrough book is James Saslow's *Ganymede in the Renaissance: Homosexuality in Art and Society* (1986). Though any alert reader will immediately start to think again about Rosalind's chosen name in Shakespeare's *As You Like It*, Saslow focuses primarily on Italian art, with a brief look at "Diffusion to the North" only in the final chapter. The Italian emphasis continues in Leonard Barkan's *Transuming Passion: Ganymede and the Erotics of Humanism* (1991) and in Patricia Simons's essays—"Lesbian (In)Visibility in Italian Renaissance Culture: Diana and Other Cases of *donna con donna*" and "Homosociality and Erotics in Italian Renaissance Portraiture."[2]

A more specific focus on the British visual connection emerges in Stephen Orgel's book *Impersonations: The Performance of Gender in Shakespeare's England* (1996) and the allied essay "Engendering the Crown" from *Subject and Object in Renaissance Culture* (1996). In the latter, Orgel revisits the iconography of Queen Elizabeth I's portraits—an area made virtually a trademark by Roy Strong, as Orgel's references attest—and rewrites the Renaissance yet again by finding an image of lesbian sexuality in the impresa of Peace and Justice embracing above the queen in the title page to Christopher Saxton's *Atlas of England and Wales*. Valerie Traub greatly expands the interpretive potential of this motif in "The Politics of Pleasure; Or, Queering Queen Elizabeth" in her forthcoming book, *The Renaissance of Lesbianism in Early Modern England*.[3]

For the study of race, the crucial moment is the fifth chapter of Kim Hall's *Things of Darkness: Economies of Race and Gender in Early Modern England* (1995), which is to date the single most important and concentrated discussion of the visual evidence of racial motifs in British Renaissance art. The distance we have traveled from Roy Strong's work can be indicated by reference to his 1965 article "The Ambassador: Sir Henry Unton," collected in *The Cult of Elizabeth: Elizabethan Portraiture and Pageantry* (1977). Although Strong notes the presence of black figures in a scene of festive

ritual, his response is to speculate in a purely symbolic realm about iconographic significance: "or, could we suggest, an allusion to the Queen, Elizabeth, as the moon goddess?"[4] In this way, blackness can be assimilated into an abstract pattern of day and night, light and dark. Strong's further reference to the *Masque of Blackness* nine years after the Unton portrait under a new monarch is part of the closed discursive circle since his interpretation continues to avoid the question of race, a term that becomes central in Kim Hall's alternative reading of Jonson's masque.[5]

We are still very much in the midst of the current developments I have just outlined but from within this as yet incomplete stage I want to raise a possible problem. Scholars of homosexuality and race seek to call attention to visual evidence that earlier criticism has passed over in silence and thus rendered invisible. But are these two new critical strands in danger of being silent with respect to each other? With only one contributor in common, the two 1994 landmark collections *Queering the Renaissance*, edited by Jonathan Goldberg, and *Women, "Race," and Writing in the Early Modern Period*, edited by Margo Hendricks and Patricia Parker, provide relatively limited opportunities for cross-connection.[6] Accenting the view toward future prospects, I would like to set our sights on a comprehensive framework able to encompass and coordinate the elements of homoeroticism and race as parts of the same larger critical conversation. My argument will be that it is particularly through the focus on the visual dimension that these two discourses can be brought together.

In this regard, Svetlana Alpers's approach to Rubens's *Drunken Silenus* (1618/20) offers a starting point for integrating the two modes of analysis. The odd conspicuous gesture of the black man's pinching Silenus's upper thigh next to the buttocks transforms him from an incidental background figure into an active player and thereby draws our attention to his racial status. When Alpers insists on the further sexual detail that the black man "follows so close as to appear to be penetrating the huge body from behind," she makes understanding the conjunction of homoerotic and racial motifs a necessary element in interpreting the painting.[7]

I can illustrate the challenge of combining the categories of same-sex eroticism and race by reference to Rubens's *Diana and Callisto* of 1637–38 in the Museo del Prado in Madrid (Figure 131). In a previous essay, I focused on the issue of race raised by the presence of the black woman in the painting. Having subsequently encountered Valerie Traub's discussion of Callisto in drama, opera, and painting in the seventeenth century, I realized that a fuller account would have to combine the two elements of race and same-sex erotic relations.[8]

Returning to Rubens's *Diana and Callisto* with Traub's essay in mind, I now see how the motif of reproductive heterosexuality, the reason for Callisto's impending departure from Diana's female circle, is counterpointed by an alternative sexuality. The heterosexual theme is accentuated if one accepts Julius Held's identification of Callisto with Rubens's second wife, Hélène Fourment, whom Rubens celebrates in portraits

131. Peter Paul Rubens. *Diana and Callisto*. 1638–1640. Oil on canvas. Copyright of Museo del Prado, Madrid.

of the two as a married couple or of Fourment as mother of their children.[9] This marital and familial context would give added emphasis to Callisto's pregnancy by placing Rubens in the triumphant role of Jupiter. The chastity represented by Diana, however, is also visibly eroticized.

While the inward-looking Callisto is gently comforted by the three women who encircle and touch her, Diana's far more demonstrative gesture of reaching out with hands open expresses ardent passion. This is not the conventional gesture of angry rejection and banishment inherited from Titian's *Diana and Callisto*, of which Rubens had earlier made a copy (Earl of Derby, Knowsley Hall, Lancashire, ca. 1630). The potential sexual current in Diana's revised gesture of passionate longing is rather indebted to another prior painting, Rubens's *Jupiter and Callisto* (Kassel, Staatliche Gemäldegalerie, 1613). Jupiter's stratagem is plausible only if we accept its premise that, despite our knowledge that Jupiter's female body is a disguise under which he is really male, we also respond to the visible sexual contact between two women.

To stop here, however, is to omit race. We would then be left with parallel readings of eroticism and of race among women that do not meet. Pertinent here is Kim Hall's discussion in this volume of Van Dyck's *Amaryllis and Mirtillo* (1631–32), which shows the copresence of explicit erotic expression between women and a dramatically central dark-skinned woman (see Figure 123).[10] Van Dyck's painting depicts a scene in which the ultimate heterosexual outcome is assured. The source, Guarini's *Pastor Fido*, presents the kissing contest among the women as a preparation for the more serious engagement with men that is certain to follow: "Let's prove among ourselves our armes in jest, / That when we come to earnest them with men, / We may them better use."[11] The irony of course is that a man—the cross-dressed Mirtillo—has already infiltrated the all-female group. His victory in the contest appeals to a simple premise: men make better kissers and this is a self-evident sign that they are the appropriate objects of female affection.

Yet the heterosexual triumph is neither total nor unambiguous. Even as the contest has ended, other options remain before us in the form of the female couples who continue actively to pursue their kissing. The distancing comic implication, that they do not know enough to stop because they do not realize that they have lost the contest and so proceed out of ignorance, is not sufficient to cancel their unmistakable ardor. The obliviousness stems from their intent focus, their undeniable positive engagement and enjoyment. Moreover, the orchestrating posture of the black woman enacts a complex intermediary role. While the sweep of her outstretched right arm and pointing finger direct attention to the heterosexual couple, she also serves as a key point in the more diffuse, overall circulation of sexual energy. Because her eyes look downward at the female pairs and her left hand holds the hand of one of the women still kissing, the visual effect is to make all erotic currents seem not only to flow through her but also to be embraced and recirculated by her. Her own armaments of bow and arrow identify her as an adherent of a Diana-like female band.

These two elements—erotic bonds among women and a strategically placed black figure—are also crucial in Rubens's *Diana and Callisto* (Figure 132). The sexual expression is more understated, but the ardor is clear; the woman of color is reduced to the social status of maid, yet she nevertheless plays a decisive role. Pursuing the question of how the black attendant functions with regard to the relationship between Diana and Callisto helps to identify a third point in the overall drama of physical gestures. In one sense, the maid seems completely peripheral. She is set apart because her subordinate position is marked by her cap, which contrasts with the white women's flowing, bejeweled hair, and by her crouching posture. She is further isolated because Diana does not acknowledge the intense physical action with which the maid hugs her lower body.

Yet, on another level, the maid's act of intervention makes her absolutely central by creating an effect of triangulation, through which she performs a complex set

132. Peter Paul Rubens. *Diana and Callisto* (detail). 1638–1640. Oil on canvas.
Museo del Prado, Madrid.

of mediations. In effect, it is the maid who insists on the integrity of the all-female group when she literally separates Diana from Callisto by holding Diana and blocking her movement toward Callisto. Moreover, the black woman's uncovered breasts link her to the other women remaining in Diana's circle, including Diana herself. Through the highly visual, symbolic display of breasts, the attendant is connected to the erotic current among Diana's peers, thereby allowing the seemingly marginal maid to gain a place in the larger action. She asserts her own claim on Diana by so vigorously protecting her and by implicitly providing a cross-racial alternative for the lost bond with Callisto. This vision of a wider drama enlarges our sense of what is happening in Rubens's painting. Combining the elements of homoeroticism and race thus provides one instance of the opportunities for further development that continue to emerge within our current critical moment at the beginning of the first decade of the new millennium.

"Watching from the Painting's Side"

In conclusion, I turn to one final example—the moment of contact between Tiepolo, himself a performer of Veronese,[12] and the contemporary Caribbean poet Derek Walcott. I summon this instance to serve as a symbolic marker that can help to define our current situation as scholars. Just as our vision of the future has taken on a postcolonial dimension, so our view of the early modern past has been reconfigured by a postcolonial interpretive framework.[13] Toward the end of his long poem *Tiepolo's Hound*, Walcott's focus on *Apelles and Campaspe* (Figure 133) brings past and future into sudden alignment, thus creating a unified postcolonial perspective.[14]

In this painting the convention by which the male artist—Tiepolo in the role of the painter Apelles—converts the female model into a desirable ideal image is shown to break down. The brush poised over the breast as though both to depict and to touch the nipple is stopped in its track as Tiepolo turns away from the canvas out toward the actual woman, who, neck and torso pulled back almost in recoil, looks askance. The painted face—the expressive ensemble of eyes, nose, and the set of the mouth—resembles the artist more than the model.

Svetlana Alpers and Michael Baxandall rightly describe Tiepolo as portraying himself as "discomforted," and he is discomforted in more ways than one. For, in addition to the dynamic play among the three prominent visual points of the artist caught between the model and the image on the canvas, there is a fourth conspicuous point: the black page who takes up a position so close to the artist that his head leans forward and edges over into the picture frame of the canvas. Tiepolo here represents the convention of the unobtrusive, decoratively exotic black attendant as disrupted. For the page has a noticeable, albeit quiet, intensity that makes a claim on our attention and

133. Giovanni Battista Tiepolo. *Apelles Painting the Portrait of Campaspe*. 1725–1726. Oil on canvas. Montreal Museum of Fine Arts, Adaline Van Horne Bequest. (Photo: Marilyn Aitken)

the artist's awareness. The claim is underscored by the formal symmetry of the parallel positioning of the page and Campaspe—on opposite sides their two tilted heads are equidistant from the artist in the middle.

Initially, it is the presence of the black figure at the scene of painting that gives Derek Walcott a seamless point of entry into the past from his location in the present, thereby making available to us a link between the early modern and the postcolonial:

An admiring African peers from the canvas's edge

where a bare-shouldered model, Campaspe with golden hair
sees her legend evolve. The Moor silent with privilege.

If the frame is time, with the usual saffron burning
of the ceilings over which his robed figure will glide

we presume from the African's posture that I too am learning
both skill and conversion watching from the painting's side. (p. 38)

The words "privilege" and "presume" stand out as tonal pressure points whereby Walcott with his customary suppleness and magnanimity manages both appreciatively to celebrate the continuity with a European cultural heritage and sardonically to register the need for cultural expansion and transformation.

The transformative possibilities resonate because Walcott is not limited to finding himself in the black page. Both as poet and as painter, Walcott also performs the role of artist and is the inheritor of Tiepolo's place. Ultimately, he is thus not only "watching from the painting's side" but occupying its very center. Since Tiepolo's discomforting is self-administered—consciously put on display—the resulting openness and vulnerability are part of Tiepolo's legacy. Nevertheless, Walcott has a further distance to travel because he has to overcome the effect of displacement caused by the way, from a European standpoint, his Caribbean location can be made to appear as the cultural periphery.

Walcott's work is postcolonial because it is forced to negotiate the uncertain relation between the established European tradition and the newly emergent traditions originated by artists of color hitherto dispersed and unrecognized at the geographical margins. Through the medium of Walcott's art, we too as critics undergo a related process of decentering and recentering, which changes the principles by which we understand the formation of a canon.[15] The consequent revision of artistic heritage is an essential part of our future scholarly activity, and Walcott helps us to see it.

Notes

1. Stephen Greenblatt's "General Introduction" to *The Norton Shakespeare* (New York: Norton, 1997) registers the impact of recent work in these two areas: see pp. 26–27 on same-sex eroticism and pp. 22–23 on blacks. An important assessment of the influence of new historicism is Steven Mullaney's "After the New Historicism," in *Alternative Shakespeares*, vol. 2, ed. Terence Hawkes (London: Routledge, 1996), pp. 17–37. The role of feminist criticism as a catalyst for new developments in the 1990s is discussed in my essay "On the Origins of American Feminist Shakespeare Criticism," *Women's Studies* 26, no. 1 (1997): 1–26.

2. Patricia Simons, "Lesbian (In)Visibility in Italian Renaissance Culture: Diana and Other Cases of *donna con donna*," *Journal of Homosexuality* 27, no. 1/2 (1994): 81–122; and "Homosociality and Erotics in Italian Renaissance Portraiture," in *Portraiture: Facing the Subject*, ed. Joanna Woodall (Manchester: Manchester University Press, 1997), pp. 29–51.

3. Although the British visual component, including especially *Queen Elizabeth and the Three Goddesses* of 1569, is limited to a footnote (p. 248, n. 6), Catherine Belsey's survey of the Venus-Cupid pairing in European painting deserves mention here for its analysis of the undifferentiated sexual orientation of the male viewer constructed by this motif—"Cleopatra's Seduction," in *Alternative Shakespeares*, vol. 2, pp. 38–62.

4. Roy C. Strong, *The Cult of Elizabeth: Elizabethan Portraiture and Pageantry* (London: Thames and Hudson, 1977), p. 104.

5. Kim F. Hall, *Things of Darkness: Economies of Race and Gender in Early Modern England* (Ithaca: Cornell University Press, 1995), pp. 128–41. See also Mary Floyd-Wilson's "Temperature, Temperance, and Racial Difference in Ben Jonson's *The Masque of Blackness*," *ELR* 28 (1998): 183–209, and Bernadette Andrea, "Black Skin, The Queen's Masques: Africanist Ambivalence and Feminine Author(ity) in the Masques of *Blackness* and *Beauty*," *ELR* 29 (1999): 246–81.

6. *Women, "Race," and Writing* does have index entries for homoeroticism, homophobia, and homosociality, while *Queering the Renaissance* has no corresponding index category for race or its equivalent. However, Jonathan Goldberg's subsequent book, *Desiring Women Writing* (Stanford: Stanford University Press, 1997), acknowledges race as a relevant issue and hence a more sustained overlapping of categories may already have begun.

7. "Creativity in the Flesh: The *Drunken Silenus*," chapter 3 in Svetlana Alpers, *The Making of Rubens* (New Haven: Yale University Press, 1995), p. 110 and n. 4, pp. 168–69. Alpers's description of Silenus's body image affords an interesting contrast with the Italian conception of the body as analyzed in Harry Berger's contribution to this volume. In the terms of Berger's coda, Silenus seems not nude but naked.

8. My earlier commentary on *Diana and Callisto* occurs in the section on pp. 507–15 in "Representations of Blacks and Blackness in the Renaissance," *Criticism* 35 (1993): 499–527. Valerie Traub's essay is "The Perversion of 'Lesbian' Desire," *History Workshop Journal* 41 (Spring 1996): 23–49.

9. In "Rubens and Titian," in *Titian: His World and His Legacy*, ed. David Rosand (New York: Columbia University Press, 1982), pp. 283–339, Julius S. Held writes: "Callisto will be what they deny themselves from becoming: a mother. It is hardly accidental that Callisto bears the features of Hélène Fourment, who in the ten years of their marriage became the mother of five of Rubens' children" (p. 324).

10. Valerie Traub also discusses *Amaryllis and Mirtillo* in the section "Theorizing Heterosexuality" in her introduction to *The Renaissance of Lesbianism in Early Modern England*. On the version of this painting in Pommersfelden as Van Dyck's original, see Arthur K. Wheelock's entry in *Anthony van Dyck* (Washington: National Gallery of Art, 1990), pp. 239–42, and Peter van der Ploeg and Carola Vermeeren, *Princely Patrons: The Collection of Frederick Henry of Orange and Amalia of Solms in the Hague* (Zwolle: Waanders, 1997), pp. 114–17. In *The Dutch Arcadia: Pastoral Art and Its Audience in the Golden Age* (Totowa, N.J.: Allanheld and Schram, 1983), pp. 107–13, Alison McNeil Kettering surveys other examples of the "Crowning scene"—a background against which the special qualities of Van Dyck's version stand out.

11. *Three Renaissance Pastorals: Tasso, Guarini, Daniel*, ed. Elizabeth Story Donno (Binghamton, N.Y.: Medieval and Renaissance Texts and Studies, 1993), p. 80.

12. I draw this formulation from the section "Performing Veronese" in Svetlana Alpers and Michael Baxandall, *Tiepolo and the Pictorial Intelligence* (New Haven: Yale University Press, 1994), pp. 21–30. Their discussion of Tiepolo's *Apelles and Campaspe* places it in the 1720s (pp. 10–11). In *Giambattisa Tiepolo, 1696–1770* (New York: Metropolitan Museum of Art, 1996), Keith Christiansen identifies the black attendant as "probably Tiepolo's servant Ali" (p. 84).

13. For the application of a postcolonial approach to the early modern period, see *Post-Colonial Shakespeares*, ed. Ania Loomba and Martin Orkin (London: Routledge, 1998), and my review in *Shakespeare Studies* 28 (2000). Also significant is the use of the term "Early Colonial" in

the introduction to *Subject and Object in Renaissance Culture*, ed. Margreta de Grazia, Maureen Quilligan, and Peter Stallybrass (Cambridge: Cambridge University Press, 1996), p. 5.

14. Walcott's poem appears in excerpted form in *The Dual Muse: The Writer as Artist, the Artist as Writer*, ed. Lorin Cuoco (Saint Louis, Mo.: International Writers Center, Washington University, 1999), pp. 19–38. The full version of the poem will appear in *Tiepolo's Hound* (New York: Farrar, Straus and Giroux, 2000).

15. In a British context, see Stuart Hall, "Whose Heritage? Un-settling 'The Heritage,' Re-imagining the Post-nation," *Third Text* 49 (Winter 1999–2000): 3–13; for the link to a visual-culture framework, see *Visual Culture: The Reader*, ed. Jessica Evans and Stuart Hall (London: Sage Publications in association with the Open University, 1999).

CONTRIBUTORS

Harry Berger, Jr. (University of California, Santa Cruz) has recently published three books, *Revisionary Play: Studies in the Spenserian Dynamics*, *Imaginary Audition: Shakespeare on Stage and Page*, and *Making Trifles of Terrors: Redistributing Complicities in Shakespeare*. His new book is *Fictions of the Pose: Rembrandt Against the Italian Renaissance*.

Karen C. C. Dalton (Harvard University) is co-author of *Winslow Homer's Images of Blacks: The Civil War and Reconstruction Years* and editor of the final three volumes of *The Image of the Black in Western Art*, covering the sixteenth through eighteenth centuries.

Peter Erickson (Sterling and Francine Clark Art Institute) is author of *Patriarchal Structures in Shakespeare's Drama* and *Rewriting Shakespeare, Rewriting Ourselves* and co-editor of *Shakespeare's "Rough Magic": Renaissance Essays in Honor of C. L. Barber*.

Susan Frye (University of Wyoming) has written *Elizabeth I: The Competition for Representation* and co-edited *Maids and Mistresses, Cousins and Queens: Women's Alliances in Early Modern England*.

Ernest B. Gilman (New York University) is author of *Iconoclasm and Poetry in the English Reformation: Down Went Dagon* and *The Curious Perspective: Literary and Pictorial Wit in the Seventeenth Century*.

Kim F. Hall (Georgetown University) has written *Things of Darkness: Economies of Race and Gender in Early Modern England* as well as essays on teaching the subject of race in Shakespeare's plays.

Clark Hulse (University of Illinois, Chicago) is author of *The Rule of Art: Literature and Painting in the Renaissance* and *Metamorphic Verse: The Elizabethan Minor Epic*. He is currently working on a study of Holbein and the age of Henry VIII.

Steven Mullaney (University of Michigan) has written *The Place of the Stage: License, Play, and Power in Renaissance England*. He is at work on two books, *Mourning/Misogyny: Cultural Faultlines in the Age of Shakespeare* and *Emotion and Its Discontents*.

Stephen Orgel (Stanford University) has recently published *Impersonations: The Performance of Gender in Shakespeare's England* and Oxford editions of *The Tempest* and *The Winter's Tale*.

Valerie Traub (University of Michigan) is author of *Desire and Anxiety: Circulations of Sexuality in Shakespearean Drama* and co-editor of *Feminist Readings of Early Modern Culture: Emerging Subjects*.

INDEX

ACKNOWLEDGMENTS

The co-editors are glad to have this opportunity to express our appreciation to the Sterling and Francine Clark Art Institute and to the Institute for Humanities and the Graduate College at the University of Illinois at Chicago for their generous support of the publication of this collection. Over the course of the project, we have been fortunate to have had a succession of excellent research assistants, Kristina Dziedzic, Elli Shellist, and Jonathan Walker, whose help with a wide range of tasks greatly contributed to the volume.

This volume was created along an imaginary line running between Chicago and Williamstown, a line that bridges time and history as well as distance, and is personal as well as intellectual. For Clark, the link between Chicago and Williamstown is woven into the life histories of his family in ways that will be understood by those who have been with him in both places. He and his wife Carolyn have spent twenty-seven of their first thirty years together in three places, of which Williamstown was the first.

During the time we were planning this collection, Peter's wife of thirty years died after a five-year illness. The volume is dedicated to her in recognition of the extraordinary courage with which she faced, endured, and fought the spinal nerve compression that deprived her of mobility. After she could no longer continue her beloved art work, Tay turned her creative energy to writing interlinked short stories, which was something she could still do while lying down, the position in which she was forced to spend her days. *Thinking About Light*, the title of her collection, originated in her view outside the window of the light filtering through the trees on the hillside in back of our house. Despite her severely restricted vantage point, the light became for Tay an image of aesthetic beauty and of ongoing redemptive power. "Stunned by the art of seeing," Derek Walcott speaks of his devotion to "the texture of light caught in paint." Tay and I experienced this light while working in Haiti in 1969–70; that's when Tay, a newly degreed English major, began to paint.